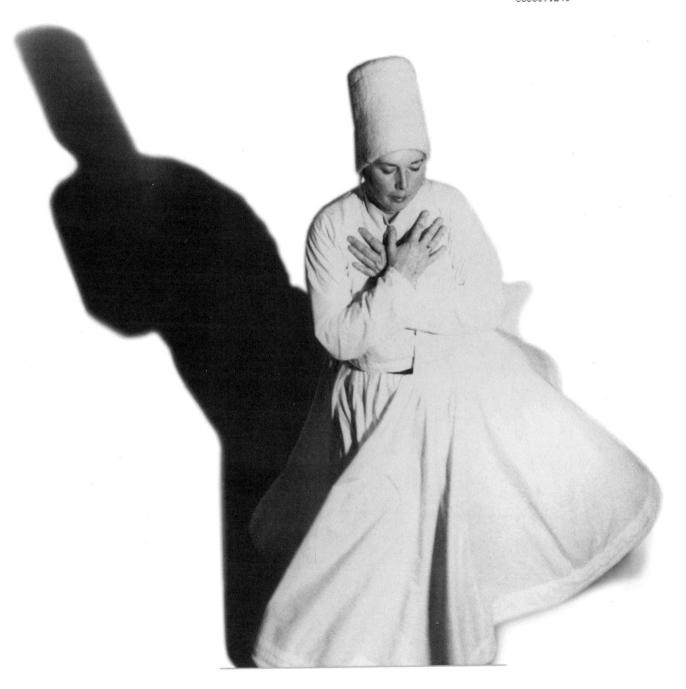

Believe me, everything which appears
is shadows and images.
The hand which draws them
is the hand of God . . .
 —*Rumi*

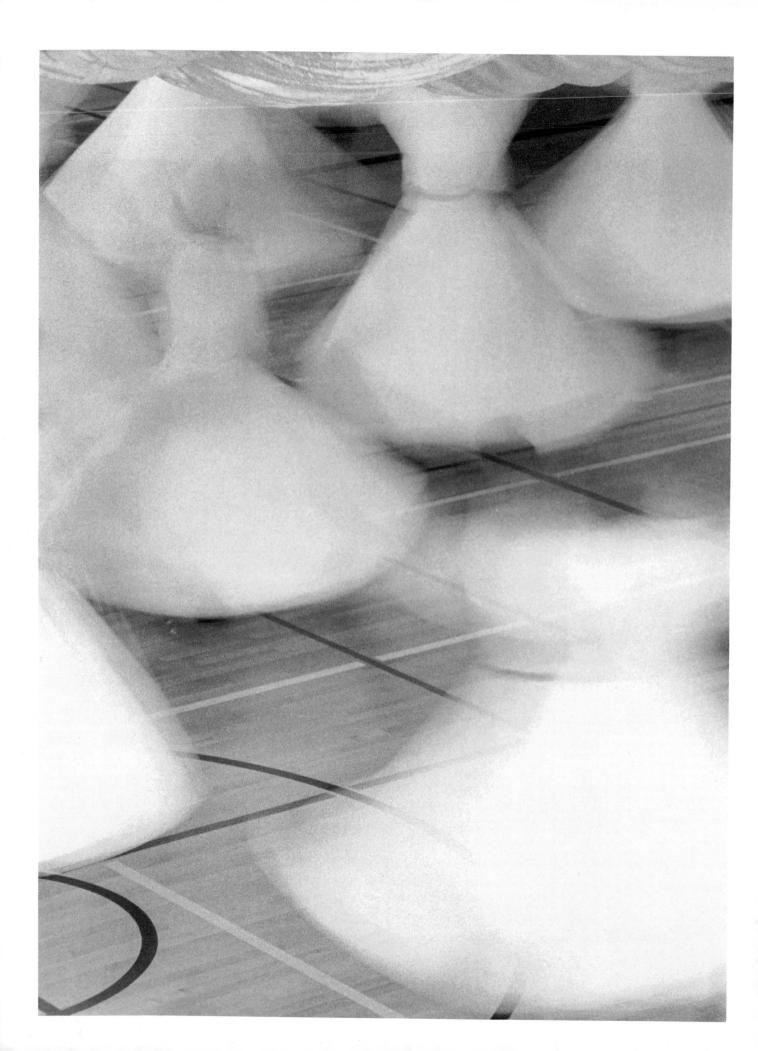

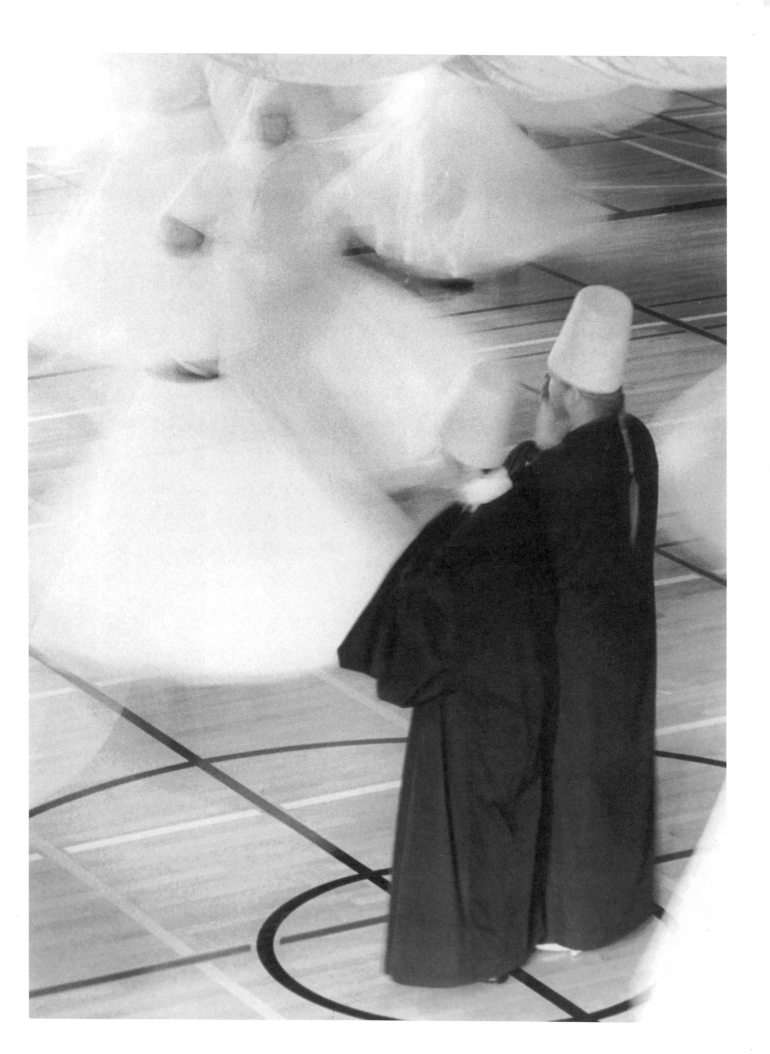

WOMEN
CALLED TO THE PATH OF RUMI
The Way of the Whirling Dervish

SHAKINA REINHERTZ

HOHM PRESS

Prescott, Arizona

Cover design: Kim Johansen

Page design & layout: Book Works

Library of Congress Cataloging-in-Publication Data:

Reinhertz, Shakina, 1945-
 Women called to the path of Rumi: the way of the whirling dervishes / Shakina Reinhertz
 p. cm.
 Includes bibliographical references and index.
 ISBN 1-809772-04-6
 1. Mevleviyeh members--Biography 2. Muslim women--Biography.
 3. Sufis-Biography. I. Title

BP189.7.M42 R45 2001
297.4'82'0922 -dc21
[B]
 00-054215

HOHM PRESS
P.O. Box 2501
Prescott, AZ 86302
800-381-2700
http://www.hohmpress.com
This book was printed in the U.S.A. on acid-free paper using soy ink.

05 04 03 02 01 5 4 3 2 1

To my husband Hadi,
who gave me the gift of time,
love and encouragement.

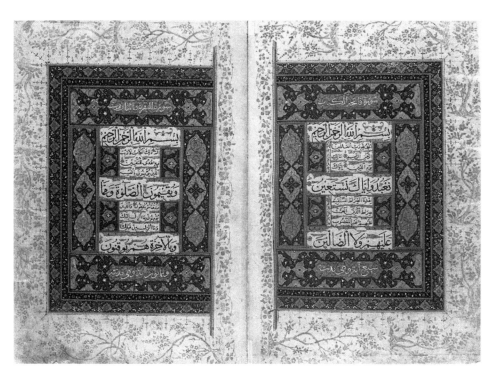

Qur'an
by calligrapher Fatima binti Maksud Aliyu'l-Rumi el-Katib

Completed June 15, 1544
Courtesy of Konya Mevlana Museum

Ghazal

by *Fatima Hanum*
(devotee of Jelaluddin Rumi, mother-in-law of Sakib Dede, 18th century)

We have friendship with God and we are the Mevlevi!
We are intoxicated by the mystical secrets revealed in the *Mathnawi!*[*]
Like the reed flute, we journey through *maqams*[‡] into spiritual awakening,
ecstatic longing leads us, bliss and love fill us!

We follow the way of our Pir not as strangers,
We are intimate companions on the caravan of True Reality!
Without falling or rising, we transcend space into the unseen world.
We are born travelers, and our camels are rays of light.
O Fatima, be like the sun set on its solitary path!
We have friendship with God, and we are the Mevlevi![1]

—(based on translations by Ibrahim Gamard and Omid Safi)

[*]Most proper nouns, foreign words, and many proper names are defined or identified in the Glossary.
Mathnawi is mystical poetry composed by Jelaluddin Rumi.
[‡]*Maqam* is both a melodic itinerary of a specific scale and a station of spiritual evolution.

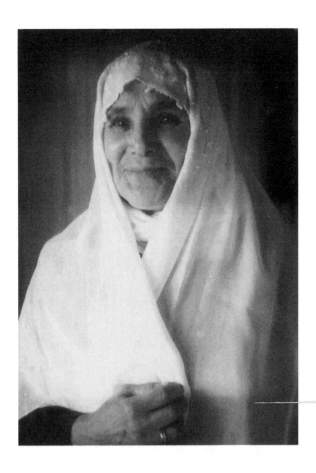

Feriste Hanum

MOTHER OF THE DERVISHES
1907–September 10, 1994

Feriste Hanum, the wife of Suleyman Dede, was feminine grace personified. From the place of home and nurturing she supported and encouraged everyone around her. She led the women's circle in her home until Dede had the inspiration to include women in the *Ayn-i Cem, zikr* and *sohbet.* Without being able to speak our language she showed us the light of her heart, so that we could catch a glimpse of the path of love through the Mevlevi ways. Several times she and Dede traveled internationally connecting pilgrims to the Mevlevi path. Feriste became known as the mother of these seekers. After her husband's death she traveled to the U.S. to visit her beloved son, Jelaluddin. She wanted to see for herself the budding of the path in the West, to witness the fulfillment of Suleyman Dede's dream of men and women turning together in *sema,* as it was in the beginning of the Order.

When we visited her in Konya, her presence nudged us gently along in the simplest manner, sharing her prayer, her home and her family with us. She held us in her arms through her glance, eyes shining with devotion, surrender and compassion, opening our hearts to the longing of love toward the One. Her *Urs* is celebrated on September 10th each year.

Table of Contents

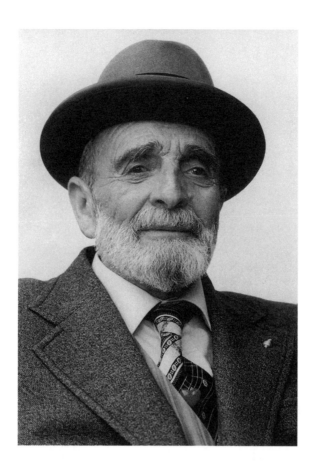

Mevlevi Shaikh Suleyman Hayati Dede

1904–January 19, 1985

Why We Turn

If you are quiet and in a state of prayer when you Turn, offering everything of yourself to God, then when your body is spinning, there is a completely still point in the center . . . The heavens respond; and all the invisible kingdoms join in the dance. But the world does not understand. They think we Turn in order to go into some sort of trance. It is true that sometimes we do go into that state you call ecstasy, but that is only when we know and experience at the same time. We do not Turn for ourselves. We turn around in the way we do so that the Light of God may descend upon the earth. As you act as a conduit in the Turn, the light comes through the right hand, and the left hand brings it into this world . . . We turn for God and for the world, and it is the most beautiful thing you can imagine.[ii]

—*Mevlevi Shaikh Suleyman Hayati Dede*

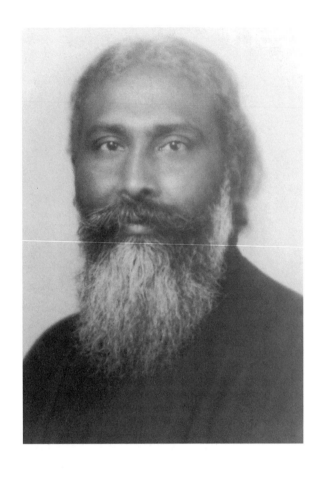

Hazrat Inayat Khan

PIR-O-MURSHID
OF THE SUFI ORDER INTERNATIONAL
CHISTI LINEAGE

1882–February 5, 1926

Prologue

It is most interesting to notice that the East and West have a different or perhaps contrary opinion on the subject of the world's evolution. While in the West, man thinks that we are becoming more evolved, that we have progressed and are going forward compared with our forefathers, in the East man believes that we are going backward and downward, that we are worse. What is the truth about this? From the point of view that there has never been such good communication in the world as nowadays . . . uniting mankind in one moment at any distance; besides the development that is taking place in every branch of science When one looks at all this and cannot doubt for one moment . . . that the world is evolving. But when it comes to delicate thought and sentiment, good manners, knightly chivalry, kingly attitude, nobleness of spirit, and generosity of heart, the tendency to sacrifice, depth of feeling, and keenness of insight, we are certain that what the man of the East says is true.

We learn from this that both opinions are right. We are evolving, and yet at the same time, going backward . . . This brings us to the philosophical conception that it is not only the world that is round, but that every thing is round: that everything moves in circles. For instance the early dawn is not very different from the late evening, age is not very different from infancy, when we realize how innocence develops as one grows old and arrives at a stage where one shows the same expression of the angelic spheres which one had as an infant. It is just like the octave: seven notes and then the key-note comes again. It is not going upward or downward, it is going in a circle . . . Progress means going upward and downward at the same time; progress should be described by a circle and not a straight line. If we look at it from this point of view, everything in the world has a circular aspect, for the real picture of motion, of movement, is a circle.[iii]

—*Hazrat Inayat Khan*

Acknowledgements

To Jelaluddin Rumi whose shining heart radiates forth into the 21st century. — Mesnevi Han, Abdulbaki Golpinarli, with deepest gratitude and appreciation for acknowledging the importance of the contribution of the first Mevlevi women. — Hayati Suleyman Dede who had the courage to have men and women turn together in *sema* as it was in the days of Rumi, may you be remembered with the fragrance of love. — Postnishin Jelaluddin Loras, who manifests for all of us the true spirit of the dervish. — Women of the Mevlevi Order of America who shared their Sacred Journey, allowing us to sit at the doorway of their heart! — Taj Inayat Glantz, who encouraged me to begin this journey. — Shaikha Muzeyyen Ansari and her husband Shaikh Tanner who generously translated whatever I needed from Turkish to English. — Dr. Nahid Angha for her early feedback on the first draft. — Shayka Feriha of the Halveti-Jerrahi Order who sat with me during the last stage of the journey and offered her blessing. — Drolma Gale for her translation from French into English for the chapter on "Women Dervishes of the Past." — Imam Bilal Hyde for generously sharing his knowledge of Arabic and the ways of Islam. — Coleman Barks for his immediate support and generosity with his versions of Rumi. — Jonathan Star, Shahram Shiva, Dr. Nevit Ergin, Nader Khalili, Andrew Harvey and Deepak Chopra for giving permission to use their translations of Rumi. — Ibrahim Gamard for his generosity in sharing translations for the text and feedback on the glossary. — Latif Bolat for your inspiring music, translation of Turkish text, and for bringing books from Turkey for me. — Rashid Patch for your willingness to answer endless questions, and Hafizullah Chisti for the gift of your calligraphy. — My sister Betsi who has always brought light into the dark spaces of my life. — Leslie Hirsch, Matin Mize, Bill Kalinowski, Peter Barkham and James (Ali Qadr) Dupre for letting me use your photographs and videos. — Susan Bein for providing Photoshop skills to create the *zikr* wedding cake collage. — Susan St. Thomas, Fatima Lassar, Deborah Koff-Chapin and Susan Najmah Arnold for the gift of your artwork. — Regina Sara Ryan for her immediate belief in this project, for her patience and insight, skillful editing and unwavering support.

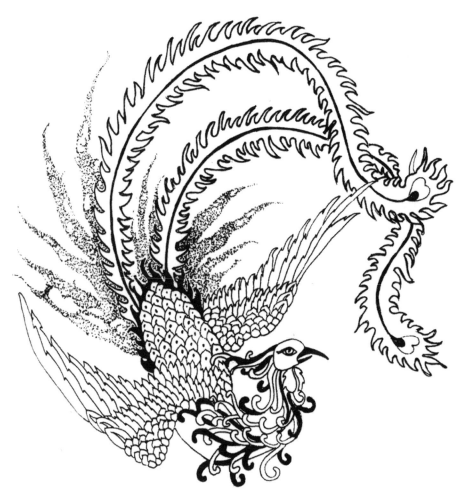

Phoenix
line drawing by Mirabai Chrin

The Phoenix is a beautiful bird with a long beak that has almost one hundred holes. Each hole produces a different note and each sound contains a particular secret. It lives for almost a thousand years and knows the exact moment of its death. When the yearning to return to its true home begins to fill its heart, it gathers a pile of date palm leaves and upon entering the mound, utters a plaintive cry sent out from the depth of its soul as its body trembles like a leaf shaken helplessly by the wind. At the sound of this cry, all the birds and the wild beasts gather to witness its passing. While the Phoenix still has breath, it beats its wings and ruffles its feathers causing the date palm leaves to catch fire. The bird and the fire become one. Finally, there remains only one spark from which a new Phoenix arises.[iv] — *Farid Al Din Attar*

. . . Start a huge, foolish project,
like Noah.

It makes absolutely no difference
what people think of you.[1]
—*Rumi* (trans. by C. Barks and J. Moyne)

What brings us to this path and how are we called? There is something in our being like the legendary Phoenix, a willingness to place ourselves in the fire, trusting that what will emerge in the burning is the deepest, truest, most sacred part of ourselves. Like a moth drawn instinctively to the flame, we are irresistibly pulled to the source of our existence. There is something about the intensity of the longing that evokes the depth of the response.

For many of us the phrase "whirling dervish" brings to our consciousness the image of a group of men spinning in white garments in a formal ceremony. This ritual was initially created by Sultan Veled as a way of honoring the passing of his father, Muhammad Jelaluddin Rumi, the great Sufi mystic and poet. Through the spiritual friendship with Shams-i Tabriz, Rumi was transformed from a scholar trained in Sufi tradition to a mystic who longed for the state of union, immersed himself in the practice of turning, and created a legacy of spiritual teachings through poetry. Surrounding these two magnificent men was a community that included women. Rumi taught some of these spiritual seekers directly, such as his daughter-in-law Fatima. His granddaughters, Seref and Mutahhara, helped their brother Ulu Arif Chelebi develop the Mevlevi Order and were teachers in their own right. Arifa Hoslika, a follower of Rumi, became a teacher by the time Sultan Veled was made *Pir** of the Order, and was

Changing Woman
by Deborah Koff Chapin

**Pir* is the head of a Sufi order.

initiated as a *halife*[*] by Ulu Arif, an empowerment given only to a chosen few. Over the first three generations men and women turned together in the ceremony of *sema*.[‡] There were women who were initiated as *postnishins*,[◊] the one who leads the turning ritual, as well as women named successors by their fathers to be the shaikha[°] of the *tekke*.[**]

Over time, the role of women was diminished and the separation of men and women more pronounced, until in this last two hundred years only men were allowed to participate in the *sema* ritual in public.

At the beginning of the twentieth century a new direction began to emerge within the mystical path of Sufism. Hazrat Inayat Khan of the Chisti Order[‡‡] from India was sent by his teacher to the West. He traveled extensively throughout North America and Europe, and by the tangible magnetism of his presence, the truth contained within his words, the way of the Sufi was planted in the Western world. By the time of his death in 1926, thousands of students had taken initiation.

After the passing of Hazrat Inayat Khan, his following was split into several branches. Over time his son, Pir Vilayat, who was only twelve when his father died, came into his maturity and established the Sufi Order International, offering teachings in Europe and North America. Murshid[◊◊] Samuel Lewis, a student of Hazrat Inayat Khan, went to Golden Gate Park in San Francisco and began attracting students from the generation who questioned "The Establishment," introducing them to the way of the mystic through the inspiration of the Dances of Universal Peace. Joe Miller, a theosophist and contemporary of Murshid Sam, created his own style of teaching by leading a walk through Golden Gate Park.

While Sufism was ripening in America, the price of the modernization of Turkey by Ataturk was the political repression of this mystic path. By the mid-fifties, however, the *sema* ritual of the Mevlevis was allowed to continue as a tourist attraction. In 1976, when the European UNESCO sponsored a 700-year anniversary celebration of Rumi's passing, a new interest was awakened in the path of the whirling dervish. Several Mevlevi teachers began to offer their knowledge to the West. Shaikh Hayati Suleyman Dede traveled extensively

One of the reasons I am teaching this music and dancing is to increase Joy, not awe towards another person, but bliss in our own self. This is finding God within through Experience.
—*Murshid Samuel Lewis*

[*] *Halife* is usually the shaikh's successor and/or representative in the world.

[‡] *Sema* is the ancient practice of moving to sacred music in an ecstatic state of remembrance.

[◊] *Postnishin* is one who sits on the sheepskin and is the living link to Mevlana while conducting the whirling ceremony.

[°] Shaikha is the feminine form of shaikh, a spiritual teacher and/or leader.

[**] *Tekke* is a convent for communal life designed to accommodate the Dervish lifestyle.

[‡‡] Chisti Order, founded by Abu Ishaq Shami Chisti, was brought to India by Moinuddin Chisti.

[◊◊] Murshid is a Sufi spiritual guide.

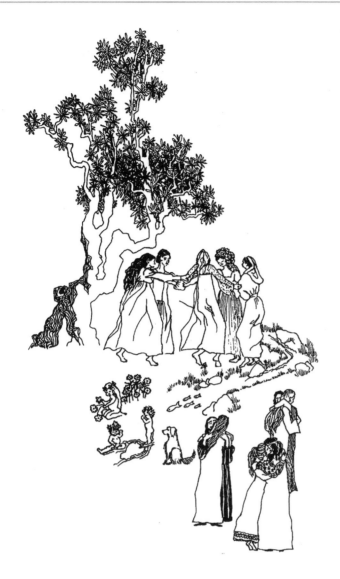

Dances of Universal Peace
Line drawing by Fatima Lassar

in the United States and Canada, and upon his return to Turkey a number of followers of Sufism from North America came to his doorstep to receive his teaching. When Dede had the inspiration to send his son, Jelaluddin Loras, to the West to water the seeds he had planted, he gave the instruction to include women equally in the teachings, as it was in the beginning days of Mevlana. That action opened the door for women and men to be trained together in the formal Mevlevi tradition.

When Jelaluddin Loras, founder of the Mevlevi Order of America, moved into Sami Mahal[*] in San Rafael, California, few of us realized who he was or what he was bringing to us. The term "whirling dervish" was just an exotic phrase that had something to do with spinning. It wasn't until years later that I came to know that the word "dervish" contained a mystery regarding a doorway, the threshold between two

[*]Sami Mahal, literally "House of Sound."

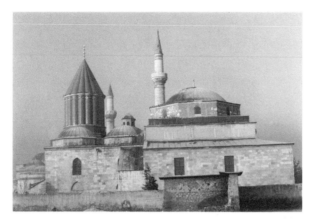

Tomb of Rumi, Konya

worlds! Over the first year as I began to follow Jelaluddin, attending *zikrs,** turn class, *sohbet*‡— the ways of teaching he offered us—I began to glimpse what he represented. As he shared stories of his father, Suleyman Dede, and his mother, Feriste Hanum, I longed to meet them. Then, one day, I came across the book by Shems Freidlander, *The Whirling Dervishes,* and saw pictures of Jelaluddin and his father in Konya. This revealed another aspect of what Jelaluddin was offering us.

Some years later, when Jelaluddin was renting a home on Mono Avenue in Fairfax, California, he invited a group of his students over for dinner. He had set up small round tables with two or three chairs at each, like an outdoor restaurant. He served us Turkish pizza he had prepared himself, and draped a little white cloth over his arm as if he were a waiter in a fine restaurant. This gift of being served was done with such consideration, respect and love.

Another time, after I became a *semazen,*◊ we had all gathered in Jelaluddin's tiny room at the Sami Mahal. We had just completed a *sema* and it was late at night. He was sharing a teaching, the words of which I cannot remember, but afterwards he began to give away all the possessions in his room. A student said jokingly, "Well, you still have the shirt on your back!" Without hesitation, he took off his shirt and gave it to him. This was the way he taught us in those first years—not so much with words but with his being, with his manner, his actions.

I remember another lesson that occurred at a time when all of us seemed to have little money. When I went through periods like that I tended to isolate myself and struggle privately, not wanting others to know my difficulties. Jelaluddin used to keep his small home on Mono Avenue open at all hours. You could drop by without calling whenever you felt like it and he would always welcome you. "Please, come in *efendi,*"° he would say. That afternoon, as we gathered one by one, he would send each of us off to the store. "My dear, could you go get us a head of lettuce?" To another, "Oh, we need three tomatoes, could you get this for us please?!" To yet another, "Perhaps you could bring us a loaf of bread?" That evening he used all the food we had accumulated and again made us a delicious meal. Many years later, when he had moved to Seattle to expand his teachings, I realized he

* *Zikr* is a practice of remembering and evoking the Presence of God.

‡ *Sohbet* is an intimate conversation regarding spiritual matters between a shaikh and students.

◊ *Semazen* is one who has undergone formal training in the turning practice of the Mevlevi Order.

° *Efendi* means "dear friend."

had left us the gift of a *sangha*,* a group of seekers who had learned to share with each other our good and bad times. This is how the door opened for us, how Mevlana Jelaluddin Rumi was given to us bit by bit, moment by moment, in small and great acts of love.

Often Rumi would place the phrase "God Opens Doors!" at the beginning of the letters he wrote; whether these communications were with government authorities, business acquaintances, family members, friends or students. Frequently, he would write such letters to ask for help, not for himself but for those around him, or to offer comfort or respond to a request. Many of us have consciously experienced the truth of this teaching "God opens doors!" Sometimes it is simply being given a parking spot at the right moment. Other times, just as we are feeling trapped in a job that is empty of soul food, a new career possibility is opened to us. For myself, the teaching that "God opens doors!" manifested through the unfoldment of this project; beginning with the initial inspiration that came in the form of a vision—a hand offering a book with its pages fanning open in front of me. With

***Sangha* is a group of people who come together through the bond of spiritual connection.

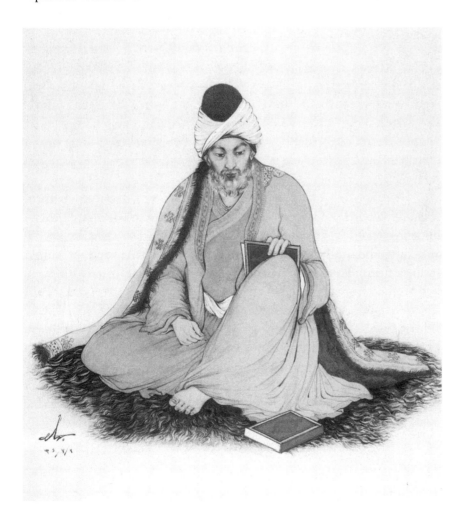

Rumi
by Kamalledin Behzad
Courtesy of Konya
Mevlana Museum

Unseen Being
by Deborah Koff-Chapin

encouragement from several spiritual teachers and my husband, this inspiration became a sacred journey that embodied the meaning of what it is to be a dervish, for the women presented in these pages opened their hearts not just to me, but invited all of us who read it to sit at the doorway between the world of form and the world of spirit. I sat with over thirty-three women, encompassing three generations, from the budding of adolescence to the fruition of the elders, who one by one shared their stories, their insights and reflections. As I followed what was being revealed by asking more questions and seeking more written information, there was always much support and generosity from the dervish community. At the very beginning, our Shaikh* looked into my eyes and said, "If you do it with purity of heart then, *Inshallah,‡* something good will come of it."

Some of the women whose stories are recorded here came to Rumi's path by seeing, the eye of the heart awakened by the ancient ritual of turning. Others breathed the fragrance of love palpable in the being of Suleyman Dede and longed to be immersed in the sweetness he offered. Some felt the fire of his son, Jelaluddin, and wanted to burn with that same passion. Others recognized something familiar, something that has always been a part of them and wanted to return again. A few were simply thirsty and stopped for a time to be refreshed. Some dug in their heels and resisted entry to this path until the heart-calling could no longer be ignored.

In 1997, when I had completed transcribing the interviews and was beginning to shape the chapters on the path itself, what I longed for was the ability to distinguish between my personal will and the voice of guidance that Hazrat Inayat had taught us "constantly comes from within." Jelaluddin had the inspiration to take a group of men and women *semazens* to Turkey. This was the second caravan he had led to his homeland. I was privileged to be a member of that caravan. With us was a woman new to our community and to the path of Rumi. I was asked to be her roommate and resisted because I missed my husband and wanted to be with someone familiar. At first, accommodations were made for my perceived need, and yet I felt a pulling at my consciousness. When we arrived in Konya, in the lobby of the hotel, Jelaluddin took the roommate list and shifted everyone. The very person I had avoided became my roommate.

*Shaikh is a spiritual leader or teacher.
‡*Inshallah* is an expression that means "God willing."

Somehow I got left in the lobby when everyone took off for the Dervish Brothers Carpet Shop. I started crying and couldn't stop. I felt angry, shattered, ashamed, rebellious and humbled. One of the women, a dear friend who had been to Turkey before, came back unexpectedly. As she put her arm around me, she spoke to my heart telling me the crying wasn't about the external situation, but that the tears were for Mevlana whose *dargah** was just across the street. How long I had waited for this day, to be in the presence of Rumi! I joined the others at the rug shop, tears still streaming down my face. I could hardly eat or talk. Finally I surrendered to a deep instinct within me, and I, who rarely cover my head, veiled myself with a scarf and shawl. (Several months later I read that some of the women who dearly loved Rumi would veil themselves in his presence.) It was late afternoon. The museum was filled with visitors. Yet, when our group entered the tomb, the space directly in front of Rumi's sarcophagus was empty. We walked together in silence and stood before the one who had called us.

In the museum we lined up in front of an octagonal glass case, which displayed a beautiful small box, said to contain a hair from the Prophet's beard. There was a little space in the glass case, to put your nose. When my turn came, I smelled a fragrance that was sweet like roses, but rare, familiar, and not of this world. Returning to the hotel, I spent the first few moments alone with my new roommate. Of course, she was naturally most gracious and considerate, a truly evolved dervish soul.

The next day we prepared for our Mevlevi *sema,* a ceremony passed down through the centuries by Sultan Veled, Rumi's son. We were to be given the great blessing of turning on a brand new hardwood floor, right next to the sarcophagus of Rumi. I found myself once again filled with surges of deep emotion. To prepare myself, I felt an urge to do *zikr,* and asked my roommate if she would like to join me. She had to go out for a while, so I took a shower to do ablutions‡ and began. She returned bringing another new *semazen* with her. As they began to sing with me, I felt myself going deeper and deeper, guided by unseen beings. The two women's voices were like angelic presences. As we chanted the names of God, I called out in my heart to all the women and men of the past to be with us and to turn through us. That night there was a full moon, stars shining clearly in an indigo sky.

The next day my roommate asked if I knew of a man who wore a dark purple hat? I immediately recalled a description of Rumi in *The Dervish Lodge.*[2] After Shams-i Tabriz disappeared, Rumi was said to have exchanged his white turban for a dark purple, almost black *duhani*◊ that he wore the rest of his life. "Why do you ask?" I said. And

**Dargah* sometimes implies a *tekke* but always contains the tomb of a saint.

‡Ablutions is ritual washing for purification.

◊*Duhani* is a felt hat.

she replied, "While we were in our room doing *zikr* before *sema,* I saw a man with a dark purple hat standing above us."

In Konya, our Shaikh had introduced us to his dervish brother, Shaikh Athan, who had stood at the *post** with Jelaluddin during the *sema* inside Rumi's *dargah.* The next day, we were in the Dervish Brothers Carpet Shop trying on turn shoes and drinking tea. Shaikh Athan wrote out from memory the first eighteen lines of the *Mathnawi* in Turkish and gave them to me.

> Listen to the story told by the reed,
> of being separated.
>
> "Since I was cut from the reedbed,
> I have made this crying sound.
>
> Any one apart from someone he loves
> understands what I say . . .[3]
> —*Rumi* (trans. by J. Moyne and C. Barks)

The poem speaks to all humanity of that longing to return to our natural state, to our true source, to union. As he wrote the words, I realized that we as women of the Mevlevi path were no longer separate. Rumi's belief, "God opens doors!" had once again been affirmed by our *sema* of the night before. Shaikh Athan shared with me that he was beginning to train his daughters in the turn practice and I felt a great hope in my heart that the door to this path would truly reflect the truth of Rumi's words.

> The door is round and open, don't go back to sleep![4]

To share this path through the feminine perspective is born out of a desire that a hundred years from now any young girl who wishes to be a whirling dervish will be able to see the faces, hear the words and know the joys and struggles of those women who have gone before her. The men of this Order are truly precious to us; it is not that our journey as women is more important, because without our brothers we would not take one step!

None of us claims to be at the station of those who see with the eyes of the enlightened viewpoint. We are all just climbing this mountain of love out of a burning desire to develop more and more intimacy with the Beloved in our life, in our heart and in our breath. A woman's way of sharing is intimate, candid and personal. We offer to you what we know of the way of the dervish, to reveal our experiences, hopes and reflections, and what it means to each of us to be called to the path of Rumi.

**Post* is the place (usually a red sheepskin) where the *postnishin* sits or stands during the Shebi Arus ceremony.

This is the tale of how men and women turned together in the days of Rumi, and how the women were separated from this practice, and how we have been called to turn together again.

. . . Once upon a time, there was a group of women called to the path of the whirling dervish. There was a door "round and open" seen by a man of vision who sent his son to America. Before him was a man of great knowledge and spiritual understanding whose heart became kindled by the flame of love. Before him was sound, a lament of separation, the cry of the ney.*

> In the path of union, the wise woman and the mad woman
> are one.
> In the way of love, close friends and strangers are one.
> That one who has tasted the wine of union with the
> supreme soul,
> In her faith, the Ka'be and an idol temple are one.[5]
> —*Rumi* (trans. by S. Shiva)

Ney is a wooden reed flute.

"In Konya, at the Turkish Brothers Carpet Shop . . . Shaikh Athan wrote out from memory the opening lines of the *Mathnawi* in Turkish and gave them to me."

Nur Jehan

⌁

Destiny is not under control of our heart.
Being is the means of reaching non-Being.
There is someone who looks after us.
From behind the curtain.
In truth, we are not here.
This is our shadow.
—*Rumi* (trans. by N. Ergin)

WHAT IS
A DERVISH

O heart, do not worry about your destiny.
In this world of alienation, come and join our gathering.
If you desire to mount the breeze-at-dawn and ride into eternity
then become the dust of the feet of the horse of the darvish.[1]
—*Rumi* (trans. by S. Shiva)

The word *dervish* (or *darvish*)* comes from *dar* meaning "door" and *vish,* which can be translated as "to beg, "to sit" or "to meditate." The image evoked is a doorway between two worlds. A dervish is one who sits at this doorway.

> The lover sits at the door of the Divine, begging for Union
> with the Beloved.[2]

In the East, the word *faqir,* connoting poverty, is sometimes used interchangeably with dervish. This concept embraces the ideal of spiritual poverty—an emptying of one's entire being to create a sacred vessel inviting the Presence of God, as well as the more obvious detachment from seeking worldly riches. This state of poverty is the beginning station on the path of the dervish. One does not ask anything from anyone, one only seeks God.[3]

> The darvish who gives away
> the secret teachings, and all he owns,
> as freely as his own breath . . .
> That darvish lives by the grace
> of someone else's hand.[4]
> —*Rumi* (trans. by J. Star and S. Shiva)

Mevlana's Tughra

The dervish embodies two aspects of being simultaneously: On the inner plane there is the constant longing for, reaching out to, and awareness of the Presence of the Beloved.

Darvish is the Persian word for dervish.

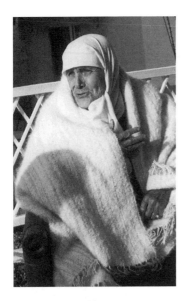

*Feriste Hanum at
Her Home in Konya*

When visitors came from all over
the world to meet her husband,
Suleyman Dede, Feriste would
always greet them, offering food,
and seeing to their needs.
She became known to us as
Mother of the Dervishes.

Burning with longing-fire,
wanting to sleep with my head on your doorsill,
my living is composed only of this trying
to be in your presence.[5]
—*Rumi* (trans. by J. Moyne and C. Barks)

On the outer plane, like the Green Tara of Tibetan Buddhism who is
depicted with one foot forward, ready to come to our assistance, the
dervish is always ready to serve.

Go perform good deeds, for that's what history
 remembers best.
The Beloved won't take back the virtue of kind acts
 from kind people.[6]
—*Rumi* (trans. by S. Shiva)

To recognize a dervish one needs only to look into her eyes, for there
is a special radiance that draws one in. In the presence of a dervish,
one may feel a longing arising deeply from the soul. Once the flute-
notes of the heart are sounded, like the children drawn to the Pied
Piper, one longs to follow the dervish, seeking to know who he or she
is. The more one seeks, however, the more elusive these dervishes be-
come, for "they are not there." Drawn by the persona or the ego, one
encounters on the inner plane a doorway to a timeless place beyond
words, thoughts and feelings.

Lift the veils tonight, lift them all.
Don't leave one thread hanging.[7]
—*Rumi* (trans. by A. Harvey)

When the dervish looks into your eyes there is a knowingness trans-
mitted and a possibility of viewing yourself in a profound and true
way—perhaps a discovery of inner light or darkness one has never
fully looked at. With the guidance of a dervish, through the willing-
ness to face fully who we are, a doorway can open to true self-knowl-
edge. By immersing ourselves into the awareness of the Divine within,
we invite transformation.

Near truth's blaze what are "doubt" or "certainty"?
Bitterness dies near the honey of truth.
Doesn't the sun hide its face before his?
What are these small lights that linger?[8]
—*Rumi* (trans. by A. Harvey)

As one joins the caravan of a dervish, the desire may awaken to mimic
or re-form oneself in the dervish's image. This conscious imitation
may open a path to enlightenment, a bringing of light into one's being,
a seeing of the schoolhouse of life from a fresh point of view.

I want to be where
your bare foot walks,

because maybe before you step,
you'll look at the ground.
I want that blessing.[9]
—*Rumi* (trans. by C. Barks)

While traveling with a dervish, we may be lifted to a plain of vastness and non-attachment to worldly things. In response, one may become perplexed, amazed, even repentant when faced with the contrast of those who live attached to the world and those who live "in the world, but not of it."

One day you will take me completely out of myself,
I'll do what the angels cannot do.

Your eyelash will write on my cheek
the poem that hasn't been thought of.[10]
—*Rumi* (trans. by J. Moyne and C. Barks)

In the presence of a dervish there is joyfulness and freedom, a potential for discovery and connection to the One True Friend; a falling down and a getting up, laughter and tears, pain and ecstasy; then a shedding of the skin of all these aspects, as one steps out of time and is filled with wonderment and awe. Through loss of rational thought and a listening to the heart's yearning, one becomes the moth ever drawn to the flame of love.

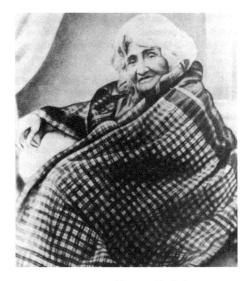

You knock at the door of Reality.
You shake your thought-wings, loosen
your shoulders,
and open.[11]
—*Rumi* (trans. by C. Barks)

Hazrat Babajan

The essence of a dervish is not limited to one sect or one path. In that moment when Jesus knocked over the tables of the moneylenders in the temple, he was a dervish. Shams-i Tabriz, by throwing the books of Rumi's father, Baha'uddin, down the well and pulling them out dry, acted from the place of a dervish. Mother Teresa, when she lifted up the first suffering ones off the streets of Calcutta and saw the face of Jesus, became a dervish. Buddha, after abstaining for so long, ate the sweets offered by the women and stepped onto the path of the dervish. Al Hallaj, the Sufi mystic, when he cried out "I am the Truth," willingly gave his life to be a dervish. Hazrat Babajan, when she raised her body slightly, still feigning sleep so that the thief stealing her shawl could get it more easily, was acting from the point of view of the dervish. Ammachi, the Hindu saint, when she

"I am the wishing Well. Yes, I wish you well. All is well that is wished by God. Do you wish God well? Well then, carry out his wish. Throw a paisa (penny) in the well and in a million years it turns to gold. That's doing without reward and wishing for someone else. If you wish for God, I will come to you." —*Hazrat Babajan*

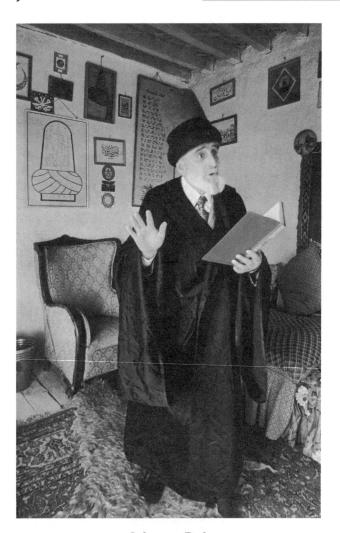

Suleyman Dede

holds you in her arms, embodying unconditional love, becomes a dervish. Suleyman Dede, Mevlevi Shaikh of Konya, Turkey, when he turned and brought tears to the eyes of those who beheld him, was a dervish. The little child in the marketplace, whose smile pierces through the sadness in your eyes, and with her glance transforms your face into a returning smile is, in that moment, a dervish. The homeless person on the street who, with simple sincerity, blesses you whether you give to her or not, speaks from the place of the dervish.

In all these beings is the presence of a love beyond any condition, and it is that love that we all long for, rich or poor, old or young, of any religion or non-religion, of any country or of any time. That is why Rumi's words still speak to us seven hundred years later. It is that love that draws us to the path of the dervish.

> Awareness cleaned my mind
> to a polished mirroring.
>
> The presence came near, and I knew
> that That was everything,
> and I nothing.[12]
> —*Lalla,* a mystic of the fourteenth century
> (trans. by C. Barks)

If you are a seeker,
Fall down upon the ground in prostration.
That you may see
What kind of mood there is
In His pure Grace.
There they will give you Incense
And in its fragrance
You will smell the scent of the Archangel
And the Secrets of the Giver.
—*Suleyman Dede* (trans. by Shaikh Murat Yagan)

Angel by Fatima Lassar

It is said that:

"*. . . you will see angels*
encircling the throne singing
praises and Glorifying God . . ."[13]
—The Qur'an, Sura Al-Zumar 39:75

Whirling

is as an expression of Divine Love

forever present on the

angelic planes.

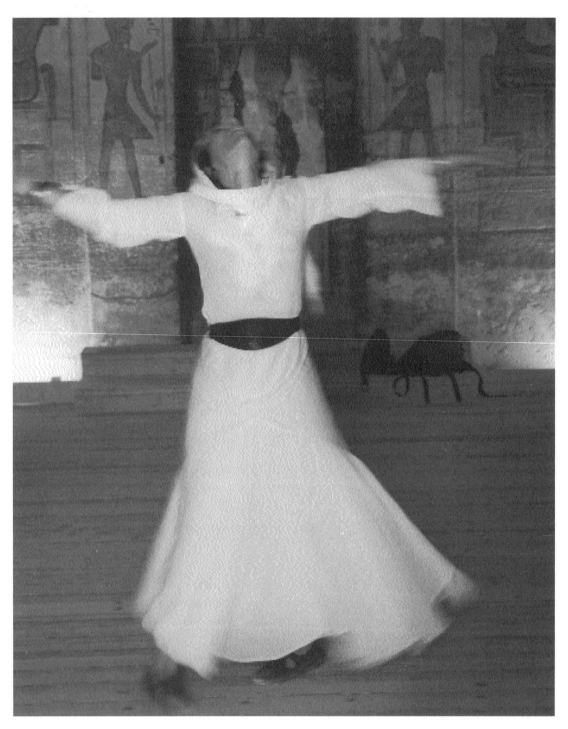

Delilah Spinning in Hathor's Temple in Abu Smible, Egypt.

We are happy even if we don't have wine and cup.
We'll be pleased if they call us good or bad.
"There'll be no end for them," they said of us.
We are filled with joy at having no end.
—*Rumi* (trans. by N. Ergin)

ORIGIN OF TURNING AND SEMA

We came whirling
out of nothingness
scattering stars
like dust

the stars made a circle
and in the middle
we dance . . .[1]
—*Rumi* (trans. by D. Liebert)

There is a legend in the East that God created a statue of clay and asked the soul to enter. This spirit of the first human being refused to be enclosed in such a prison, as the soul's nature was to fly about freely without limitation. But when the angelic realm began to play the music of the spheres, the spirit began to dance in ecstasy and in the joy of the moment, entered into the form of clay and thus brought life.[2]

In the beginning, humankind learned quickly to mimic the beautiful living sounds of nature: the song of birds, the cry of beasts, the whisper of a breeze, the movement of the babbling brook, as well as our own inner sound, the rhythm of the heart. As early as the Paleolithic period, artifacts reveal the development of the frame drum, which suggests sophisticated knowledge of the power of rhythm. The drum's round shape is possibly symbolic of the primordial waxing and waning of the moon and the blood cycles of women.[3] The earliest calendars reflect knowledge of these very cycles.

We have always been surrounded by the outward manifestation of the dancing universe: a small whirlpool in a creek, a dog chasing its tail, mating dances of the animal kingdom, the play of the wind through the trees, the destructive power of a tornado, and the circling of the seasons. Certainly the ancient cave drawings reveal the importance of nature to tribal life and illustrate the very human need for creative expression. When the tribe gathered around the evening fire, music, singing and dance provided a means of communication and

Bismillah Thuluth Round

~

The ova spins down the corridor
 to the sacred meeting place.
The planets circle the Sun
 like moths drawn instinctively
 to the flame.
We turn, seeking union with
 the Divine.

communion. It is easy to imagine the first turning in such a gathering. Filled with the ecstasy of music and overflowing gratitude for the gifts of our Creator, one is easily lifted into motion. The naturalness of whirling is seen in a small child who spins on one foot and afterwards falls down delighted with this brief journey. As we developed knowledge of the physical universe—such as the circling of the stars and the sun, and the majestic turning of the ova on its journey down the fallopian tube—we have learned that this circular motion of life is present on every level.

> A secret turning in us
> makes the universe turn.
> Head unaware of feet,
> and feet head. Neither cares.
> They keep turning.[4]
> —*Rumi* (trans. by C. Barks and J. Moyne)

As tribal life developed, the need to seek blessing from the Creator for fertility, birthing, the hunt, a journey or a healing, as well as to recognize and honor rites of passage such as puberty and death, birthed the development of ritual.

In Greece we can see the remains of ancient vases covered with drawings of the dances from Dionysian mysteries.[5] In these drawings the skirts are clearly flowing, head and arms lifted in supplication and joy expressing the ecstatic state that arises naturally when turning. Some trace these Dionysian dancing rites back to influences of ancient Egypt and India.[6]

Within the Indian culture, ancient dances evolved from tribal days, such as Odissi, a sacred system of movement containing prayer, myth and ritual, whose restoration into modern times is based on ancient drawings and sculptures from the oldest of temples. Legends speak of the Apsaras, beings who were neither fully angelic nor completely human. They brought Odissi into the temples honoring Lord Jagannatha, an incarnation of Krishna, who represents Divine Love. In this dance form there are at least eight ways of turning.[7]

~

Dance of the Gypsies,
19th Century

During the great rise of the Mother Goddess religion throughout all of Europe and most of the civilized world, the Greeks of Thessaly and Macedonia created an ecstatic whirling dance performed by a young woman as the basis of a ritual for bringing forth rain.[8]

An inherent role in most tribal life was that of the healer or shaman. This one, naturally attuned to the secrets of the animal and plant kingdom, would use movement such as turning as a pathway to enter states of altered consciousness to bring forth hidden knowledge from a place of non-linear thinking.

You're song
a wished-for song.

Go through the ear to the center
where the sky is, where wind,
where silent knowing. . .[9]
—*Rumi* (trans. by C. Barks and J. Moyne)

The Tibetan religion evolved a New Year God Dance. The participants form a circle with the priest in the middle. Each one whirls around their own axis.[10] The Dogon of West Africa built their houses in a round shape. They viewed the heavenly granary, the house of Amma, as descending through the spiral of a rainbow, spinning.[11] Botticelli's drawing of Beatrice and Dante depicts the dance of the stars and the heavens, as nine circles enclosed in one another, opening in ever-expanding circles.[12] Thus in many cultures the significance of the circle and spinning play an important role in ritual life and human evolution.

There is a place where words are born of silence,
A place where the whispers of the heart arise.

There is a place where voices sing your beauty,
A place where every breath
 carves your image
 in my soul.[13]
—*Rumi* (trans. by J. Star)

*Persian Stone Carving
of Rider, 6th Century*

Nomadic tribal life was well established when the followers of Islam entered the borders of Anatolia, ancient Turkey. The marriage of Islam with the shamanistic traditions of the nomads, which contained ecstatic turning, gave birth to a unique brand of Sufism. So the practice of turning was not new to the Turkish culture. These seeds of shamanism were still present in Rumi's lifetime. Shams-i Tabriz, Rumi's teacher, came out of the Qalandar tradition. These were dervishes who wandered from place to place carrying the transmission of the mysticism of Islam as well as the great earth magic of the shamans.[14] Some scholars say it was Shams who introduced Jelaluddin Rumi to the practice of turning as a form of sacred prayer[15] and the Sufi ritual of *sema,* a practice that had been part of the Sufi tradition for at least four hundred years.

Sema comes from the words "to hear," "to listen." It is a listening from the heart in which all thoughts are dropped from the mind and the devotee listens to the music with their whole being with the intention of opening to the eternal Presence of God.

In the earliest days of the development of *sema,* a few devotees would gather together. Perhaps one would play a *ney* or a drum, or someone with a beautiful voice would begin to sing. The others would sit in silence listening, the beauty and sacredness of the music drawing them closer and closer to God. When one of those sitting felt the music

fill and lift them, they would get up and begin to move, letting the sound transport them until they were no more, only the music and the moving remained. A companion to Muhammad tells a story of the Prophet, who, upon hearing a song by a Bedouin entered a state of rapture and afterwards tore his cloak to pieces giving it to the crowd.[16]

> Dancing is not rising to your feet painlessly like a speck of
> dust blown around in the wind. Dancing is when you rise
> above both worlds, tearing your heart to pieces and
> giving up your soul.[17] —*Rumi*

Sema in the Courtyard of Rumi's Tomb

Men and women turn together publicly for the first time in over two hundred years.

In Baghdad, by the second half of the ninth century, houses could be found where mystics would gather and listen to sacred music and be drawn into ecstatic states, turning and dancing and rending their garments.[18] For the vast majority of traditional Muslims, the use of music and dance was considered an unorthodox practice. However, the *Qur'an* itself says:

> You will see the angels encircling the Throne, praising and
> glorifying their Lord.
> —*Sura Zumar,* verse 75:39[19]

An ancient manuscript in Istanbul by an unknown author of the fifteenth century describes a creation myth that when Allah formed the universe, *divine energy resounded* from which arose the twelve tonalities of music. These tonalities correspond to the twelve months which are contained within the four seasons. The *sound gave birth* to the four types of movement, which also relate to the four elements. Out of this creation emerged a Sufi dressed in blue who started whirling.[20]

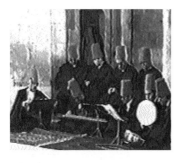

The Konya *mutrip* plays *sema* music for the American *semazens.*

> No one knows what makes the soul
> wake up so happy!
> Maybe a dawn breeze has blown the veil
> from the face of God . . .[21]
> —*Rumi* (trans. by C. Barks)

Over time, this practice of mystics gathering together to listen to beautiful music and to invite the spirit of God to flow through them and take form through song, movement and turning, evolved. A certain night would be set aside. The gatherings became larger. The leader of the spiritual community began to structure the evening. Each of the devotees would prepare themselves beforehand through cleansing their bodies, perhaps fasting for a day or sitting quietly to still the mind of worldly thoughts. The practice of *sema* continues today as a tradition within many Sufi orders including the Chisti, Bektashi and of course Mevlevi.

After the disappearance of Shams, Rumi continued to explore the potential of this practice. For a time "when drowning in the ocean of love" he turned round and round a pillar in his home.[22] One day,

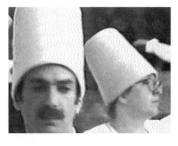

American *semanzens,* Suleyman A. *(left)* and Jabbara

Rumi wandered into the marketplace and heard the sound of the gold beaters. We can imagine that the sound became, "Allah, Allah!" in the ears of such a one as Rumi. It is said that he turned for thirty-six hours without stopping when at last he fell to the ground. He began to explore this practice in depth as a way of becoming closer to God and shared it with his friends, family and students.

Aflaki, student of Rumi's grandson, Ulu Arif Chelebi, records a story in which an acquaintance of Rumi's was shocked to hear that he used music and dancing as a sacred practice. When he came to visit, Rumi explained:

The sound of the call to prayer fills the air.

> It is an axiom in the sacred canons that a Muslim, if hard pressed and in danger of death, may eat of carrion and other forbidden food, so that their life be not sacrificed . . . Now, we as people of God are exactly in that position of extreme danger to our lives: and from that danger there is no escape, save by song, by music, and by dance . . .[23]

After Rumi's turning in the marketplace, Zarkub, the goldsmith, became Rumi's beloved friend and teacher. When Zarkub knew he was dying, he requested before his death that his passing not be mourned, but celebrated. Rumi honored that request and on the day of Zarkub's funeral there was music and turning.[24] Indeed, Rumi himself wrote many poems about the nature of death and dying.

Semazens listen with the inner ear of the heart.

> On the day I die, when I'm being
> carried toward the grave, don't weep.
>
> Don't say, "He's gone! He's gone!"
> Death has nothing to do with going away.
>
> The sun sets and the moon sets
> but they are not gone. Death
> is a coming together . . .[25]
> —*Rumi* (trans. by C. Barks)

Throughout the latter part of his life, Mevlana would continue to use turning and music as a gateway to God. Often, while returning from prayers on Friday night, he and his followers would begin turning spontaneously in the street.[26]

Postnishin Jelaluddin Loras sits in prayer.

> The Sema is the soul's adornment which helps it to discover love, to feel the shudder
> of the encounter, to take off the veils, and to be in the
> Presence of God.[27]
> —*Rumi* (trans. by T. S. Halman and M. And)

When Mevlana Jelaluddin Rumi died on December 17, 1273, they say the sunset blazed red. People from all traditions—Buddhist, Christian, Hindu, Jewish—came to honor his passing. Rumi's devotees asked these others, "Why are you here?" One Christian replied,

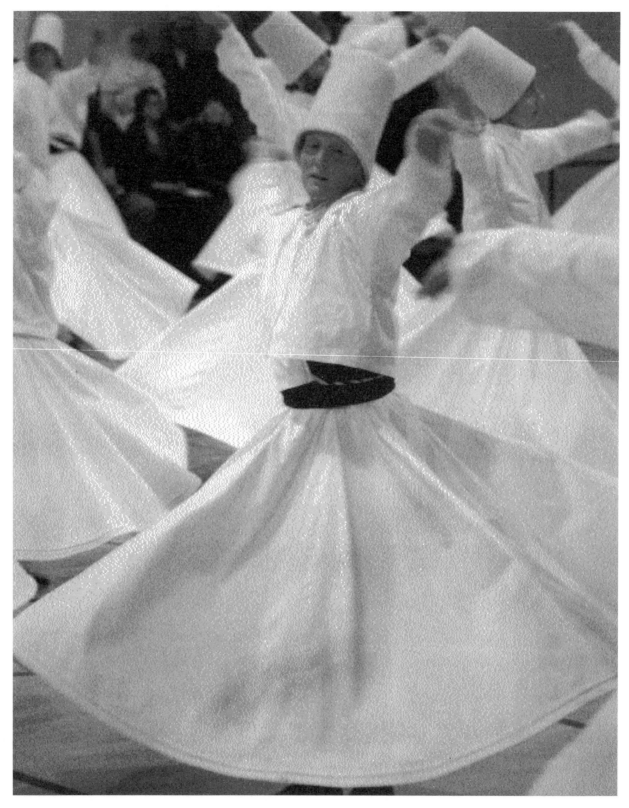

Amina

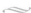

I am your garden beneath a tree that grants every wish.
—*Rumi* (trans. by J. Star and S. Shiva)

"Because he reminded us of how Jesus must have been." A Greek priest spoke out, "Mevlana is like bread which is indispensable to all. Has anyone seen a hungry man run away from bread?"[28]

It was after Rumi's death that the turning ceremony of the Mevlevi order was formalized. Rumi's son, Sultan Veled created Shebi Arus, the Wedding Night, to honor the passing of his beloved father. Over the next two hundred years this ceremony of turning was refined and passed down intact, generation after generation, to the present day. The way of Rumi became the Mevlevi Order. It is this order, the Mevlevi Order, commonly known as the Whirling Dervishes, which has mastered the practice of turning, and it is their ritual, Shebi Arus, the wedding night, that is presented throughout the world on December 17th in honor of Rumi's passing.

The *sema* is at the heart of Mevlevi tradition. This blending of sacred sound, turning and *zikr* invites ecstasy and a dissolving of the individual self into the group's call to the Beloved. The lament of the reed crying of separation is a symbol of Rumi, which resonates in the hearts of humanity. The cry stretches back in time connecting us to the soul of Muhammad, peace be upon him, as he knelt in solitary prayer filled with the truth of God's eternal Presence, to the nights of Rumi and his disciples turning spontaneously in the streets on their return from the mosque, and to the wedding night of Mevlana, which we carry, God willing, into the twenty-first century.

> My goal is to know through the eye and the vision . . .
> the desire of the vision tells me: Rise up and move . . .
> In the same way that the child washes his tablet before inscribing
> his letters on it.
> God transforms the heart with blood and pitiful tears before
> engraving His mysteries on it . . .[29]
> —*Rumi, Mathnawi* (trans. by S. Fattal and
> E. de Vitray-Meyerovitch)

Embroidered Cloth

Sikke reads, "O our Venerable
Master, Friend of God."

Cemetery Guardian
photo by Andalieb

Saints and angels

sometimes share a common fate.

Coated with dust

and left unattended

they still radiate a spirit of sacredness.

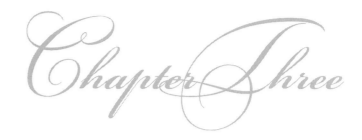

WOMEN DERVISHES OF THE PAST

> . . . console me for it is Thine to console this state of mine.
> Thou has given me life and cared for me and Thine is the glory.
> If Thou wert to drive me from Thy door, yet would I not forsake it,
> for the love that I bear in my heart towards Thee.[1]
> —*From a prayer attributed to Rabi'a of Basra* (M. Smith)

One of the great Sufis of Islam, Rabi'a of Basra was born about five hundred years before Jelaluddin Rumi.[2] Her nature was rather fiery, with a no-nonsense approach to religion, but the profound inspiration of her being was an unwavering devotion to the true Beloved of her heart.

> I love God: I have no time left
> in which to hate the devil.[3]
> —*Rabi'a of Basra* (trans. by C. Upton)

This concept of the Beloved was a transformational insight in the development of Sufism, a turning away from God as a wrathful taskmaster and a leaping into the stream of unconditional love. This view opened the way for Rumi's awakening through the friendship and inspiration of Shams-i Tabriz; that fateful and mysterious meeting of the wandering patched-robed dervish with his wild, unkempt appearance and the refined, youthful scholar in whose soul the seed of Sufism had already been planted and nourished. In one piercing question, Shams penetrated the heart and mind of Rumi, "Who was the greatest, Bayazid Bestami or Muhammad?"[4]

On the surface, there could be only one answer to Sham's question, for no mystic—no matter how evolved—could be greater than a prophet. Yet, by examining the mystical states of each, hidden truths were revealed, and in that moment the learned philosopher was turned to the path of the dervish. Scholars of the Sufi path have placed this relationship of Rumi and Shams above all others. Certainly, Shams was the catalyst for the alchemical transformation of Mevlana.

Rumi's relationships with the women in his life—who were an integral part of his family, his friends and students—reveal another

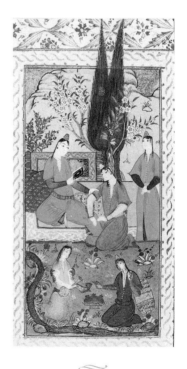

"Women in a Garden"
Circa 1603. Courtesy Topkapi
Sarayi Museum of Istanbul

aspect to the depth of his being. It was, after all, his students and relatives, both male and female, who helped to establish the path of Mevlana, the Mevlevi Order.[5] With few exceptions, historians permit only tiny glimpses into the lives and relationships of these women. From these precious fragments, however, we can weave a quilt that offers a more intimate touching into the character of these women dervishes from the past.

* * *

Not much is known of Rumi's mother, Mu'mine. The historian Aflaki links her ancestry to the Prophet himself, but modern scholars find this evidence in dispute.[6] Rumi's family left the city of Balkh when he was a young boy to begin a long period of traveling. They stopped in Laranda, where Rumi met and married Gevher "who was extremely beautiful and gracious, unequaled in education and perfection."[7] During this stay Rumi's mother died and was buried in a little mosque. Gevher gave him two sons, Alaoddin and Sultan Veled. She died when they were infants, and Rumi, his father, Baha'uddin, and their family continued their journey into Anatolia.

They arrived in Konya about 1228, where Baha'uddin as a learned Sufi theologian began to teach under the auspices of the Sultan. After the death of Mevlana's father, a former disciple of Baha'uddin, Seyid Burhaneddin, arrived from Balkh to Konya. Rumi continued his studies with him for approximately nine years, until Seyid left Konya around 1240. It was almost four years later that Rumi and Shams-i Tabriz had their fateful meeting. After Rumi had lived for a number of years in Konya, he married Kerra, a Christian, who converted to Islam. She gave Mevlana another son, 'Alem, and his only daughter, Melike.[8] Kerra was described by Aflaki as a model of virtue, the Mary of her age. Aflaki records that one morning Jelaluddin emerged from a small room in their home after being with Shams in deep prayer all night. In his hand was an unfamiliar blooming plant, which he gave to Kerra, saying that it had been brought to her as an offering. Later that morning, she sent some servants to the perfumer's stall with a few leaves to see if anyone could identify it. A spice merchant from India happened to see it and recognized it as coming from a flower that grew in Ceylon in the south of India. How did the flowers get to Konya in the depth of winter? Just as Kerra learned of its origin, Jelaluddin came into the room and requested that she take the greatest care with it as it had been sent by "florists of the lost earthly paradise, through Indian saints as a special offering." It is said that she tended it carefully as long as she lived, once giving some of the leaves to Gurcu, her dear friend and Rumi's devotee, to relieve an illness. The flowers never lost their freshness or fragrance and when applied to an ailing part effected an immediate cure.[9]

Many of Mevlana's students were jealous of the relationship between Rumi and Shams. Finally, Shams left unexpectedly and Rumi was desolate. He sent his son, Sultan Veled, to look for Shams and to

A white flower grows in the quietness, let your tongue become that flower.
—*Rumi* (*Secret,* trans. by C. Barks and J. Moyne)

bring him back. When Shams returned, Rumi approached his adopted daughter, Kimiya, about the possibility of marriage to his beloved friend. She had been part of Mevlana's family since she was a child and he loved her as much as his own daughter. "She had the disposition of an angel and was well versed on the inner and outer virtues. Her richness of heart and purity made her a fit companion for the mystic." Although she was much younger than Shams, she willingly agreed to this union. For a brief time, Rumi, his family and Shams with his new bride, all lived in the same household, at a *matrisse** built especially for Mevlana. When Kimiya died suddenly after a short illness, Shams was grief stricken and it was only a short while later that he disappeared for the final time.[10]

After Shams's final disappearance, Rumi's friendship with Selaheddin Zarkub, the goldsmith, deepened. Rumi sought out Zarkub's spiritual advice. The goldsmith's daughters, Fatima and her sister Hediyya, as well as Latifa, their mother, were all devoted to Rumi. Mevlana taught Fatima to read the *Qur'an* and other books. "She learned of strange systems of knowledge and marvelous fantastic thoughts from his blessed mouth." She knew the secret thoughts of men. She performed both inner and outer miracles in great number. Most of the time she fasted during the day and she stood praying all night. She ate only three times every two or three days. She gave her food to the poor, to orphans and to widows. She distributed clothes and gifts to the needy. She spoke little. The mysterious forms that are the spiritual beings of heaven were actually visible to her eyes, and she showed them to her lady friends, such as Gurcu and her daughter Koumadj, who were deserving of this rapture. She was elevated by her spiritual master, Rumi, and her own skillful sensitivity. Rumi called Fatima his "right eye" and Hediyya his "left eye" and Latifa "the personification of God's Grace."[11]

Rumi had many *murids* (students) and friends outside of his extended family. Some of his most devoted followers included a wide diversity of interesting women. The wife of Aminoddin Mika'il, a viceroy, invited Rumi to meetings at her home and used to shower his head with roses during the *sema*.[12]

Gurcu Hatun, the wife of the Pervane‡, also known as Princess Tamara, was very devoted to Rumi. A story is told that whenever she was out of the Master's presence she missed him so much that she hired Ayn'l Devla, a famous painter of the time, to draw a picture of Mevlana. When he approached Rumi and before the artist could say a word, the mystic spoke, "If you can draw my picture it will be a great achievement." When Ayn'l Devla actually began to draw, each time he looked up Rumi's face had changed. Ayn'l Devla drew about twenty pictures, finally giving up in astonishment and bowed before Mevlana. When Gurcu received the pictures, she kept them in a box. Whenever

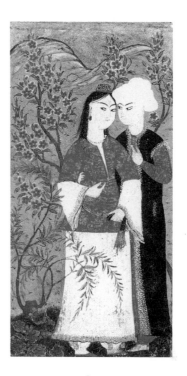

"Lovers"
Circa 1560. Courtesy of Topkapi
Sarayi Museum of Istanbul

Matrisse is a university for religious study.

‡*Pervane* is a position of political power similar to a local governor.

Tear Drop Ornament

she desired to see Rumi she would look at those pictures and his actual face would appear before her. This filled her with happiness.[13]

In contrast to Gurcu's royal position, Siddiqa, another devotee, was a slave of Roman origin, owned by one of Rumi's followers. She had certain psychic gifts: "She used to see aureoles of heavenly light: green, red, and black. Various angels used to visit her and souls of the departed." Her owner became jealous of her ability to have visions. In order to console the owner and protect Siddiqa, Rumi minimized her gift and assured the owner that a seeker who used every effort to progress toward God would have a greater chance of success than someone who might become distracted by such a gift. Her master was comforted and Siddiqa was spared from his jealousy.[14]

Nizama, a friend of Kerra's, had the inspiration to host a spiritual gathering for Rumi and provide entertainment. Her only possession worth selling to pay for this event was a veil she was saving as a *thevr,* the winding cloth to be used for her burial. On the same morning that she had determined to sell it, Jelaluddin Rumi appeared at her home with his followers and said, "Nizama do not sell your veil, we have come to be your entertainment!" They remained with her for three days and nights participating in spiritual exercises.[15]

Fakhru-'n-Nisa, the glory of women, was known for her saintly nature. She too was a devotee of Rumi. When it came time for her to make the pilgrimage to Mecca, she sought Rumi's advice. That evening there was a gathering at his house, which she attended. As was Rumi's habit, late that night he went up on the roof for further prayers and invited Fakhru-'n-Nisa to join him. While he was praying he took her hand and she looked up into the sky and saw the Kaaba spinning above them. She fainted in wonderment and upon awakening she felt certain in her heart that her personal journey to Mecca was completed.[16]

One of the greatest joys in Rumi's life was the marriage of Zarkub's daughter Fatima to his son Sultan Veled. Fatima developed as a mystic under Mevlana's guidance and Sultan Veled would be Rumi's eventual successor to the evolving order. Apparently there were difficulties in this marriage as Rumi wrote a letter to Fatima offering his concern:

God Opens Doors.
Your spirit and mine are amalgams melted
into each other. When you grieve, I grieve.
With God as my Witness, it's true, when my daughter-in-law
 hurts, I hurt more . . .
My one request of you is that when you are annoyed with anyone
 about anything, that you not keep it from me. I want to help!
If my dear son, Sultan Veled, does something to hurt you,
 I'll banish him from my heart! . . . I'll forbid him to come
 to my funeral! And this is true for anyone else too.
I don't want you to be sad! If anyone says something against you,

remember Allah is on your side
... Tell me everything that has happened, every detail,
 one by one. You are a temple of Trusting. God comes
 to us through you and your children,
Don't any of you be sad, ever![17]
—*Rumi* (trans. by C. Barks and J. Moyne)

Hediyya, Fatima's sister, and the calligrapher Nizameddin wanted to be married. Zarkub and his family lived quite simply and had no money for the customary bridal trousseau. Her brother-in-law, Sultan Veled, and Husameddin, Rumi's senior disciple, spoke to Mevlana regarding the situation. Rumi told them to seek out Ousta Hanum, a saintly and learned woman who taught the sultan's daughters. Rumi requested that she go to see Gurcu Hanum and ask her to prepare a trousseau with the help of the Emir's wives and daughters. Ousta hung a basket around her neck and ran to the palace crying, "Something for God!" She conveyed the salutations of the Master, Rumi, and recounted the situation. All the noble women showed themselves to be very generous. They offered many thanks to the Master for the kindness of suggesting a good deed of this nature. Gurcu ordered the treasury to prepare all sorts of

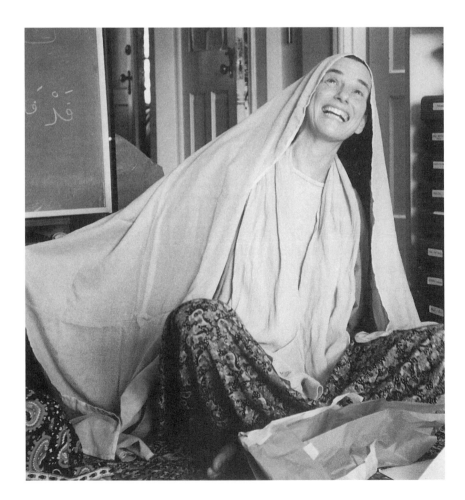

*Hilal Celebrating
with Her Friends*

~

This marriage be women laughing
together for days on end ...
—*Rumi* (*Hand,* trans. by C. Barks)

vestments, jewelry, carpets, candelabras and a full set of cooking uten-sils. Each gave according to their own ability as was the custom of no-bles during that time. Ousta delivered the gifts by mules from the royal stable. Zarkub was extremely satisfied and Rumi expressed intense joy. He offered prayers to the heavens that the benefactresses be blessed. So much was given that Rumi ordered half to go to Fatima and the rest to the betrothed couple. For years the inhabitants of Konya entertained themselves with stories about the splendor of that marriage.[18] On their wedding day Rumi composed the following *ghazal*:

> This marriage be wine with halvah, honey dissolving in milk.
> This marriage be the leaves and fruit of a date tree.
> This marriage be women laughing together for days on end.
> This marriage, a sign for us to study.
> This marriage, beauty.
> This marriage, a moon in a light-blue sky.
> This marriage, this silence fully mixed with spirit.[19]
> —*Rumi* (trans. by C. Barks)

The spiritual friendship between Zarkub and Rumi, which developed after the disappearance of Shams, lasted for ten years. The humble goldsmith suffered a long illness and looked to his own death as "an appointment with his Beloved."[20] He requested that Mevlana celebrate his passing. When Rumi buried his dear spiritual brother and mentor, family members and friends joined with him in a glorious *sema*.[21]

> Call the drummers, tymbal beaters and tambourine players.
> March towards my grave dancing thus,
> Happy, gay and intoxicated: with hands clapping, so that people
> would know that the friends of God go happy and smiling
> towards the place of meeting.[22]

Rumi now turned to his disciple Husameddin, who encouraged him to write down the *Mathnawi*. It is said that the moment he suggested it, Rumi lifted his turban and pulled out a scrap of paper with the first lines, "Listen to the sound of the reed how it tells a tale of separation." They spent long hours together, Rumi reciting spontaneously and Husameddin conscientiously recording the words. The *Mathnawi* is six volumes with 25,700 verses composed over a fifteen-year period, completed shortly before Rumi's death. Husameddin was known to be eloquent, pious and a gifted administrator who distributed gifts and donations with equality and generosity to the men and women of the growing Mevlevi community. It was about five years after Zarkub's death that Jelaluddin Rumi named Husameddin as his successor.[23] Rumi left us three great works: *Fihi ma Fihi, The Divan of Shams-i Tabriz* and the *Mathnawi*.

When Rumi died, his devotee, Gurcu, along with her husband, Emir Pervane, contributed much of the funds for the establishment of

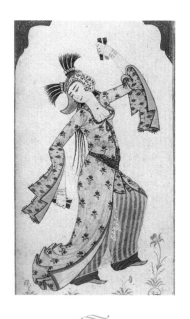

"Dancing Girl"
By Levni, circa 1720.
Courtesy of Topkapi Sarayi
Museum of Istanbul

his final resting place.[24] Shortly after Rumi's death, Kerra, his second wife died. Aflaki records that her corpse was carried to its place of burial through the town. As the procession passed through the gates, it was stopped by an unseen force and delayed for about a half-hour. Sultan Veled started up music and began to turn, and soon the procession continued forward. That night, one of the Mevlevi followers had a dream in which Kerra appeared. She explained that, on the day previous to her funeral, a woman had been stoned to death for adultery at that very gate. She revealed to the follower that she had interceded, asking for forgiveness for this woman, which caused the delay in her funeral procession. On Kerra's tombstone was inscribed that "she had a good character and was pure hearted."[25]

Sultan Veled did not take up the mantle of leadership until after the death of Husameddin, Rumi's senior disciple, whom he acknowledged as Mevlana's spiritual successor. While Rumi was still alive, Sultan Veled and Fatima had two daughters, Mutahhara and Seref. Mutahhara, the older sister, was known as "The Adoring One," and Seref, the younger, as "The Mystic." Both of them possessed the gift of miracles and saintliness. Mutahhara and Seref became leaders in the newly established Mevlevi Order and had many *murids*.[26]

Their Aunt Melike, Rumi's daughter, was also active in the Order. She belonged to the Baciyan-i Rum, women of various Sufi orders who joined together for support and development of their spiritual life.[27] Yet she had her human side. One story is told of her berating a servant. Rumi entered unexpectedly and admonished her for it. "What if she was the mistress and you were the servant, what then? Shall we abolish all positions of servitude? For in truth, we all are brothers and sisters. Has it not been said, God has created us and will resurrect us as one soul?" Melike was so ashamed of her behavior that she gave all her clothes to the servant.[28]

Mevlana had a cat of which he was very fond and it never left his side. When Rumi died, the cat refused to eat or drink, but sat beside the locked door to his prayer room. A week later it was found dead on the threshold. Melike wrapped it in a shroud and buried the cat close to its beloved Master.[29]

After many miscarriages, Rumi's daughter-in-law Fatima gave birth to a son, Ulu Arif Chelebi, much to the delight of his grandfather. When Ulu Arif was a baby, he cried, *"Allah, Allah."* Both Kerra and Melike were very devoted to Ulu and helped raise him.[30] When Rumi died, Fatima lost her milk and her chest became a fiery forge. For three days and three nights she did not go near her baby because she was so overcome with grief at Mevlana's passing. Then Rumi appeared to her in a dream and said, "Oh Fatima Hanum, why do you mourn and lament? If you do it for me or because of me, know that I didn't go anywhere. Look for me in the crib of Arif because that is where I am. The rays of my light fall upon him and my mystery is upon him." Startled by this dream, Fatima got up from her bed and

If you can't smell, don't come
 to this side.
If you can't undress, don't plunge
 into this river.
There is a place from which all
 places originate.
Stay there: don't come to this side.
—*Rumi* (trans. by N. Ergin)

her milk began to flow, wetting her garments. The fire in her chest began to cool. When she arrived at the crib, Arif opened his eyes and regarded her, smiling, and from his eyes the light of the splendor of the Master began to shine on her soul. She saw the luminous ways of his thoughts. Fatima bowed at the foot of the child's crib and became his disciple. She kept this intention for the rest of her life.[31]

When Arif had grown into manhood and leadership within the Order, Fatima visited him at the Tokat *tekke* and prostrated herself in front of him. Gomec, wife of King Rukneddin Kilicarsaln the Fourth, and a student of Rumi, said to Fatima, "This is your son, why are you showing this much respect for him?" She replied, "I am an old woman, I don't feel like he is my son, he is my Shaikh." While Fatima was at the Tokat *tekke* visiting Ulu, the women made *sema* in her honor. It was during the time of Ulu Arif that the role of women flourished.[32]

Turkish Kiosk Motif
18th Century
Manuscript

Seref Hanum, Ulu's older sister, recounts a story about their parents. Here we see yet another aspect to Fatima's complex nature. One day, Seref's father, Sultan Veled, became ill and took to his bed. All of his friends despaired of his life. Fatima sat attentively beside him. Suddenly Sultan Veled opened his eyes and said, "Oh Fatima Hanum, grab your mourning clothes because I'm going. This is the moment of departure!"

"No! It isn't!" Fatima replied. "That day is far from you. I saw that you will not leave and that you will come back to good health. Moreover I will die before you and you will bury me with your own hands."

Sultan Veled replied with effort, "No, assuredly, I'm going!"

"No, by Allah!," said Fatima, "You are not going! On the contrary, you will marry two other women and one of them will give you a dear son and the other will give you two. I see with the eye of certitude. All three of them are playing around you and calling you Papa."

Sultan Veled once again defended himself, but at the end of the seventh day he was completely healed. Seref recounts that after a year passed, "Everything happened the way my mother said it would."[33]

After Fatima died, Sultan Veled married his two household slaves, Nusret and Sunbule. Nusret became a mother to one boy and Sunbule gave birth to two boys. The historian and Mevlevi Shaikh, Golpinarli, remarks that Rumi would not have approved of this because as slaves they would have to obey Veled. Also, Golpinarli felt that Rumi would have disapproved of his son being married to two women at the same time, even though it was an acceptable practice in the path of Islam.[34]

In addition to the leadership offered by Kerra, Melike, Mutahhara, Seref and Fatima, all of whom were relatives of Rumi, there was also a woman known as Arife-i Hoslika who became a disciple of Rumi during his lifetime. As her spiritual development grew, she was given the rank of a shaikha, and had many students, both men and women. She participated in the *tekke* at Tokat and led the *sema* ceremony as *post-nishin*.[35] Toward the end of Arife-i's life, Ulu Arif Chelebi, Rumi's

grandson and successor after his father Sultan Veled, recognized her as a *halife,* which at that time was considered a high rank given only to a few "most sincere" dervishes, like Husameddin. Seref Hanum, Arif's sister, also participated in *sema* in the *tekke* at Tokat along with Arife-i Hoslika. Like his ancestors—Rumi and Sultan Veled—Ulu Arif Chelebi clearly had men and women participate equally in *sema.*[36] These women were all active in helping to establish the Order during the first three generations following the death of Rumi.[37]

Many years later, women continued to hold positions of public leadership and acknowledged spiritual development within the Mevlevi community. In the Afyon *tekke,* Shaikh Sultan Divani made his daughter, Destina, shaikha and his successor. When he died the *post* was given to her and she wore the full formal attire and conducted the *sema* as the *postnishin.* While she was the shaikha, the *tekke* at Afyon burnt to the ground and there was no money to rebuild it. One evening Destina prayed, concentrating on her father. That night he appeared in a vision telling her to go to the fountain where the dervishes performed their ablutions and she would find what she needed. Early the next morning she went to the fountain and pulled out a silver vessel, discovering enough gold coins to begin the reconstruction. Whenever she needed money for the *tekke,* she would return to the same place and the vessel was always there waiting for her.[38]

Gunes Han, granddaughter of Destina, also was a *postnishin.* At that time in the order, women still held positions of public leadership. The dervish poet Yakin wrote a *ghazal* in her honor while she was still alive—an unusual and profound acknowledgement of her respect within the Mevlevi community:

> With the ray of her grace, she made the Mevlevi order the
> singer of her praise . . .
> With her mystic power, she made her holy night prayer room
> a banquet place for the seven shining spheres of heaven
> and all that are in them . . .
> She made the Khanqah of four posts into a palace of unity . . .
> It is no wonder that she made the sun to be a moth circling
> her candle of Uniting . . . even the mystic knowers are
> silenced and in awe at the thought of her sweetness . . .[39]
> —(Trans. by I. Gamard)

During the thirteenth century women banded together through trades such as weaving and formed dervish communities. They continued the tradition of the Baciyan-i Rum (Anatolian sisters), the same organization that Melike, Rumi's daughter, had been active in during her lifetime,[40] and "played a prominent material and spiritual role in the transformation of Anatolia into an Islamic and Turkish Land."[41]

Over the next century, the role of women changed. Women were no longer welcome in positions of public spiritual leadership. At the

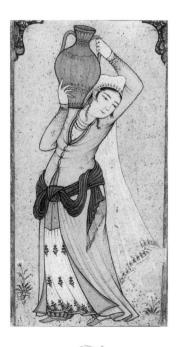

"Woman with Pitcher"
By Levni, circa 1720.
Courtesy of Topkapi Sarayi
Museum of Istanbul

turn of the fourteenth century, a Mevlevi Shaikh, Seyyid Harum, one
of the founders of the town Seydisehir, was on his deathbed. He de-
cided to name Halife Sultan, his educated daughter, as his successor,
rather than his younger male nephew, Musa. In order to make this
choice more acceptable, her supporters declared her an hermaphrodite.
Some even claimed that she had changed sexes and become a man.[42]

With the passage of time the separation of the sexes became more
stringent. Women were no longer included in the public dervish cere-
monies and were relegated to sitting and watching in a separate section.[43]

In the nineteenth century the poetess Leyla Hanum knocked on the
door to the Mevlevi prayer hall to be admitted. When it became clear
that no one would open the door to her, she cried out, "My God, why
did you begrudge me this scrap of flesh?" Golpinarli relates that the
whole town was silent and thoughtful for a period of time after her out-
burst. For Leyla Hanum, there was no admittance to the Mevlevi path.[44]

> . . . Be always scraping away
> the dirt from your well.
> A Treasure appears to anyone who suffers.
> Everyone who strives sincerely comes to good fortune.
> The prophet has said each prostration in prayer
> is a knock on Heaven's gate.
> When anyone continues gently tapping,
> Felicity shows her smiling face.[45]
> —*Rumi, Mathnawi,* 2045

Turkish Woman With Distaff
18th Century
Bibliotheque Nationale de France

Silsila of the Mevlevi Order

In creating a *silsila* of women in the Mevlevi Order, certain liberties have been taken. Traditionally a *silsila* is an unbroken chain of spiritual teachers who have passed their responsibility of leadership to each successive generation. The *silsila* of Mevlana Jelaluddin Rumi was traced by Aflaki back to Abu Bakr, a companion and follower of Muhammad, recognized as the first caliph after the prophet's death and the father of Aisha, one of the wives of the Prophet Muhammad. This chain can be traced forward in time to Faruk Chelebi, the current Pir of the Mevlevi Order in Turkey.[1]

Because of the lack of documentation as well as separation from public life, the recorded history of the women teachers of Mevlevi is not complete. The "chain" of spiritual sisters who are being named in this *silsila* begins with Rabi'a of Basra who was not directly connected to the Mevlevi's succession of teachers in the orthodox manner but whose spirit and philosophic viewpoint was a pivotal leap in consciousness, laying the foundation for the development of the mystical path of "burning," characterized by intense longing, devotion, and annihilation in the Divine Beloved. Some of the women listed are of the same generation so that the chain becomes horizontal as well as vertical. Leyla Hanum was never admitted to the Order at least on the physical plane, and there were at least a hundred years between Fatima Hanum and Fariste Hanum.

When you find yourself with
the Beloved,
embracing for one breath,
In that moment you will find
your true destiny.
—*Rumi* (trans. by S. Shiva)

Rabi'a al-'Adawiyya Al-Qaysiyya of Basra	A great Sufi who preceded Rumi by four hundred years and opened the door to the concept of God as the Beloved.[2]
Kirai Hanum	Mother of Kerra, Rumi's second wife.[3]
Melika' i-Jihan (Queen of the World)	Grandmother of Rumi.[4]
Mu'mine Hanum	Mother of Rumi.[5]
Gevher (Gowhar) Hanum	First wife of Rumi, daughter of Serefeddin Lala of Samarkand, mother of Sultan Veled.[6]
Kerra (Kira) Hanum	Second wife of Rumi, originally a Christian, converted to Islam, helped to establish the Mevlevi Order. Died 1292.[7]
Melike Hanum	Rumi's daughter, married Shahabuddin. Active in Baciyan-i Rum.[8]
Gomec Hanum	Wife of King Rukneddin Kilicarslan IV, student of Rumi.[9]
Selcuk Hanum	Daughter of Gomec, a devotee of Rumi.[10]
Gurcu Hanum	Also known as Princess Tamara, daughter of widowed Georgian Queen Rusudan, wife of Mu'inuddin Parwane, devotee of Rumi. She and her husband helped to finance the construction of Rumi's mausoleum. Originally a Christian.[11]
Koumadj Hanum	Daughter of Gurcu, friend of Fatima and follower of Rumi.[12]
Ayn-al-Hayat	Devotee of Ulu Arif Chelebi, daughter of Gurcu Hanum.[13]
Arife-i Hoslika‡	Devotee of Rumi; shaikha at Tokat, both men and women were her *murids;* made a *halife* by Ulu Arif Chelebi, Rumi's grandson. Helped to establish the Mevlevi Order.[14]
Fakhru-'n-Nisa (the Glory of Women)	A saint of her time, devotee of Rumi.[15]
Siddiqa	A bonded Roman servant and visionary, disciple of Rumi.[16]
Nizama Hanum	Friend of Kerra and student of Rumi.[17]
Kerime Hanum	Daughter of Muhammad Hadim, *murid* of Rumi.[18]
Kimiya Hanum	Wife of Shams-i Tabriz, adopted daughter of Rumi. Died 1248.[19]

Fatima Hanum	Wife of Sultan Veled, "right eye of Rumi" and daughter of Selaheddin Zarkub, the goldsmith; mother of Ulu Arif Chelebi; helped to establish the Mevlevi Order.[20]
Latifa Hanum	Mother of Fatima, "personification of God's Grace."[21]
Hediyya (Hadiyya) Hanum	Sister of Fatima, "left eye of Rumi," married to Nizameddin, the Calligrapher.[22]
*Mutahhara Hanum**	Daughter of Sultan Veled, had many *murids,* helped to establish the Mevlevi Order.[23]
*Seref Arife Hanum**	Daughter of Sultan Veled, sister of Ulu Arif Chelebi, had many *murids,* known as "The Mystic," helped to establish the Mevlevi Order.[24]
Nusret Hanum and Sunbule Hanum	Wives of Sultan Veled after Fatima's death. They were household slaves.[25]
Devlet Hanum	Daughter of Emir Kayser Tabrizi, wife of Ulu Arif Chelebi.[26]
Pasa Hanum	Wife of Keygatu, devotee of Ulu Arif Chelebi.[27]
Melike Hanum	Daughter of Arif Chelebi, (named after Sultan Veled's sister) Rumi's granddaughter. Helped to establish the Mevlevi Order.[28]
Celale Hanum	Rumi's granddaughter (died 1283), daughter of Melike (Rumi's daughter).[29]
Destina Hanum‡	Daughter of Shaikh Sultan Divani, shaikha of Afyon *tekke.*[30]
Gunes Han‡	Granddaughter of Destina, daughter of "Little Mehmet Chelebi," led the Mukabele *sema.*[31]
*Halife Sultan**	Daughter of Seyyid Harun, shaikha of Seydisehir.[32]
Leyla Hanum	Poetess (1848), begged to be admitted to the Order but the *tekke* would not open the door to her.[33]
Fatima Hanum	Devotee of Jelaluddin Rumi and mother-in-law of Sakib Dede of the eighteenth century.[34]
Feriste Hanum	Wife of Suleyman Dede, mother of Jelaluddin Loras, known in America as "Mother of the Dervishes." Died September 10, 1994.[35]

*shaikhs
‡*postnishins*

Garden of Inayat by Fatima Lassar

The Khanqah is the nest for the bird "purity,"
it is the rose garden of pleasure and the garden of faithfulness.
—Sana'i (*Dimensions,* trans. by A. Shimmel)

TRAINING OF
A DERVISH

Then and Now

So you want to put your neck
 in the shackles of Love?
Well then, don't complain about the pain
 and the hardships.
Just go through them with a quiet mind.

In the end your rusty chains
Will become a necklace of gold.[1]
—*Rumi* (trans. by J. Star and S. Shiva)

In the first several hundred years after the death of Mevlana, a tradition arose for seekers of the path of the dervish to go directly to a *tekke*. There, at the side of the kitchen, the aspirant would sit silently with folded legs on a bench with a *saka* (sheepskin), for three days. During this time the seeker would remain in a state of meditation and reflection, and their only contact with the world would be to watch life as it was presented in the Mevlevi kitchen. Food would be brought to them and they would have to ask permission to relieve themselves. At the end of the three days the aspirant would be given the opportunity to leave. But, if they chose the life of a dervish, they would be brought before the *kazanci dede,* the master of service, who would send them into the kitchen to begin their training through service.[2]

 This newly-accepted *murid* would stay in a small room with several other initiates and all would be given such menial tasks as sweeping the floors, washing dishes and mending the dervishes' shoes. During the first eighteen days, if at any time the *murid* failed to live up to the standards of the *tekke,* their shoes would be placed facing the door and they would know this was a sign to leave at first light without protest, never to return again.[3]

Mevlevi Sikke

"Ya Hazrati Mevlana,
may God preserve his secret."

If you're afraid of this fire
You will stay raw and uncooked.
You will be trapped
If you try to escape from this circle . . .[4]
—*Rumi* (trans. by N. Ergin)

At the completion of the eighteen days the novice would be given a service *tennure* (*hizmet tennuresi*): a collarless, sleeveless, v-necked shift in black or dark brown, with a full skirt and split panel, essentially shorter and narrower than the *tennure* worn during *sema*.[5] The *asci dede,* the master of novices, would place an *arakiyye,* a light service-hat, on their head. This was known as the ceremony of undressing, or *soyunma*.[6]

The novice would return once again to work in harmony with others, following directions without questioning. Any task given was to be done with the words, *"Al-hamdulillah"* that is, "All Thanks be to God!"[7] Sometimes the tasks were given in a harsh manner, or the novice would be asked to go to a particular store some distance away even though there might be one much closer, to reveal if they had the ability to serve peacefully and willingly.

Throughout the ages, Sufi mystics have used salt as a symbol of Divine Essence. As we sprinkle the nail with salt, we invite transformation by Divine Essence through the practice of turning.

The real training of the dervish took place in the kitchen. Not only was the food prepared in a conscious manner, but the dervishes themselves through their work and practice were transformed from their raw state by being "cooked" and often "burnt" (metaphorically) as preparation for the path. Each evening they would attend sunset prayers and return to the main *tekke* for discourses on the *Mathnawi* or a *sohbet* with the shaikh. Thus would begin their thousand-and-one-day *chille*.*[8]

At this beginning stage the aspirant was called a *tchella kash.* The day was filled with work, the evening with study, and there were formal prayers five times a day. During the night the novice slept in a small room with only a cloak for a cover. Simple meals were served on a piece of leather placed on the floor, with all the dervishes using the same plate to encourage moderation in eating. When the aspirant made a mistake or was disrespectful to the elders, the group could be assembled and the shaikh might give a punishment of ten to twenty lashes on the legs of the offender in front of all the dervishes.[9]

In between prayers, cleaning, or helping with food preparation, the *murids* would be taught how to serve guests who arrived at the *tekke.*

**Chille,* in Mevlevi tradition, a 1001-day solitary spiritual retreat.

Whether it was a prince or a poor traveler, each would be received in the same gracious way—as the honored guest. In addition, within the context of day-to-day life the aspirant was always to show great respect for any member of the dervish community who had entered the path before them.

During this period of seclusion the *murid* would train daily in the turning practice. Before each class the *chille*-initiate would perform *abdest,* ablutions, repeating the name of Allah while ritually washing with water. The turn practice took place on a wooden board about three-feet square and one-inch high, with a round-headed nail in the middle. The initiate would kneel beside the board, kiss the nail, and with the right hand, carefully sprinkle salt over the nail head. Next they would step on the board in *muhur,* a position of humility in which the left foot was placed on the board with the nail between the first and second toe, and putting the right large toe over the left, bowing and saying, *"Eyvallah,"* that is, "With God's permission." From this posture of surrender, the initiate was ready to receive instruction. The arms would be folded across the chest. One would always begin the practice with a deep bow, then stand upright and look to the left, placing the right foot turned in and slightly in front of the left. Together, the two feet would form a right angle, creating a half T-shape.

First the *murid* would be taught half-turns and then a full *chuk,* or circle, keeping the nail between the toes as they moved and returning to the same place and position each time. With each rotation the *murid* would silently chant the name of God in their heart. Over time the *murid* would be taught to open the arms with the left palm facing the earth and the right palm facing toward the sky, turning always to the left, toward their own heart. This practice would last about two hours daily for nine months.

After completing about a year of training the *murid* might be allowed to participate in the *sema.* Once a week, usually on Friday night, the *tekke* would be open to visiting guests. Sometimes, members of other Sufi orders would come to visit and a *sema* would be part of the evening with food offered either before or after.[10]

In the last days of training the *murid* would go through a final stage of testing. They would be given the worst job—cleaning the latrines—and many tests of physical labor; they would be subjected to spiritual questioning to reveal the depth of their commitment and readiness. At the end of the 1001 days there would be a ceremony of confession. On the day of the ceremony, the initiate would be taken to the baths and presented with the new garments of

Beginning from *muhur (last image this page)* we open into making this T-step. With each *chuk,* or complete turn, we return to this position.

We twist our bodies one-half turn, keeping our left foot on the earth, symbolically connected to the *Ishq* (Divine Love) of Allah, as we release the right heel preparing to lift the right leg.

At the beginning and end of each turning session, we return to the position of *muhur,* the state of being sealed, in remembrance of Atesh Bas, Rumi's cook.

a dervish. A special meal would be prepared and, during the secret ceremony, a *sikke,* the cylinder-shaped *sema* hat, would be given to them during the chanting of communal prayers. Afterwards, the initiate would go to a newly assigned cell and the door would be closed for three days of silent meditation and reflection. Other members of the order could visit during this time, bringing gifts known as *niyaz.* Returning full circle to the days outside the kitchen, the initiates would leave the cell only to relieve themselves or to perform ritual ablutions; even meals were brought to the room. At the end of the three days, the initiate would take the oath of allegiance, *bayat,* before the shaikh of the *tekke.* Again the initiate would return to the cell for eighteen more days of retreat. The final initiation would be a full *sikke* ceremony. At that point the initiate could choose to leave the *tekke* and return home, go to a different *tekke,* or remain. Further training would continue based on individual skills. More advanced study would be offered depending on an initiate's interest and potential as a performer of the sacred dance, a musician for the *mutrip,* a composer of classical music, or perhaps for the study of languages, for interpretation and recitation of the *Mathnawi,* or for training as a calligrapher.[11]

Over the years another way of training was developed. A new initiate could choose to become a *muhip,* who would live at home but would come to the *tekke* every day to learn the *sema,* music and the *Mathnawi.* Still, there remained some who continued to train in the old way, living in the *tekke.* In the twentieth century, Osman Dede was the last living person to successfully go through the three-year Mevlevi *chille.*[12]

> . . . Listen to my words, not from my mind but from my heart
> will I speak.
> What the dervish needs is burning with love for God.
> Whatever the lover has is a sacrifice for the Beloved.
> Sema is a joy, healing for the soul, food for the spirit . . .[13]
> —*Sultan Veled*

Ahad, The Only One

Into the Twentieth Century

In the beginning of the twentieth century the way of Mevlana had expanded, with *tekkes* established in other countries. However, Ataturk, the leader in Turkey, decided to make sweeping changes in order to modernize the country. In 1925 all the *tekkes* were closed. This way of living together, training and offering hospitality to all came to an end. When the police locked the doors to the *tekkes* the townspeople came and placed burning candles on the padlocks.

> If the Tekke is closed you must become the Tekke.
> —*Sadettin Heper of the Mevlevi Order*

Two years later, in 1927, permission was given to open the tomb of Rumi as a museum. By December of 1953, Sadettin Heper, the

kudumzenbashi of the Yenikapi *tekke* in Istanbul, persuaded the mayor of Konya to allow a celebration in honor of Rumi. This *sema* was held in a cinema and performed with only two *semazens* in street clothes and three musicians.[14]

Behind closed doors and with a very real threat of imprisonment, Sufis continued to meet for spiritual practice. Among them was a handful of dervishes who brought their sons together to learn the turning practice. This small group of boys began to train traditionally with the peg, the salt and the wooden board for two hours a day for nine months.

Slowly, the Mevlevi celebration of Rumi's passing was reinstated as a tourist attraction and people began to flock to this event. Over time, the one night of *sema* became a week of performances. By 1973 the Turkish government allowed presentations in London, Paris and the U.S.A. to mark the 700th anniversary of Rumi.[15] It was during this period that Suleyman Dede as shaikh of Konya began to share the way of Mevlana with the West.

Allah Thuluth

Turning Comes to America

During Shaikh Suleyman Dede's travels in the 1970s he visited Sufi communities in Honolulu, New York, Los Angeles and Vancouver, British Columbia, as well as the Gurdijeff Center at Claymont in West Virginia. At each stop he planted the first seeds of the dervish path in the West. When not travelling, he was visited by many Westerners who made their way to Konya to meet him, and he immediately became a source of inspiration to all of them.[16] During this period he began to form his vision in regard to the training of women.

Late in the afternoon of December 16, 1978, Suleyman's son Jelaluddin Loras was standing outdoors in Konya looking at the view, reflecting that for the first time in his life he was free—that he had completed his schooling and his duties to his country.[17] From his earliest days he had been trained in the path of Mevlana. When he was five, his father had begun including him in *zikr*. By seven, he was serving tea and coffee to the dervishes and arranging their shoes outside the door when they gathered. During *zikr* he was allowed to turn in a spontaneous manner. By 1962 he opened his *tennure* for the first time in the Konya *sema,* and in 1964 had traveled with the dervishes to perform in Europe. He studied in Istanbul with Muzaffer Ozak and Sephr Baba, successive heads of the Halveti-Jerrahi Order of Dervishes, and every year returned to Konya to help his family host the many lovers of Mevlana and to celebrate Mevlana's *Urs.*

One of the *semazens* approached Jelaluddin saying that his father wanted to see him. When he reached the house, Suleyman in his role as shaikh met his son formally. He handed Jelaluddin, who did not know a word of English, a one-way ticket to America. Jelaluddin's mother Feriste Hanum stood at the door with his suitcase packed.

Jelaluddin Loras arrived in New York on December 17, 1978. Dede's instruction to him was clear: Train men and women of the West in the path of Mevlana. The cry of Leyla Hanum had been heard!

> . . . People think they are born only once
> But they have been here so many times.
> In the cloak of this ragged body
> I have walked countless paths.
> How many times I have worn out this cloak . . .[18]
> —*Rumi* (trans. by J. Star)

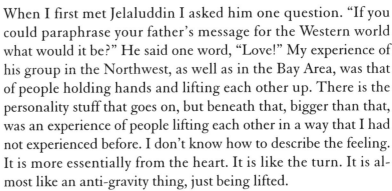

MAILE SPEAKS ABOUT DEDE'S MESSAGE & JELALUDDIN'S WORK

Maile
In the Sultan Veled Walk
during her first *sema*.

When I first met Jelaluddin I asked him one question. "If you could paraphrase your father's message for the Western world what would it be?" He said one word, "Love!" My experience of his group in the Northwest, as well as in the Bay Area, was that of people holding hands and lifting each other up. There is the personality stuff that goes on, but beneath that, bigger than that, was an experience of people lifting each other in a way that I had not experienced before. I don't know how to describe the feeling. It is more essentially from the heart. It is like the turn. It is almost like an anti-gravity thing, just being lifted.

I was raised in a family where you joked and made fun of each other in a good-natured way, but nevertheless it was harmful, habit forming and belittling. Jelal has taught me how to be honoring. He has also taught me to reinforce the practice of the Diamond Work, which is not to react; to be with whatever feelings are coming up, and not have to do something about them. To compulsively do something about them reinforces the behavior; whereas to just be with the feelings allows those structures to dissolve, and then the love can come through.

A Training for the West

The training of dervishes was simplified to adapt to the needs of the culture and the twentieth-century lifestyle. In the first few years the board and salt were used, but only for a short period of time.

Today, training class is usually held once a week with additional gatherings for the *semazens* to practice turning and to do *zikr* together under the guidance of the shaikh. Everyone is requested to practice at home daily, doing at least eighteen *chuks* per day. Generally, new students make a full-year commitment to learn to turn and to begin their study of the Mevlevi path.

The training for a new student is a progression: from turning in place with the arms closed, with the turn broken down into three or four parts; to half turns; to full turns, known as *chuks*. The next step in training is to hold a staff, three to four feet in length, above the head with both arms while turning. This helps to develop strength in the arms and shoulders. Then the *murid* is taught how to open the arms, followed by mastery of the walk turn, and finally the ceremony itself is practiced. During the year the *sema* ceremony is practiced by experienced *semazens* on a regular basis.

About six months before Shebi Arus, the Wedding Night, the students jointly purchase material with which to make their *sema* clothing. Under the direction of a more experienced *semazen,* the new *semazens* gather on a designated night and cut out their sacred garments: the *tennure,** *destegul*‡ and *hurka*.◊ *Murids* then sew their garments themselves. Usually, a seamstress in the community is found to guide the process or to make the costumes for those who don't sew. Shoes and *sikke*° are ordered from Turkey months ahead, and just prior to *sema* the new *murids* are given their *sikke* by the head of the Order in a ceremony formally recognizing them as members of the Mevlevi community.

As the night of *sema* approaches, all *semazens* are asked to help with preparation. The hall is rented and decorated, invitations to the public are sent, and food is prepared for after the ceremony. It is a time of reflection and purification. For the *semazens* the ceremony itself is a mystery, and although the outer form remains unchanged, the inner journey is shaped by all the individuals who participate. It is an initiation for all; and for some, a returning to a place they have always known.

> It happened that a King said to a Dervish: "What is this frock
> and what is this bonnet on your head?"
> The Dervish answered: "Oh most illustrious King, the frock
> is my tomb and the bonnet is my tombstone."
> . . . "Have you not heard, oh King, that there is an interrogation in the tomb and that one has to answer?"
> . . . "At the very moment that the trumpet blasts, the dead
> will rise to dance."
> "What is the secret of the whirling dance of the Mawlawis,
> oh my friend?"
> . . . The other said; "When it comes to secrets, this would be
> enough:
> You have to go back to where you came from . . ."[19]
> —*Divane Mehmed Tchelebi* (trans. by S. Fattal and
> E. de Vitray-Meyerovitch)

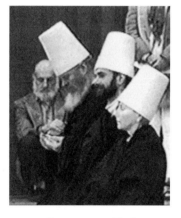

*Semazens at End
of Fourth Selam*

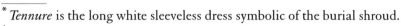

* *Tennure* is the long white sleeveless dress symbolic of the burial shroud.
‡ *Destegul* is the white jacket signifying a bouquet of roses.
◊ *Hurka* is the long black cloak representing the grave or limited ego self.
° *Sikke* is a tall cylinder-shaped hat symbolic of the tombstone.

Sacred Garments

The act of sewing the sacred garments is a physical way of remembering God through every action. Each stitch, each breath becomes a prayer, a way of focusing the mind with purity of intention to create from the unformed to the manifest. The *tennure,* with its long full skirt represents the shroud, a covering placed carefully on the body when the spirit returns to the Beloved. The *destegul,* or bouquet of roses, is a small jacket that covers the top of the turning dress, with the left side open, the right side fastened, so the fragrance, the sweetness of Remembrance permeates the *semazen.* When the heart or *qalb* becomes softened, the rust removed and purity unveiled, then a palpable sweet fragrance is apparent to anyone who comes in the presence of one who has attained this *maqam* or station. The *elifinemed,* or belt that separates the lower chakras or *latifas* from the higher, is a physical presence of intention to shed that which addresses the individual need in order to become a pure vessel for union with the Beloved. The *sikke,* or dervish hat, is symbolic of the tombstone, that which testifies to how we use this gift of a life. And the turn shoes, gloves for the feet, help us to stay connected to the earth and expand into the heavens. Each garment is placed with loving tenderness and a gentle kiss as they are put on the body. They are worn only in the *sema.* Once the garments are placed on the body, no food or drink passes the lips. Once adorned the *semazen* consciously enters a state of humility and surrender. After the ceremony the garments are removed with care, to be stored for the next Wedding Night.

Sema Stories

Amina Speaks About Making the Sema Costume

Making the costume was wonderful. At first I was doing *wazifa** practice as I worked, but then I just got so focused on the actual sewing of the clothes and it was so empowering. I was proud of myself, actually. In fact, my partner bought me a sewing machine because I was so enthusiastic.

Then, two very strange things happened. I had finished the *tennure,* and the following morning as I was ironing it I noticed a tiny hole right over the heart. I don't know how it got there! This perfect *tennure* that I had made had a hole in it and that was a dashing of my pride. It wasn't *perfection* anymore.

Then, when we got nearer to the *sema,* I got white leggings and a beautiful white turtleneck, to go under the *tennure.* On Thursday, the day before we were to set off for the dress rehearsal, I put them separately in the washing machine so they couldn't possibly get dyed. I checked everything. Then I put them in the dryer. When I get them out they were covered in black marks—the dryer had broken and chewed them. My brand-new white garments now had black marks all over them. I collapsed in tears. "What have I done?"

We went to the *sema* rehearsal on Friday. I had stayed up until two o'clock for many nights before, trying to finish everything. In fact, I finished sewing the braid in the car coming down to the dress rehearsal using the inside car-light.

When the *sikkes* arrived from Turkey and I tried mine on, I looked into Jelaluddin's face. "Oh, you look so beautiful, honey!" he said, in his accent.

"Oh, it is so hot!" I said.

"Yeah, we cook!" he replied.

In my mind, I thought, "Oh my God! I'm going to die!" because I knew what he meant. He didn't just mean "hot," he meant we "stew" until there is nothing left.

Johara (left) and Amina

Expecting the worst, you look
and instead,
here's the joyful face you've been
wanting to see.
—*Rumi* (*Three,* trans. C. Barks)

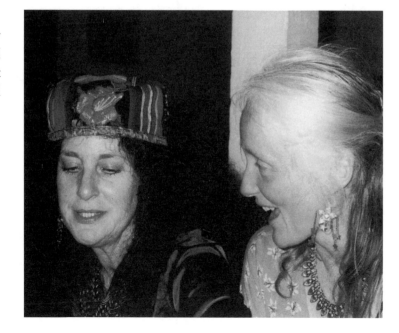

**Wazifa* (*wazaif,* plural) is a quality of God as it appears in the *Qur'an.* The *wazaif* are known as the Beautiful Names. (See p. 146.)

Johara Speaks About the Commitment to Turn Class

When I began the turn class my back was hurting and I went to see a chiropractor. The next class, I approached Jelaluddin to tell him. I even rehearsed what I was going to say before I went. I told him, "I'm very sorry, but this isn't good for my body, and I must not do it any more." He didn't understand what I had said. "What?" he asked. I said it again and he just looked at me. Then he just threw up his arms and said, "Do what you came for!" I realized that what I really came for was to be able to do this and to heck with the chiropractor or anything else. After about five weeks the pain went away and I started to see that this practice could be part of my being.

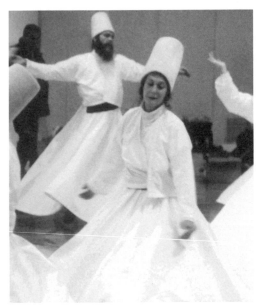

Johara in Sema

The whirling, see, belongs to you and you belong to the whirling.
—*Rumi* (*Look*, trans. by A. Schimmel)

I wanted the *sema* to be a pilgrimage for me. I studied and practiced for a year and made my own turning costume. Right around that time, however, my relationship of about six years split up and he began seeing another *semazen*. My heart was broken. I thought, "Well, everything is ugly now, so I can't possibly go out there and turn." Then I realized I was committed and I really had to. It made me look at my rock bottom values. I thought, "If I don't keep this commitment how will it affect my life?" I knew that the kind of person I wanted to be was one who, if I said I'd be there, I'd be there. So, this was a test. I didn't have confidence that I could participate in *sema* beause I was so emotionally broken up and was concentrating so much on myself rather than what this group prayer means.

I was part of *sema* that year and I realized that is what life is about. You have good times. You have bad times. Something is born, something dies. You just keep turning. That commitment and following through with it gave me something for the rest of my life. The "No, I don't want to" part of me doesn't have to stop me. I can keep turning, regardless. Dealing with that resistant part is still a challenge every day. But that experience gave me something for myself and rooted me personally in the turn, not just spiritually, or community-wise, but in a way that was mine forever.

Amina Relates an Unexpected Lesson of Her First Sema

On the way to the *sema* that morning there were three of us in the car. We stopped at a traffic light and a man was standing by the side of the road carrying a sign: "Help, food, anything!" I have never seen a human being look like this before, like he was starving to death. Although he was young and tall, his whole body was bent like a bow, and he was leaning forward so you could see his ribs. Another young guy

with a backpack crossed in front of the car. He saw me looking at the man and said, "Well, why don't you do something!" We had some bananas and an apple with us, and one of the women got out of the car and gave the fruit to the hungry man. He said, "Thank you!"

When we arrived at the place of the *sema,* instead of getting out of the car, we sat and held each other and cried for half an hour before we could go in. The whole process was one of being cracked open. It had been so painful, excruciating, to see this man dying, and we speculated that he probably had AIDS. I realized that he had chosen to go out like a beacon, a really bright light, standing by the side of the road. He wanted people to see him, and I began to see him as a saint. To do what he was doing, to just *stand* there, was to lose all ego. For me, he was "burning" on the side of the road, and I felt really blessed to see him. I realized that we can choose to burn and show people by our example.

I wondered if everybody went through this kind of testing before their first *sema.* I wondered if this testing continues on through the years.

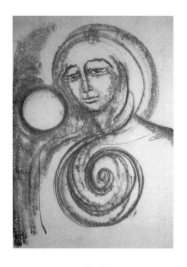

A Heart Opening
by Deborah Koff-Chapin

Linda's Dream of Dede

I never met Suleyman Dede in this world, but in the dream world I met him once. It was during the time when I was working on healing my heart, through poetry and singing. In the dream I met him just outside the door of my room—the room in which I did everything; it was my bedroom, a study and a retreat. I have seen pictures of him, but more importantly, I felt people's energy when they talked about him. It was always heart energy.

In the dream he stood with his arms crossed and said to me, "Now you know how to do this!" Then he said . . . it wasn't exactly in clear English, but the message was, "Now you are going to learn this!" And then he opened his arms.

Of course, I pondered that dream. He was wearing a black *hurka,* and at that time I wasn't a *semazen,* but I knew what those movements were. One movement was obviously turning with arms closed. The opening of the arms means to me that you really open out into the world. The message was that I had learned how to turn within, and now I would learn to turn on the outside, in the world as well!

Last year was my first *sema* as a *semazen.* At the time, I was a director of studies in the school where I worked. I felt really close to the people I worked with, as I had hired and trained them all. I had good creative relationships with them, but I didn't share much of my personal life. However, two people were aware that I was going to be in this whirling ceremony.

Shortly after the *sema,* they each reported that they had had dreams about me. One said that in her dream she had walked into a room as the ceremony was unfolding, and she saw these people whirling, with white skirts. She had a feeling of ecstasy. In the other woman's dream, she watched me whirling from a distance.

Linda Turning in Zikr

There's no need to go outside.
Be melting snow, wash yourself
of your self.
—*Rumi* (trans. by C. Barks
and J. Moyne)

You are my Sultan, you are my
 Lord:
You are my heart, my soul, and
 the faith of mine.
By your breath I am alive;
What is this one life?—you are
 a hundred lives of mine.
—*Rumi* (trans. by J. Star
 and S. Shiva)

Gulistan

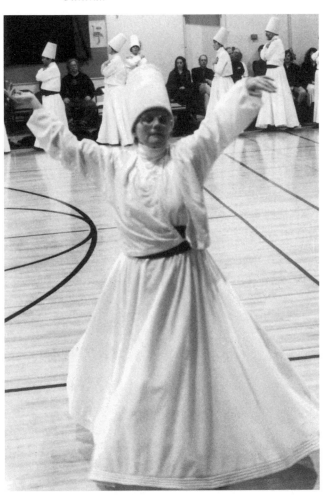

At times I wonder what the purpose of doing this practice is. If the turn is being transmitted in that way—in the dream world—then it is a confirmation that what goes on in this world goes on in more subtle realms. The turn can affect people telepathically, or whatever words we want to use. If they are touched by that beauty or that sense of unity, *Alhamdulillah!*

Gulistan Speaks About Prayer and the Turn

I firmly believe in the power of prayer. Studies have been done using sound and the power of thought and concentration for healing. It is not a new field. Each of us, while praying, is having our own direct experience with the Divine Beloved, our Creator. It is very powerful because it is a mystery. In *sema* there is respect for that mystery. The form itself is a graceful reminder. The *hatti istafa,* the centerline that divides the room, reminds us that this world is transitory and we cross over into another world. Why do we do this formal ritual again and again? What is this about, the death shroud that we wear? This tombstone that we place on our head? The black *hurka* representing the personality, the ego that we drop? We tune to the Presence of the *postnishin,* to that station; to the attitude the prophets hold, their state of realization, the kind of example and ideal they brought to earth. There is respect for that mystery that goes beyond language, beyond catching and defining. That is the beauty of *sema.*

For me the turn is a prayer. Mevlana Jelaluddin Rumi used turning to experience unity or oneness and to feel love. The Shebi Arus, or the wedding night of the remembrance of his crossing, developed over several hundred years. It is a gift to be gathered in this turning prayer with brothers and sisters on our planet. It isn't about what you do for a living or what your schedule is, or when the next bill is due. When we drop our *hurka* what is left collectively is this beautiful support for souls who want to express our prayer, who want to reach into the depth of the heart, which is for me, the temple or Holy of Holies, where the One beyond names, the Sacred One, dwells. We are gathering together to bring, *Inshallah,* light, sanctuary, guidance, solace and inspiration to humanity. It is a blessing to pray together.

O God, give me light in my heart
and light in my tongue
and light in my hearing
and light in my sight
and light in my feeling
and light in all my body
and light before me
and light behind me.

Give me I pray thee,
light on my right hand
and light on my left hand
and light above me
and light beneath me,

O Lord, increase light within me
and give me light and illuminate me!

These are the lights the Prophet asked for,
verily to possess such light
means to be contemplated by the Light of Lights.[20]

Brieana

~

We whisper gentle secrets to each other
and the child of the Universe
takes its first breath.
—*Rumi* (trans. by J. Star and S. Shiva)

SHEBI ARUS

The Wedding Night

Tonight we go to that place of eternity.
This is the wedding night—
a never-ending union
of lover and Beloved.

We whisper gentle secrets to each other
and the *child of the universe*
takes its first breath.[1]
—*Rumi* (trans. by J. Star and S. Shiva)

The *sema* ceremony represents the spiritual journey. The sacred music calls us forth from our worldly slumber to awaken into the Presence of God. We cast aside our daily life with all its concerns and enter a state of timelessness, of peace and surrender, opening our hearts in prayer for the unity of all beings. With God's blessing, each step of the ceremony brings us ever closer to the One in All. Through the process of prayer and turning, we offer our devotion and love with the sincere desire to dissolve into the one True Reality. By the end of our journey we seek to offer ourselves in service to all of God's Creation.

Traditionally, the Sufis honor not the day of a person's birth but their *urs,* the day of their death, the wedding night, when the soul returns home for union with the Beloved. The whirling dervishes celebrate Mevlana Jelaluddin Rumi's passing through this ancient ritual of the soul's mystical journey into awakening and union. Those of us who carry this tradition prepare ourselves for the sacred ceremony. There is purification through cleansing and fasting, a time for reflection and anticipation, and attuning through meditation and prayers. For experienced *semazens,* it is a time of rededication and service. For new students it is an initiation.

Bismillah Star

Preparation

Before the ceremony begins, men and women gather in their separate dressing rooms. White undergarments and turn shoes form the foundation; each garment is gently kissed and placed with prayer upon the body. The sacred garments themselves are a symbol of union with God. The "skin of light," the *tennure,* represents the ego's shroud. The jacket, the *destegul,* is a "bouquet of roses," the *hurka* or cloak is symbolic of the tomb, the part of the being that lures us to sleep. The *sikke* or hat is the tombstone. The *elifinemed* or belt represents the conscious separating of the higher *chakras* from the lower, the Divine self from the human.

During this time *semazens* share stories, sacred songs and especially Rumi's poetry. There are quiet moments of prayer or silence together. Rosewater is offered in the sweetness of love. Just before the ceremony begins the *semazens* line up two by two waiting for instructions from the *postnishin,* who is the living link in the spiritual chain or *silsila* of Mevlana, and the *semazenbashis.** Traditionally, the most experienced *semazens* are at the front of the line and the newest *semazens* at the end. This is the time for *niyat,* setting our intention and entering into the heart.

The *semazenbashis* lead the line of semazens into the sacred space. We enter with a bow, internally praying, *"Bismillah ir Rahman, ir Rahim . . ."* "We begin in the name of Allah, Who is Mercy and Compassion." Slowly the *semazens* walk in unison to line up in *muhur,* the state of being sealed,[2] head bowed, right foot over left, arms folded, beside the *post* represented by the red sheepskin, an archetypal symbol of blood, life, the color of love and the sunset at Rumi's passing, as well as the place of sacrifice and burning.

The *postnishin,* who holds the spiritual initiation connecting us to Mevlana, enters the hall last, to stand opposite the *post* in the place of humanity. The *semazens* connect to the presence of their shaikh. When the shaikh bows, all the *semazens* merge into the one motion. All of *sema* is contained

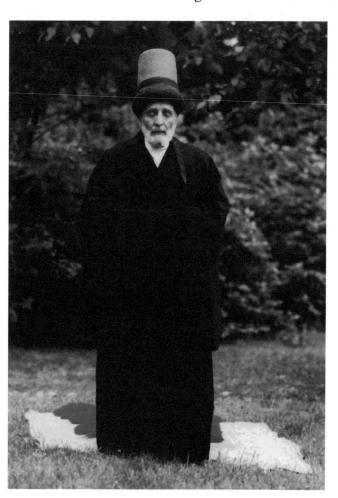

Suleyman Dede Standing on Post

⁓

The sheepskin on which he stands represents the *post,* the place of burning. The *postnishin* willingly opens to this burning so that we can receive the blessing.

**Semazenbashi is the one who assists the postnishin in conducting the sema ceremony.*

within this moment. Slowly the *postnishin* walks across the room beside the *hatti istifa* that divides the room in half, an invisible line symbolizing the straight path to union. Arriving at the *post,* the shaikh walks around the sheepskins and steps on it from behind. The shaikh gazes at the *semazens* and in that glance asks for their love. With complete surrender all the *semazens* bow and sit, reflecting the motion of the shaikh.

Now, the *Na'at,* a prayer written by Rumi himself praising the Prophet Muhammad is sung. It is a time for tuning the heart to begin the still and deep listening; a time

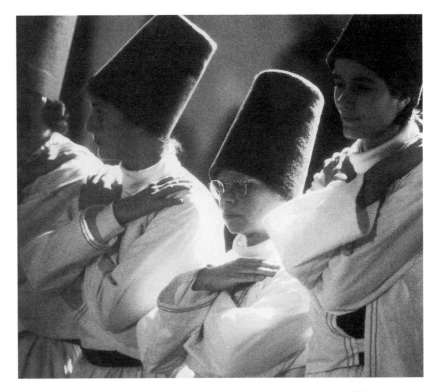

*Semazens Waiting
in Position of Muhur*

God is in the look of your eyes
in the thought of looking,
nearer to you than yourself.
—*Rumi* (*Secret,* trans. by
 C. Barks and J. Moyne)

for letting the remaining aspects of the worldly self drop away. The music of this song, after the silence that has preceded it, takes one back to the beginning of creation. During the *Na'at* the *postnishin* and the *semazens* lower their heads four times in unison to these words that honor Mevlana and Shams-i Tabriz: *Ya Hazreti Mevlana, Ya Mevlana Haqq Dost, Shams-i Tabrizi and Moustafa.* At the end of the *Na'at,* a drum— the *kadum*—sounds four times, followed by the cry of the wooden *ney* expressing the Divine breath which gives life to everything.[3] Slowly the *semazens* bring their hands to their knees, the mind present for the moment of awakening. At the end of the *ney* solo there is one beat of the *kadum* symbolizing the Divine command, "Be!" Together the *postnishin* and all the *semazens* slap the ground in unison with the drum, thereby sounding the *derbi celali,* "blow to glory," symbolic of the day of judgment and the trumpet call of Israfil, the angel of Resurrection.

The Sultan Veled Walk

All arise and bow. Led by the *postnishin,* the *semazenbashi* followed by the *semazens* begin the *devri veledi,* the "Sultan Veled walk," named for Rumi's son, creator of this ceremony. The *postnishin* steps off the *post* and begins the counter-clockwise walk. The *semazenbashis* follow the *postnishin,* crossing the *post,* and turn to bow to the first *semazen.* The *semazenbashi* steps back, turning away from the *post,* to follow in the footsteps of the *postnishin.* Each *semazen* steps across the front of the *post* with the right foot, turning to face the next *semazen.* We bow

in unison to greet each other, face to face, known as the moment of *mukabele*. We stand facing each other on opposite sides of the *post* to acknowledge and greet the Divine Presence that lives in each of us.

As the first *semazen* steps back and faces away from the *post,* the second *semazen* follows in rhythm with the first, being led across the *post* as the first *semazen* is leaving. Now the receptive becomes the active. Each *semazen* completes the bowing and turning away, and then joins the line, instantly returning to the state of receptivity to follow in unison the footsteps of the *postnishin,* repeating *"Allah, Allah Allah!"* in the heart with each step. At the end of the line the youngest *semazen* bows to the *postnishin* who has led the line, and the link between the past and the future is now complete.

The *semazens* walk around the space three times, moving counter clockwise, repeating the bow each time at the *post.* As we walk in the circle and reach the opposite side of the room from the *post,* we bow at the *hatti istifa,* the invisible line dividing this world from the next, acknowledging and honoring the existence of both; the external from the internal, visible from invisible, the descent of the soul into matter, the ascent of the soul toward God.[4]

The three circumambulations are symbolic of the literal human evolution and the path of spiritual development: knowing, seeing and being. The first round is a shedding of all doubts and uncertainty, to surrender fully to the Presence of God. The second round is seeing the Presence of God everywhere, and the last stage is becoming one with the Presence. We return to our line by the side of the *post.* When the *postnishin* reaches the red sheepskin and bows, all bow in unison.

The shaikh stands at the threshold of the spiritual world—on the right is the external world, on the left is the internal world.[5] The *semazenbashis* step forward one step, and the other *semazens* reach with their right hand to lift and kiss the *hurka* as it is removed and folded three times to the floor, representing love, beauty and unity. By shedding the cloak, the burden of the ego is released, opening the *semazens* to be spiritually reborn to the truth. Freeing themselves of their "graves," the *semazens* step forward to join the *semazenbashis* and together they bow with the shaikh.

The Turning Begins

The *semazenbashis* then go to the other side of the shaikh. They bow and ask permission for the *semazens* to begin. All bow with them. The first *semazen* walks forward, bowing to the station of the *post,* awaiting the shaikh's blessing and permission. The shaikh bows to kiss the *sikke* of each *semazen,* as one by one they begin to enter eternity: stepping right, left, right into the first turn, whirling continuously forward until all the *semazens* form a circular shape reflective of the floor space leaving the end of the *post* open. The right hand is open to the heavens, the left hand is extended to the earth as the *semazens* open their arms like wings.

The *sema* ceremony represents the human being's spiritual journey, an ascent by means of intelligence and love to Perfection.
—*Dr. Celaleddin Celebi*

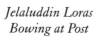

*Jelaluddin Loras
Bowing at Post*

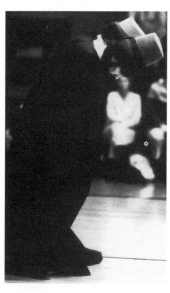

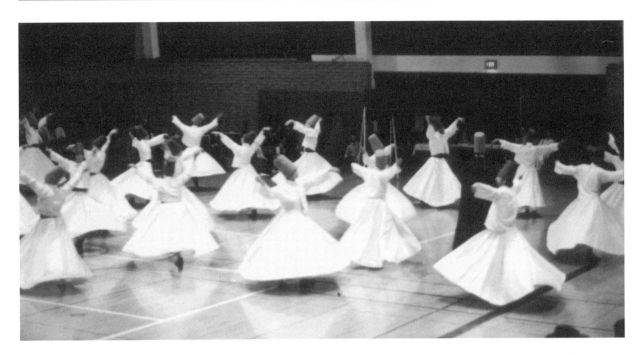

Something opens our wings . . . we taste only sacredness . . .[6]
—*Rumi* (trans. by J. Moyne and C. Barks)

God willing, we disappear in the embrace of the Beloved. Each of us seeks to become a vessel for the Presence of the Divine.

As we *semazens* begin our turn we look to the *semazenbashis* who signal with their feet where each *semazen* will take their place. Depending on the size of the hall and the number of *semazens,* one, two or even three concentric circles may be formed. The shape created on the floor represents the planets revolving around the sun, as the *semazens* turn toward their own hearts.

Once all of the *semazens* have entered the floor whirling, the first *semazen* begins spinning across the arc to the other side of the *postnishin* creating the shape of a crescent moon in front of the *post,* unless signaled by the *semazenbashi* to remain in place. The *semazenbashis* watch the flow of the *semazens* and through silent signals keep the *sema* harmonious: smooth, equally spaced and flowing. At the end of the first *selam** when the music stops, the *semazens* immediately stop turning and return to *muhur,* backing up quickly and gracefully to stand, gently touching, shoulder to shoulder, on the outer rim. The second *selam* begins with the same series of bows.

The Four Selams

As each *selam* begins the *postnishin* prays silently for all the *semazens.* Each *selam* is preceded by a different prayer.

You knock at the door of Reality. You shake your thought wings, loosen your shoulders and open.
—*Rumi* (*Three,* trans. by C. Barks and J. Moyne)

**Selam* refers to the four turning sections in the whirling ceremony.

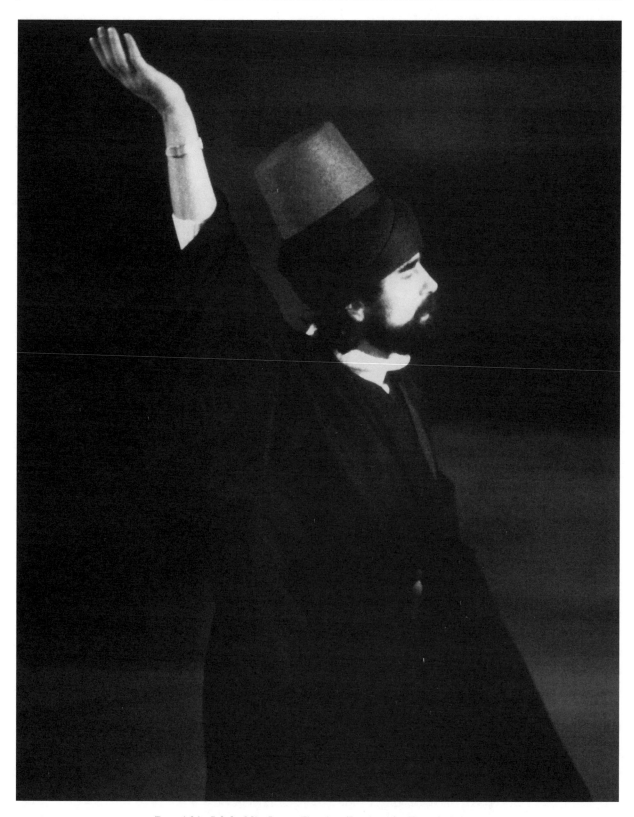

Postnishin Jelaluddin Loras Turning During the Fourth Selam

The clear bead at the center changes everything.
—*Rumi* (trans. by C. Barks and R. Bly)

Turn in the Circle of your True Existence
Be in Harmony with your capacity, with your created nature
Be in active submission.

The first *selam* represents complete surrender and awakening to the Presence of God.

O Beloved Ones who turn herein, may Allah give you health
May God make your awareness and intention sound
May God bring you in readiness to the center of real
 beginning.

The second *selam* is entering the beauty of God's Grace and Majesty wherein the *semazens* witness the splendor and beauty of God's creation.

May Allah grant you total soundness
O travelers on the Way of Love
May the Beloved remove the veil from your eyes.
That you may see the secrets of your time
and of the True Creator.

The third *selam* is opening to the radiant Presence of God's all-embracing love. By dissolving into the rapture of love, the *semazens* annihilate themselves in the Beloved.

O Lovers and real ones
Soundness from Allah
has made your turn complete
It has purified your souls
Allah has brought you close to the true Center
the state of those closest to the One in All.[7]

The fourth *selam* symbolizes the return to the manifest world in service. During the fourth *selam* all turn in place with the *postnishin* and the *semazenbashis* entering the inner circle. The *postnishin* whirls in the center—the *kutup noktasi* or polar point, representing Mevlana and the sun.[8] It is a beautiful moment as all continue to pray silently and together throughout the ceremony with each revolution, *"Allah, Allah, Allah!"*

Completion

At the end of the fourth *selam* there is a moment when the music stops and the *semazens* turn in silence; only the sound of the feet and the skirts can be heard. When the *Imam*[*] begins *Fatiha*,[‡] everyone stops turning, bows briefly and sits quietly while the words of the *Qur'an*

[*]*Imam* is the leader of prayer in the Muslim religion.
[‡]*Fatiha* is the opening prayer of the *Qur'an*.

pour through the *sema*. *Semazens* not turning in the fourth *selam* gather the *hurkas* and with gentle sensitivity offer the *hurka* to the seated *semazens*, who kiss the garment and put it on. At the end of the recitation all kiss the ground and rise, and the *postnishin* chants the final prayer:

> *Inayet-i Yezdan Himmet-i Merdan Ber ma hazir-nazir bad!*
> *Dem-i Hazret-i Mevlana Sirr-i Cenab-i Shams-i Tabrizi,*
> *Karem-i Imam-i Ali.*
> *Sefaat-i Nebi Hu Diyelim Huuuuuuu!*

> May the Grace of God and the spiritual aspirations of true
> dervishes be present and witnessed in Us!
> For the sake of the blessed breath of our Master Mevlana, the
> secret of Shams-i Tabriz, the generosity of Imam Ali and
> the intercession of the Prophet, let us all say *Hu!*[9]

The *postnishin* offers a farewell blessing to the *semazenbashis*, *"A Salaam Alleichum,"* "May God's Peace and Tranquility be upon you!" To which they respond, *"Waleichum A' Salaam wa Rahmatullahi, wa Barakaata, Hu!"* "And may Peace and Tranquility, everlasting Mercy and Compassion, and the Grace and Blessing of God be given to you!" All the *semazens* join the intoning of the *"Hu."* The *postnishin* walks beside the *hatti istifa* slowly, repeating the chant to the *neysenbashi** of the *mutrip*,‡ *"A Salaam Alleichum!"* The *neysenbashi* responds with the prayer and good wishes of God's Peace, Mercy and Grace. A final *"Hu"* is joined by all.

> Peace be upon you oh Lovers, in dying you are liberated
> from death.[10]
> —*Divane Mehmed Tchelebi*

On December 17th, the actual *Urs* of Mevlana Rumi, the *postnishin* completes the ceremony with the ritual of kissing hands, a moment of sweetness among all the turners and musicians. The *postnishin* then bows and leaves the *sema* hall. Slowly the *semazens* walk out, one following another, exiting by the same door entered, with a bow of surrender and gratitude for the blessing of being part of this sacred ceremony.

> To God belong the East and the West.
> For which ever way you turn, there is the Face of God!
> Truly, God is All-Encompassing, All-Knowing! . . . Those
> who have no knowledge say,
> "Why doesn't God speak to us directly, or give us a
> miraculous sign?"

**Neysenbashi* is the chief *ney* player or leader of the *mutrip*.
‡*Mutrip* is a musical ensemble that plays for the *sema* ceremony.

In previous ages, those before them said the same. Their
 hearts are all alike.
Yet We have made clear the signs
for people whose hearts are certain.[11]
—*The Qur'an,* Sura Baqara 2:115-8 (trans. by I. Gamard)

Turkish Design From 16th Century Manuscript

The Wedding Night

The Sema Ceremony in the Tradition
of the Mevlevi Dervishes

يا حضرت مولانا حق دوست

يا حبیب الله رسول خالق یکتا توی

برترین ذوالجلال پاک بی مثلا توی

نازنین حضرت حق صد در كاثنات

دو چشم انبیا چشم چراغ ما توی

وشب معراج بود جبرائیل اندر رکاب

پا نهاده برسره کند حضرا توی

یا رسول الله تو دانی امتانت عاجزند

رهنمای عاجزانی بی سر و بی پا توی

سرو بستان رسالت نوبهار معرفت

كل بن باغ شریعت بلبل بالا توی

شمس تبریزی که وارد نعت پیغمبر زبر

مصطفی ومجتبی آن سید اعلا توی

The Na'at, Arabic Calligraphy.
Na'at frame and illumination by Susan Najmah Arnold

The Na'at

O Dear Master, Friend of Truth
O Beloved of God, The Divine Message Bearer of the Creator without equal
You are the pure one, whom the Lord of Majesty has chosen among His creatures,
O My Friend and Sultan,
You are well beloved of the Eternal, the light of our eyes.
O Protector, Friend of Truth!
O My Friend and Sultan, Messenger of God,
Thou knowest how weak and defenseless are thy people
Thou art the guide of the powerless and the humble in spirit.
Friend of Truth, my Sultan,
Thou art the cypress in the garden of the Prophets!
Thou art the spring season in the world of Knowledge!
Thou art the rose-tree in the Garden of the way of harmony and surrender!
Thou art a nightingale of the world above!
The Sun of Tabriz has praised the glory of the Prophet;
Thou art the purified, the Chosen, the Exalted,
Oh Thou, who heals the heart,
The True Friend of God![12]

This *ghazal* is traditionally sung during the first part of the *sema*. It was composed by Mevlana Jelaluddin Rumi in honor of the Prophet Muhammad.

Ya Hazreti Mevlana Haqq Dost
Ya Habiballah Rasul-i Yekta tuyi
Ber guzin-i zuldjelal pak-u bi hemta tuyi
Dost Soultanim
Nazenin-i hazreti haqq sadri bedri kainat
Nour-i tcheshm-i enbiya tcheshm-i tcherag-i ma tuyi
Ya Mevlana Haqq Dost
Soultanim mahboubimen dost
Ya Resoulallah tu dani Ummetanet adjizent
Rehnumayi adjizani bi ser-u bi pa tuyi
Haqq Dost Soultanim
Servi bostan-i risalet nevbahar-i marifet
Gulbun-i bag-i shariat Bulbul-i bala tuyi
Shams-i Tebrizi ki dared nati Peygamber ziber
Moustafa vu mutchteba an seyyid-i a'la Tuyi
Ya tabibel kouloub
Ya Veliyyallah Allah Dost!
—The Na'at, Turkish Transliteration

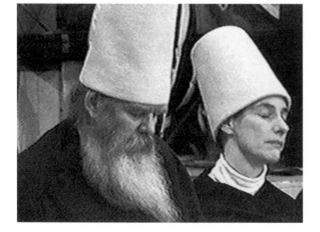

Listen to the cry of the reed,
how it tells of separation . . .
—*Rumi*

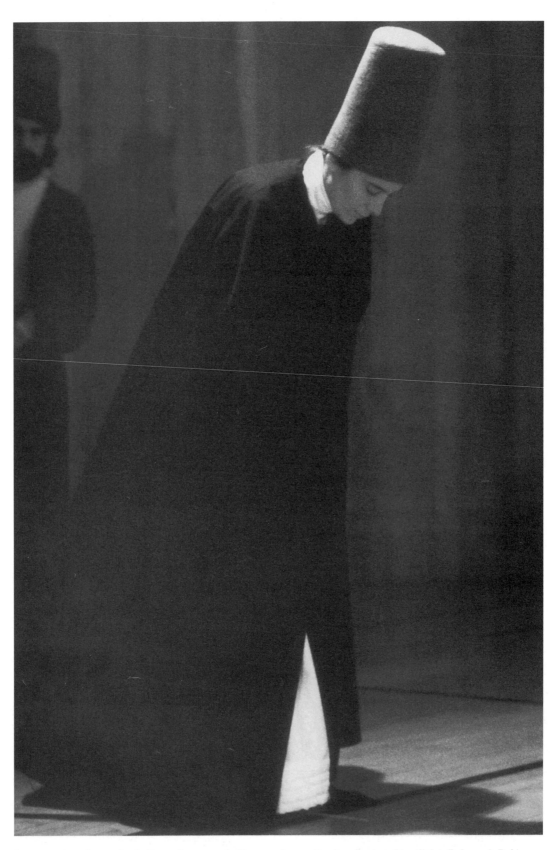

As we step into the turning hall, we place our mind into our heart, silently reflecting, *Bismillah ir Rahman ir Rahim:* We begin in the Name of Allah, who is Tenderest of Mercy, Infinite Compassion . . .

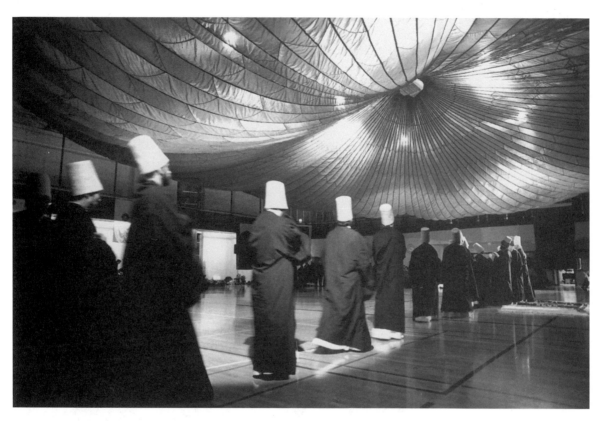

The *semazens* file into the hall to stand beside the red sheepskin representing the *post,* and attune to the entrance of the *postnishin. (above)*

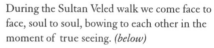

During the Sultan Veled walk we come face to face, soul to soul, bowing to each other in the moment of true seeing. *(below)*

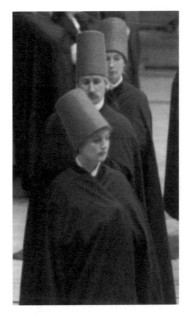

In the Sultan Veled walk we circle the space three times, symbolic of human evolution and the stages of spiritual development.

Since I was cut from the reedbed,
 I have made this crying sound.
Any one apart from someone he loves
 understands what I say.
—*Rumi* (*Essential,* trans. by C. Barks and J. Moyne)

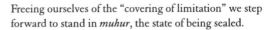

Freeing ourselves of the "covering of limitation" we step forward to stand in *muhur*, the state of being sealed.

As we lower our *hurka* to the floor, it is folded three times, representing love, beauty and unity.

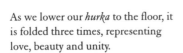

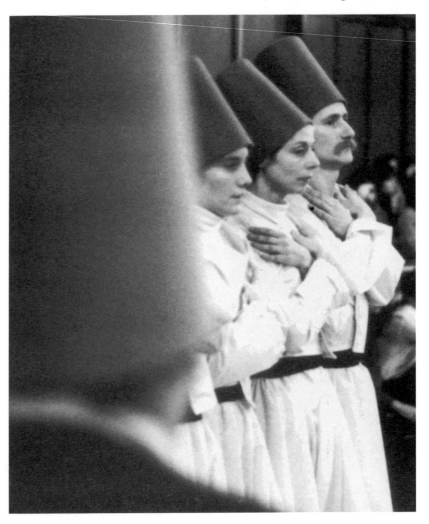

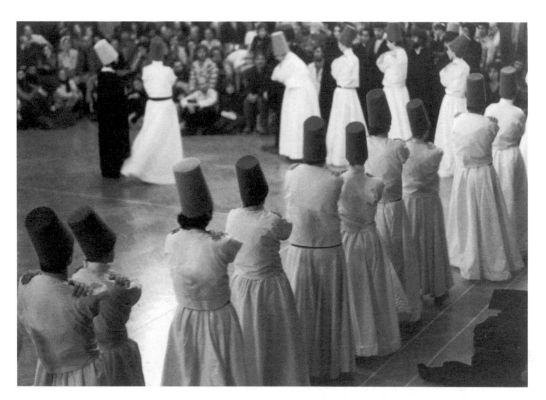

We step forward to kiss the *postnishin's* hand. The shaikh kisses our *sikke* signifying the asking and granting of permission to turn. *(above)*

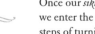

Once our *sikke* is kissed by the *postnishin*, we enter the place of eternity with our first steps of turning. *(below)*

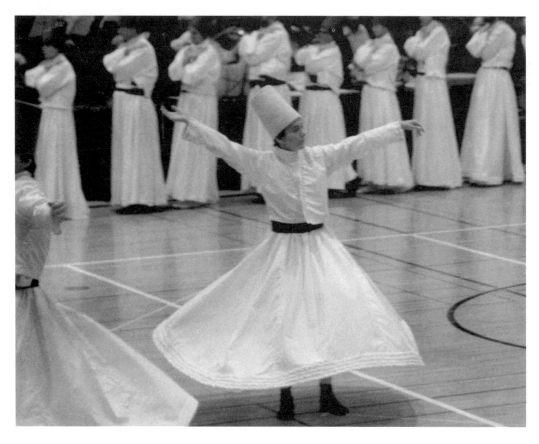

…Head unaware of feet, and feet head.
Neither cares. They keep turning.
—*Rumi* (*Essential,* trans. by C. Barks and J. Moyne)

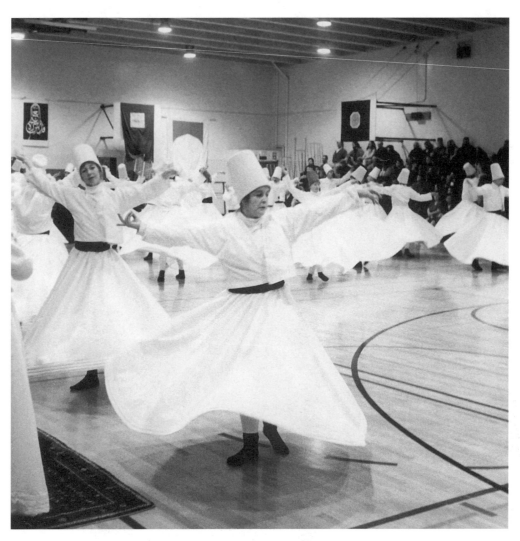

The *semazens* form a circular shape, filling the space, as they whirl continuously around the hall.

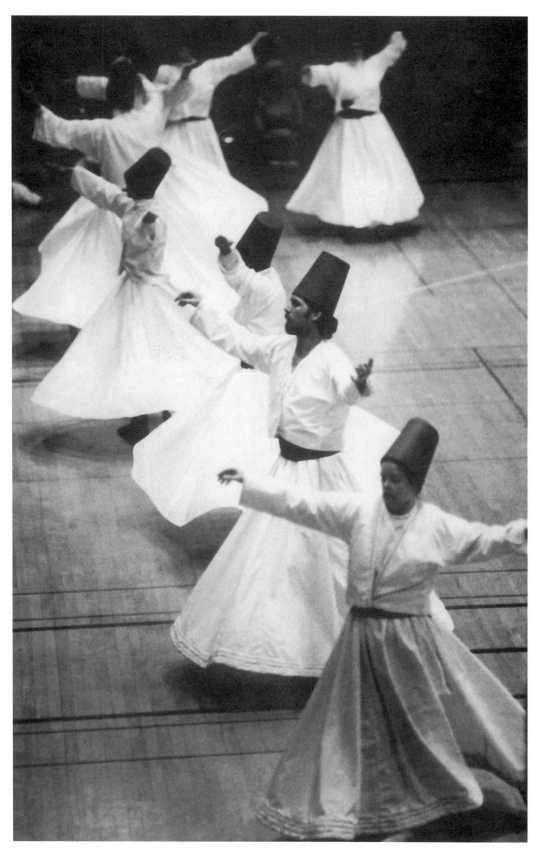

As we tune to one another, we silently call out with each revolution, "Allah, Allah!"

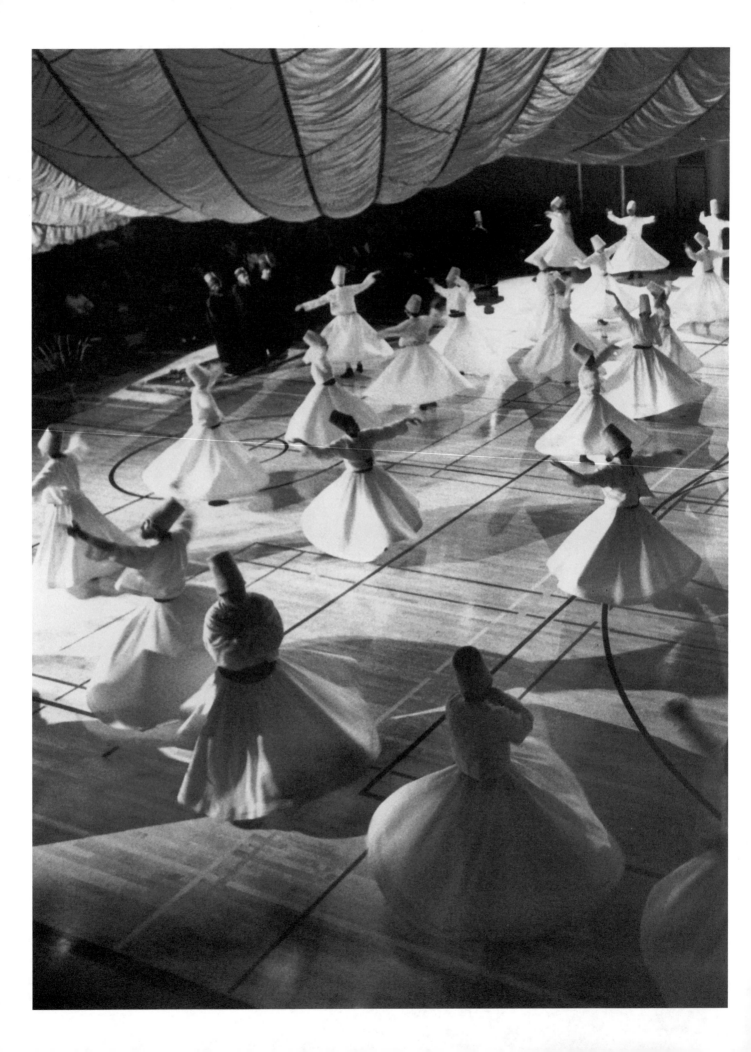

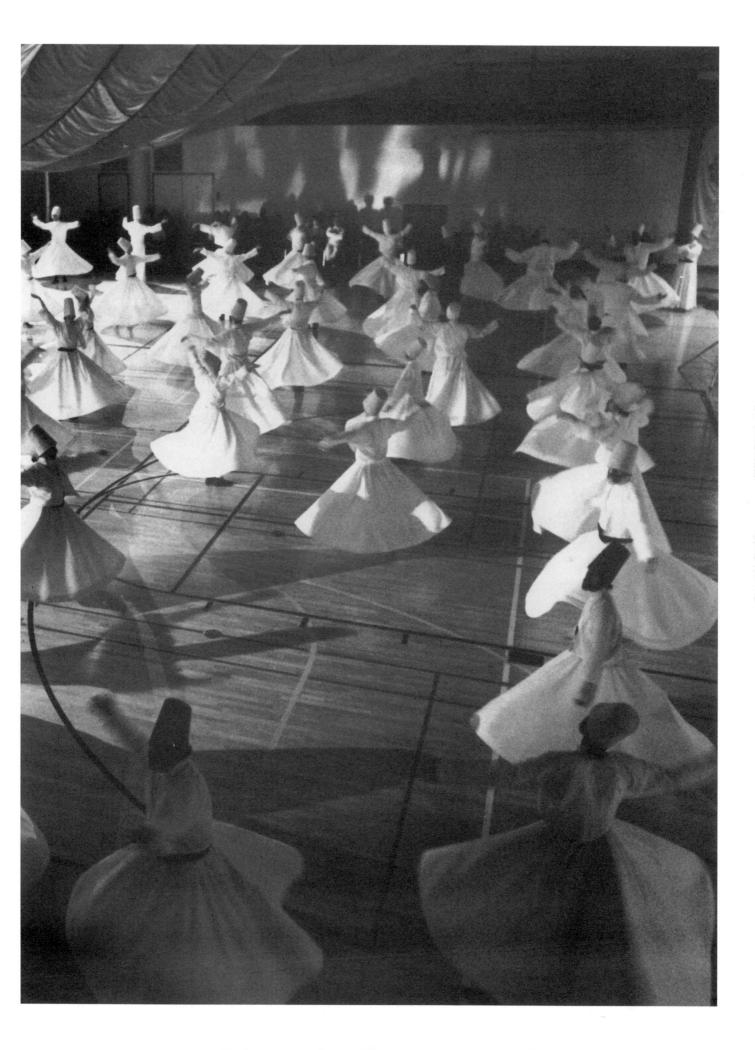

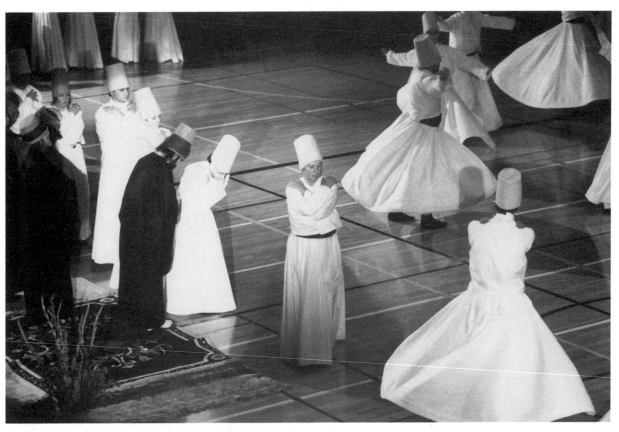

Before each *selam* we return to the *post*, bowing in unity and surrender. In the third *selam* we dissolve into the state of Love. *(above)*

In the fourth *selam*, the *postnishin* turns in the center point surrounded by honored shaikhs and/or *semazenbashis*. *(below)*

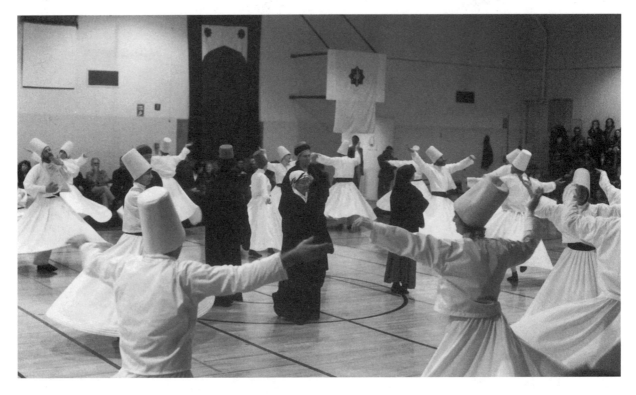

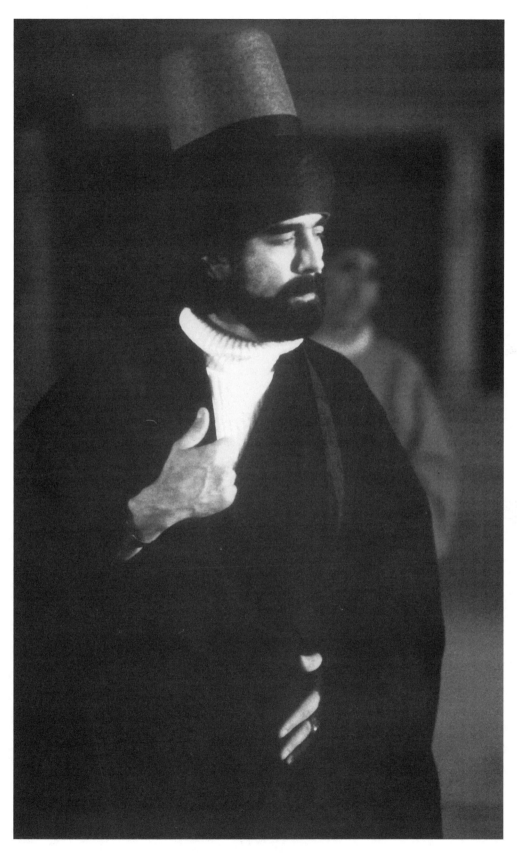

Postnishin Jelaluddin Loras

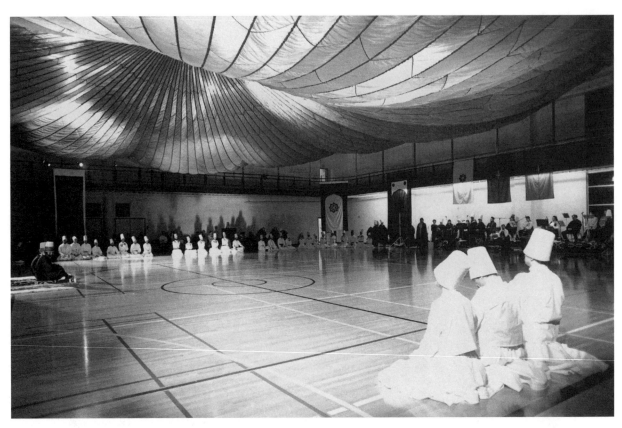

As the sound of the Fatiha resonates in the hall, all the *semazens* stop turning and sit side by side returning from the state of eternity into manifestation. *(above)*

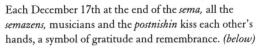

Each December 17th at the end of the *sema,* all the *semazens,* musicians and the *postnishin* kiss each other's hands, a symbol of gratitude and remembrance. *(below)*

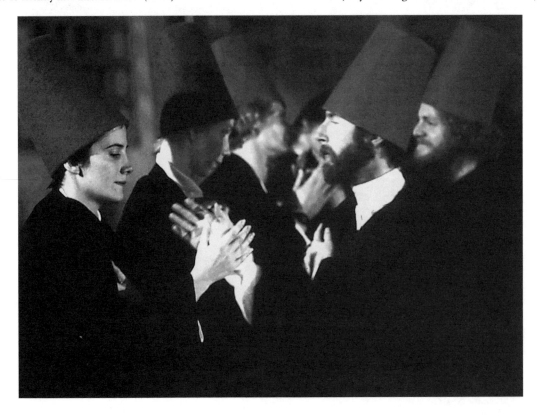

Fatiha

THE FIRST SURA OF THE QUR'AN

Bismi-llah ir-Rahman ir-Rahim
Al-hamdu lillahi rabb-il-'alamin
Ar-Rahman ir-Rahim
Maliki yawm id-Din
Iyyaka na'abudu wa iyyaka nasta'in
Ihdin-as-sirat al-mustaqim
Sirata-lla dhina an'amta 'alaihim
Ghair-il-maghdubi 'alahim
Wa lad-Dallin
 Amin
—Transliteration by Imam Bilal Hyde

*This sura completes
the closing of the sema.*

We begin in the Name of God,
Everlasting Mercy, Infinite Compassion.
Praise be to God, Loving Lord
 of all the worlds.
Everlasting Mercy, Infinite Compassion.
Eternal Strength of every living being,
Whose Majestic Power embraces us
 on the day of the great return.
Only You do we adore, and to You alone
 do we cry for help.
Guide us, Oh God, on the path of Perfect Harmony,
The path of those whom You have blessed with the gifts
 of Peace, Joy, Serenity, and Delight,
The path of those who are not brought down by anger,
The path of those who are not lost along the way.
So be it.[13]
—Rendition by Imam Bilal Hyde

Calligraphy and illumination
from the *Qur'an* of Imam Bilal Hyde.

Carpet of Joy
by Susan Najmah Arnold

Form, symbolized by the square, is permeated with the joy of life. The central
square knot reads, *"Alhamdulillah!"* (All Praise or Joy to God). The outer
band repeats, *"Bismillah ir Rahman ir Rahim"* (In the Name or Presence
of the Merciful, the Compassionate). Both are in Kufic script.

SEMAZENS OF MORE THAN TWENTY YEARS

Interviews with Noor Karima, Anna and Susan

On December 17, 1978 Jelaluddin Loras arrived in the U.S. from Konya, Turkey. He was taken to Claymont, a residential Gurdjieff Community in the Shenandoah Valley of West Virginia, where he lived as part of that spiritual community, teaching students the practice of the turn and showing through example the path of the dervish. Two of the women interviewed here were part of that community experience.

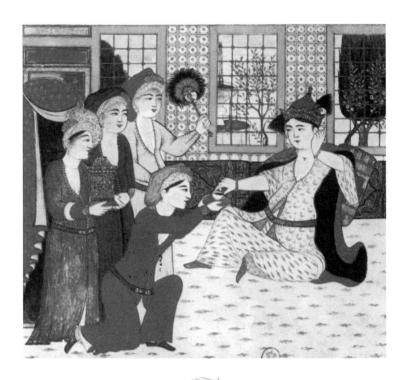

Wife of Sultan Ahmed III Being Served Coffee
Circa 1720, Bibliotheque Nationale de France

Noor Karima

Noor Karima met both Jelaluddin and Suleyman Dede at Claymont in 1979. Suleyman Dede reveals anew what is love and how to live a life filled with Presence, and Noor Karima receives his teaching. Through the path of turning she discovers the kind of burning that draws a moth to the flame. Through her story we can glimpse the shaping of a heart through longing and a willingness to love.

In 1979, my first day at Claymont, Jelaluddin was in the foyer. I did not even know his name. Yet, when I looked at him I could see something of who he really is (and that doesn't happen to me every day, and it especially didn't happen much in my early twenties); but it was visable, the essence of his being. Then I discovered that he was not only a student at the course, but he was also there to teach us the turn. At that point, having freshly arrived in America, he didn't have much English, so there wasn't an opportunity for conversing in the way I was accustomed to. Instead, he could perceive our hearts and our hearts could experience his presence.

His hospitality was remarkable. Most of us lived in the dormitory, and he had a room to himself in the same building, and his door was always open. Often he offered us coffee, cheese and cigarettes—things that were luxuries at Claymont. The quality of the presence in his room was magnetic. Some people would go through their own trips about whether they could be there or whether they felt excluded from that, but the door was open. Something was available when you walked into the room.

Cracking Open

We were part of the fifth course at Claymont, eighty-something students who were chosen to represent a broad spectrum of human characteristics and personalities, put together in a pressure cooker. We were presented with experiences that allowed us to encounter within ourselves the material for progressing in our personal development. It was a calculated experience, directed to guide us through that process. We had been working for some months in the Gurdjieff tradition as well as learning the

Noor Karima

"Turning brings a certain alignment that allows a person to be centered in the heart. It is a beautifully elegant situation."

turn and *zikr*. At that point, there hadn't been any significant opening of my heart, although I had been at the Gurdjieff work since I was seventeen. (It took me five years to get to Claymont as I was too young to go to the first course.) I was accustomed to working in this serious, "work-face," disciplined way, steeped in the intellectual approach to the readings and the Gurdjieff sacred dance. Just as we completed the beginning turn training and were ready for our first *sema*, Suleyman Dede came.

We had been preparing Claymont for his visit. The day he arrived I was on the house-keeping crew, in my little blue kerchief, bustling about when the car pulled up. The first I saw of him he was just getting out of the car and was kind of stooped over. Then he stood upright. Something happened when I saw him. Something quickened, and it gave me a lot of energy. I rushed into the building to finish getting the place ready. I was hurrying through the meditation room by the empty piano, and just then the

shell of my heart cracked open. I stopped. I was trembling and afraid to look inside myself, into my heart. The intensity of my longing had been increasing, but up until then I didn't have a clue what I had been longing for. We had done much *zikr,* practices and processing, but when I would try to look into my heart, all I would see was a bony breastplate. In that moment, however, I found the courage to look. What I found wasn't a really pleasant sight, yet there was light, and something was still alive there. Nurturing that aliveness became the only thing of any importance. That was the beginning.

Presence

That same day, or the next (I don't know because time became irrelevant), Dede met with the students upstairs. He wasn't feeling well and he didn't stay long, but he passed out a few trinkets from Turkey and he talked, although I couldn't hear a word he said anyway. Instead, I was perceiving an inner sound that has taken me many years to even begin to fathom. It contained certain realities that were present and apparent within it. At the time it seemed to be the sound of the planets moving. There was a sense of vastness.

In Dede's presence, all of us could experience a feeling of dearness. Dede walked through life in a continuous stream of love; his love for God and God's love for him just flowed. I remember one occasion when Dede started to dance. He opened his arms and lifted his foot and it was as though he, a minuscule human being, was climbing into the loving arms of something greater than the universe. At the same time, he filled the tremendous stature uniquely possible for human beings: to be a conscious, willing connection between heaven and earth. Dede was serving that large function for humanity. The experience of his presence led me closer to an awareness of being in the ever-present love that is the fabric of our existence. It is not something separate. It is right there, constantly available in every moment—so vast and so real; more real than our ordinary illusions. Suleyman Dede

touched so many people over the years.

This sense of the presence of love is still blossoming for me, yet I am still the difficult person I always was. There are people who don't like me, and I am not particularly virtuous or accomplished in the usual sense. But now when I look in my heart I see something besides a bony chest. I am not afraid to look anymore. If I do see something that isn't in alignment with that reality of love then, God willing, I move in whatever way necessary to return to that ever-present state.

First Sema

Our first *sema* was huge, with many *semazens,* all who were new. Jelaluddin had spent many months teaching us the turn. Because of this, I was surprised when he walked over and sat next to his mom, Feriste, in the audience—a beautiful gesture of surrender; very intentional, right and clear. Dede was to be the *postnishin.* Jelaluddin's action wasn't that of a little boy deferring to his Dad, or a big ego making a gracious gesture, none of those extremes. This was a perfect gesture, an outward action that corresponds to the inner reality. It had the same true clarity that

Collage of Suleyman Dede
Mevlevi Archives

The practice of *tassawuri* is to immerse oneself in the being of the teacher. Even in the simplest living quarters the teacher can be tangibly present.

was Dede's characteristic. For me that gesture opened the experience of true humility, and to have had that at the beginning of our first *sema* was exquisite.

In the fourth *selam,* Dede turned. At the time, he was an old man and he turned slowly, very contained. Yet, in his turning he encompassed the whole spiritual community, the solar system, the universe and something beyond that. At the same time, he moved with such love, and within that containment there was an openness. Such energy flowed through him! My perception was of a person who can rise up and allow something to come through them, not necessarily registering or holding onto it themselves. But he was really beyond that. He was right there present with what he was perceiving.

Capacity for Love

What I think made it possible for Dede to be so present was that he felt this love that was so vast and, at the same time, spoke intimately to each person—something that is accessible for all of us. You have to be willing to stand before what is essential, as a human being. We are all calibrated to be able to handle a certain amount of electrical current. Various energies pass through us and other things are beyond our capacity. We can hear a certain range of sound and other sounds are present but we can't register them. In the same way, we can register a certain range of love and for each person it is a little different.

That is what I want for myself, to expand my ability to love. That day when my heart cracked open, my range was so small. It is still small, but it has vastly expanded in this twenty years. I hope that in the next twenty it will expand more. I have always felt there is a reality larger than this life. For years I tried to remember and then realized that remembering isn't the way it is going to happen. It is not an intellectual process.

The Practice of Turning

There are physical difficulties in turning and each person experiences them in his or her unique way. What happens in the process of turning is a balancing of energies within the person. If people are stuck in the head, these people tend to get dizzy; if they are stuck in their instincts and fears, they tend to get an upset stomach; and some people even get both. Turning makes it so uncomfortable to be out of balance that we are brought into a centering. The practice of the turn brings a certain alignment that allows a person to be centered in the heart. It is a beautifully elegant situation. Along the way, however, we will have to confront various resistances. For example, often people's bodies will object before they come to turn class or before they come to the *sema.* They will get sick or they will get a sore back or their leg will go out. Their body is saying, "You are going to do *what* to me? You want me to do *what?* You have got to be out of your *mind!*" One encounters this resistance and either overcomes it or not.

Many people don't make it past the resistance, but the ones who do . . . well, you can see something. There may be incredible longing to get beyond it, or there may be a sense of an imperative: "I don't know why, but I have to go on with this! It is calling." There are other people who are so stubborn that they are not going to let the physical limit them. They really suffer because that stubbornness prolongs the experience of suffering, but their stubbornness is also their gift!

Emotional reactions can also manifest. For years, when I would turn I would have a wonderful time turning and then ten minutes after leaving the room I would be yelling at my husband. We would both be scratching our heads, asking "What is going on here?" because it wasn't my usual way to be like that. I realized later that things would get stirred up and would have to be cleared. One day, right after turning class, this huge cockroach came flying up to me as I was going on and on in frustration, and flew into my shirt, hitting me right in the heart. I *really* didn't like cockroaches! But there it was, wiggling around in there; such a physical expression of what was happening. My husband and I both just cracked up laughing. He kindly got the cockroach out, which for me was the best part.

Learning to turn as part of community is a continuing journey. In the beginning our awareness is usually limited to our feet or our heart. At first we can't see where the next *semazen* is standing when we turn. But, as we become skilled at turning around our own central axis, there is an expanding awareness that happens and we can see the *semazens* on either side of us. When we travel together with the caravan, there is a growing experience of turning as a community. And then there is another level of awareness, when we learn to turn together as one with the shaikh.

When I turn now, I experience energies of life, of vitality, of being here on the planet. There are energies that are beyond this life that are present in the turn. Spiritual realities can be raised to life in the *sema*. This can become apparent to the people who are watching, as well as to the people who are turning. Of course, in every moment there is the possibility for those realities to come to life.

Seeing

Some kind of inner seeing opened early in me. I could see people through the point of view of their spirit. As a child I could not fathom why people acted the way they did because it didn't fit with what I saw of who they really were. So nothing made any sense. It was so confusing and there was nobody to talk to about it. If I stood near somebody or if I concentrated on them I could feel something of what they were feeling in their physical body, in their emotional feelings, and to some extent their thoughts as well. When a child feels so open to those around them, it attracts all kinds of strange stuff. Everybody has their own way of reacting to a bit of grace: some people bow down, some try to hurt you, and others try to steal it. Certainly, all this had an effect on the development of my heart. Because of my abilities I found that I would be right there with someone, with who they were, and I would be carrying the impressions of several hundred people around with me, everywhere I went. It was very lonely. When I was young, I needed to protect myself and I really didn't have a clue how to do that, so I became very sarcastic, revolutionary. I did things, became sort of delinquent, to try to turn it off.

As I matured, I tried to sort things out. I went to college and began the Gurdjieff work, which was the first time I encountered a living teaching. I came to Claymont not just to learn, but to become. I count this as an incredible blessing; to follow the trail of the Beloved

Karim (left) and Karima

Ishq Allah Ma'abud Lillah, God is Love, Lover, and Beloved.

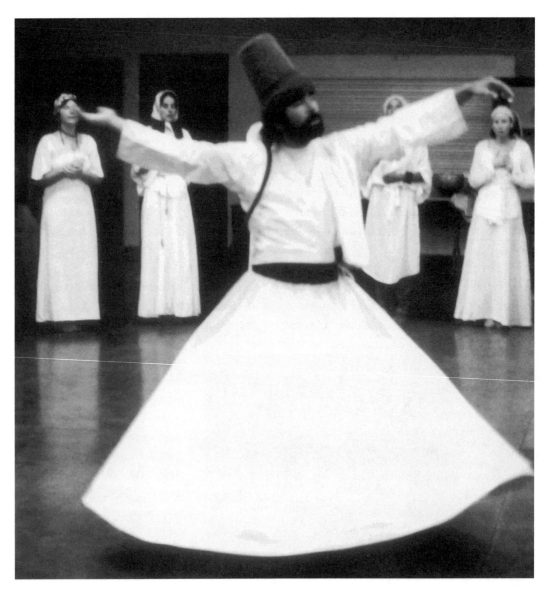

Jelaluddin Loras
Turning in *zikr* at Claymont, 1978.

"In the beginning of *zikr* we are tuning ourselves to the Divine Presence,
and thus we intensify the awareness that we are not alone." —*Karima*

through a whole lifetime, especially when the early part was so difficult and lonely. It isn't anymore.

Expanding Our Wings

I started having moments of awareness, of ever-present all-pervading love, but then I would do something very quickly to shut myself off from it. I would find myself turning away, and then I would get so angry and cry. Eventually I real-ized it was a matter of capacity (the experience with Dede revealed that), and over time I was able to see myself being more aware.

Through the burning of love, obstacles in the heart are cleared away. Then the next arrow flies from the hand of the Beloved and when it hits we know what we need to work on next; we know what the "firewood" is. And then something comes to burn that! So, here we are, and we are burning!

As followers of Rumi, we are on this path of burning. There are moments when I get a glimpse of higher perspectives; moments where all of this makes sense. I love the truth. The process of cooking and burning is what allows that perception to come through me without my having to say, "This is mine, look at me!" That would be the booby prize. The real experience is being able to be cooked and burnt so that something can come straight through.

That is what I see in Jelaluddin Loras. Like the esteemed Mulla Nasrudin who has all kinds of difficulties that show us the human condition, Jelaluddin shows me the human condition, the predicament we are in. He will never allow me to adore him or think that he is virtuous, and is very particular to make sure nobody is going to put him on a pedestal. If they begin to, he will do something outrageous that will blow it. Sometimes he seems to do it on purpose, and sometimes it appears he doesn't. It doesn't make any difference though—either way something comes through him that has a catalytic effect on people. It is going to have that effect regardless of whether he is virtuous or not. Jelal doesn't make the mistake of having people think it is him. When something comes through of Divine Presence, that is perfectly clear, just like in the *sema* when he sat down next to his Mom.

Honored Guest

The inner aspect of hospitality is that anyone who is before you can be seen as the Divine Beloved. God is present in every human being. When you serve a human being, you are serving the Divine. For me, hospitality is one way to overcome separation—a way in which love can be expressed to the people around us. Hospitality is a very Mevlevi way and it certainly is Jelal's way. When he serves a cup of coffee, the gift is in the regard with which he serves. It is right action, right alignment with a true impulse; a symbol of actively loving God.

Zikr: Manifestation and Being

In the beginning of *zikr* we are tuning ourselves to the Divine Presence and thus we intensify the awareness that we are not alone. When a group of people sing or chant *zikr* together, moving our bodies in the same way, breathing together, it is possible to enter into Divine Remembrance together. Something can happen when the heart is open. Certainly there is ecstasy, but *zikr* is also a means for cleaning and clearing the heart. The repetitive words, tones and movements are not a trance state because we don't sacrifice consciousness. We are fully present in body, in feelings, in mind and, *Inshallah,* in our spirit! Sometimes I experience that there are more beings there than just the ones that are physically in the room. Our particular group could just as easily be a group that lived a hundred years ago . . . or seven hundred years ago. We are just placeholders in that particular moment.

It seems to me that every human being is longing for the Divine. In some people, that longing appears to be stronger than in others, but we all have that desire and we all show that in different ways in our lives. When we are in *zikr,* everything that we are doing, everything that we are concentrating on, is in alignment with that longing. There is such a relief in having everything going in the same direction—the direction that we most intimately want to go in! In my life experience, so many people have that desire yet often what they tend to do in their outward life is at odds with that. When I'm doing *zikr* it is like I've come home.

When people turn in *zikr* it is different than turning in *sema;* in *zikr* we are not all turning at once. Often there is a unique quality that will come through each person, as though there is a longing for love to be expressed in a particular way. We could give that expression a name, like generosity or purity or hidden treasure or compassion. As each person turns, something is revealed through them and it is not separate from us in the *zikr* circle. We share in each other, and that is something we take with us.

Sema: The Gift of the Earth

One of my favorite parts of the *sema* is the Sultan Veled walk. As we walk together, my feet feel the floor and I am immediately put in

touch with the love that has provided us this planet to walk on. In order for us to turn in the *sema* we walk on the earth, which appears to be a firm unmoving floor beneath us. Yet, in actuality, we know our planet is spinning at an incredible pace, just like we are about to do. The earth is so much larger than we are that it appears to be staying very still, like a mother who loves to dance and to dream, but because she loves her children she reaches out to give them that firm foundation of reality that they need. To have the *sema* ceremony begin with the walk—with a connection to love and that kind of generosity—is wondrous! Otherwise, who knows? I might stay in my head all night and that would be such a waste. As we circle the floor we stop and greet our fellow *semazens,* beholding the Divine Presence in them, just for a moment; we don't stay and linger. That is the heart of the Sultan Veled walk—seeing the Divine Presence in each person.

The word *legomenism* means "a symbol that contains a teaching"; in and of itself the symbol reveals what it symbolizes. The *sema* is a legomenism for those who have the eyes to see.

Western Culture

Our society is so separated from what people truly long for. We experience a certain disconnection that leads to aimlessness, anxiety and greed. While I wouldn't want to live in a society that mandated that everybody live in the same way and follow the same path, I do feel that there are probably people who would be well served by having a way of being with each other that allowed their deeper longings to manifest, so that our animal nature doesn't play out our lives with lesser means like drugs, sex and violence. When you do simple actions like offering a cup of coffee while seeing the Divine Presence in a human being, or doing *zikr* with a group of people remembering the Divine, or simply breathing together, all those experiences can bring an alignment between true longing and what we do on the planet. When we live from that place, we don't have to be caught in unfulfilling activity. Everything we do becomes trans-

formed by that reality. I believe there is a place for that in our culture. Whether people will embrace Islam or Mevlana, I don't know. But I tell you, I don't think it would hurt at all for people to learn the Sultan Veled walk, no matter what their religion or walk of life.

Daily Life

I live a pretty ordinary American-housewife/ part-time graduate student kind of life. I wear conventional clothing. I don't think anybody seeing me on the street would know that I do *zikr* or turn. I seem to be on a similar level of sanity to people in my community. There isn't anything unusual about my daily existence. There isn't really any separation between my daily life and my spiritual life. *Ishq Allah Ma'abud Lillah.* "God is Love, Lover and Beloved." God brings all the realities of love to us, through different ways, people and dimensions. When I am with my advisor at school, I am looking in the same way at her that I am looking at you now. I have to be a little careful of what I say and how I say it, because different people understand things in different ways. But I don't have to shut myself down spiritually in any way in order to be with my advisor or with anybody else. If there is a need to express, I harmonize with who the other person is in the moment.

Being With Others

I have learned that I can let the things that I perceive wash through me. Because I was so open as a child, I still have a learned inclination to close myself off. But now I realize that it is not necessary to do that. I learned that I am not responsible for what I see—I just see it. When tragedies happened during the first half of my life, I regarded myself as the most despicable human being. When I looked at myself, it was with loathing. I was really looking at the otherness. What I attracted to myself was violence, abuse and ugliness. Now I look at the Divine love that comes through each person, and allow myself to see that in myself as well, and what is attracted is beautiful!

Difficulties come up, no question about it, but those difficulties are just more burning that allows me to see more beauty!

The Future

I hope that we as a community will establish a Mevlevi household that is run in the traditional way so that there will be a living example of a Mevlevi *khanqah* for those of us who are bringing this path into our daily lives, into our homes. Although you would think that after twenty years of *sema* and turning together we would be experts, many of us know that we are only just beginning in our understanding of what we are doing. That is part of the beauty—that we haven't been able to dissect this with our intellects because we weren't offered intellectual material; we simply experienced, and that really is a blessing. But the time is coming for a more complete understanding so that we can bring this path into a clearer reality for our children, our friends, our community and ourselves as well. This is just the beginning.

> I was dead then alive.
> Weeping, then laughing.
> The power of Love came into me,
> and I became fierce like a lion
> then tender like the evening star . . .[1]
> —*Rumi* (trans. by C. Barks)

ANNA SPEAKS ABOUT SULEYMAN DEDE AND FERISTE

In 1977, Dede came to visit Shaikh Yakzan and our Honolulu group. We were sitting in the house of one of our "family" members, and the room had a thick shaggy carpet. We learned that Dede was going to turn and I thought, "How can he turn on that?" Someone brought a Formica tabletop and put it on the floor, and I saw this man who appeared to be in his early eighties, get up and start turning. I wept—I had never experienced anything like that before! When I recall this night I can almost say that there was a fragrance; not that you could smell something physically, but it was like the air was rarefied, something was made so refined, so sweet. That example of Dede turning contained so much of the earth and ordinariness, and yet so much of the ethers and the angelic plane at the same time. That was my first real taste of turning.

The second year that Dede came to visit was just before he sent Jelaluddin to America. He thought it was very curious that some of us were asking for a new name. "How come Americans wanted Turkish or Arabic names?" he asked. He

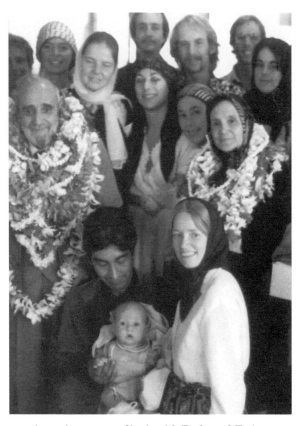

Anna (center standing) with Dede and Feriste.

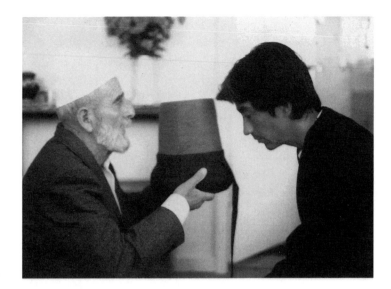

Oh Beloved, accept me and liberate my soul.
Intoxicate me and liberate me from the two
 worlds.
—*Rumi* (trans. by S. Shiva)

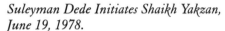

*Suleyman Dede Initiates Shaikh Yakzan,
June 19, 1978.*

Shaikh Yakzan passed from this world
on May 24, 1993.

thought this was very funny. He also taught us the prayers to be done five times a day.

On one of Dede's visits he brought his wife, Feriste. I remember the two of them, these two beautiful elders. We all felt so humbled to be around them. Such a state of joy emanated from these two. Feriste Hanum sat back a little and wasn't as much in the fore. I remember looking in the face of this woman, whose hair was all covered, and she had the most refined bone structure. I saw that her nose was the nose of Jelaluddin, the same incredibly refined nose. There was something about her, even with her age, about her eyes, a brilliant light, like crystals. The words I kept hearing in my mind were, "This woman must have been the most dazzling beauty in her youth." It was still there!

We were all sitting on the floor and Dede was on the sofa. We were looking up in incredible anticipation, and I was thinking, "Who is this man? What is it?" feeling his presence. He asked that each of us come and sit on the floor in front of him. Then he looked in our eyes, and took our hand. There was a kissing of the hand, and a touching of the forehead. He was very present with each of us, connecting to everyone in the room.

As distant as this Turkish culture seemed, especially from Hawaii, it felt so familiar to me, looking into Dede's eyes. A feeling of resting in something familiar. Even the gesture of kissing hands and touching the forehead, something about it was very familiar, even though it was the first time I had ever seen or experienced it.

After each person sat with Dede, he said through his interpreter that he had an initiation for us. He pulled out a packet of cigarettes. Many of us had a very clean lifestyle. I mean CLEAN! No cigarettes, very little alcohol if any at all, pure organic foods, no sugar. And Dede pulls out this pack of Turkish cigarettes and starts lighting up. He gave cigarettes to everybody and we had to light them up. I was absolutely horrified taking that first puff; it was all very humorous, very wonderful, and that was our initiation. When I think of Dede, I remember this incredible light and refinement, a sweetness; heart and fire. When I close my eyes I can picture his face and almost smell the fragrance his presence emitted.

Susan

How does a young Jewish girl from New York discover the need to bring Allah into her life? The mystery and humor of the true Beloved is revealed in the life of Susan and how the gift of Dede's teaching becomes a way to approach daily life. Susan looks beyond the practice of turning into the heart of Rumi's teaching. From her early days with Sufi teacher Reshad Feild, author of The Last Barrier, *to life at Claymont with Dede and Jelaluddin, and her adventures as an American woman in Turkey, Susan shares her perceptions of love and surrender.*

I can't say that I choose to turn—I think it chooses me. And I'm not very good at it. Some people really have the body to move with, which I don't have. I was the kind of kid who got nauseous at the drop of a hat. I'm not exactly an ecstatic person, either—more intellectual—but when I first saw the turn in 1976, it struck my heart.

Reshad Feild had just moved to Los Angeles with a group of people. I was living in L.A. and had an extra room in my house that I rented to a couple of his students. I resisted going to the *tekke*. I didn't want any part of it. *Me, a Jewish girl from New York, am going to start saying Allah!?* It sounded really weird, so it took me a while before I would even visit. But, one of the students told me about a performance, so I went with a friend and sat in the back, right on the aisle so that I could leave at any point. When I saw the turning, I fell in love.

I started studying with Reshad and that is when I first met Dede. Immediately I felt like I already knew him. I realized this was a person I could trust. His name, Dede, is an honorific that means grandfather and he was very much that—just this little old man from Turkey who loved everyone. Dede had a look in his eye that was one of love, with no judgment. He was, in some ways, a very ordinary man. He had worked in the *tekke* providing food for those in need.

The Way of Mevlana

To me, the study of Mevlevi and of Mevlana (Rumi) is not the turn; the turn is a minor part of it—the turn ceremony became formalized after Mevlana. Certainly the turn is a way to pray, but the heart of the Mevlevi way is love and acceptance; questioning oneself before one questions others. One of my favorite poems of Mevlana is, "Come, come, whoever you are . . . even if you have broken your vow a thousand times . . ." Judgment isn't there, just loving acceptance, which is not something I do well myself. Honestly, I'm probably one of the most judgmental people you will ever meet!

Dede never told me what to do. He would make suggestions and I knew that whatever I chose would be okay. He said things like, "It would be nice if you wanted to be a Muslim." Or, "If you want to, it might be nice to go to Claymont."

At Claymont we studied Gurdjieff and Bennett. There were eighty people on this course. In a converted barn, twenty-four hours a day, seven days a week for almost a year, we lived and worked with people we had never seen before; people from all over the world. We studied the Gurdjieff movements, which are absolutely amazing to do, and very magical.

The Gurdjieff people are very serious folks. They don't smile a great deal and they believe in doing the Work, with a capital "W." Then along come about forty ecstatic Mevlevis from Hawaii who are staying up late, drinking coffee and breaking every rule in sight. Jelal was teaching the turn to the people who were interested—a real crossing of lines between who was a resident and who was a student. There were some difficulties at times, which gave us a wonderful opportunity to work on ourselves. For me that was the point of it all.

The Practice of Turning and Sema

I find turning to be physically miserable most of the time. For the first two and a half *selams* your

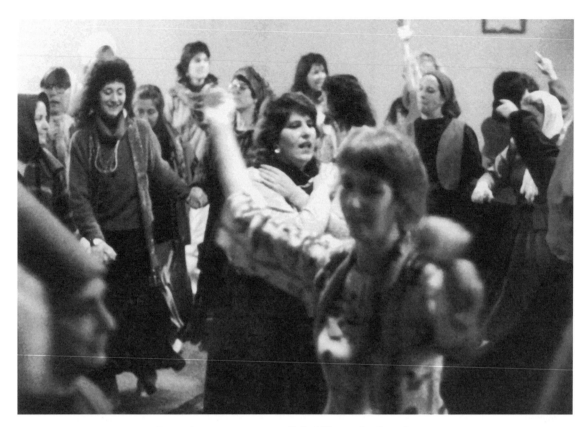

Susan (center, arms crossed) in Zikr at the Semahanue

"There is a Sufi saying, 'If you don't see God when you pray, pray as if you see God.'"

arms hurt, your legs hurt, you can't breathe and you want the music to stop. *Already, enough!* Talk about identifying with the body! By the third *selam* I'm ready to die. Then something magical happens, something in you lets go and you finally succeed in getting out of the way. At that point, you are *being* turned; *you* are not doing the turning.

My mind just chatters all the time, but I tend to ignore it. I've learned, however, that the only thing that allows me to turn is doing *zikr* (chanting *Allah* inside myself). If I am not doing *zikr*, I would fall over. The *zikr* keeps me centered. When you are doing *sema*, you are not a person, you have died. So it is not maleness or femaleness present. We are all dressed the same— covered up. The *sikke* comes down to your eyebrows and the turtleneck comes up your neck, you have no make-up, no jewelry, so the costumes are very androgynous. When you take the *hurka* off, you are shedding your body.

The *sema* is something one builds up to, even if it is just for that day. You start the day in prayer holding intention and doing *abdas,* ablution, so you are clean both inside and out. While dressing in the sacred garments for the ceremony with the other *semazens* one maintains this intention to be with that stillness and quiet, to carry on a tradition that has been going on for seven hundred years, to be aware that the garments one is wearing are the representation of nobody. To talk about this is such a contradiction in terms because you are talking about something that isn't language, something that is outside linear thought. The point is to step out of the way and to allow whatever else is to come through.

Living in Turkey

The basic rule of thumb, in the old-fashioned Islamic country, was that the men did everything outside the house and the women did everything inside the house and never left the home. They

weren't locked in, but there was an enclave. The men did all the shopping, all the interacting with the external world. The women did the housework, cooked, and chopped coal. As a woman in such a culture you live in a very rarefied environment. You don't have to deal with the difficulties of the world. You are protected and you are respected, by the very nature of who you are.

When I lived in Turkey, about every two weeks the women would have a gathering. It was wonderful—a very protected space, and we had some of the best times, dancing and laughing. There is all the usual stuff . . . this one doesn't like that one . . . but somehow a cohesiveness is formed and an honesty exists that is really remarkable. Something special happens when women are alone with themselves; a bonding, a real intimacy takes place when we have to rely on each other. The mood changes when men come into the room. I find that true in the U.S., too. (Probably this same dynamic applies when there is a group of men and a woman enters.) In the women's circle there is a trusting, a quality of helping each other because you are being repressed to a certain extent, and that dynamic forms a cohesion.

Family is very important in Turkey—huge extended family. They visit frequently, even every day or every other day. One's friends are almost always of the family and they were always there to help. That kind of thing doesn't exist so much here. I do think that we sacrifice something in this country for the equality that we want. Sometimes we tend to throw the baby out with the bath water here. I am not saying we shouldn't go after equality, because I believe, in the final analysis, that it is really important. But I also think we have to realize that we don't have the truth on this with a capital "T." We have our version. To live in a society of separation of the sexes you give up equality of interaction. To live in what we call "an equal society," we are giving something else up, and we need to be aware of what that is.

Hierarchy and Transformation

To my understanding, the cook is the next in line to be shaikh, after the bloodline, which is part of the reason Dede got to be shaikh of Konya. The Chelebi who was supposed to be the shaikh didn't want it and Dede was the *atesh bas,* the cook, not of the Chelebi bloodline. When Dede either retired or died, it would go back to the Chelebis.

Think about what the role of the cook is: the act of cooking is a transformative process. You can take a stalk of celery and you can chop it, you can mince it, you can grind it, but you haven't changed it. You have made it into smaller pieces but it is still chemically the exact same thing it was before. But when you cook something, a chemical transformation happens. You have made changes to the actual structure and content of the food that can never be erased. Conceivably, if you chop a carrot you could glue it back together, so it is still a carrot. But once you cook it, the sugar changes, the structure breaks down, and all is changed forever.

On the enneagram, if you look at the diagram of the circle that contains the nine-pointed star representing the personality types, the space between point four and five is the only place on the circle where there is no connecting inner line. That is the place of transformation. There is no going back. There is that same truth in terms of being a cook. This is where the magic, where the alchemy takes place. It is also that which gives us nourishment. To prepare food in a conscious way is a great teaching. To really be able to nourish others with that consciousness is what it's about.

In going through the *chille* you are being cooked, as the poem says, "I was raw, I was cooked, I was burned!" It is an actual chemical process. They are not talking about a superficial level of change, but an irrevocable chemical change. You can't go back. That is why the cook has always been the person who traditionally holds that space next in line from the shaikh. The cook is the one with the recipe.

To Be A Dervish

One can follow the path of a dervish, but I'm not sure if one ever "gets there." To me a dervish is one who works toward not identifying with who

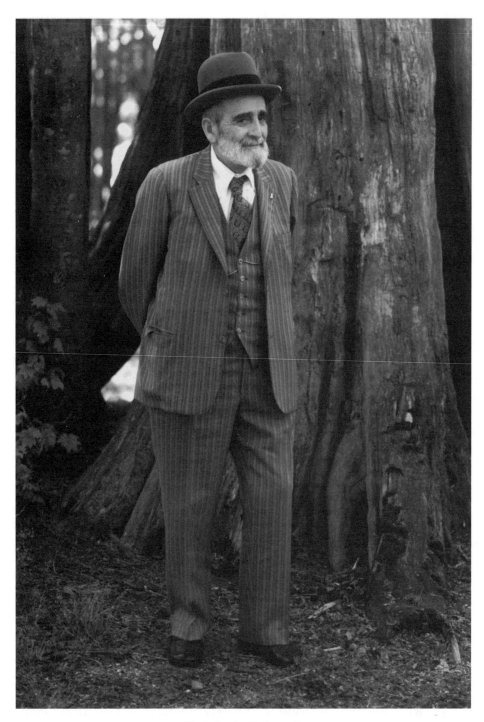

Dede in the Redwoods

"Part of spiritual work is to see what has 'got' you. The mark of a good teacher
is someone who can show you where you are caught, with humor!" —*Susan*

he or she is, in terms of an ego. A dervish isn't there, God is there. I think that the West doesn't understand what being a dervish is. People in the West tend to aspire to something of more power. One of the words I like better than dervish is *faqir*.

To call oneself a dervish is very arrogant, I think, whereas *faqir* means seeker. *Faqir* also means poor like a beggar, like one who has nothing, but a religious beggar, similar to a *sadhu* in India—the one who begs with a begging bowl, like Buddha did.

SEMAZENS OF MORE THAN TWENTY YEARS

More Dede Stories

While at Claymont in 1980 I was in a serious car accident. It was interesting to watch, because all these people on the course would come up to me with all kinds of opinions and judgements as to why I had this car accident. One person actually said I was "the karma for the course."

The accident was so serious that the doctors were thinking of amputating my arm. The only two people who didn't say anything, in terms of judgment, were Dede and Pierre, the head of Claymont. Dede would just come and sit and pray with me. That was it. He had no need to offer an opinion as to whether I was being punished or anything. Dede would just love and that was a real blessing. I realized that all these other people were just laying a trip on me. Then there was Dede saying, "Oh, *Mashallah, Mashallah!*"* He would come and hold my hands and we would sit out on the front porch.

* * *

I got to cook for Dede when I was at Claymont. Every morning, I got up at the crack of dawn because Dede got up very very early. At that time I was in a cast, but I had one good arm. I would go over to the cottage where he was staying and start cooking breakfast. He would come downstairs in his striped pajamas with his suit jacket. Sometimes there would be somebody else there. Commonly, we had cheese, toast, tomatoes, cucumbers, olives, yogurt and jam. In the morning, he would usually have *chai,* tea. At the time, I spoke no Turkish, and he spoke no English, but it made absolutely no difference. He would sit down and light up a cigarette and just start chattering, just talk and talk, and somehow you would understand what he was saying. That was so miraculous!

Pierre would come, and Dede loved to tease Pierre. Dede would get this gleam in his eye and he would nudge me, as if to say, "Watch this!" Pierre came from an austere background, he is

half-Scotch and half-French. He comes from Gurdjieff training, and he lived with Ouspensky for awhile. Pierre can be very work-faced serious, but Dede would just laugh. Pierre would come in and get a plate and serve himself a tablespoon of yogurt and three olives. That would be breakfast! Dede would be sitting there with us, and we would be smoking and drinking *chai,* and Pierre would come sit down with his yogurt and olives and Dede would look at him. Then Dede would put toast on Pierre's plate and Pierre would say, "Thank you Dede, that is enough." Dede would put jam on his plate. If the sheikh gives it to you, part of the *adab* is that you have got to eat it. So Dede would just pile Pierre's plate with food! Then Pierre would finish it all and Dede would have him smoke a cigarette. He would do it all with such a gleam in his eye. One night we were sitting around when Reshad was there. Dede said to Reshad, "You need to stop smoking!" Then he turned to Pierre and said, "And you need to start!"

* * *

I also got to cook with Dede. He made this wonderful desert named *asure,* with twenty-one ingredients, a wedding pudding. It is like a tapioca or rice pudding that is made with fruit and nuts. He made a big batch of it and we all cooked it together. What a treat to work with him in the kitchen. We would do things like smoke in the kitchen. The residents would get so uptight that they would go to Pierre: "Do you know what they are doing in the kitchen?" Pierre would know. He would say, "Well if Dede is doing it, it is okay." Dede would just drive people crazy because it wasn't in the rulebook! I actually think that is the mark of a good teacher—somebody who makes you take a look at what you are doing, with love. It was done with total love, you could see it in Dede's face.

Part of the work on one's self is that your reactions are your "food." If you see yourself react, the reaction is a gift; it is what you are given to work on. When you are attached to something it has "got" you. Part of spiritual work is getting

Mashallah means "by the Will of *Allah.*"

to see what has "got" you. If you can do it through love and humor, all the better. I would say that also is the mark of a good teacher. Someone who can show you where you are caught, with humor.

In This Moment

I can honestly say my life is happier now than it ever was before. I am a Muslim in the sense of "to surrender," which is the literal Islamic meaning. Do I believe in that? Yes! Surrender to God? Yes! The spiritual path is the only thing that makes sense to me. We live in a world that is so violent, so hateful. So many people are into grubbing and taking. It just doesn't make any sense. I have always felt that we are all each other. How can I not? It doesn't compute for me that we are discreet individuals who have no relationship to each other. For me, it wasn't a log-

ical conclusion to be able to look at the universe and say there is no order to it. There is an order . . . something that we know within ourselves . . . something other than our ego. We are all seeking the same thing, and there are many paths because we all have different likes and dislikes, but to me there is absolutely no difference at all among the paths.

> . . . Humankind is being led along an
> evolving course,
> through this migration of intelligences,
> and though we seem to be sleeping,
> there is an inner wakefulness
> that directs the dream,
>
> and that will eventually startle us back
> to the truth of who we are.[2]
> —*Rumi* (trans. by C. Barks)

*Symbol of The Mevlevi Order
Created by Jelaluddin Loras*

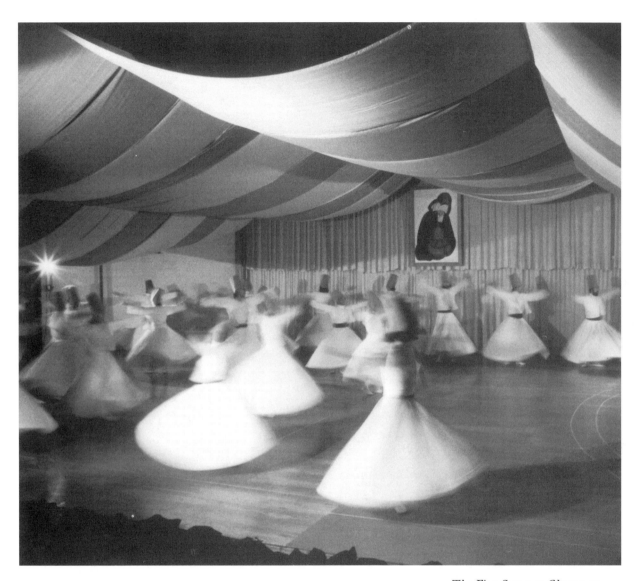

The First Sema at Claymont

We long to disappear.
To enter the moment when
we are no longer turning,
but are being turned.

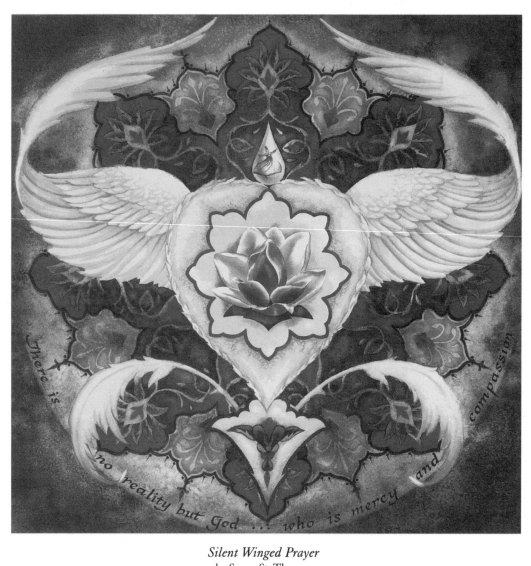

Silent Winged Prayer
by Susan St. Thomas

The winged heart is a symbol for the mystical journey.

MEMBERS OF THE FIRST CLASS

San Francisco Bay Area

Interviews with Melike, Fadhilla, Kera, Andalieb, Alice and Khadija

In 1980, Jelaluddin Loras was invited by the Sufi community in the San Francisco Bay Area to visit and, on the occasion of Murshid Samuel's *Urs,** he presented the Mevlevi turn and led a *zikr* in the Samuel Lewis Dance Studio. The following year, Jelaluddin returned to the San Francisco area, where he lived and taught for the next fifteen years. In the early '90s he established centers in Seattle and Portland.

In 1994, Jelaluddin took a small group of his students to Turkey, and on April 1, 1994 they presented a *sema* ceremony in the courtyard adjacent to the tomb of Rumi. This event marked the first time in over two hundred years that men and women had turned together publicly. This chapter contains the stories of a few of the women in that first class in the San Francisco Bay area.

Islamic Design
From Qur'an, Circa 1000

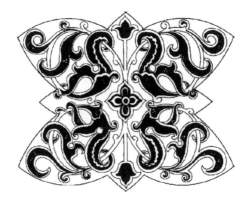

**Urs* is the anniversary of the person's death.

Melike

Together with her thoughts on the Mevlevi path, Melike shares some tender reflections upon her visits to Turkey: especially the first one in which she met and stayed with Suleyman Dede and his remarkable wife, Feriste. Melike's story is a testimony to her early bond with the eternal nature of this work. Even after years of separation, and seemingly beyond her control, she was inexorably drawn back to the circle of love.

I had always heard of whirling dervishes. Actually my mother used to associate whirling dervishes with crazy people. Maybe she started the whole thing! When I was a child, she used to say, "Oh, you're acting like a whirling dervish!" So I grew up thinking it meant crazy. Little did I know.

I had seen Suleyman Dede with the whirling dervishes sometime in the 1970s. Then, in 1980, when the Sufi community invited Jelaluddin Loras to San Francisco, he dressed in *tennure* and turned for us. Some time later, after he was invited to live here, I kept asking, "When is he going to start a class? I want to learn it." As soon as he did, I was there. I knew I was going to take the class even before he decided to give it.

Meeting Suleyman Dede

In 1984 I went to Turkey on my own to meet Jelaluddin's family and to visit Mevlana's tomb. The hospitality of the Turkish people overwhelmed me. It began with someone on the plane who took me to the bus station in Ankara to help me get on the right bus and insisted on paying my way. The day after I arrived, I decided to go to Dede's, but I wasn't sure where he lived. I walked up to a taxi cab driver and said, "Suleyman Dede's" and he took me to a little house. It seemed that everyone in Konya knew Dede, which was interesting, as it is not a small town.

The family had no idea that I was coming. Jelaluddin had sent them a letter about my visit, but they hadn't received it. All they knew was that somehow I was acquainted with their son in California. They made me feel very welcome and were so happy to hear news of Jelaluddin. I brought a Turkish translator, because I knew I couldn't speak to them without one.

People were coming to see Dede, staying for a few minutes and then leaving. I remember being filled with light, filled with love. His whole being was love, he loved everybody—it made no difference who they were or what they were. Immediately, he insisted that I move in. For various reasons I wanted to stay in the hotel, at least for that night. I wasn't feeling well and I wanted a little bit of space on my own, but Feriste Hanum, his wife, also insisted that I stay. "Dede told you to stay, you must stay!" she said. So I moved in.

After that first brief meeting I went back to the rug shop that was a base for me because several of the people there spoke English, including an English girl who had come to visit Mevlana. She was connected with the Sufis in Spain and with Idries Shah. I walked into the rug store after being at Dede's and she said, "My God, what has happened to you, you're totally filled with light! Light is just pouring out of you!" It was from being in Dede's presence. It was a blessing to be around him and his love.

The Power of Rumi's Love

The girl from the rug shop had brought her mother with her from England. The older woman had been in a difficult relationship and wanted to get away, so she went on this trip with her daughter. At Rumi's tomb she walked in the door and started crying without understanding why. Later, she came to me thinking I could explain it. I certainly couldn't, but I loved that she had that experience, especially since she had no

Melike

"'You cannot escape this circle of lovers!' [words of Mevlana].
It's true. Once you've been touched, you are part of this circle."

previous connection with Mevlana at all. Every day that she was in Konya she went back to the tomb and cried. That was my experience too—going to his tomb and being filled with love and the tears of my heart opening.

The Shaikh and My Feet

When I stayed with Dede and Feriste it was the middle of winter and very cold. In the house they only heated the one room where we slept. There were two beds raised off the floor, and a mattress on the floor. The previous year, Dede had a stroke, so he would mostly stay in that room, and was always happy to see people. He sat up cross-legged all the time on his bed. Feriste insisted that I sleep in her bed and she slept on the floor on the mattress.

In my training, I had been taught not to put my feet toward the head of the shaikh—it is considered very rude, an insult. The way my bed was situated, however, my feet were pointed straight at Dede's head. I couldn't go to sleep the first night, because I kept trying to curve my feet away from his head. He realized what I was thinking and he sat up in bed, gently reaching over to tuck my feet in, like I was this little child that he was taking care of.

Feriste Hanum

Feriste was a strong, fiery woman, unafraid to speak up. She also was very aware of culture. For her, Dede was the final word—like when she said to me, "Dede asked you to stay, you must stay!" While I was staying with them, I wanted to go to town. I was an experienced traveler and wanted to go sightseeing in Konya. Feriste didn't think it was such a great idea for me to go off by myself every day. I had my headscarf tied behind my neck, which is the way I was comfortable in wearing a scarf. As I was leaving, she'd stop me at the door, untie the scarf from behind my neck and tie it real tight under my chin.

Feriste was very devoted to her children. They came first, and she wanted to know that everyone was happy and taken care of.

Inspiration From a Saint

While I was in Konya in 1984, I visited different places connected with Mevlana. One day I took a bus to a place with very beautiful rolling hills that I thought was the gravesite of Mevlana's cook, Atesh Bas. No one was there. For a long time I looked at the landscape on the outskirts of Konya and then I just started turning. I turned and turned in this incredibly inspirational place. That was the end of the experience, so I thought.

On the next trip to Konya, in 1994, we all went to the cook's grave and it wasn't the same place! I described to Jelaluddin where I had been previously and found out it was the home of a woman musician who had lived at the time of Mevlana. She was a hermit and she would play music that Mevlana could hear from a distance. When she died unexpectedly, he was very sad. At her home, I had felt so inspired, although at the time I didn't know her story or who she was.

There was also another woman dear to Rumi buried in Konya, one of his *murids,* a saint known as Fakhru-'n-nisa. When Dede was alive they had to exhume this woman's body to relocate her grave. When they opened her original casket, she had not decomposed. She was exactly like she had been when she died, except for one tiny spot on her foot.

The Spirit of Guidance at Work

Before that trip to Konya in 1994, I was living in Virginia and hadn't been connected to the whirling dervish scene for probably five or six years. I had an old invalid cat that had just died and I was feeling very sad. A friend of mine told me that the whirling dervishes were coming to Washington D.C., so I went to the performance. One of the singers began singing the *Na'at*—it was Kani Karaca, a world-renowned singer whom I had always wanted to meet. I had heard his voice on tapes previously. He is a blind man with an exquisite voice. Tears started pouring down my face as I watched the ceremony. I realized how much this tradition really moved me; that it was such a deep part of me.

That night I wound up staying in a couple's house in a room they had originally been prepared for Celaleddin Chelebi, the head of the Mevlevi Order. At the last minute, Celaleddin Chelebi had decided to stay at the hotel with the dervishes. On the wall of this room was a drum—a *tar*—painted with a Mevlevi symbol. The moment I saw it, I knew that Jelaluddin had painted it. "Where did you get this?" I asked my host. "Jelaluddin Loras gave it to me," he said. We looked at each other and realized, simultaneously, that he had stayed at my house many years before, for several weeks, and here he had anonymously invited me to stay at his home! We were both totally amazed.

"We've got to call Jelaluddin," he said. Jelal was in Turkey at the time, so I called some friends who had his phone number. "We are going to Turkey in a few weeks, Melike, you really should go," my friends suggested. The next week I was on the plane to Konya! That journey was such a blessing. With the Grace of God we were allowed to do the turning ceremony at Mevlana's tomb and at the Galata Turbe in Istanbul.

I had dropped out of the whole scene for years, but when I was in Konya during that last trip I saw the words of Mevlana, "You cannot escape this circle of lovers!" It's true, you cannot escape! Once you've been touched, you are a part of this circle. The heart yearns for more of that feeling of unity and love and joy!

The Mevlevi Path

I studied turning not knowing what it was going to be. Previously, I'd read Rumi's poetry, which I love. In the years since, I have gotten deeply connected to him. His path is love and that has always been my path—to love everyone and everything.

When I was studying with Jelaluddin Loras, participating in *zikrs* at least once a week, and turn classes, my life became filled with understanding the Mevlevis. I began to understand the practice of honoring the guest—cooking for others, putting their needs before one's own, really practicing love—seeing that the practice of

love is the greatest teaching, and seeing people transformed. At the same time, I realized that we have our human ways and there are ways to refine our humanness and to work on ourselves. What better way than to try to treat anyone who comes into your midst as the honored guest?

The Nature of Turning

I've been thinking about why I do the turn—something I've never asked myself before. Through my involvement in Tai Chi and trying to understand the way energy moves in a body, I have come to know that there is a force, a strength and an openness of spirals that is infinite in nature. A friend of mine was explaining the mathematics of infinity: numbers spiral, shells spiral, flowers spiral and the internal martial arts spiral. Energy is much stronger and alive in that type of movement, because the form itself creates movement. The spiral energy creates vortexes.

Without blockage, energy flows through unimpeded. It happens in turning too. An energy is coming through and moving out. If there are blockages, like when your mind is busy, the energy doesn't move, it doesn't flow. It flows only if the mind is empty, so it is a fabulous practice in emptying oneself. Physically, you need to have your spine open, because that is the axis you turn around. Your arms are your wings, and they are flying. They are wide open.

It is not always possible to be empty, and that is part of life too. When you can let go and become empty, you become full, but not filled. As it pours through, it is like a cleansing. The energy is pouring down and through, in and out, no stopping, no grabbing. Let it go. Bless the world!

At the same time you are grounded and you're centered because you have to be. If you are not, you lose it. Turning encompasses many ideals of being; of relaxing and emptying, opening and meditating, grounding and centering. Breath is really the key to all of it. If your breath is not in harmony you lose your rhythm.

When you are turning with others, in *zikr* or *sema,* you need to have a consciousness of more than yourself. You have to flow with the group, feel where the whole circle is, feel the turners on

both sides of you. You need to be in harmony and balance with everyone in the circle. Where does it need energy? Where does it need to get a little clearer so that the circle is more harmonious? You are always looking for that harmony while you are turning around the center of yourself; looking to know where the center of the circle is, as well as your own center. The more *semazens* there are turning, the more blending one needs to do. This creates more energy in the spiral that is being created, which in turn creates the vortexes through the synchronized harmony. That is what people feel when they watch the *sema*. Something happens in the energy and atmosphere that keeps them coming back, because they feel the transformation in the space. I also agree with Murshid Sam when he says, "The watcher is the prayerful devotee; the dancer is Divine."

As I turn I just pray that I do God's will. It is a time to remember, a time to just let go of everything else and pray, a time to be open, to be centered, to be focused and to be loving. Something happens. I don't know what else to say. It is a sacred journey as all of life is. I don't really see any beginning. It is beyond the beyond. The cause behind the cause.

Adab

Adab is common sense with respect. Rumi said, "There are hundreds of ways to kneel and kiss the ground." It is the respect that matters, not the way you do it. If you respect a plant, if you respect a dog, if you respect another human life, you treat it correctly. *Adab* can be translated as "manners," but manners can be such a superficial thing. You can be really good in your manners and a real creep. You can try to charm people all you want, but what comes through is who you really are.

Adab is kindness and respect for a person. Kindness in how one treats another, awareness of the other and what they are needing, and that they are the most important. Learning can come with it too—how to make others feel special, to have them become the honored guest.

God is everything, *La ilaha illa 'llah Hu.* This is a huge realization, that everything is God. So where do you start? Hazrat Inayat Khan says, "If you have no God, create one." If you start respecting one, it grows to two; soon it can be all, if you really work in that direction.

Out beyond ideas of wrongdoing and
 rightdoing,
there is a field. I'll meet you there.

When the soul lies down in that grass,
the world is too full to talk about.
Ideas, language, even the phrase each
 other
doesn't make any sense.[1]
—*Rumi* (trans. by J. Moyne and C. Barks)

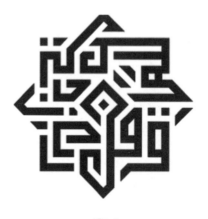

Iqraa Star

FADHILLA SPEAKS OF DEDE

I was on a tour with a group. By the time we got to Egypt, a lot of people didn't want to continue, but I couldn't imagine not going to Konya, so I went by myself. I had written some letters, through Jelaluddin Loras, and therefore expected someone to know I was arriving. Unfortunately, the person I had written to was out of town, and nobody knew I was coming. I found my way to the Dervish Brothers Rug Shop where I met two other Mevlevi *murids* who took me under their wings.

It was winter, and very cold in Konya. I went to see Suleyman Dede, who was quite sick at the time. Suleyman didn't say much, except to make sure that I had a proper place to sleep, and food. It was his way to make sure that everybody was taken care of. Feriste, his wife, asked (through the translator I brought) about Jelaluddin. "Is he eating well? Is he happy?" They were concerned about him.

At the time I was lonely because I had just fallen in love with someone and he had gone off to Yugoslavia, while I went to Turkey. In fact, I was maudlin about it. But the fact that I was a *semazen,* just perked everyone up. They hadn't met many American *semazens,* certainly not women, and I was recognized in a way that I wasn't accustomed to: "Oh, she is a *semazen* of Jelaluddin! Come to dinner . . . Do this . . . Do this. . ."

The last time I saw Dede, I went alone and just sat with him. It was very intense, although I don't think that was his intention. Everybody thought he was going to die at any minute. There was a lot of speculation that he might die on the seventeenth of December (the day of Rumi's death), but he actually lived another year or two.

I felt like I was seeing him for the last time. I was very teary and cried all the way back to my hotel. He was definitely old and sick, but so present for me. I felt he honored me, and I hadn't experienced that from anyone before. He was being so solicitous. I think Dede would be nice to anyone.

There wasn't much conversation; we couldn't chat. At the time, I was more used to words than Presence. Yet, I felt he was like a father who was pleased and impressed that I had come.

"There is a phrase in Sufism, 'A Sufi is someone who can see another person's point of view.' We seek to become more skilled at seeing another person's point of view, and recognize it whether we agree with it or not."

Fadhilla

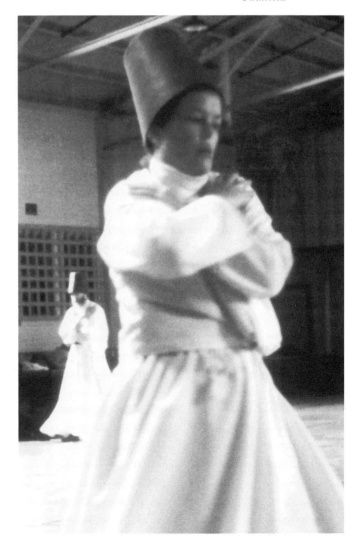

Kera

For Kera, the practice of turning leads her to a discovery of the nature and power of intention. She learns what lies behind the outer form of ritual and practice. From her evenings in college exploring comparative religions, to the Dances of Universal Peace, Kera is drawn inward to the path of the whirling dervish. She traces her journey and reflects on how to bring what is sacred into the activities of daily life.

There were about twenty-two of us in the first class, and many of those people are still turning today. The class was not what I had thought it would be in terms of learning how to actually do the turn. It was hard. We had these boards with pegs in them, and salt, since Jelaluddin wanted us to learn the way that it was taught originally.

Jelal told us a story about Shems Friedlander, author of the popular classic *The Whirling Dervishes,* who had studied the turn with Jelal's father, Suleyman Dede, in Turkey. They had this especially grueling practice with the boards and the salt. Shem's toe had gotten cracked or cut, and it hurt. It was raw, and here he was putting salt on it. It was painful and bleeding, but Shems was really into the turn, so he was still practicing. Dede came over to him and said, "What are you doing?" Shems said, "Oh, I'm doing the practice!" Dede said, "No, you're not, you're making stew!" That story stuck with me and reminded me that it wasn't about the form, it wasn't about getting it right or standing up straight, it wasn't about all the things that Jelal always used to correct us for. The practice is about intention.

Why I Turn

The first time that I was ever in *sema* was like nothing I'd ever felt before. It was a lift-off. I was a bird in flight. In those days I practiced a lot and was competent with the form, so I didn't have to worry about being dizzy or falling down and I was freed from the concern of doing it right, which gave me the opportunity to be involved in what it really was. In that first *sema* there were moments of true connectedness to the tradition and the power of the practice, incredi-

ble joyfulness and freedom of spirit! I was hooked! I said to myself, "This will always be important to me; this will always be part of me, and will always be my path, my journey."

Before a recent *sema* I hadn't practiced and I knew I was going to wobble. I said to Jelaluddin, "You know, I'm really kind of worried because I haven't practiced. What happens if I fall down?" He looked me square in the eye, and said "Just get up!" and I said "Oh, okay." I got it again, that this practice is not about doing it right. I'm here because I am grateful to be invited to turn, and that I'm part of the tradition. Jelaluddin, as guardian of this sacred ceremony, has given me permission to turn, and the opportunity to participate. I want to be part of *sema* because it has such power and beauty. It's like coming to the well and taking a cup of light out of it and having a drink. That is why I turn.

My Spiritual Journey

As I got older I felt there was something really missing from my life. I was fortunate enough to go to Boston College, which in and of itself was kind of a strange thing. A nice Jewish girl from New York, going to a school where all the professors were Jesuit brothers! I thought they were fascinating. I remember having this one teacher who, I believe now, was a truly enlightened man. I remember watching him and thinking that I was hallucinating—he was so animated in his speech that I saw sparks flying off his fingertips. I had never experienced anybody with that much life or that much energy. He taught a comparative religion class, and I loved it. "Here's what I've been looking for!" I thought, "a pallet of religions."

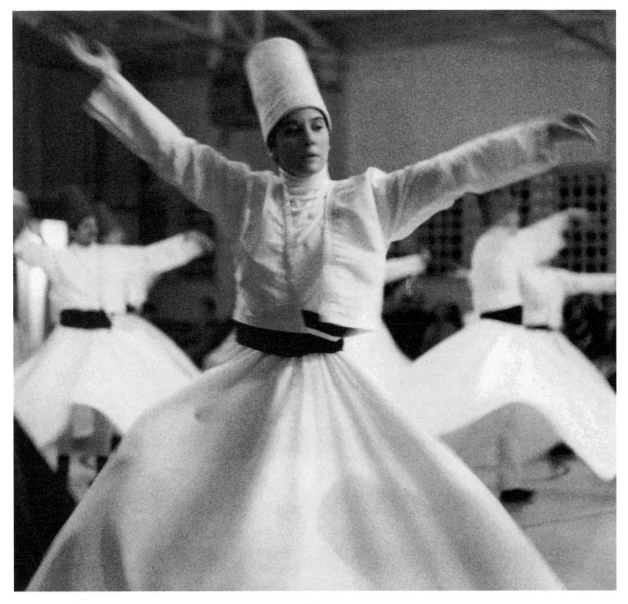

Kera

"I want to be part of *sema* because it has such power and beauty. It's like coming
to the well and taking a cup of light out of it, and having a drink."

The class went into Buddhism, Hinduism, Judaism, Catholicism and more. Among the videos that were shown was a clip on Sufi Sam and the Dances of Universal Peace. I was captivated. When I spoke to my teacher he was extremely encouraging, telling me to pursue my interest in religion. I took many, many classes and got a degree in Philosophy. In Boston I also became aware of Sufi dancing, and started going.

When I moved to San Francisco I wanted to meet people and be part of something. I knew that Sufi Sam had been in San Francisco and when I looked in the *Bay Guardian* I found a little ad announcing a group. I went. That first night I walked in, Andalieb, who also joined the first class, was at the door. Immediately I felt welcome, drawn in, so I started going once a week. I began other classes too, going to the

khanqah, * participating in activities and becoming part of the community.

Eventually, I moved into the *khanqah*. When I started to get involved in the Mevlevi order and the turn, I felt like I had found what I was looking for. I knew this was really the point where it all came together for me. I think this may apply to any spiritual path: there is the time spent getting there, time for figuring out where you are, and then you just need to keep going. Everything just funnels down to this point of understanding. Once you understand, then you are free.

The Practical Application of Spiritual Life

My spiritual practice helps me in my daily life. I know that when I'm frightened or worried or angry I can start doing a practice in my mind. I can be in the middle of my office, with all these people around, and I can bring what I know to the situation. That remembrance changes how I feel, right then and there, and nobody knows about it. It always is a challenge. How do you live the inner journey and the outer journey at the same time? How do you integrate your spiritual path into your daily life?

Washing the dishes or mopping the floor, or rocking your baby, or driving to work; whatever it is, you have the opportunity to bring your spiritual self into that situation. What is really challenging is to not lose sight of who you are or what you are connected to, and still be in this world and bring heart to what you do. At times I forget. I'm not around other people who remind me, so I have to remind myself, which is hard with all the distractions in my daily life. I'm distracted by my children, by my job, by the people I'm with. But this is all the more opportunity to think about what I need to do, so that I can bring harmony to my life and not be frustrated or feel abandoned.

**Khanqah* is a Sufi center where seekers live together to practice their faith in day to day interactions.

Semazenbashi

When Jelaluddin told me he wanted me to be the *semazenbashi,* I was honored and also scared. I thought, "I'd rather turn. I don't want to do that." I thought that it shouldn't have been me, and I questioned if I could fulfill the trust he was giving me—to pull everybody together during the *sema.* I had never even led a dance class.

Once again I realized it wasn't about the form. The importance of the feeling became even clearer, since in this role all communica-

⁓

"I have a new baby, Kia, which means 'Grace of God.' Prior to her birth, I had a miscarriage, which was a very sad thing to me; like this very dear being had been taken me. When I became pregnant again, I felt so blessed that I gave Kia this name. I hope that she will understand someday how blessed I feel, and that it was by the grace of God that I had her."

tion would be in silence. What happened that night was very special—I really grew into myself as the person that Jelal believed I was. I was able to facilitate as opposed to leading. It was about inner guidance, and being in the moment. There is really nothing that you can do if someone gets off center while they are turning. You can simply stand there with them and just breathe, and see if they get it. A great experience for me!

Reflections on Our First Class

In the first class with Jelaluddin we grew as people as much as we grew as *semazens,* as Mevlevis, and as seekers on a spiritual path. In the process of training, we all tried to be so precise, to have the form right. I think we all wanted to be perfect. Until the first *sema* all we knew was the form. But that first *sema* was so different from the practices, so alive! It has always felt like a special gift to me that I was there, and I was part of it, and that I'm still part of it. As long as I'm alive, I will always be part of the *sema.* Whenever I can, I will be there, and if I'm not there in presence, I'll be there in spirit.

> When a darvish spills the secrets of the
> world
> with his every word, he bestows great
> lands and palaces.
> The darvish is not the person who begs
> his way through
> The darvish is the one who surrenders
> his life in one asking.[2]
> —*Rumi* (translation by S. Shiva)

Shahadah Mosque, Kufi Style

Andalieb

Like a tree, Andalieb's life roots go very deep. The language of nature, long friendships and the practice of loving-kindness has created the framework of her life. Joe Miller, an American mystic, shaped the longing of her heart. Through turning, Andalieb has created a bridge from the past to the future through the practice of living presence.

When I heard that the turn class was starting, I felt strongly drawn to being in it. Then I looked at my life. At the time I was working Monday through Friday, and every Saturday was a workday at the *khanqah* where I lived. I was doing evening practices, morning practices, communal dinners five nights a week, classes six nights a week, and I had a daughter in the second grade and a five-year-old son. The only time I had to myself was Sunday, and the class was from twelve to three every Sunday.

I didn't go to the first session, or to the second. On the third Sunday, I was in such a bad mood, really upset, that I knew I had to go to the class. When Jelal let me in he said, "It is a one-year commitment, and you cannot miss a class." And you know, we kept it quite seriously. If you look at the first-year students there are quite a few of us who are still involved. I have been doing this now for more than a third of my life.

Finding Sufism

The roots of my life go back to Tucson, Arizona. One day when I was eighteen, driving with my brother, we couldn't find a parking space. Finally we found one, and a little old woman was standing nearby on the corner. She invited us into her house for tea and two hours later I walked out of her house a vegetarian and a theosophist. She became a godmother to me.

When I moved to San Francisco she came to live with me for six weeks. It was she who took me to the lodge and introduced me to Joe and Guin Miller.

I moved up to the Sierras for a few years. One day, on a visit to the city with my son, we went to the arboretum in Golden Gate Park.

Who was there but Joe Miller feeding the ducks! That was how I was drawn into Sufism.

Joe was a man who was unconditional love. He loved everyone and he didn't have a big ego about who he was. He liked "nobodies." Joe also had a great sense of humor and was very intelligent. All my life I wanted to see world peace manifested, to find the unity amongst all people. I really feel that was Joe's message, "Unity and Unconditional Love." Anybody who met him couldn't help but like him. He always saw the Divine in all of us.

Spiritual Life

My spiritual life is the belief that everything in the universe is made of spirit, and that there is nothing, anywhere, that is not on a spiritual path. All things are made of the same essence. There is only one being, one unity.

A friend told me that someone close to him had died. I said, "What do you think happened?" He said, "Well, the body falls away, but there is only one breath." I agree. Everything is breathing, moving, and just is. The spiritual path that I follow is to always try to practice loving-kindness, to be part of the Divine Beauty, to make things beautiful, and to reflect the beauty in each other more and more, so that is all we see.

I believe that everything is God, *Allah*. That is all there is: there is only God. I believe that we are all the same—no one is higher, or lower, or more. We find we are all one, and I try to see that in everything, to look for the essence rather than the concepts, or the dogma, or the differences. To see that underneath all there is only love; to see life as sacred; to see the divinity in all things—this is my path.

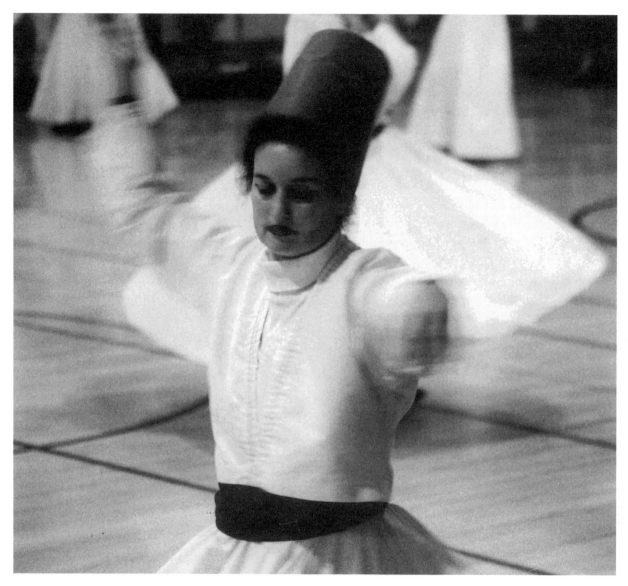

Andalieb

"My spiritual life is the belief that everything in the universe is made of spirit;
that there is nothing, anywhere, that is not on a spiritual path."

I feel like I am a Christian, a Hindu, a Jew, and yet I'm none of them. I don't really like to put myself into categories, because conditioned beliefs immediately surface. A Sufi might say, "I'm just a lover of God."

The Mevlevi Way

One thing that I have noticed in the Mevlevi circle is that so many couples are so strong in their relationship. It is amazing to see this love and unity manifested within each individual, within the couples and within the greater circle.

There is a bond of brotherhood, love, harmony and real strength behind our Mevlevi circle. I'm not always a part of the nucleus of the community because I don't do a lot of the workshops and seminars, or travel with the caravan. I taste some of it, but I'm certainly not there for

everything. Yet my spirit and my mind are always there.

I see the old dervish or even the modern one as a mystic, a lover of God, a seeker of truth, a holder of the light, a messenger. The message is in the form, rather than in the talking—people are moved by our turning and we don't even say a word. It is through experience that one can get close to the dervishes.

I don't identify the dervish as only being the beggar, or the symbol of the wool coat, or the ones who have nothing and live off what they are given. For me, the dervish is Jelaluddin Rumi. I feel that he had the power of love. His poetry, for me, is in the moment. It is so old and yet so present.

I am deeply grateful to be an American Mevlevi in this country; to be taught by a teacher who has treated men and women equally. I have never felt that Jelaluddin Loras made distinctions between us or that men could advance higher than women. He had respect for us as *semazens* without distinction of age or sex, and that is truly a wonderful gift.

It is good to see that in Turkey the ban on turning is being lifted, somewhat, which gives the opportunity to the way of Rumi to rise to the surface again. My hope is that someday men and women from all walks of life can turn together throughout the world. I feel that Jelaluddin Rumi came from that point of view, and that Jelaluddin Loras does too. I am enormously thankful that we were given the teachings through him.

When I saw the Turkish whirling dervishes, I realized that we follow the same *sema*. It was extremely validating to see that what we are doing is authentic; that we are doing the same practice. I joke sometimes when people ask, "How long have you been turning?" I say seven hundred years. Perhaps we were all there at the time of Rumi, and we are doing it again here this time around. I liked it when one of the women *semazens* threw the rose petals at Suleyman's *Urs* and said she knew that women had turned before.

> Your dance just took me today
> and suddenly I began to whirl.
> All the realms spun around me
> in endless celebration.
> My soul lost its grip,
> My body shed its fatigue.
> Hearing your hands clap and your
> drum beat,
> I floated up to the heavens![3]
> —*Rumi* (trans. by J. Star and S. Shiva)

Allahu Ahad Square, Kufi Style

ALICE SPEAKS
ABOUT JOE MILLER'S WALK

Every Thursday at eleven in the morning, we would meet at the arboretum in Golden Gate Park. Joe would say, "Okay, let's get going!" and this whole crowd would go walking through the arboretum, down into the redwood grove where Joe would give a talk. We would walk to the meadow, form a big circle, and do some Sufi dancing. Joe would call on different people to lead dances.

At a certain point he would say, "Okay, enough of this serious stuff, let's go feed the ducks!" We would walk over to the duck pond, and he would pass out bread to everybody, and we would feed the ducks. Then he would call us all together again to sit in a big circle. He might call on someone to share a dance or a song or a poem. Or if Iqbal was there, he would lead a short *zikr*. Then Joe would speak a little bit more. Some people would leave at that point, and we would continue to walk all the way to the beach. There were stops on the way at which he would always ask someone to do something. Sometimes he asked me to dance, and David would always do an astrology update.

When we got to the beach, we would cross the highway, walk down into the sand, and then walk a bit toward the cliffs. Someone would run ahead and get ice cream for everybody. We always ended singing, "May all beings be well. May all beings be happy. Peace, Peace, Peace." Joe would belt that out and then everybody would say good-by and people would head home, car-pooling back to wherever their car was, usually about three in the afternoon.

A few years back, the walk got kicked out of the arboretum. The police came up to Joe and said he was going to be arrested for having a parade without a permit. Joe said, "This is not a parade, these are all my friends! We have just come to take a walk together!" But this was one of the big days like Christmas or Thanksgiving, with three hundred people there. It was just too much for the arboretum to handle, and some plants had gotten hurt. From that day on we never went there again, but started another route.

Now that Joe and Guin are gone the walk happens at Christmas time and Thanksgiving, but without them it is definitely not the same. We all loved Joe and Guin so much and we came to love each other too. The walk is still such a joyful reunion. By being together in the old way we touch base with that time and the connection we all shared with them.

Everyone is floating and
everyone is free,
I have no one to call mine
for everyone is me.
So don't you try to hold on
to anyone you know
Just feel the life within you
and let the changes flow!
—Song by *Joe Miller*

*Joe Miller Tribute
in Golden Gate Park*

Khadija

Khadija has journeyed both in the outer and inner world. From her personal experience of dance, Sufism and Buddhism she has found a way of viewing life that gives her access to the place where all paths meet. Through careful examination of the activity of the mind, Khadija reveals her perceptions of what lies at the heart of life's mystery.

I first saw turning while traveling overland to India and back, from Turkey up through Iran, Afghanistan, Pakistan, and from Egypt to the Sudan. When I went to the Sudan, I was very fortunate to be the guest of the Halife of the Qadiri Order who resided in the desert. No Western woman had ever been his guest. I was there because of Hassan, my previous husband, not because of myself. We were put up in this empty palace with beautiful flower gardens in the middle of the desert. The Halife had a palace because the president of the Sudan was his disciple, and wanted him to be comfortable when he came to study. For forty days we lived in this palace with hot showers, fans and electricity. When we went to see the Halife, he lived in a hut with no electricity, no fans, no showers, no floor, no screens, only mud walls. He saw people twenty-four hours a day as their servant. That was who the head of the Sufi Order was! That gave me a real understanding of what a true Sufi is.

Turning and Sema

I was in the first turn class that Jelaluddin taught in the Bay Area. I had already studied modern dance and ballet with masters, and I had a genuine knowledge of alignment, posture, breath and vertical axis. I had to learn how to turn in the alignment that I had developed. To stay in alignment and turn is difficult. That, for me, was like taming a wild horse. The axis at first appeared as a barber pole—it was bigger than my physical body. I had to refine it and refine it. As I learned the turn and it became more comfortable, I perceived the axis as a little pole, then as a hair and finally as the center of a hair.

When you can maintain a vertical axis, and go truly to the center of the center, then there is nothing there. The center becomes the total expanse of the universe. The ultimate contraction becomes the ultimate expansion, and here you are experiencing yourself as that! This, then, is the true self. What a miracle! That is *sema* for me, when you get to that place.

When I speak of *sema,* I am referring not to the formal turn ceremony but to the state of *sema,* which is literally translated *sama,* "to hear." It is an inward listening or a turning inward to the self, the true self. We have to examine, what is the true self? For me, this is where Zen and Sufism come together. There is no self.

Turning is such a good spiritual practice because it is so demanding. It demands that you pay attention. Even if there is distraction, like people are too close, or too far away, or some one has just had an argument with someone else, or something has gone wrong with the hall, or the floor is sticky or whatever it is, you have the opportunity to transcend the situation, or you can't truly turn. I don't want to waste that moment. My intention is very strong to come to true *sema.* But there are these other things going on that can pull me out of my concentration.

Turning with the same people over the years, seeing them again and again, it is like being with your children, or your old brothers and sisters. That part of it is very sweet. Anybody who has a an intuition that this is a practice for them, I would encourage to try it.

Rumi's Poetry

The one line that comes to me all the time is, "to meet Joseph and know the smell of his

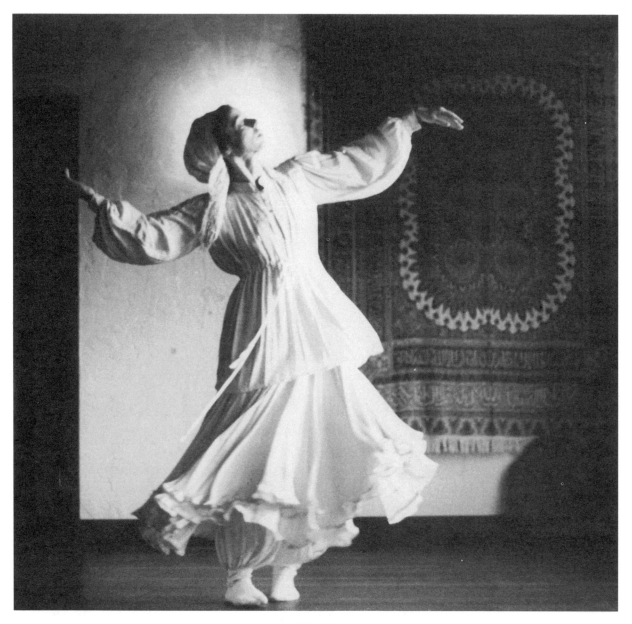

Khadija

"Turning to disappear means that you surrender your identity
as the doer, and you become the witness to the body turning."

shirt." That image for me speaks of an intimacy that can translate as the knowledge of yourself. When you have a little baby, you smell his head or her head, because it is just so delicious, particularly breast-fed babies! When you take that whiff you lose the self, you become the smell of your baby's head. When I imagine meeting the consciousness of Joseph, and smelling his be-ingness, one can disappear into that presence!

Spiritual Practice

If I had to think of who was my earliest teacher, and what was my earliest practice, it is dance. When I was five, my mother took me to see

"The Nutcracker" and I was bitten with a disease that has never gone away. I have even tried to shake it, "Come on, you're fifty, you can retire from this!" But I can't. Even in the hermitage, when I am on retreat, dance comes. In a seven-day *sesshin,* for eighteen hours a day, I can cross my legs and sit even though it is very painful. But I can do it in order to study with my Zen teacher, Kyosan Joshu Sasaki Roshi. Still, he knows that is not my way. That my way is dancing. The turn for me is dance, but it's the pearl!

When people are looking for spiritual practices, there are different motivations but basically two categories. One orientation is toward salvation, meaning that something will make something else okay. The other orientation is that of no salvation. I'm of the "there is no salvation" school. There is no *wazifa,* there is no practice, there is nothing that is going to make you better, or enlighten you, or clarify something for you. Now that may seem like a contradiction to what I just said about the turn, but what I'm addressing is the motivation of why you are turning, not what the turn is. If you are turning to get high, I would recommend a good margarita instead. But if you are turning to disappear, it is a very strong practice for that. Disappearing doesn't mean running from your problems, or making the pain better, or being cooler, or being more spiritual, or any of that. It means that you surrender your identity as the doer, and as the manifested self, and you become the witness to the body turning. The Sufis say, "Be in this world, but not of it." So, on one level it is, "Do your thing, but remember God." For me, "Being in this world but not of it" is to always know that what the mind constructs as the self is just the activity of the mind, and only that. Turning to disappear is true *zikr.*

We sit here, and it's you looking at me looking at you. But really, everything I see of you is just impulses through my eyes to optic nerves, to converters in my brain. Sensory perceptions of what is beyond you, such as the wind blowing, are merely activities of the senses that are coming into my brain. There is constant input making you. Our tendency is to identify with that. But that is just mind activity. What is prior to mind activity? Witnessing. That is what I find to be the closest thing to salvation. When you understand that there is mind activity, and that there is the consciousness witnessing the mind activity, then you can, with practice, go beyond the witness of the mind activity, to the absolute quiet, nondiscriminating consciousness. For me, that is truly spiritual practice. If turning facilitates that, all well and good.

I will tell you a wonderful story about Roshi. Years ago, David, my husband, was watching the Olympics on TV at the moment when the three-gold-medal winner was performing in the diving competition. David asked Roshi, "Does that person experience *samadhi?*" In Zen Buddhism, *samadhi* is becoming the experience. It is not *satori,* which means the witness knowing that it is witnessing the *samadhi.* Roshi said, "Yes, absolutely, he is in *samadhi,* but this is his only access to *samadhi.*"

The turn is that access for me; not all the time, but an appreciable amount. But that is not going to give me access in any other activity in my life. It can give me an intimacy of that particular spiritual state. I believe that's why the old dervishes went into a retreat for a thousand and one days, in order to know the self and have the access that came from a deep surrender.

Hunger, Loss and Fulfillment

My path is that every expectation that I ever had never came to fruition, even on the level of dancing. I was a soloist in a highly paid dance company, but it never brought satisfaction. You have this sense, "If only I were . . . whatever . . . then I would be satisfied." I was given every "if only," and was never satisfied. When I came to realize that nothing out there was going to give me everything, I was forced to turn inward. I was very fortunate to study with masters. Jelaluddin is a wonderful teacher of the turn, so I had a master to teach me the turn. But no one took my hand and said "This is the way." In fact, quite the opposite. I was always shown how to walk into a brick wall! I guess I learned that you just make a sharp right angle immediately be-

fore the brick wall; that is *neti-neti*—"not this, not this." It is always *neti-neti* for me.

I became a nun with Roshi when our house burned to the ground. We lost everything. The next morning Roshi invited me for tea and during that morning tea he said he was going to ordain me.

The day of the fire I had left my house in New York in the morning and flown to New Mexico, arriving at the retreat center in the late evening. Ten minutes after I got there the telephone call came. When she heard what had happened the abbess of the retreat offered me a glass of vodka, and I said, "No, no, I have my own medicine, but I would like to use the hot springs."

It was a full moon, and the night was Passover, which is why my family wasn't home when the house burned. They were at a Seder. It also was the Saturday night before Easter Sunday, and it was Ramadan*. Three religions were celebrating their holy nights. It was Roshi's birthday too, and it was blue moon! Before I left New York I kept saying to David that something incredible was going to happen on this day. These three religious days probably come together only every hundred years or so, because Ramadan moves eleven days every year, and they are all using different calendars. Then to be a full moon and a blue moon, which is the second moon in a lunar month, is just too much. That is when the house burned down! When I heard the news I had this intuition that it was very fortuitous. I didn't know how, but I knew. The fact that nobody died was remarkable. Any other night, they would have all been inside asleep.

Later that night when I was out in the hot springs and there was a mist rising between me and this gorgeous full moon, I was thinking that everything I owned was in this form now, except the clothes on my back. When you go to *sesshin* you wear your robes, so you don't bring changes of clothes, only underwear. And so these were the only things that I had from before the fire.

**Ramadan* is the annual Islamic holy month of fasting from dawn to dusk.

Everything I had was in this form, and I was trying to "grok" it. I remembered all my things, like the jewelry from when my mother died, the photographs and videos, everything! Then I had this flash that I was in this form . . . that in this space, time, world, I was Khadija in the hot springs. But truly, in terms of physical manifestation, I was just passing through, as fast as the fire passed through. If you step back trillions of years, and see how long my life is taking, it is like, "Wait! Go back a frame, I missed it!" So that was a great revelation. I went in and told Roshi that, and he said, "Yes, and you must remember that; as it keeps going, it also keeps coming. There was nothing lost. Your job is to build another center this year."

Then he decided to make me a nun. When I returned home, my dance with the insurance agent was really magnificent. We got a huge settlement and we built a beautiful center, much better then the original center. Life goes on.

Love, Emptiness and Form

When I think of the Mevlevi way I think of two things: the turn and love. Love, especially in the West and especially in English, is a terribly abused word. I think what true love is, is experiencing nothingness. In Buddhism it is said that form is exactly emptiness, emptiness is exactly form. That is part of the *Heart Sutra* in Buddhism. To me, one translation of *La ilaha illa'llah* is, "There is no God, there is Allah." One could then interpret it, "form is exactly emptiness, emptiness is exactly form." "There is no . . . there is" Once that becomes your experience, it is no longer a belief, it is love. It has nothing to do with oohy-gooey kissing and sentiment toward your fellow dervish. That is all personal stuff. To call that love, for me, is a sacrilege.

When I was four-and-a-half or so I used to play this game in which I would sit on the stairs and try to catch what I called "the little man that put the thought in my mind." I would be very aware of the birth of this thought, the instant the thought appeared. But I knew some spark came before that thought and I wanted to catch it.

Today I might say that I know there is nothing except consciousness, and yet there is something, prior to that consciousness. There is the experience of witnessing, a settling into the emptiness prior to the activity of witnessing; a stillness that has no desire to stop or to start, and that, to me, is love.

Judaism, Buddhism and Islam

I am a faithless person. The fuel of my seeking was suffering; faith never showed up as anything I could count on. I had a daughter who was dying of a birth defect and I couldn't even pray—I saw that as a futile attachment. All I could do was be present for her, which was my most effective curing ability for her.

Judaism is my culture, if you will. Buddhism has been a great teaching for me. I take advantage of a deep practice, which is just to sit, cross your legs and be still and not try to do anything except to be present for my breath. Sufism has some practices that I find valuable, and some teachers who are inspiring.

Islam is the path of surrender. There is a deep and true surrender that is given to us all the time. We can actually witness it. The surrender of the in-breath to the out-breath and the surrender of the out-breath to the in-breath. That intimacy with the breath fosters an experience of no self, when it becomes an absorption like the absorption of the turn. That is where Buddhism comes in for me, the turn is where Sufism comes in, and Judaism comes in as a culture for me. It teaches the same thing too, ultimately. There can't be separate truths. There can only be what is.

Fate, Time, and Space

Do I have a choice? There is the apparent choice. Einstein says that past, present and future are

going on simultaneously. So, if all of this is going on at the same time, how can we just have it linearly? Past is here and present is here.

One of the things that I teach is an exercise called constructive rest. I guide students into a sacred space where they feel safe to work. The participants have different themes and people can look at their life through this frame. I say, "Now I want you to put in your space your very biggest worry: dying, abandonment, shame, whatever it is. See if it is nothing more than reaching into the past and projecting into the future? If it is not that, then you are *really* worried. And if it is that, then it *is* just the activity of the mind. Even if you know you have cancer, I'm not belittling your situation, but I want you to understand what worry is, and how it doesn't help you. It is an activity that the mind loves to do; a very intriguing activity. You can really get lost in it. But it doesn't heal. It is not a healing energy."

The past is what the mind reaches into. The future is what the mind projects. The mind projects as a result of the past, not even as a result of the future. So all we have is presence. If you have a practice that gives you a "present" experience, it is a deep practice, whether it comes from the form of *zazen,* or *wazifa,* or prayer or turning.

> . . . When you stay tied to mind and
> desire, you stumble
> in the mud like a near-sighted donkey.
>
> Keep smelling Joseph's shirt.
> Don't be satisfied with borrowed light.
> Let your brow and your face illuminate
> with union.4
> —*Rumi* (trans. by C. Barks)

Hilye Panel by Serife Fatimatu'l Mevibe, Mid-19th Century
Courtesy of Topkapi Sarayi Museum of Istanbul

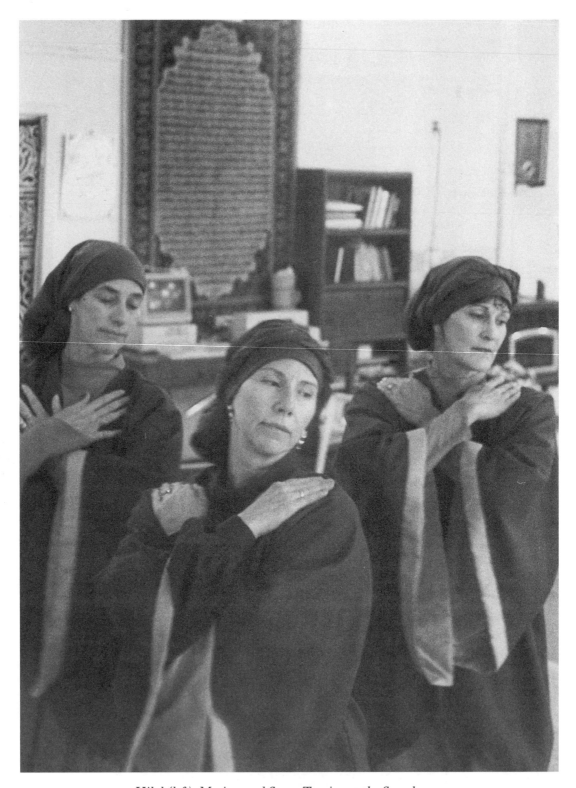

Hilal (left), Mariam and Susan Turning at the Semahanue

Ya Allah, with love, reverence, and humility,
we surrender to Thee and to Thee alone and
Thou does raise us spiritually. —*Murshid Sam*

ATESH BAS

Interviews with Nur Jehan, Mariam, Hilal and Susan S.

On December 17, 1993, Postnishin Jelaluddin Loras, after fifteen years of training students in North America, initiated a group of his senior students as shaikh(a)s and *atesh bas*. Included in this group were several women, the first Mevlevi shaikhas to teach publically in several hundred years. He called this *sema, The Sema* of the Beginning.

The initiation of *atesh bas,* was given to couples only. These couples were given permission to open their homes as Mevlevi centers and to lead *zikr,* train *semazens* and offer Mevlevi teachings in their respective geographic areas as authorized by Jelaluddin Loras.

The title of *atesh bas* comes from the name of a devoted follower of Jelaluddin Rumi who lived in Meran, Turkey and was Mevlana's cook. One evening, unexpectedly, he received word that Rumi was coming and wanted a meal served to his *murids* who were traveling with him. On this night, however, there was not enough wood for the fire, so Atesh Bas put his foot into the dying embers to help catch the flames onto the awaiting logs. When he removed his foot, only his big toe was burnt, which was a sign to him that his faith was not perfect. When Rumi arrived Atesh Bas put his right foot over his left burnt toe so that his sacrifice would not be noticed. When Mevlana saw the position, he understood what had happened. He embraced Atesh Bas before all the dervishes saying, "Few on earth have such faith as Atesh Bas. In the future, all of our dervishes will bow with one foot placed over the big toe to remind us what faith really means."[1]

Persian Phoenix
From Illuminated Manuscript,
15th Century

Nur Jehan

Nur Jehan and her husband Shemsuddin were given the initiation of atesh bas. *She also received a special blessing from the Mother of the Dervishes, Feriste Hanum. That blessing has shaped her role in the Mevlevi Order; for many years she has given endlessly of herself to bring financial stability and a clearer, more efficient organization to the Mevlevi Order in America as well as being available as a friend who gladly shouldered anyone's sorrows or complaints. She shares precious memories reflecting upon our heart connections, the dynamics of a group bound by love of the same path, and the connection to our living heritage and to the guiding spirits who are ever present.*

There is a kind of crust that we assume in this lifetime through our experiences. We make this crust from our protections and our reactions to the situations that life presents to us. We have an idea of the *persona* that we are, but when I saw the turning for the first time, all of that dropped away from me. All my fears and preoccupations with the world whirled out of me like a vortex into the ground. I was just there, clean and clear and empty. The feeling of the spiral, of that energy, was what drew me to the turn. I thought to myself, "If this can happen to me standing here, just on the periphery of the circle, then if I learn to be on the inside, what else can be in store for me?!" So that was the lure. I started the turn within two weeks.

At that time, Jelaluddin didn't speak English as well as he does now, so I had to listen to him with my whole being to catch what he was saying. I don't find that my mind is such a reliable barometer for what is going on. In my childhood I grew up very intimidated by people and situations. With Jelaluddin, I didn't have to experience that intimidation. All I had to do was open my eyes and my ears. It is refreshing to learn to respond to the world in that way.

When we come to *zikr*, bow at the door and enter the room, we drop all of life that happens outside that room. We don't talk about our lives. We don't talk about money or about husbands . . . not too much anyway. *Zikr* is just for us to be together with other hearts and souls, whose form is human, and whom we know nothing about. It's such a pure way of being together. Talking about "stuff" is sort of exhausting. It despiritualizes. It takes the presence out of our life experience.

My Relationship with Feriste Hanum

When I was a first-year student, Jelaluddin's mother, Feriste Hanum, came for a visit and we prepared for a *sema* in August.

Nur Jehan

"When we come to Jelaluddin's *zikr,* when we bow at the door, and enter the *semahanue,* we drop all of life that happens outside that room."

Feriste Hanum

We had to be ready early so we had two classes a week. Although Feriste didn't speak any English she helped us dress for the *sema*. She really didn't have to use any words. Every time she would look at me, she would say, *"Allah, Allah!"*

That day, I was so nervous that my knees had been shaking since early that morning, and they wouldn't stop! I was ironing our *tennures,* and shaking and shaking. Feriste would just say, *"Allah, Allah!"* She repeated that all the time to everybody. There was something about her that got into my heart. (Afterwards, Jelaluddin told me that she said that when Shemsuddin, my husband, and I entered the room, it was like a window opening for her.)

When I saw her again in Turkey, ten years later, she remembered me. I couldn't believe that of all the people she had met she was able to pick out of our group exactly all the ones she had met before. I had made her a blanket on my loom, because I am a weaver. I gave it to her when she came to visit us in California. When I

was in Turkey, in her little room, she had somebody translate, telling me that she used the blanket that I gave her to pray on. That was like a blush on a rose—I just blushed with the love that she shone on me.

Connectedness

I don't believe we are here in this world once and then never again. I feel that we all cycle together. I'm not sure if it is a group consciousness, or what it is. I just know that the kind of cohesion that keeps the *semazens* together as a group is very deep and timeless. When I look around at our circle, many of us have been together for almost as long as this practice has been in this country. When I was at Mevlana's tomb in Turkey, I just kept saying, "It is impossible that we haven't been here before, following this path!" So it gives me great comfort and surety to be part of this practice. You can't put into words how it changes your life, and what direction your life takes, once you commit to a path. This is true for any spiritual path. For me, it just happens to be this one.

Sometimes I say to Jelal, "You're my family!" I feel that way about his Mother. It was very important to me that she gave me my *sikke,* that she initiated me. When I was a child, I was interested in religion, not from dogma or from the church organization, but from the tribal perspective. I was interested in belonging to a family and knowing who I was, knowing what my place was, and knowing who my people were. The yearning was always there, but it has been a long road to being able to say, "Yes, I belong in this family!"

Sometime in our life we have to admit to what is real for us. Lucky is the person who can find truth in that experience, and then have the nerve to say, "This is what I believe in!" and really believe it, without a shred of doubt!

My Spiritual Path

I have great gratitude for the way in which I came to this practice. In 1968 I had a teacher named Dr. Ajari Warwick, who has passed on

now. He always said, "Well, if I can't teach you, if I don't think you are on the path that I'm teaching, I will take you somewhere else," and it happened that way. I went with him to meet Murshid Sam. Although I didn't spend a lot of time with Murshid Sam, he is always here for me. He is not dead, even though he is not here in the body, which probably makes it even easier for me in a way. His wisdom, his love and his generosity is always available to me through prayer.

It was through my connection with Murshid Sam that I met Jelaluddin, and through him, essentially, I came to Mevlana. My path feels like a long, long road that traverses the past, the present and the future.

Some of the very strongest and most impressionable experiences that I've had have to do with God being real. Those experiences, if you were to put them on our time line, would be only seconds, like a flash, like a second's brightness. But the residual effects of those experiences are what has shaped me.

I think when it's your turn, or when you look for a teacher, or when you find a teacher, and then when you do the practice, whatever it is, all of that is "walking the path." Whether one does it turning or whether one does it sitting *zazen* or one of the many other ways. For me, the spiritual path is the act of turning. It spins off my gross self and leaves me just an essential being. It is a real privilege to have a time in your day, or in your week, to be able to do such a practice.

The Essence of Turning

Not every turning is a "high," you know, or even every *sema*. In fact, most *semas* are, to me, like a workout. I don't get the rewards that I expected initially, "Oh, I'm going to feel so bright!" or whatever else I wanted at the time. But if we look back on our life, after we have begun the practice, and we see all the graces that have come our way, then, maybe part of it is that we are polishing our heart, or polishing our being, by the practice that we are doing. For me that is turning.

I go into each *sema* with beginner's mind. Each time we walk the circle of the Sultan Veled

walk it means a different thing to me. When I was in Turkey, for the Istanbul *sema,* I was asked to be *semazenbashi* with Shemsuddin, my husband, but he got sick. Jelal said, "Well, you do it by yourself."

"I don't think I can do that!" I answered.

"Yes you can!" he said.

Then, I conceded. "Okay, if you think I can, you are probably right." I was willing to do it by myself. At the last minute, the *semazenbashi* from Konya showed up, and I was so relieved! He and I were *semazenbashis* together.

A Moment of Magic

The *Semahanue* in Turkey is this beautiful old octagonal building. During the ritual of the *sema* there, I was sitting on the floor. I looked down at the floorboards, big planks about eighteen inches wide and two inches thick—a heavy, dense kind of wood that had been in use for many hundreds of years for the same purpose. Then the *ney* sounded. When I heard that music I was somewhere else. In that moment I realized that the reason people come to earth, the reason they are born as human beings, is because of the music of this world. It is so alluring that we can't resist it. We are just like the children being led by the Pied Piper. We become full of this breath, filled with beautiful sound. Then we become a human being!

At the *sema* in San Francisco recently Jelaluddin spoke about the *derbi celali,* the slap to the ground and the coming to life. Before that happens in the ritual there is a *ney* solo. In that moment in Istanbul, I had that experience of being brought to life from hearing the sound of the *ney* and slapping the ground. It all happened without the mental knowing of the symbolism.

Hospitality in Turkey

The people of Turkey were so generous and gracious to us—the person giving us tea, and the rug seller, everyone. They allow themselves to experience their joy with other people much more than we do and in a different way than we do. I do have one regret from that trip, however.

The shaikh of the Mevlevi in Konya offered me a cigarette. I don't smoke and I refused it. I wish I could have taken that, but I didn't.

My Day to Day Life

My biggest occupation is to be the mother around here. That is really who I am in the world. I listen to all the kids and I try to share with them; if I have anything that I can say that will make it easier for them to bear whatever it is that is troubling them, that is my work. These young people, maybe they have funny hair, or one earring too many, but I find them fascinating, so fresh, and so honest in their searching. They are trying to figure it all out. They are becoming people with their eyes wide open to everything that is going on. My husband, Shemsuddin, has introduced them to Rumi, just giving them a little to juice them up. They are the next generation. They deserve it!

> Walk to the well,
> Turn as the earth and the moon turn,
> circling what they love.
> Whatever circles comes from the center.[2]
> —*Rumi* (trans. by J. Moyne and C. Barks)

Hilal and Nur Jehan (right) in Konya

Beauty manifests with confidence.
Ecstasy and beauty come if we harmonize . . .
Harmonize. Don't be selfish.
Think first of others.
—*Jelaluddin Loras*

Mariam

Meeting Mariam face to face one is struck by her radiance and grace. She carries responsibility with ease and laughter, and her voice is gentle, refined and soothing. Yet her soul resonates as a seeker of truth and the fire of her heart burns brightly in her words. She is quick to find humor in her own nature, at the same time she is unafraid to speak out on sensitive issues bringing light into the dark corners of spiritual life and addressing global concerns that affect humanity. Her search for the feminine face of God relates to all women seeking to discover the "She" in the One too frequently referred to as exclusively "He."

For me as a woman, any empowerment, such as becoming an *atesh bas,* is really an acknowledgement that you are ready to do more work. It is like a little kick in the pants, "You are needed, get to work!" *Atesh bas* means the one who works in the kitchen, the one who feeds, the one who is of service on that plane of nurturance. I see this title as a reminder from my friend and teacher Shaikh Jelaluddin that there is hunger in this world and I am being called forth to help feed the hungry.

The Practice of Turning

I experience a myriad of feelings doing the practice of turning and it changes with my life experience, like while I was pregnant with the little babies. Each time I enter this practice I encounter the element of purity. Through the movement, through the concentration, through the turning to the source, to the Beloved, my experience is one of cleansing and purification. That is consistent. I have turned during so many different emotional times and yet there is always a way that I am stretched beyond a capacity that I believe I have in terms of ability and experience. This practice shatters my concept of who I am.

My Early Years on the Spiritual Path

I grew up in a strong Catholic family and there has always been an element of mysticism in my life, a strong attachment to the saints and to Mother Mary. A certain magic has always been present and I can't remember a time that I didn't have life involved in Spirit, God, Goddess.

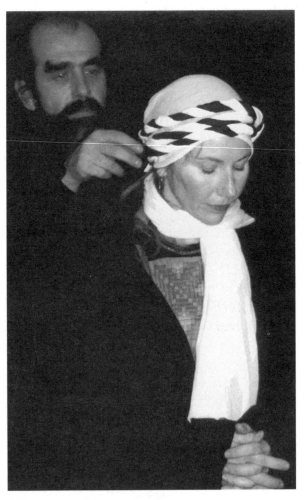

Mariam

"In sitting zazen and whirling, even though they are radically different externally, the ultimate goal or outcome is similar, to be silent, empty, still."

When I was seventeen and strongly into *hatha* yoga, I became a radical vegetarian. I began looking for a path that was inclusive of women and inclusive of everyday life in a way

that worked for me. When I finally did meet Pir Vilayat and was exposed to the teachings of Murshid Sam, I felt an immediate attunement, a sense of inclusiveness and possibility.

On one hand I was yearning for a spiritual path that would work in terms of my everyday life, my sexuality, my personality. At that same time, there was this mystical longing in me. I became a spiritual feminist. I would go through the Bible (or any book you could think of) and cross out "he." This was not popular with anybody. This came from a deep yearning in me for a different consciousness, for the Feminine Face of God. I wanted that not to be hidden.

When I look back now I see that it was a realization of this missing part in the mirror of the face of woman in our culture. I could find no reality of women as sacred, other than what I had experienced through Mother Mary and the women saints. I came to a place of such longing to understand the Divine's manifestation in the female form that I began a quest. I went to original sources of material and actually did discover that much of the feminine manifestation had been hidden, clearly a bias in the material readily available. Through this quest and the research that resulted, I wrote a book called *Woman, As Divine: Tales of the Goddess.* I still feel very involved in this process.

Peace

Another part of my spiritual quest was the worldview: looking at the world and asking how do we come to peace and knowing that we are not going to come to peace through political means, through diplomacy as it currently exists. I have come to truly believe that until women and children are respected there will be no peace on this planet. Part of that respect is honoring the Great Mother, honoring our earth, honoring women saints and prophets, honoring the manifestation of the Divine as Feminine, as well as Masculine, and embracing that.

In any spiritual discipline that has come to us, women are quickly able to surrender the position that they already know everything. I think this allows us to become students more readily, whether it is a student of Tibetan Buddhism, Shamanism or Sufism. That is one reason why in the United States, in particular, there are more women involved in these practices. It is a phenomenon of our times. We as women, right now, are ready, because we can see so clearly the non-working of past history. We, as women, have always been involved creatively, whether it is in our families, or in our jobs, with making things work on the earth plane. We are receptive to new ways of knowing, new ways of interrelatedness, with one another and with the Divine.

Adab

At this time in our development as a Sufi culture, in all the Orders that I have come in contact with, *adab* is a word that is gravely misunderstood. It is very disturbing to me to find any one of us, in whatever aspect of our Sufi culture, pointing a finger at someone and saying, "That is not proper *adab*." If one is pointing to someone else and being accusatory or pointing out their lack of something, this creates diminishment. *Adab* then becomes a word that connotes power, as in "I have something that is sacred and righteous and holy that you don't have. You didn't bow properly, or you didn't salute the shaikh properly, or your sleeves weren't rolled up the proper way . . ." The most ridiculous things!

To me, Sufism is a mystical path, and because of that we must scrutinize ourselves. I'll just speak for myself—I try not to be attached to certain concepts of right and wrong because it takes me from the path of love into the path of judgment. That is not part of our Sufi heritage, although as human beings we all fall into it. I don't want to judge anyone. As soon as I begin to do that, there isn't room for beauty, there isn't room for compassion, there isn't room for forgiveness. Once a person assumes the job of judge, there is not much room to be the lover.

To me, passion is important, passion for God. That is the way of *bhakti,* the way of love for the Divine. The mind is not the primary tool within our Mevlevi work. Rather it is the heart, the element of love, which carries with it forgiveness

and compassion. When we use the heart to disengage the mind, to engage it in another way, that allows us to align more closely to the Beloved, with the Divine.

True *adab* is subtle and hidden. It is something that perhaps one can't define—a quality, a presence of life and relationship that, *Inshallah,* we can observe operating in our teachers and friends.

Going to Konya

I was four-and-a-half months pregnant, carrying these baby twins in my belly, and definitely on a pilgrimage. I knew that this would be the last trip that I would take for awhile and I felt blessed to be able to take this pilgrimage with Jelaluddin and the group, to receive the blessing of Feriste, to be able to turn in Konya and in the tomb of Mevlana. The trip to Ephesus, which was the last home of Mother Mary, was a wonderful place of deep silence and contemplation for me, being pregnant with little dervish boys.

Feriste stayed mostly in just one room. She invited several women to come and join her there, for *sohbet.* We spoke little Turkish and she did not speak English, yet we were able to communicate. Through a translator, Feriste talked about being in our country and visiting the redwood trees; how in the core of the redwood trees is always this constant heartbeat of Allah. She spoke about reforestation, which was a delightful surprise to me as a woman from a different age and a different culture. When she spoke about this she had tears in her eyes. She talked about the global importance of this issue and how sad she was that in her country they were so far behind ecologically. She shared with all of us the great importance of caring for the earth and of doing *zikr* with all of life.

We were privileged to do a formal *sema* in the courtyard at the tomb of Rumi. To fulfill the dream of Suleyman Dede, which Jelaluddin had shared, of men and women turning together in his country, Jelal had to do a huge amount of political work to get permission for us to do this. In Turkey it is extremely uncommon for men and women to pray together in public. We needed to get the permission of the mayor of the city and the governor of the province, to be culturally correct and not offensive to anyone. Jelal accomplished this, and in fact the governor, the mayor and other dignitaries were present at the ceremony.

The courtyard is a public place and people who were walking by would stop and observe. All of the Turkish women who saw us were so ecstatic that they had tears streaming down their faces. They had never seen men and women turn together. They had never seen women recognized in a formal *sema,* in a public way. To have the support to do this and also to feel all the implications of that for these Turkish women was very moving.

Family Life

My daily life is full in terms of my family. I am blessed with five children. There is a hand on my back propelling me forward, in a way that I cannot resist. It is just much stronger than I am. In my day I don't think too much about not having time to do this or that, perhaps because I don't have time to think that way. I don't think my life would work if the spiritual component were not an integral part of it. I don't think my family life would work if we didn't say prayers together. I don't think I would have as much energy as I do—physically, intellectually and in relationship—if the life of the spirit and the consciousness of breath were not a part of my everyday life.

Prophets and the Place of Love

What I am interested in as a seeker of truth, a seeker on the Sufi path, is what underlies religion. Rumi certainly was a Muslim and came from that tradition, Jesus was Hebrew and came from that tradition, yet both of these beings who incarnated as men were lovers of God, both were mystics, and that is what I am interested in.

As a woman, I feel it is imperative to become more articulate, to address the issues of cultural gender oppression. We need to recognize gender oppression as it shows up in literature, religious and secular, as well as in the interpre-

tations of religious literature. As women come forward, not with a desire that comes from a place of power to be over, under, right, or wrong, but from a place of love—Divine wisdom—a wisdom that is larger than just our mental capacity, we help everyone on the planet. I am strongly committed to the belief that when women and children are respected that there will be peace.

Each woman is being looked to for leadership, particularly by younger generations. There is a huge potential before us in terms of not turning away from the pain on this planet, the shadow—the oppression of old people, of children, of women, of the homeless. We must not turn away from learning how we can make peace within ourselves, and how we can support one another toward greater wholeness.

The Sufi Path

The Sufi path that opened to many of us in the West through Hazrat Inayat Khan and Suleyman Dede is certainly a good one for me. I have a fear of fundamentalism because I don't find the qualities of mercy and compassion within fundamentalism, nor the living way of the master, saints and prophets. When our world is so complex, it is very easy to embrace answers that are black and white, yet fundamentalism does not embrace the entire human family.

Sufism is a mystical path, not a fundamentalist path. Rumi was not a fundamentalist. Because of the way our mind tricks us, in this culture the one who becomes educated is thought to have the knowledge, and the one who doesn't have the knowledge is the one who should collect our garbage. But that doesn't resonate with me, with the reality and experience of a loving God. It does not resonate with the reality and experience of a heart that is larger than the universe.

Suleyman Dede, who was a strong Muslim, a lover of Muhammad, and completely immersed in the way of Islam, was a mystic; his reality is one of equality. That the old, the young, black, white, male, female, all can be lovers of God, is the mystical way. This is a radical way, a way beyond control, a way that is frightening to political structures. The lover cannot be controlled. Love is a magic, which if it is truly ignited, melts slowly or quickly, our projected grids and boundaries of control upon one another.

Suleyman Dede was a radical lover—a lover of God, a lover of people. I know that is where his dream came from. I feel that Suleyman Dede was *tassawuri** of Mevlana who embraced all as lovers as God, without differentiation of age, gender or color. This was also the way of Muhammad, Peace be upon Him.

> . . . If you want peace and purity,
> tear away your coverings.
> This is the purpose of emotion, to let
> a steaming beauty flow through you.
>
> Call it spirit, elixir, or the original
> agreement between yourself and God.
>
> Opening into that gives peace,
> a song of being empty,
> pure silence.[3]
> —*Rumi* (trans. by J. Moyne and C. Barks)

Tassawuri is the practice of imitating one's teacher, through mannerisms, consciousness and/or through interactions in the world.

Hilal

In a moment of clarity while turning in a zikr *gathering, Hilal recognized the choice before her: to continue to seek a life of beauty and affluence or to follow the way of the heart. The choice she made has shaped her life, drawing her deeper and deeper to the well of love. Placing her body in the posture of total surrender, she discovers the way that is natural to her spirit and through the path of Islam discovers the joy of daily prayer.*

The *atesh bas* is an initiation for a couple to hold the concentration together. The significance of the *atesh bas* itself, which my husband Rashid and I laugh about, is that it means you get to do the dishes. We have often felt that when we worked in the kitchens at the Sufi camps, we were not just ordering, preparing and serving food. We took that position seriously, regarding the focus of the camp and the well-being of everybody through the heart-centered consciousness of what we were doing. From that experience I've learned that the kitchen is my place to teach from and also the place I could learn from.

At the beginning, I was reluctant to accept this responsibility of *atesh bas* because my sense of a shaikh is somebody who embodies the transmission of an entire lineage of the order; somebody who has been through all the stages, has experienced the full transformation to the degree that they are capable and can give it back. I haven't gotten to square one of that. Yet I wanted to get my feet walking to that level of experience, to be able to teach from there.

Murshid Samuel Lewis said, "You think you are the teacher, and find you are the taught. You think you are the seeker and you are the sought." Through the initiation of *atesh bas* I was put into that reality.

The Turn

Turning is making a choice; it is choosing nearness to God. It was a revelation for me when I found that kernel and realized what that is. Turning is a practice of choosing—with every breath, through total concentration, with the lifting of the foot and putting it back down, through

Hilal

"It says in the *Qur'an* that 124,000 prophets have been sent. Every people have been sent a prophet and a teaching. What is important is that we find the teaching that is there for us and follow it."

the turning around and around—the thought of *Allah, Allah, Allah.* It realigns all the parts of my being to this choice, to go for God, to choose Remembrance and to choose drawing nearer.

I love the whole impulse of the turn: turning our heads and listening to hear the call of God. This gesture in our turn contains the image of how Rumi turned, walking through the marketplace and hearing the beating of the goldsmiths, which perhaps sounded like Sham's voice calling him, and in a deeper sense the Beloved calling him. That impulse to turn to God is what keeps me in this practice.

Over twenty-five years ago, in the early 70s, we did little bits of turning in the dervish cycle of the Dances of Universal Peace, and that was

the first experience of turning for me. Then I met Jelaluddin in New Mexico at a Lama camp. That gathering was for the purpose of clearing the ground around the Maqbara, creating the beautiful gravesite that we have for Murshid Samuel Lewis there. At my second Lama camp I met Rashid, my then future husband. He sent me money to come to the Bay Area to see the *sema* in 1983. It was amazing. I felt like I was seeing the dance of the soul, seeing these beings in their light bodies, in their soul bodies, whirling. I always knew from that experience that someday I would study it, but it took a long time before I did.

Choosing the Path of the Dervish

When I came to that '83 *sema* I also had an experience, another point of choice, which changed the course of my life. I was visiting Rashid for the first time. I saw how he was living and it was such a shock to me: a man living with two other men, in this crummy bachelor pad. I was looking for a lifestyle of much more affluence and a particular standard of beauty, but I also realized that if I was uncomfortable in their environment, I had the choice that I could leave.

While I was reflecting on that question we went up to Sami Mahal in Marin to be part of the *zikr* there. In the course of that *zikr,* with turning, it was as if I got spun out of my mind into my heart. I realized that the choice was actually on a deeper level. I could be firm in "my standards" and therefore separate from this person, or I could go for the dervish—I could go for The Friend, choose the love that was in this being.

That is the choice I continue to make and it keeps renewing itself. This choice to go for love, to go for the dervish, for the being that is focused entirely on love and God is a big part of the turning for me. It is a choice to be the one who trusts and throws everything out because nothing else is as important. Ultimately, by making that choice, I found it truly manifested. I found that things would just happen, naturally, without my efforting. And other things would drop away effortlessly too, because they were unimportant. It is as if all kinds of adjustments got made on other

planes of mental and physical reality. My experience was that God was really taking care of everything. The choice of love is the one to focus on. When I am hit with difficulties in my life—in our relationship or in myself—the place I go now is into submission, to the deeper surrender to God. I just say, "Well, God, you have got to fix this one, I can't do it. So here I am, I fling myself into your arms." It takes whatever process it takes, to get to that point and I am thankful that eventually I remember.

The practice of turning helps me to keep remembering. In a certain way it is like throwing yourself off the edge of a cliff. You are grounded in your body, the left foot is always on the ground, while other parts of your being experience the otherworldliness, the other dimensions. It is such a submission. It says in the *Qur'an* that our religion is not to be difficult. It is about ease, and within every difficulty there is ease. So here is this practice that can appear really difficult and can have stress, but there is this incredible ease in it because it is giving yourself over, constantly with every step, with every breath. It is letting yourself be turned.

Hearing the Inner Calling

In mid-December 1993 a paper went around our group for anybody to sign who thought they would like to go to Konya in April. Both Rashid and I wrote our names with a huge *Inshallah*. At the time, he wasn't working and there didn't seem to be any conceivable way that we could go. Between Christmas and New Year I was so ill with flu that all I could do was lay in bed. I could hardly even keep my breath focused, so I wouldn't go into a panic. I had never been that ill. But, as I began to come back into my strength and into some ability to hold a thought, a *wazifa,* or the name of God on my breath, I got this sense that we *were* going to Turkey. The "how" was of much less importance than the fact that we were to go.

We pulled it together through small miracles all along the way—borrowing some money here, a tax return there. I truly don't think that I would have received that clarity if I hadn't been

stopped so utterly by my illness. It was an indication to me that this was a gift. A strong message that this trip was for us to do together.

There came a point when there was enough money for only one of us to go. It was "my" money, because it was my tax return, from the income I had earned. It was frustrating to me because the trip was to be an incentive for Rashid to get his money together too, yet that didn't happen. In my frustration, and with a few of my dear friends looking at the issue with me, I came to the logical decision that I could go alone. But very quickly I came to the realization from my heart that I couldn't. I really didn't want to go alone, and it wasn't necessary. Consequently, we just found other sources and worked it out. Such a blessing! An incredible gift to us to manifest the original intention! I think that is where every pilgrimage starts, with the intention, with the sense that it is not something you make lightly. What draws you to take a journey such as that, and the levels that it manifests on, is so deep.

Visiting Feriste

This trip in 1994 was the second time I had been with Feriste, because she had previously visited Jelaluddin in the Bay Area. I really felt like she was our spiritual mother, she held us all so much in her heart. Our presence in Turkey was the gift that we had for her. We brought material gifts, but the real gift was our attunement to her and Mevlana. We all came to Konya to be in that sacred space and we brought to her a fulfillment of Dede's and her son Jelaluddin's work at that time.

Feriste embodied the ideal that we have of ceaseless prayer. We couldn't say much to her as we didn't have her language, but just sitting in her presence, listening to her breathe *Allah Allah, Allah Hayy,* sometimes it was audible and sometimes silent. When she came in for the *zikr* I felt like she brought Dede with her. I had never thought about whether she would be there again or not, but as I see it now, it was a blessing that we could be with her. I keep remembering that the wives of the prophet Muhammad, Peace be upon Him, were called "The Mothers of the Faithful." That phrase comes back in thinking about Feriste. For us she was the Mother of the Beloveds, of those who love Mevlana. She was a mother to us all and carried that. She carried having lived and breathed in a *tekke.* Jelaluddin, her son, was born there. Her life was in the heartbeat of Mevlana's resting place and her home was such a permeated space. She carried the seven hundred years of the lineage in her being. Some of the women were going through a lot of emotional pain and crying all the time. She didn't move physically toward them, but she took them into her space. She held them, without having to do anything physical, without language or knowing the details of what was going on.

The Sema at the Tomb of Rumi

The *sema* in Konya wasn't an announced event. Not until the last moment, when we were changing our clothes, did we know that we had permission to do it. It was completely by the Grace of God that it happened at all. If I tried to think about what we were going to be doing, my mind would not encompass it. You could only be in your heart in that space, because it was so overwhelming.

I felt completely shattered by that *sema,* and like Mevlana was holding us all and we were doing *sema* in the palm of his hand. In the third *selam,* when the *muezzin* called the *adhan,** it brought all my worlds together and to the deepest place. When we got back to the States I was shocked when we looked at the videos of that event. There was traffic noise and honking, but I had no memory of any of it.

After *sema* we were told to change clothes quickly, not talk to anybody, and get right on the bus (as if I could have talked to anybody!). I sat down next to Rashid and allowed everything to break. Rashid and I wept together. We went to our hotel room and again dissolved into tears.

**Adhan* is the Islamic "call to prayer," which is traditionally chanted five times a day.

This shattering was a sense of being broken open and dissolved. This spiritual state is only painful if I try to resist, it doesn't have a quality of good or bad, as it is not a common state. The experience of being broken open puts you into that state of intense longing where everything else is dropped away. I think that is why I feel it as a shattering.

There is nothing more important than yearning to be in the Presence of God. This state is different from the calm kind of place you can get in meditation, where you are expanded and you encompass a place of light. You don't arrive at "shattering" gently; the veils are *ripped* away. It is a *hal,* a state, not a station. It is an exquisite shaking and trembling, and there is a sense that one doesn't stay there. There is also the sense of the mystery, "What will emerge from here?" None of this is conscious. Afterward you can try to wrap some statements around it, but at that time it is too huge.

We yearn for the ecstatic experience, we do *zikr* in search of it. But just somewhere beyond that is this understanding that only what one can absolutely embody and carry with them is the reality. I believe that the soul knows that it is not going to be able to embody all that is present and be able to carry all that back into life with it. Yet there is the yearning to do so.

Adab

Adab is consciousness. It is being awake and conscious of my actions and intentions, not doing things unconsciously, or without awareness. *Adab* is translated as "proper manners," yet it's really the level of respect that we have for each other, the level of awareness of serving another before you serve yourself, the practice of honoring another being, honoring a space, honoring our *sema* clothes by kissing them before we put them on. *Adab* is honoring and respecting, being mindful of what our intentions are within our actions.

If we are conscious of *adab,* then we are conscious of the places where we need to improve, to work on ourselves and our actions. Doing *zikr* can open the door to show us a better way of

being, a bigger picture. It can clear out our being. But if we keep falling back, and don't apply it, then it is an empty practice.

Adab is about serving. We serve our shaikh and then back away from him because that is the way. We don't turn our backs on him, just like we don't turn our back on the *post* when we are in *sema.* It is not because that human being thinks they are better than anybody else, it is because we are saying by our action that this being, at this point in time, is embodying the full transmission of our lineage and we want to respect that.

Becoming a Muslim

I knew that there was only one place for me to go, because the only way I prayed was to Allah. *La ilaha illa 'llah Hu* means to me that the only reality is God, and nothing else has any reality except God. The way that I kept coming back to was to put my head to the floor to pray.

Since God is the only Reality, I can stop everything and be in that reality. Afterwards, I have to go back to the world of daily activities— the phone, the driving, the business—and *Inshallah,* in the background of all that is "*Allah, Allah*"; in the background of all that is Remembering. Of course there are periods of forgetfulness. But I set my intention to remember God while I am doing these things.

Everything comes from God, the signs of that are all around, even in the breath. I'm aware that much of the time I am walking down the street and doing things and Allah is there. And there are times when that awareness is not there consciously, yet it comes back.

Then there is the prayer, five times a day; those times when the world goes to the background and God comes to the foreground. I'm beginning to feel like I really stop and turn off the world by putting my head on the floor and praying, giving that time to God. I get to say, "*La ilaha illa 'llah Hu*" or "*Bismillah ir Rahman ir Rahim*"; "In the name of God who is Mercy and Compassion." Whatever the prayer, putting God first I kneel down, surrendering to God. Ideally, on the prayer mat there is only room for one. I don't experience that very often, but that

is a goal. I just feel so grateful every time I do stop and make that prayer. I thank God for bringing me to prayer since I don't feel like it is something I can do on my own. I also pray to know how to pray.

When you stand up and go back to answer the phone or deal with whatever, the experience of the prayer is with you, and it stays with you. What I'm really trying to hold onto is this perspective of a reality that is more real than what we normally call reality. Certainly, filling out of reports or talking on the phone or working at the computer is activity, but what is the real transaction going on? Can I maintain that vision of this in my life? The image that comes to me is that it is learning to walk or talk, like a child, or a baby.

I feel blessed to be involved with both the Muslim and Sufi community. A tradition that has been taught is that Sufism is the secret of Islam. From my years in being involved in Sufism in America, I'm beginning to find Islam as a secret within Sufism.

Path of Love

In my heart I am finding that this whole path is about love, that it's love for God that draws us on. It is the love of choosing God that turns us. It is the love that brings our heads to the floor in prayer. Love weaves together all that is important to me.

There is no compulsion in our religion. The *Qur'an* says, "Let there be no compulsion in religion." For me, it's because of this path of love that I want to do more, to pray more, to surrender more, to serve more, to understand more, and to have God woven throughout my daily life. To keep the Presence alive you have to choose to love.

I look forward to the month of Ramadan; I look forward to doing this practice of prayer and fastings, for God. It is just great love! There is no other reason to do it. It is to remember God. In this way, and *Inshallah* in every way, what is coming up out of digging the well deep, is love.

> The way of love is not
> a subtle argument.
>
> The door there
> is devastation.
> Birds make great sky-circles
> of their freedom.
> How do they learn it?
>
> They fall, and falling,
> they're given wings.[4]
> —*Rumi* (trans. by C. Barks)

Persian Carved Stone Pattern,
14th Century

Susan S.

Susan's journey to Mevlana embraces dreams, art, and prayer circles as a form of soul expression. In the tradition of the dervish she opened her door and home to a "friend of a friend" and was led to the ritual of sema. *From this place of the sacred, she met her life partner and dream images began to blossom for her. As an* atesh bas, *Susan speaks of the powerful bond of marriage within the context of a shared spiritual practice.*

My dream life is a parallel universe to my waking life, not separate. I think of dreaming as a movement in spirit. These are messages from me to me, from forces beyond my conscious understanding. My dream journal and my artwork are essential to recording those contacts, those experiences, those inner journeys that are so important to me. "I am sifting through sand at an archeological site, finding little fragments of amethysts." That is the way I feel in my inner work, I'm sifting through all this sand to find the precious stones, the jewels.

I paint from my own personal experience of my spiritual life. What I have learned through Jelaluddin's practices and the poetry of Rumi has definitely infiltrated my artwork. A painting may start with an image from a dream and then I build on that image with symbols from life. They all are interconnected so I pull from both worlds, dreaming and waking.

I painted "Magic Carpet" during the time I was sewing my *tennure* and training for my first *sema*. It is a personal prayer that includes the symbolism of Mevlana. The white tigers represent the magic and majesty of ancient Persia. The yellow rose is fully open because that is our state in turning. The hawk represents freedom and grace. As the dervish turns she becomes the starry night, her hair is like the spiraling galaxies in the sky.

Who Are Mevlevi?

Mevlevis are lovers of God and students of Mevlana. We study the *Mathnawi*, which is essentially Rumi's poetry and teaching stories. Yet, for me, there is no distinction between people who call themselves Sufis or Mevlevis and people who don't because we are all of the same

Susan St. Thomas

"I see life as a spiritual path, so I don't separate my spiritual practices from my life, I incorporate my prayers along with everything that I am doing."

family. To call oneself a Mevlevi means an acceptance of all beings and a unity of the heart that encompasses all practices, all ways of life. We are all from the same Creator, but most people are asleep. To be on a spiritual path is to be on a path toward awakening.

Atesh Bas

To be an *atesh bas* feels to me like being the keeper of the tradition and keeper of the light. I take it seriously. Jamaluddin, my husband,

teaches the turn, and I assist him in keeping the tradition alive and in continuing the teachings. I am looking for what I can bring to those teachings that enhance them and make them dynamic for this century.

I first met Jamaluddin at a *zikr.* He had been a *semazen* for many years and was very supportive of my training. He went with me to practice every Monday night for a year, even though he had done that years ago in his own training. He accompanied me to every single class as well as to several weekend *zikrs* and special practices before *sema.* That is part of what keeps us together. It is said that people who pray together stay together, and it is very true. That bond seems to pull us through any difficulties we may have.

I view our first marriage as the *sema* on December 17, 1992, and every *sema* we are in together feels to me a marriage, both personal and mystical. Truthfully, *sema* is a wonderful way to connect to the tradition of marriage. You can't go through this practice, this ceremony, without being changed. When we go back into our lives, we are back chopping wood and carrying water, but it is with new eyes. It is with a new body.

I feel that I marry all the people in the *sema* every time we do Shebi Arus. We have all been joined forever, again and again. Exploring the dimensions of our personal relationship is a part of Mevlevi practice too. My husband and I share these lines because they were part of our wedding ceremony:

> We came whirling
> out of nothingness
> scattering stars
> like dust . . .[5]
> —*Rumi* (trans. by D. Liebert)

That is the imagery I painted in "Magic Carpet." The woman dervish is scattering stars like dust even though I didn't put a trail of stars by her hand. For me, when we have our hands open and receiving and sending, we are scattering stars. Light is coming through in the dust that moves us.

> . . . let the water settle;
> you will see moon and stars
> mirrored in your being . . .[6]
> —*Rumi* (trans. by D. Liebert)

Magic Carpet
by Susan St. Thomas

"'Magic Carpet' is a personal prayer. The dervish in the center of the painting
is female to represent all women. Her uncovered hair is golden light, becoming
like the nebula. The white tigers represent the magic and majesty from ancient
Persia. The yellow rose is fully open because that is our state in turning, fully
open, wide open."

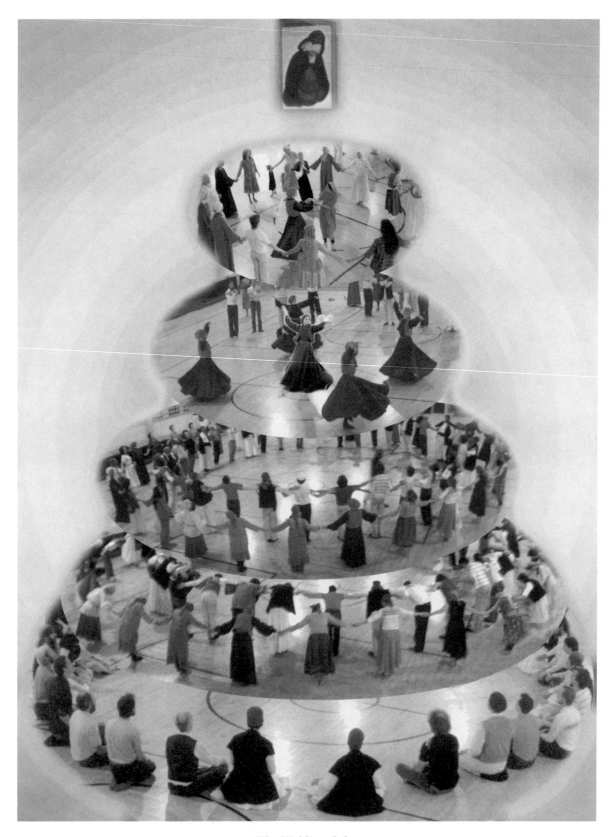

The Wedding Cake
Collage of Mevlevi *zikr* created by Susan Bein and Shakina Reinhertz

ZIKR

The Practice of Rememberance

I drank that wine of which the soul is its vessel.
Its ecstasy has stolen my intellect away.
A light came and kindled a flame in the depth of my soul.
A light so radiant that the sun orbits around it like a butterfly.[1]
—*Rumi* (trans. by S. Shiva)

From the beginning of time, human beings have held an inner knowledge, an inner certainty of the existence of something within and beyond the self, a connection to that which is both immediate and tangible and at the same time limitless, mysterious and unfathomable. From the earliest days, this knowledge has been affirmed through signs within nature: the circling of the seasons, the waxing and waning of the moon, and the ebb and flow of oceans—all of which speak of a power and force beyond time. When tribes formed community life, this recognition of a Supreme Being was acknowledged collectively through prayers, rituals and celebrations. As the many prophets and saints appeared on the earth, the form of these prayers and conversations with God became formalized and set within specific frameworks. By the time of the birth of Muhammad, great religions had arisen with their own methodology of reaching out to the Divine.

Within the tradition of the Prophet's time, the practice of *khilvat* or retreat was a known but rarely practiced part of spiritual life. Every year a few sincere seekers would arrange their affairs to leave behind their daily activities in order to direct their entire being toward the inner journey. Other intimates of God who were catalysts for the development of religious tradition followed a similar path. Jesus spent forty days alone in the wilderness and Buddha sat for many days without moving under the *bodhi* tree to remove all obstacles to enlightenment. So it was during what has become Ramadan, the month of

*Muhammad Star
Kufic Style*

sizzling heat, Muhammad withdrew to a cave for fasting and prayer. It appears that he had no idea what would come. Indeed, when the angel Gabriel manifested on that fateful night and commanded him to "recite," bringing forth the revelation of the first verse, the *Sura Iqra,* Muhammad left abruptly for home and sought out his wife Khadija's advice, fearing he had lost his senses. How could this visit by a mysterious being be a true reality? Khadija's heart-certainty was immediate. She knew without question that what was happening to Muhammad was a great blessing and a Divine transmission. He was being chosen as a messenger for his people, the bearer of God's word.

In the subsequent years, with the outpouring of the *Qur'an* through Muhammad, came the practice of Remembrance. Muhammad affirmed what other prophets had revealed. This revelation is the heart of the practice of *zikr:* namely, the words *"La ilaha illa 'llah!"* "There is no Reality except the Reality of God." This sacred phrase is a portal into the eternal state of oneness. To the Sufi, it is this realization that forms the essence of Remembering.

> . . .
> Through your grace I have found
> a treasure within myself.
> I have found the truth of the Unseen world
> I have come upon the eternal ecstasy.
> I have gone beyond the ravages of time.
> I have become one with you!
> Now my heart sings,
> "I am the soul of the world.". . .[2]
> —*Rumi* (trans. by J. Star)

Ibn Arabi, a great Sufi mystic who died when Rumi was in his early thirties, experienced the Divine Essence through the shape of the word *"Hu."*[3] Some Sufi orders intone this syllable along with the sacred phrase of Muhammad. Within the Muslim religion, formalized prayers that are centered on surrendering to and honoring the Presence of God are repeated five times a day. These prayers invite a direct conversation with God. The followers of Sufism go beyond this; they have created ways to remember God constantly, whether awake or asleep, seeking always to be in a state of Remembrance.

There are two distinct paths to the practice of *zikr.* One is a solitary journey inward, through the doorway of the heart. Under the guidance of a teacher, the *zikr* may be part of one's daily practice, and thus every individual has the possibility of discovering his or her unique connection with the Beloved. For those who seek to immerse themselves completely in the Living Presence, the vehicle of retreat offers the most potential. The other path is by uniting one's heart-longing with a group of fellow seekers, reaching collectively to experience the one True Being. Both ways—the solitary journey and the group practice of *zikr*—are essential to the path of the Sufi.

Hu

The Retreat of Remembrance

The moment when a soul takes fire or begins to burn with Divine inspiration is often catalyzed by this process of turning inward as exemplified by Muhammad, Jesus and Buddha. Moses alone on the mountain heard the voice of the Divine from the burning bush. Mother Teresa received her true purpose while riding in a train on the way to a retreat. Joan of Arc heard the voice of her destiny while in the middle of a field. Rumi and Shams withdrew to a private room for a retreat of forty days after their fateful meeting in the marketplace.

Prayer
by Deborah Koff-Chapin

∽

This piece was created while watching turners during Ayn-i Cem ritual in Seattle.

The tradition of *khilvat* or retreat, the drawing away from daily life in order to immerse oneself without distraction, exists in many traditions. In the early days of the Mevlevi Order, a seeker to the path of the dervish would withdraw from daily life and enter a *tekke* for 1001 days. Here, within the setting of an active life of service, there would be periods of absolute aloneness and silence in a small cell, not unlike that of a contemplative Christian monk or nun in a monastery.

In the twenty-first century, the practice of *khilvat* continues. In 1991, Michaela Özelsel fulfilled the requirements of a traditional forty day retreat in a small room in Istanbul. She spent her waking hours reflecting upon her dreams, studying the *Qur'an,* immersing herself in *zikr* and the 99 Names of God. Despite the distraction of the sounds of the city and the voices of the family on the other side of the wall of her room, as well as her own feelings and thoughts, Michaela entered deep spiritual states, sharing her experience in her book, *Forty Days.* Tenzin Palmo, a Buddhist nun, whose story is recorded in the book *Cave in the Snow,* completed a twelve-year retreat in 1988. She lived in the Himalayas in a tiny cave, 13,000 feet above sea level. Most of her inward journey took place in a traditional meditation box without a bed to sleep on.

Many Sufi orders have also continued this tradition of *khilvat* into the new millennium. Whether the individual goes on retreat for three days, forty days, or one thousand and one days, the retreat process provides a structure for leaving behind the pull of daily life and merging into a state of contemplation and reflection, emptying the mind and entering the doorway of the heart through the practice of *zikr.* One seeks to dissolve into the living Presence of God. Although it is possible to take a retreat anywhere anytime, the process is heightened by the support of silence and a natural setting. In modern times, a tent, a sleeping bag, and perhaps a *tasbih,** a shawl and a meditation cushion

**Tasbih* is a set of prayer beads usually a total of ninety-nine, divided in sections of thirty-three.

are possible tools of the journey. In the Mevlevi tradition the seeker slept on the floor in a tiny room wrapped only in a *hurka*.

The Alchemical Retreat

In the twentieth century Pir Vilayat of the Sufi Order International created the alchemical retreat, which has been refined over the years under his guidance by Puran Bair and Aziza Scott, successive leaders in Pir's esoteric school. This process provides a roadmap for the inward journey for those who seek passage into the realms of light and holds the possibility of self-transformation. Each stage of the retreat corresponds to alchemical stages of dissolving and recreating the personality.[4]

To prepare for the alchemical transformational process one turns away from daily life by completing what needs to be completed, setting aside daily cares, worries, and responsibilities. One begins the inward journey by making a vow of silence and setting one's intention. As one enters potentially transforming states of inner prayer and reflection, support is offered through the natural environment. The sound of a creek flowing, the call of a bird, the flapping of wings, the kiss of the breeze may transport the listener into more refined states of attunement. One cleanses and purifies the physical body and mind, turning one's attention to the subtle bodies, the *latifas* or *chakras,* and the simple act of breathing. The senses become heightened and the possibility opens for addressing and honoring the unseen world through the elements, and through the angelic beings who are the essence of each element. Various breathing practices—such as alternate nostril breath, *shagal* or the purification breaths of earth, water, fire, air and ether—are given. There is the divine heritage of the Sufi path in the form of *wazaif:* each quality an aspect of God that can be called forth as a living presence, a guide, a friend, a medicine for the soul and an aspect of the self. During retreat, if one is awakened at around 3 A.M., there is the possibility that an angel has knocked on the door of the consciousness. One can choose to rise up and open to the blessing of that quiet hour.[5]

Prayer Rug

Muhammad, when written in Arabic, can be seen as a visual symbol of a figure prostrating before God. When we kneel in *sajada,* with forehead upon the floor, there can be a feeling of returning to the Divine womb; the possibility of dissolving into the infinite ocean of *ir Rahman ir Rahim*, Ever-flowing Mercy, All-embracing Compassion.

Stars burn clear
all night till dawn.
Do that yourself, and a spring
will rise in the dark with water
your deepest thirst is for.[6]
—*Rumi* (trans. by C. Barks)

La Ilaha Illa 'llah

Throughout the inner journey the sacred phrase of *zikr,* in all its forms
and ways, is repeated over and over: bowing, standing, sitting still,
singing, whispering, placed on the heart with the breath and listening
in silence. It is a bit like smelling a rose deeply for a long time and then
being aware of the fragrance even though the physical rose itself is no
longer there.

> . . . God . . . caused spiritual gardens
> and plots of sweet flowers to grow
> in the hearts of His friends.
> Every rose that is sweet-scented within,
> that rose is telling of the secrets of the Universal . . .[7]
> —*Rumi* (trans. by R. A. Nicholson)

Within the retreat setting, the sacred phrase of *zikr, La ilaha illa 'llah
Hu,* becomes a vessel for re-forming the personality. Parts of the
phrase may be used alone such as *illa 'llah Hu,* "only God exists, only
God." Each phrase opens the door to a level of consciousness so that,
God willing, the devotee becomes more and more immersed in the
Presence of the Divine. The practice of *zikr* is often accompanied by
simple movements such as a circling of the head and then a drop-
ping down into the heart and lifting up. The 99 Names of God con-
tained within the *Qur'an* are often evoked as part of the inner
journey; qualities such as *Ya Haqq,* The Truth; or *Al Fattah,* The
Opener; or *As Sabur,* The Patient are beautiful facets which reflect
the One Shining Reality. They too can be recited aloud, placed in si-
lence on the heart, or refined to an impression mingled with the
breath. The Prophet gave Fatima on her wedding day the prayer:
"*Subhan Allah! Alhamdulillah! Allahu Akbar!*" "Make me Pure Oh
God, All Thanks be to Thee! God alone is the Great One!" These
glorifications have continued to be used on retreat and in group *zikrs*
to the present day.

A guide usually structures the retreat to meet the individual needs
of the retreatant with a balance of practices. For some practitioners
each step becomes an opportunity to pray. All daily conversation is set
aside. One in enfolded in a cloak of silence. Most of the waking hours
are spent in conscious continuous prayer on the breath. Moments of
silence and stillness are balanced with active prayer so that one returns
to a natural state of being without the cumbersome activity of the mind
drawing the attention away from the present. If directed by the spiri-
tual guide, *zikr* can be done at any time within any moment. Some

advanced practitioners keep the *zikr* in their minds and hearts at all times whether awake or asleep.

Once the path of retreat is entered, where each moment one can enter the here and now without agenda or direction, there is a tradition of returning to this place of solitude and silence annually. Such a yearly commitment allows for the real possibility of transformation, of renewal, of strengthening one's sense of purpose and restoring one's magnetism.

Integration: Body, Mind, Emotions and Spirit

Sometimes the retreat process may not have immediate discernible results. A person seeking to know God in an intimate and personal way may become discouraged. Along the Sufi path one may go through a "dark night of the soul," a period in which one's faith is tested. The Divine Presence seems remote, inaccessible.

Murshid Sam addressed this issue:

> I feel like a gardener who planted a bunch of seeds and nothing came up; and again the next year, I planted more seeds and nothing came up: and again the next year more seeds and the same result; and so on and on and on. And then one year, I planted a bunch of seeds and not only did they all come up but all the seeds from the previous year came up and all the seeds from the year before and so on. So I've just been frantically running around trying to harvest all these plants until Allah came to me and said, Don't worry. Harvest what you can and leave the rest to Me.[8]

Turkish Female Musicians,
17th Century
Bibliotheque Nationale
de France

By the end of the twentieth century the need for addressing belief systems as well as emotional issues that surface during the retreat process sparked the creation of a new orientation within the framework of Sufism. It involved a group-process focusing on the practice of inquiry,* a foundational element in Diamond Heart Work.‡ Inquiry allows each person to follow the thread that appears moment by moment, ultimately leading to the unveiling of the authentic self. Each layer of the personality is carefully sifted through with openness and curiosity within the support of a group structure. All that separates us is dissolved by that which we share, Living Presence. Within the framework of their thirty-year practice of Sufism, three Sufi representatives—Taj Glanz, Blanchefleur and Gayan Macher—early students of Pir Vilayat, are the pioneers of this work called "Sufi Retreats" and they have formed groups on the east and west coasts of the U.S.

*Inquiry literally means to seek truth, to search for information through questioning; to study; to explore.

‡Diamond Heart Work, which was developed by Hameed Ali, is an eclectic spiritual path integrating modern psychological methods.

Most mystical traditions seek intimacy with God through austerity, severe discipline, strictness, self-deprivation and a turning away from the confines of daily life. "Sufi Retreats" offer a different approach: that it is possible to be awake in life to the Living Presence of God through a process that is nurturing and gentle; to both accept and to "be with" who and what we are, moment by moment. As this work is in the beginning stages of development, it will be interesting to see how it unfolds in this new millennium.

Zikr as a Group Practice

The transition from the retreat space into daily life can be a difficult experience. A source of comfort and connection is offered within the community or *sangha* in the form of group *zikr.* There is a legend that, in the days of Muhammad, a group of forty composed of both men and wo-

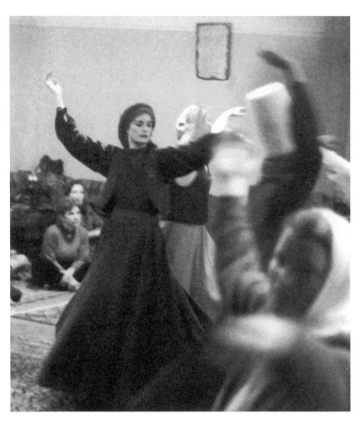

Zikr at Semahanue

men began to do *zikr* continuously without ceasing throughout Muhammad's life. He would on occasion come in their midst and join them in this practice. The group continued after his death, keeping this number of forty until about the year 1000 C.E., when they were persecuted. It is said that this same group continues on the angelic planes.[9]

When two or more are gathered in God's Name a group is formed. Here the focus is two-fold. Every person sets their intention to turn to God. At the same time, there is an attuning to the other members of the group. Ideally, one hears each individual voice in the circle. The movement of the body, the pitch and volume of the voice, even the breath can be in harmony with all. In the Mevlevi tradition, a group *zikr* can be a simple sitting together gently calling out *"Allah, Allah."*

Within the context of daily life, *zikr* as a group practice can manifest in myriad forms. Usually there is a weekly meeting with *zikr* and *sohbet* on a designated evening. For many Sufis it is Thursday night. The group may sit in a circle intoning *La ilaha illa 'llah,* simply moving the head from side to side or rotating it in a circular movement. As the group *zikr* progresses, the movements and repetitions can become more complex and the *zikr* may go from sitting to standing, with inner and outer circles. In the Turkish tradition, *zikr* is usually accompanied by a drum (*bendir* or *kadum*), and often a *ney* or other musical instruments. Within the Mevlevi tradition, the *semazens* under the direction of the shaikh enter the center of the circle to turn as the chanting goes on. By the end of the *zikr* the shaikh may have led everyone to turn together.

Sometimes the group *zikr* is a known and familiar pattern, repeated at each gathering. At other times the *zikr* is created in the moment under the direction of the shaikh, lasting only ten minutes or as long as all night. The shape of the group may change from a circle to a rectangle or simply two lines moving back and forth. The group *zikr* can be spoken, chanted or sung with simple phrasing or complex harmonies and with shifts in tempo, volume and changes in movement and breath. Sometimes poetry of famous mystics is interspersed in the chanting. Yet always, the participants have a focus on attuning to the shaikh and to each other, and above all else to an intense calling out with the heart, mind, body and breath to awaken fully into the Presence of God.

> This moment this love comes to rest in me,
> many beings in one being.
> In one wheat grain a thousand sheaf stacks.
> Inside the needle's eye a turning night of stars.[10]
> —*Rumi* (trans. by J. Moyne and C. Barks)

For beginners, much of the *zikr* can be spent in learning to tune to what is happening; a struggle with mind and body interwoven with possible moments of clarity and harmony. For advanced practitioners one can enter states of wakefulness, of joyfulness and gratitude, of aliveness and surrender sometimes interspersed with sudden insight or inspiration. The limited self can dissolve into the living Presence. At any moment one can experience a shift in consciousness, and there is an opportunity for awakening and for *muhasibi,* coming face to face with one's shortcomings as well as one's Divinity.

Zikr contains the possibility of intoxication from engaging one's being on so many levels simultaneously. It is in that moment of ecstasy that the mystic can open to the quality of *Ya Shahid,* one of the Divine Attributes, which can be cultivated through the Retreat process. One can call upon the ability to witness the self without judgment, but with true seeing at every moment, whether one awakens to the depths of their personal limitation or the height of ecstatic union. This clarity of seeing allows us to know where we are in that moment without judgement or attachment. This seeing can open the door of perception for reflection and contemplation during periods of sitting meditation.

Over the years Jelaluddin Loras of the Mevlevi Order of America has developed a series of *zikrs* based on a sacred phrase of the

Jelaluddin Turning in Zikr
Ballard Oddfellows Hall, Seattle

"In the Mevlevi *zikr*, we start with forgiving and forgiveness, wiping the rust from our hearts, letting go. We set out intention, *niyat*. We wipe the dust from our hearts and offer ourselves to the only being." —*Jelaluddin Loras*

Mevlevis, *Estaghfur ul'llah,* meaning to seek passion-ately for the forgiveness of God. There is a stream of forgiveness that is ever present, and to immerse our-selves in this stream of forgiveness is to recognize our humanness. This *zikr* allows us to long for God's Mercy to cover our shortcomings, offering our sincere intention to make amends and to learn from our mistakes as we consciously forgive ourselves and release resentments toward others. As the heart be-comes free of old impressions, its true nature can be more fully revealed.

In the Mevlevi tradition we begin and end the *zikr* with *Fatiha,* the first *sura* of the *Qur'an.* At the end of the *zikr* we kneel and kiss the ground ex-pressing our surrender and gratitude.

Seclusion, Covering and Cleansing

In Turkey and other Islamic countries the men and women are usually separated during prayer. Women are placed behind the men or in a differ-ent room. In some countries, women are kept in seclusion, a practice that comes from the time of the Prophet. Some say it was for the safety and pri-vacy of his wives that the "Verse of the Curtain" came through, which addresses proper behavior in the home of the Prophet. Yet it is known that both

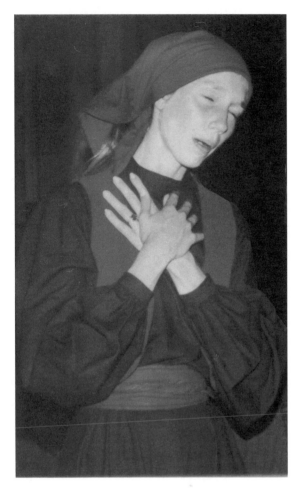

Singing in Zikr

"You are the precious one. Every treasure is right there in your own heart. You are each a rose, with a different fragrance, a different sweet smell. When we chant the name of God, we pull water from the well. Pull this water from the well in your heart." —*Jelaluddin Loras*

male and female followers of Muhammad attended the mosque for prayers. Even twelve years after the death of the Prophet, one of the conditions of Atikah bint Zaid, a widow of Umar, the second caliph, was that her new husband would permit her to continue to attend the mosque.[11]

Rumi addresses the issue of seclusion in *Fihi ma Fihi.* "There is no need to keep good women secluded, because they know what to do and how to behave, while a bad woman will always find a ruse to escape and misbehave in proportion to the attempt to keep her secluded."[12]

In the West, seclusion is not part of our culture. Most of us have been raised with total integration of men and women at home, in the workplace, and in the church as well. In the Mevlevi Order of Amer-ica, men and women participate in *zikr* together.

When doing *zikr,* women cover their heads honoring the tradition from which this practice has evolved. Men, too, often wear some head covering as the *Qur'an* addresses appearance and decorum for both men and women. This custom reflects the example of the Prophet who was said to have covered his head with a mantle whenever he prayed. There is a sense of dressing modestly to come before God in a respect-ful manner.[13]

Know that my beloved is hidden from everyone
Know that she is beyond the belief of all beliefs
Know that in my heart she is as clear as the moon
Know that she is the life in my body and in my soul[14]
—*Rumi* (trans. by D. Chopra)

Prior to participating in *zikr* there is a physical preparation of purification. One washes oneself consciously or performs ritual washing with prayers. This preparation is an outward manifestation of attuning oneself to enter fully into union with God.

At the end of the gathering, traditionally tea and sweets are served and there is *sohbet,* or spiritual discussion, in which the shaikh shares teachings and students have the opportunity to ask questions. At times, the closure is simply giving a gentle hug or a kissing of the hand in the Mevlevi way, acknowledging with respect and tenderness our connection with each other through our shared love for God.

* * *

A phrase found frequently in the *Qur'an* is *Bismillah ir Rahman ir Rahim,* "In the name of Mercy and Compassion." The Grace and Mercy of God are ever present, and we only have to attune ourselves to experience that. *Zikr* is a real and tangible doorway to the Divine, which offers the possibility of dissolving the self into the constant stream of unconditional love and to feel the true heart connection of all humankind.

. . .
I am not of wind nor fire
 nor of the stormy seas.
I am not formed out of painted clay.
I am not even Shams-e Tabriz—
 I am the essence of laughter,
 I am pure light . . .[15]
—*Rumi* (trans. by J. Star)

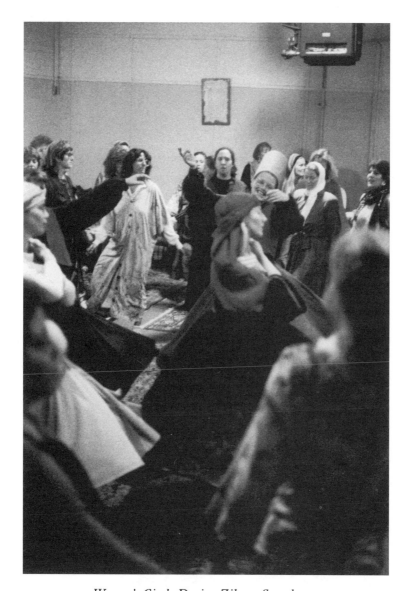

Women's Circle During Zikr at Semahanue

How could sorrow take root in us,
we who are filled with joy?
The earth bears the weight of misery,
Holding it in her bosom
like a planted seed.
But we have left this earth
and all its hardship—
All we see is the ceiling of paradise.
—*Rumi* (trans. by J. Star and S. Shiva)

Hilal Serving Tea in Her Home

"I am hungry, I am hungry, I am hungry;
Show mercy, O Lord, open a door for me.
I long for a bowl from the soup of paradise;
I long for two or three rolls from the dough of light."
—poem of Sultan Veled (in Lifchez)

Adab

The Tradition of the Honored Guest

For a dervish, there must be a purpose,
a cause for existence, and inside the cause,
a True Human being.

Learning communities are being built everywhere.
The whole world is a learning community!
Where is the True Human Being?[1]
—*Rumi* (trans. by C. Barks and J. Moyne)

The word *adab* is commonly understood as proper behavior or the way of refined manners. It is respect that comes through graciousness, consideration and love.[2] It is the ability to manifest right action in the right moment, reflecting the attunement to the Divine of a tranquil soul.[3]

Clearly the practice of *adab* is beyond behavior or manners. It begins with purification, a clearing of the rust off the heart. Held feelings such as resentment, bitterness, anger and jealousy form a coat of rust over our hearts as we grow into life. This coating blocks the flow of love through the heart, and prevents one from fully experiencing inner joy and happiness, which is the natural state of the soul. To cleanse the heart of this rust is the first step in creating a pure vessel for the influx of Divine guidance.

In the Mevlevi tradition we use the phrase *Estaghfur ul'-llah,* "to seek God's forgiveness." Through constant repetition, we use this *wazifa* to clear out old impressions of hurts or wounds held from the past, to forgive ourselves for any harm we have done knowingly and unknowingly, and if possible to make amends.

Use of prayer, *zikr* and *muhasibi** are tools for removing this rust. We can also examine the self through inquiry and reflection by being

Turkish Stone Architectural Design, 13th Century

**Muhasibi* is the practice of seeing oneself as in a mirror.

Shakina in Semahanue

In the tradtion of Mevlevi, we gather together
and honor each other by serving food that we have
prepared with prayer and love. In the moment of
receiving, there is the possibility of remembering.

> . . . we are the tasting, the taste,
> this minute of eternity . . .
> —*Rumi*

attentive to thoughts and feelings which arise in the mo-
ment. As we consciously and continually work with these
feelings, we can renew our state of purity. One can then
act from a place of tranquility, easily tuning to the con-
stant guidance that flows from within. When the mind,
body and emotions are at peace, then one's intuitive na-
ture can flow as an eternal spring from within.

. . .

> The Ocean of Purity said to me:
> *Nothing is attained without effort.*
> *To get the precious pearl*
> *you must first smash the shell.*

. . .

> Close the door of words
> that the window of your heart may open—
> The Moon's kiss
> only comes
> through an open window.[4]
> —*Rumi* (trans. by J. Star)

Once the heart is cleansed of rust, open and receptive, we
can become a vessel for the flow of inner guidance. In that
state the purpose of our life can be clearly revealed. We
can direct our attention to know God and to learn. When
the constant stream of unconditional love is awakened in
the heart, joy arises effortlessly, a sense of fullness emerges,
and an overwhelming gratitude is awakened. From this
state of thankfulness, a natural desire to serve others
arises. When one constantly opens to this state of peace
and joy, gratitude and generosity, then the tradition of
honoring all as most revered guests becomes a delight and
offers a fulfillment that tastes of the very nectar of life.

> When you do things from your soul,
> you feel a river moving inside you, a joy . . .[5]
> —*Rumi* (trans. by C. Barks)

The sweetness of a soul at this station becomes a palpa-
ble fragrance, drawing us to this source of nectar like bees
to honey. This combination of sweetness and purity is the
foundation for refined behavior. When the mind is filled
with Remembrance of God, we can open to the witness
of our nature, *Ya Shahid,* to observe with new clarity. The ways of *adab,*
which may have been hidden or unrecognized, become visible. For
now we have eyes to see the more subtle interactions around us.
Through a constant listening to the heart and cultivation of the wit-

ness within, we prepare ourselves to join the service of others. It is from this point of view that the rules of behavior have evolved.

The Rules Evolve

The Prophet Muhammad, who became a recognized spiritual leader in his time, at home would become the servant to his wives. He would cook for them and even mend their garments.[6]

Abu-Sa'id ibn Abi-l Khayr, who preceded Rumi by two hundred years, wrote down rules of conduct in his *tekke*. These thoughts lay the foundation for developing the attitude of a dervish.

> Keep our habits clean and ourselves always pure.
> Let us devote much time to nocturnal prayers.
> Let us welcome the poor and needy and bear with patience
> the task of serving them.
> Let us eat nothing unless we share it with another . . .[7]
> —(trans. by S. Fattal and E. de Vitray-Meyerovitch)

On each shoulder sits an angel recording our deeds: good and bad, Munkir and Nakir.

In our present age, Dr. Javad Nurbakhsh of the Nimatullahi Order addresses relationship in community. He reveals the ideal underlying interaction among dervishes:

> . . . Sufis should not speak angrily with each other . . .
> One holds the belief that one is below the other . . .
> . . . Dervishes should be sincere and withhold nothing from
> each other . . .
> . . . A Dervish should never be arrogant, conceited, or act
> superior to others . . .
> Dervishes should not give orders to fellow Dervishes . . .
> . . . A Dervish should never withhold help to a fellow Dervish,
> nor should one make the Dervish feel obliged to help in return . . .[8]

Shaikh Taner Ansari Tarsusi of the Rifa'i-Qadiri Order offers the following advice for cultivating the spirit of the dervish:

> Give thankfulness during good and bad times. Accept bad times
> with kindness and smiling.
> Do everything for God's sake only. Don't expect any thing
> in return for it.
> To receive love, we must be soft, unselfish, and think only of God
> at all times.
> Show tolerance to others even when they do wrong.
> God is love and truth. Find what is true and live by that.
> To teach another or to point out an error we must do it without
> breaking their heart.
> That is why Sufis love to teach through stories, so that we can
> offer guidance indirectly without giving offense.[9]

Persian Angels in Paradise,
12th Century

The Way of Mevlevi

In the Mevlevi tradition we kiss all that is given to us as an expression of humility and gratefulness. We kneel to kiss the floor upon which we pray, surrendering to the One who is most High. This simple gesture is an active symbol of remembering. The task of the dervish is to act from tranquility and love. To view life through the lens of our individual self as well as the point of view of the other.

The true *jihad** is our own eternal battle with the *nafs*‡: the struggle with our false self to unveil the Divine Nature within; to view each situation not only from our personal perspective but from a vaster point of view; to see the right in the wrong and the wrong in the right; to stay awake even though our ego is constantly inviting us to sleep.

During the 1001-day *chille,* a Mevlevi *tchella kash,* as the novice was called, was given tasks such as repairing shoes or cleaning the baths as part of the training. They were to accomplish these tasks faithfully, readily and obediently always saying, *Alhamdulillah!* "Thanks to God," showing great respect for those who preceded them in the Order.[10] When the realization that all of us are part of God becomes a

**Jihad* is commonly understood to mean "holy war." The deeper meaning implies a physical, moral, spiritual and intellectual effort to create a just and decent society.

‡*Nafs* are the false self, the limited aspect of our being.

Khadija (left) and Kera Help Each Other Prepare for Sema.

⁓

"In *sema,* we wear the *sikke* 'this hollow wholeness . . . a symbol of our origin and return.'" —*Hilal*

*Davi Jai (right), Maker of
Sema Garments, with Jabbara*

Daylight, full of small dancing
 particles
and the one great turning, our souls
are dancing with you, with out feet
 they dance.
Can you see them when I whisper
 in your ear?
—*Rumi* (Secret, trans. by C. Barks
 and J. Moyne)

reality, then serving another is serving the Beloved. It is a recognition
of the Divine spark that is our birthright. Though our paths may vary
as we advance through the terrain of life, this spark of Divinity in each
of us is from the same flame. For the Mevlevi, serving food is an active
expression of our love of God and the unity of all. The manner in
which we prepare the feast, the way in which we invite the guest, the
consciousness with which we serve the food, all reflect this love. In a
community where it is possible to grow one's food, attunement to the
Creator through prayer, *wazifa* and inner listening while actually
planting, growing and harvesting the food lays the foundation for spir-
itual as well as physical nourishment. Implicit in the offering of nour-
ishment is the aspect of generosity and abundance, which cultivates
the atmosphere of celebration.

The manifestation of *adab* can be a simple matter of greeting
a friend who comes to the door with a warm hug and offering a cup of
tea and some sweets; serving them graciously, spending the time to-
gether to attune to their state and their needs. It may be attentively

listening to their concerns of the moment without instantly offering advice or solutions, to tune with them through a tender touch, a smile of understanding. These are some of the ways of experiencing love: to be truly heard, to be really seen, not through the lens of old snapshots from yesterday, but in the eternal state of the present, meeting the soul as if for the first time. Thus we return to the innocence of childhood and the discovery of the wonder of the universe. Nothing is taken for granted, every moment is fresh and new.

> . . . Here is the new rule: Break the wineglass,
> and fall toward the glassblower's breath.[11]
> —*Rumi* (trans. by J. Moyne and C. Barks)

The essence of *adab* is learning how to instantly forgive ourselves when we act less than who we wish to be, and returning again to manifest our image of the ideal self. It is being present to our emotions and thoughts with a sense of openness and curiosity; clearing out those that don't serve us by weeding the garden of our soul. It may require sitting down and carefully digging out the roots of the weeds, getting all the strands separated from the soil of our mind with care, attention and love. Through this careful attentiveness to what arises at any given moment, we can unfold the beautiful flower of our authentic self, releasing the old patterns that no longer serve and actually prevent us from manifesting the Divine within. Over and over we clear and prune and feed our inner garden. This ability to distinguish between the weeds and the flowers: to recognize what holds the promise of nourishment and what crowds the soil and leaches energy and life from our soul—these are the gifts of the human spirit.

> . . . God is in the look of your eyes,
> in the thought of looking, nearer to you than yourself,
> or things that have happened to you
> there is no need to go outside
> Be melting snow
> Wash yourself of yourself.
>
> A white flower grows in the quietness.
> Let your tongue become that flower.[12]
> —*Rumi* (trans. by J. Moyne and C. Barks)

Suleyman Dede Cooking at Claymont

We are the Sufis on the Path
We are those who sit at the table of the King.
Make eternal, O Lord, this bowl and this spread.[13]

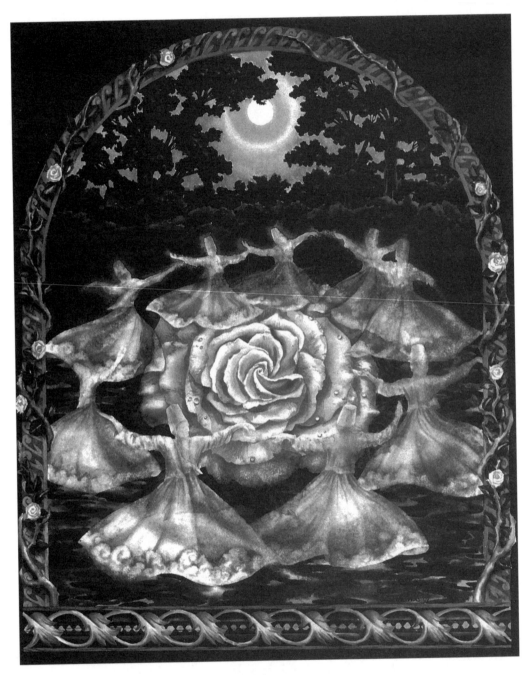

Sufi Dreams
by Susan St. Thomas

Nine dervishes of light turn around the yellow rose, symbol of Mevlana's presence.

Chapter Eleven

AYN-I CEM

A Ritual From Past To Present

Abdulbaki Golpinarli, a shaikh in the Mevlevi Order, was also known as a Mesnevi-Han, one who is recognized as the master of understanding of Rumi's *Mathnawi* in his time. He wrote in modern Turkish *Mevlana Dan Sonra Mevlevilik* or "The Mevlevi after Mevlana," which contains a chapter on the hidden meaning of the words *"Ayn-i Cem"* and a description of the ritual that bears this name. The following sections of this chapter—"Stages on the Path" and "The Ritual"—are a translation and interpretation of Golpinarli's chapter on *Ayn-i Cem*.[1]

> If you are in search of the place of the soul, you are the soul.
> If you are in search of a morsel of bread, you are the bread.
> If you know this secret, then you know
> that whatever you seek, you are that.[2]
> —*Rumi* (trans. by S. Shiva)

Stages on the Spiritual Path

To understand the depth of this ancient ceremony, one looks to the hidden meaning in the words, *Ayn-i Cem,* literally "gathering for prayer." Yet the word *cem,* commonly meaning "to gather" or to "bring together," also is translated from the Turkish as "distinction" or "difference." The ability to distinguish or discern is the first step of "knowing." In Sufism we are given the phrase *La ilaha illa 'llah,* "There is no reality except the Reality of God." This is the true knowing that we seek to fully comprehend as followers of the Sufi path. It is a belief that must

Entrance to Rumi's Tomb, Konya, Turkey

The life and poetry of Rumi opens the way to the first stage of realization, "knowing."

become unshakable and ever-present so that all of life, the whole of creation, is viewed from this fundamental truth. This is the first stage of realization. It is called, *Tawhid-i Ef'al,* which means "Unity of Action."

God is everything and everything comes from God. We as human beings have distinguished from the earliest of times that there is God, *Haqq* or Truth, and there is *Halk,* which is humankind. Seekers on the path of truth perceive that there is something beyond us that is greater, which creates all of life, eternal without end. We seek true knowledge—the ability to discern the difference between God and humankind and to know that everything, all activity in life, comes from God. For the *salik,* or pilgrim on the path, this is part of the first stage of realization, Knowing.

> . . . When you walk among the people,
> you walk on a secret path
> from garden to garden.
> You go to the Source
> Where all these forms and shapes appear . . .[3]
> —*Rumi* (trans. by N. Ergin)

The second stage is called *Tawhid-i Sifat,* "Unity of Attributes or Qualities." Here we experience God's Divine Nature. In Sufism we call these qualities *wazaif,* the beautiful Names of God given to us in the *Qur'an.*

> He is God, the Creator
> The Evolver,
> The Bestower of Forms,
> To Him belong
> The Most Beautiful Names . . .[4]
> —*The Qur'an, Sura Hashr,* verse 24

The *wazaif* describe the nature of God. The most common are the Ninety-Nine Names and include such attributes as Mercy, Compassion, Strength, The Subtle One, Generosity and Greatness. God is all these qualities and infinitely more.

These qualities also exist in human beings. As we are all part of God each of us has the blessing of certain Divine attributes. Yet we also have many faults and shortcomings. A Sufi entering this stage of realization begins to see the manifestation of God's qualities or attributes everywhere, permeating the fabric of daily life. Instead of focusing on the limited aspect of human nature, at this station of spiritual development the Sufi sees the Divine attribute that is inherent and visible in each person. Here begins the realization of unity and diversity. A *salik* sees everything created as a reflection of God. A Sufi observes from this understanding and applies this knowledge when regarding the relationship between the Creator and the created. It is this ability to see the sameness and the difference simultaneously that is the foundation of this station of spiritual development, Seeing.

Ya Latif, The Subtle One

Collage: Prayer Rug and
Postnishin Bowing

Here, silently, put your head down.
Engulf yourself in the wonder
 of God.
—*Rumi* (trans. by N. Ergin)

Who sees inside from outside?
Who finds hundreds of mysteries
even where minds are deranged?

See through his eyes what he sees.
Who then is looking out from his eyes?[5]
—*Rumi* (trans. by J. Moyne and C. Barks)

The third stage is known as *Tawhid-i Zat,* "Unity of Essence." The *salik*
at this stage returns with a deeper understanding to the realization that
there is no Reality except God, and seeks to experience the Presence of
God in all aspects of life. At this stage of the spiritual journey one longs
for the death of the personal ego, to dissolve into God's Presence. It is
from this state that famous Sufis like Al Hallaj cried out, "I am the
truth!" and Bestami declared, "How great is my glory!"

 Until a disciple annihilates himself completely,
 Union will not be revealed to him.
 Union can not be penetrated. It is your own destruction . . . [6]
 —*Rumi* (trans. by S. Shiva)

We of the Mevlevi path seek to dissolve ourselves in the Presence of
God through the practice of turning by a continual process of purifi-
cation, remembrance and self-examination, and by viewing all who
come into our lives as the "honored guest." We seek to know God and
to become one with God not after we die but now, in this lifetime, in
this moment.

*Turning Floor of a Small
Tekke, Konya, Turkey*

～

They say, Love is the end of silence.
The beginning is chaos, the end
is tranquility.
—*Rumi* (trans. by N. Ergin)

In the waters of purity, I melted like salt
neither blasphemy, nor faith, nor conviction, nor doubt
 remained.
In the center of my heart a star has appeared
and all the seven heavens have become lost in it.[7]
—*Rumi* (translated by S. Shiva)

The Ritual

These stages of the spiritual journey are represented through the ritual of *Ayn-i Cem*. In the early days of the Mevlevi Order followers of this path would gather on an appointed evening. The *meydanci** would have prepared the room by placing a sheepskin on the floor opposite the entrance. This sheepskin is where the shaikh or *postnishin*, literally skin-sitter, sits. Nine candleholders would have been placed in two rows on either side of the room, eighteen in all. These candles would be lighted just before the ritual started. At sunset everyone would gather, share food together and do evening prayers. Each person would enter the space in a humble manner to stand in the position of *muhur*,‡ with the right foot over the left, arms folded and head bowed in a moment of prayer, setting their intention. They would enter the room one by one to line up and wait. When the shaikh entered, all would bow in unison. As the shaikh crossed the floor all would follow, taking their places behind the lighted candles on either side of the *post*. The shaikh would turn slowly around, truly seeing each "soul" in the room. When the shaikh sat down, all the dervishes would sit at the same time. They would all kneel and kiss the ground in a gesture of humility. Coffee would then be served to all and after the coffee cups were removed, the *neysenbashi* would begin a *taksim* or musical improvisation on his wooden *ney*. Everyone would sing an *ayin*◊ together and those who felt inspired would get up and bow before the shaikh, turning in the space between the two rows of candles while the music was playing. They would not wear their white *tennure* nor would they open their arms. After the end of the music, the shaikh would offer a *gulbang* or traditional prayer:

> *Inayet-i Yezdan, himmet-i merdan, mubarek vakitler hayrola,
> hayirlar fethola, serler def'ola, sahib cem'iyyetin muradi hasilola,
> bilcumle sahib-hayratin ervahi sadola, bi bitti, ganisi gele, dem-
> ler, safalar, muzdad ola, dem-i Hazret-i Mevlana, sirr Sems-i
> Tebrizi, kerem-Iman-i Ali Hu dyelim.*

**Meydanci* is the one who arranges the *Ayn-i Cem* celebration.
‡Muhur is the position dervishes stand in before turning in remembrance
 of Atesh Bas.
◊Ayin is ritual prayer that can be set to music.

Through the Grace of God and the truth of our spiritual aspiration, may this blessed moment be made holy. May we find goodness in the time we spend together and our sins disappear during this time. May the wishes of the companions of this gathering be accepted and all the spirits of the companions be joyous! This ceremony has ended. May there be even more abundant blessings in the future and may all joys increase! Through the breath of Hazrat-i Mevlana, the mystery of Shams-i Tabriz and the generosity of Iman Ali let us all say "Hu!"[8]

The Soul is the stone in the mill.
All these restless appearances are
Turning parts, fragments of
 the stone.
—*Rumi* (trans. by N. Ergin)

After chanting "*Hu*" all would kiss the floor. Then everyone would sit cross-legged in a more informal way. There would be *sohbet,* spiritual discussion, with the teacher sharing insights and the dervishes asking questions. The *meydanci* would bring seasonal fruits and sherbet (sweetened and flavored water).[9] The *mutrip* would continue to sing *ilahis** and *ayins.* The music and *sohbet* would continue all night until the call to prayer, heard in the early hours of the morning. The singing of the *adhan*‡ would be a sign for the shaikh to lead *Fatiha.* Afterwards, all would leave the room in the same manner they entered. Everyone would then do ablutions and go to the mosque for morning prayer.

The *Ayn-i Cem* was a time for the dervishes to gather together. At any moment one of them could offer sherbet, fruit or coffee to the shaikh. The Mevlevis used *Ayn-i Cem* for three purposes: in honor of someone's death, to seek God's aid, and for the pleasure of praying together followed by the gift of *sohbet.* The words of the *gulbang* would change accordingly.

To be part of an *Ayn-i Cem* one didn't have to be a dervish or shaikh, they could be a friend. Sometimes the ritual would be held in a garden or in someone's home or in a *Semahanue* designed for turning and prayer. Often, wealthy people would offer to pay for the expense of an *Ayn-i Cem.*[10]

*Ayn-I Cem
in the 21st Century*

In the Mevlevi Order of America in the twenty-first century we offer a small taste of *Ayn-i Cem* before the *sema* ceremony. *Ilahis* are played and more advanced turners tune to each other and turn spontaneously to the music expressing the feelings pouring through their hearts. It is a taste of the intensity of love evoked through the inspiration of Rumi's poetry, sacred music and movement. With God's grace it gives a fragrance of the tradition of our lineage.

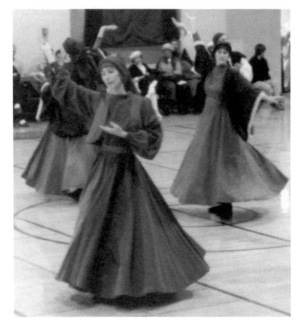

Illahis are devotional songs. Usually the lyrics are
 poetry of Sufi mystics.
‡*Adhan* is the call to prayer. In Islamic countries
 it is usually sung five times a day by the *muezzin*
 from the minaret of the mosque.

Inspirational Turning

After twenty years of learning the formal *sema* ritual, we return to the earliest form of sacred turning. For Jelaluddin Rumi, *sema* was not only a religious ceremony but a spontaneous reaction, showing one's emotions. He and his disciples would turn in the streets on their way home from Friday prayers. In those days, sacred turning was performed at any time or place, even without music.

But when the heart throbs with exhilaration and rapture becomes intense and the agitation of ecstasy is manifested and conventional forms are gone, that agitation . . . is a dissolution of the soul. . . It is a state that cannot be explained in words.
—*Hujwiri,* early Sufi writer
(in Halman & And)

If you could get rid
Of yourself just once,
The secret of secrets
Would open to you.
The face of the unknown,
Hidden beyond the universe
Would appear on the
Mirror of your perception.
—*Rumi* (trans. by N. Ergin)

Dancing is not rising to your feet painlessly
like a speck of dust blown around in the wind
Dancing is when you rise above both worlds
tearing your heart to pieces and giving up
 your soul.
—*Rumi* (in Lifchez)

Visionary
by Deborah Koff Chapin

Deborah's drawing was created while the *semazens* turned in *sema* and Ayn-i Cem.

FORMING THE BRIDGE
1978–2001

Interviews with Barucha, Jabbara, Delilah, Astara, Farishta, Thorn, Violetta, Mary, and Rabia

At the beginning of the twenty-first century, Jelaluddin Rumi is among the most widely read poets. Though he lived seven hundred years ago, his words still speak to the eternal truths we all share. With the establishment of the Mevlevi Order in America, women of all ages and cultures have access to this path of the heart. Some make it a life-time practice, others drink from it only briefly.

One of the great accomplishments of this last century was the ability to "fly." Today, from the window of an airplane, all below looks perfect and symmetrical. Yet, as we stand on the earth, imperfections are revealed. The perspective of the ocean creatures is quite different from the view of a bird. Similarly, the lotus blossom as viewed from above offers great beauty and perfection; from the perspective of the fish, the lotus becomes mostly roots and mud. Whirling brings moments of great ecstasy and passion, clarity and grace. Yet, Mevlana and the whirling dervishes are irrevocably linked to Islam, which can be viewed as both a blessing and a living example of the repression of women through misinterpretation and misuse of religious doctrine.

The women whose interviews follow share both the pain inherent in many women's spiritual journeys and the glorious privilege that has been gifted to us. With honesty, candor, humor and love, several generations of women from various religious backgrounds share their evolvement with turning and examine the mud out of which the individual lotus blossoms of their spiritual practice arose. These women bridge the practice of turning from the twentieth to the twenty-first century, from the closing of the doors in Turkey to the opening of the way in the West.

Persian Lotus, Safavid Era

Barucha

The unseen hand of guidance touches Barucha's life and leads her to Konya to be one of the first women to turn in Turkey in over two hundred years. As an American, she views the distinctions and differences of a culture not hers. Yet, as she is drawn near to a great soul such as Rumi, time, language and culture are transcended and moments of grace and communion permeate her and all who are present with her.

While you are turning you become a perfect centerpoint that is completely balanced. You see the blur of things around you with your eyes open, but it doesn't disturb you. In life, that would be excellent, to have your eyes open and to see all that is going on, while you remain centered and balanced.

My Spiritual Journey

When I was seventeen I had a teacher from India who gave me the gift of meditation. I had some metaphysical experiences that couldn't be denied. I couldn't say, "Oh well, that is all just nonsense!" because I knew what I had felt.

I first met Pir Vilayat Khan through a very strange circumstance. I hope to find out someday what he was doing in a tiny Unitarian Church in the little Florida town where I lived. My brother, who had met a number of Sufis when he was in college in Boston, said, "Oh, that is Pir Vilayat, go see him." I almost didn't go, because I didn't like doing things my big brother told me to do. But I went and had an amazing experience.

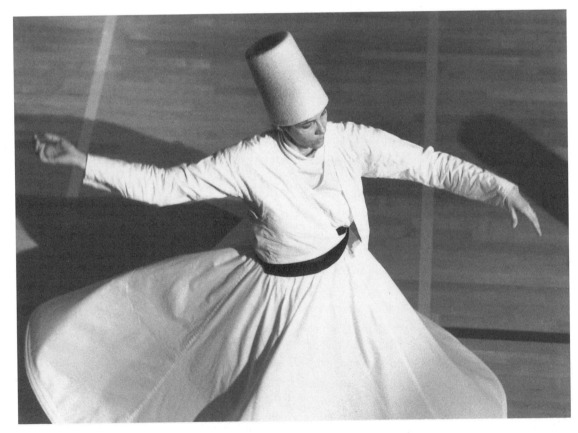

Barucha

"Turning is a great metaphor for life."

Twelve years later Pir Vilayat came into Tucson, Arizona. I was living in Phoenix, and he was on the front page of the weekly paper. When I saw this I knew I had to go to that retreat. Immediately, I went home and wrote a check. I received initiation there. In Phoenix there were only three Sufis, and I had a longing for a larger community, which is how I ended up in Seattle. I was very active with the Sufi Order. I wanted to know about tradition, to see other Orders and learn what they had to offer. I loved what I had, but I was curious to know what else was out there. Then I met Jelaluddin Loras.

Trip to Konya

We had flown ten hours from San Francisco to Frankfurt to Istanbul, and then took a bus ride across half of Turkey. On the second day there we met the Konya *mutrip,* the musicians, who played for us at a rug shop and Jelaluddin told some of the American group to put on their turn shoes. That was the first time that anyone of the American group turned in Turkey. It started with two male *semazens,* who turn absolutely exquisitely, Suleyman and Raqib. The Turkish *mutrip* watched them turn as they played, but when Jelal pointed to two female *semazens,* the *mutrip* wouldn't look up. Their eyes were glued on their instruments. They would not look at the women.

The following night we got together again with the *mutrip* and some Turkish *semazens.* They were athletic young men, and a lot of them turned quite beautifully. They were new to the practice, as I was. Despite the distance I felt from their side, I felt an affinity for them because, like them, we had just gone through a year's training and had completed one Shebi Arus in December.

At Jelaluddin's house in Konya there is a big living area, and it felt as if *zikrs* had been going on there for a long time. The room was rectangular and the *mutrip* was down at one end. The men sat in such a way as to keep themselves separate from the women, in the traditional manner. On the other side of the room were the women *semazens,* Jelaluddin's sisters and their daughters, and a couple of young girls, who later said that they very much wanted to learn to turn.

When the music started, the Konya *semazens* turned first. Two of the *semazens* would get up at a time and turn in this limited space, while everyone chanted together the Names of God. Then two more would turn, and so on (at least twenty of them turned) while we continued *zikr.* The men seemed happy turning, and I got the feeling they were showing us how it should be done. When all the Turkish *semazens* had finished, we were nervous, not knowing what was next.

I was at the end of the female line, with a very lovely twenty-year-old American woman, who turns beautifully. I looked over at Jelaluddin and he pointed with two fingers at this young woman and I. He did a little turn with his fingers, a gesture that said "the two of you turn," and my heart sank for a second. But since we had been doing *zikr* for so long, and the energy in the room was joyous, we simply got up and turned. It was a time when you know that there is grace and great beauty. I felt like an instrument being played by the room and the energy of the moment. I could have turned forever, even though it was smoky, and a limited floor space. It was an honor to be one of the first.

Feriste Hanum was there, along with other family members, and Jelaluddin's sisters were smiling, as if it was amazing to them.

Rumi's Tomb

In all of Turkey, Rumi is so loved. When we walked through the gate at his tomb we were extremely respectful, bowing at the entrance before we set foot on the grounds. I even saw someone kiss the gateway and I think the Turkish people saw that and tuned in to us in that way. I had my scarf on, of course, as we did in Konya, but some of my bangs were showing. A Turkish woman came up to me and gestured that I should pull my scarf forward so that none of my hair showed, and I felt that her communication was a sign of true respect for Mevlana, a sign that she wanted me to be dressed properly. I didn't feel criticized in the way that she did it. Rather, like I was being taken under her wing.

The tomb itself was exquisite. Everyone in Turkey who has ever had something beautiful

Traveling With the Dervish Caravan,
Barucha Shares a Moment of Turkish Village Life

wants to lay it at Mevlana's feet, so the place is a museum with many treasures. It is a big room with very high ceilings, and you can feel this majesty and this bounty. The main building, which contains his sarcophagus, is opulent—with gold and paintings all the way up the walls.

Another room has a big archway, and that is where the *sema* used to be, where the dervishes turned. It is a square room with a balcony on the second floor where the *mutrip* would play. Now it is a treasure room with priceless carpets upon the floor, upon the walls; and in a glass case—the hat of Shams-i Tabriz. Because of our history, the history of the Mevlevi Order, and of those who had turned in this room before, it was very meaningful to us. Of course we wanted to turn there. But that wasn't allowed, and hadn't been allowed in a long time. The room has a wooden floor underneath the carpets. So while I was there, and while I felt a great deal of respect, I also had this overwhelming urge. I kicked off my shoe and sneaked my toes underneath the edges of two carpets. I had my foot down on the wood floor and I just stood there for a moment and felt the vibration of it, in a true way. I felt all the history, and the connection with people who had been there before and turned.

We did get to turn, through great grace and blessings, at Mevlana's tomb, outdoors on the marble patio. As we turned in the third *selam,* the call to prayer was heard everywhere, and the timing of it amazed us all: "Come, come to prayer, come to success!" As we moved in our turning prayer, we just breathed in the blessing.

Reflections on the Trip

I knew Turkey was a different country regarding the roles of men and women and I made a pact with myself to not judge people; not to go there to try to "fix them." That attitude really helped me because there are some things that would have been abrasive to me normally, like the women working hard out in the fields while the men sit in the tea shop together. In some ways the separateness of men and women was really sweet. The women were so welcoming to us; a sisterhood that included us in their lives. When the men would go do whatever they did we were invited into the women's world. They sat and spun while we talked with them. They nursed their babies, and the grandma played with the grandchild. There was an instant connection and acceptance by the Turkish women. The fact that we were turning brought a lot of joy, as it was something that wasn't a possibility for them at that time. We were told that we were the first women to turn publicly in Turkey in two hundred years, and when we walked down the street in Konya people knew that we were the American *semazens.* They wanted to meet us. Traveling around Konya we were beautifully taken care of. The shaikh and the *semazenbashi* from Konya traveled with us and we had lunch at a different place every day, because so many people wanted to share with us. People were sent to translate for us and even to go shopping with us so that we could get what we wanted.

Feriste Hanum

At the *zikr* in Jelaluddin's house, Feriste looked joyous the entire time. She sat on the couch while the women she had met before came nearest to her, sitting next to her and holding her hands. She was beaming joy and love, and said

a few words in Turkish, *"Cok guzel!"* which means "very beautiful." Then she said, *"Allah,* boom boom!" I said, "What?" *"Allah* Boom-boom, boom-boom *Allah,* Boom-boom *Allah!"* She was making the sound of her heartbeat, saying that *Allah* is in her heart. She kept repeating it, "Boom-boom *Allah!"*

Later, she invited us back to her room because she needed to rest and was extremely frail, but she wanted to be with us. She had to walk with someone on either side, holding her arms for support. There were about fifteen of us who came into this little bedroom. Our female "translator" spoke very little English, but the translation wasn't really necessary.

Turning in Practice, Sema and Zikr

It is very different to turn in *sema* as compared to turning in practice. Just as it is different to turn in class versus turning at home by yourself. The energy of being with people who are on the same path and who have the same intention is so strong that it makes the turn effortless.

Sema is so structured that a part of me has a really hard time with it. For so many years I said, "I don't like ritual!" and here I am now involved in this highly ritualized experience! But it is great! It puts me in my place. One can't tell what they are going to end up doing!

The form of *sema* is very specific and I would rather just be really free and have that feeling of flying, the feeling of just getting lost while having to stay grounded enough to keep your eyes open and not fall over, which is what I experience while turning in *zikr*. But *sema* takes you a few steps further. You can't be oblivious of your surroundings at all; you have to be very tuned, to the people who are on both sides of you and the people across the way from where you are. At the same time, that experience of freedom can still happen, partially because of the beautiful people around you, who are also experiencing that energy. And partially, I believe, because of the transmission that we get from the linkage to all the souls who have been doing this practice for centuries.

JABBARA'S EXPERIENCE

In Jelaluddin's house in Turkey we were all doing *zikr* and turning in the same room, men and women; Jelaluddin sending out his *semazens* and the *semazenbashi* from Konya sending out his *semazens*. For me this was very special, turning in his house with his mother present and his sisters; this whole group of girls watching the women turn and the men turn. It was so sweet and so powerful. They are going to be the next generation in Turkey, *Inshallah,* to be able to turn.

I had the realization of *adab* as being the heart connectedness between human beings. Not a set of rules, or even politeness, but this feeling of inner connectedness and out of that comes the way we treat each other. That it is not something set down and written, but something living, because we care about each other. To tune to where the practice of Mevlevi turning comes from: the sound of the goldbeaters and of Rumi turning in the streets of Konya. It is a ritual that holds the vessel, creating the space for our heart connectedness.

Jabbara With the Young Women in Jelaluddin's Family

Delilah

Delilah presents the struggle often encountered when our soul longs for the purity of a path but our eyes perceive the distortion which humankind has created in its manifestation. She speaks candidly of her reluctance to respond to the call of the turn as well as what allowed her to embrace it. She shares her exploration of dance as an act of sacredness, a direct vehicle for connecting to the Divine.

I feel a calling to turn. Where these callings come from, I'm not sure. They have been with me always.

I tried to participate in a turn class, but my life was at a certain point where I really wasn't being allowed to. I didn't feel like I fit into this groove, into this group. So I spent a year in a quandary, observing from afar, wondering what was drawing me and yet keeping me from it at the same time. I have a lot of reservations with the way women are treated in the mid- and near-East. I don't completely blame Islam, although I find some of the religious attitudes unkind and unpleasant toward women. I see it as a much broader cultural problem. (Our culture isn't perfect either in regards to the treatment and considerations of women, yet I am far more comfortable here than there.) In thinking of becoming part of the turn circle, the question for me was, do I want to take part in this? Where are the women placed in this Order? Is this really a brotherhood? These questions were a major concern for me.

Then I met Jelaluddin Loras. I spoke with him at a few gatherings and got more of a sense of the true direction and calling. I attended a *zikr* he led, and loved it. It had real juice to it. I was overwhelmed. It was even more of what I had been looking for, and Jelal drew me in. As I got closer to the circle, I realized that none of the American women involved were weak or seemed about to put up with any unequal treatment. What I have learned is that Jelal is teaching the turn at the risk of criticism in his own country. Women have been a traditional part of the Order from the beginning. There have been women shaikhas in the Mevlevi Order. Outwardly the Order became all male because the cultural seg-regation surrounding it made it impossible for the women to publicly participate. Jelal is following his father's instruction to teach women in the West.

The first year of the turn circle had been completed and a *sikke* ceremony was held for all the *semazens* who had finished their first year of training. I was sitting on the sidelines with my first year of hesitation, kicking myself inside. I felt like I was being welcomed into the circle, even though I hadn't participated in the class. My inner voice said, "It doesn't matter if you were in the class or not, you are part of this." I surrendered myself into the turn that night.

My Spiritual Journey

> To the universe belongs the dancer,
> Whoever does not dance, does not
> know what will come to pass.
> —*attributed to Jesus in the Round Dance
> of the Cross; Acts of John*[1]

Dancing, to me, is a spiritual expression. Any kind of dance is a metaphor for living. You are born into this world to move through two elements—time and space. Therefore, one could think of one's whole life as dance. One way to totally praise the gift of life is through dance, yet culturally so many religions have been antidance for some very sketchy reasons. I believe it is because it is the key to God. It is *the* direct relationship with God that doesn't need a minister or a priest, or anybody in the way, and most religions in the world were primarily dictated by men who wanted to keep control of people.

Dancing, to me, wakes people up to the beauty and the love of the universe. When they see and feel and trust in those qualities, they can

Delilah

"Every day when you walk out the door you can see symbols
that are messages from the Divine. You can read your life like
a Rumi poem. It is an intuitive process."

move through the world with less fear and more
creative power and awareness.

With belly-dancing, which I teach and per-
form, there is no established school to go to even
though it is one of the oldest dance forms there is.
It is connected to women's awareness, to life, to
the birthing process and to this relationship with
God. It is an archetypical experience. As women
start to dance and move, all of a sudden it has an
effect. The same kind of spiritual experience hap-
pens when studying Sufism and the turn. You
can't put words to it. Words are limitations.

Joining the turn is probably a subversive
action because Jelal is welcoming women into
this form that had evolved into a brotherhood.
Turning is totally a women's liberation act,
which is probably how I finally decided to par-
ticipate. Any action, movement or dance in that
direction, I am going to gravitate to and support.

Adab

In relation to the meaning of *adab* I had this vi-
sion of glasses full of water. When you respect a
form, you don't go into a room and spill out all
the glasses onto the table. There might be truth
in some of the glasses . . . and there might not
be. This is an important issue and a fine line to
consider. The question becomes, when *do* you
change tradition? When we ended slavery in
this country, we probably had to break some tra-

ditions to stop it and to decide that it was not a
good idea. There are some traditions that need
to be broken. When is it right to respect the
form, and when is it time to stand and say, this
glass needs to be broken?!

Sema and Turning

The way I like to relate to *sema* is with the image
of the shaikh symbolizing the sun and the
semazens representing the planets. We are spin-
ning in front of the light of that sun, and being
illuminated. The astrological aspects take it
back to nature. It's an intuitive, wordless and
fact-less experience.

I would like to see the practice of turning
evolve and bloom like a garden of roses. I love
the other movement practices that Jelal has been
teaching us with the *Estaghfur ul'llah* and when
he encourages us to move from a place of inspi-
ration. That is the prayer that is real to me.

I just love this universe and I'm glad to be a
part of it; glad to hold within myself a sense of
awe. Life is a process. Every day when you walk
out the door, you can see symbols that are mes-
sages from the Divine. You can read your life
like a Rumi poem. It is an intuitive process.

My sense of the future is to watch for the un-
folding of each new lesson that comes my way.
Being grateful is giving praise to the whole
process. Where it is all leading, I don't think that
is for us to know. What is important is living,
being in this body, and enjoying this body; liv-
ing this natural life, not waiting for some after-
life. Life is right here, now, in this and every
moment. The life force that animates us is the
hand of God.

> Rise. Move around the center
> as pilgrims wind the Kaaba.
>
> Being still is how one clay clod
> sticks to another in sleep,
>
> while movement wakes us up
> and unlocks new blessings.[2]
> —*Rumi* (translated by C. Barks)

Astara

As a Japanese woman living in America, Astara reflects on her culture and how Hazrat Inayat Khan and Rumi have affected her life. She shares her unique insights into the turning practice, the importance of a spiritual guide and the meaning of zikr, *as well as the value of yearly retreats and its effect on daily life. Through her experiences we taste some of the ways to reach the Beloved offered through the Sufi path.*

I attended a *sema* for the first time about ten years ago when my husband and I moved to San Francisco from Tokyo. There was something mesmerizing, timeless, eternal about it—a sense of a long tradition and of the sacred that I could not name. I had this urge, "Oh, I have to learn this!" But I didn't act on it immediately.

Training

I began training when Jelaluddin returned to the San Francisco area to teach after some years of being absent. I was drawn to it without knowing what to expect. Physically, I found it hard to stand on my left foot and keep my balance. For many weeks I fought nausea and the lack of balance. I'm a perfectionist, so it was a struggle to find myself unable to do what I thought I should be able to do better and faster. After about three months, there was one particular evening when, as I was practicing, I simply gave up. I decided, "Well if I'm going to get very sick, or if I'm going to fall, I'm going to fall. Never mind." Somehow that seemed to relax my body. After that I wasn't trying so hard to make sure I did it right, and I was able to turn without feeling sick. This surrender opened up the sense of being turned.

Sema

Sema is indeed a wedding for me. Naturally not the same wedding as my personal one with my husband, but there is this sense of giving up your identity as who you have been, and merging with the unknown. You become something different, something that you have always wanted to be. There is a sense of longing and the first step to fulfillment.

One year, when it was time for *sema,* I had a relatively high fever and it was out of the question for me to turn. I was really looking forward to it. Instead, I stayed in my bed with a book of Rumi's poetry that was hand printed by a precious friend of mine. I burned incense and played *sema* music. As I read the book, I was in ecstasy the whole evening. That too was a turning for me. Although on one hand I was sad that I wasn't there with my friends, I had a very special *sema* anyway, because the spirit of Mevlana was there with me.

Whether it is in a *sema* or *zikr* (where one is invited to turn spontaneously), when "I" am no longer there the turning remains. What makes *sema* special is preparing many months ahead. Even in the actual ceremony you prepare with the Sultan Veled walk. When you put that much concentration and dedication into the preparation, what happens through you is of a different dimension, a different magnitude. I also feel a history and tradition of all these beings who have turned before who are helping me. When I am in a *zikr* and turning spontaneously there is more a sense of my union with God, an expression of my true self within the existing universe, a place of the eternal. *Sema,* on the other hand, has the space/ time dimension about it, the historical perspective. *Sema* is like an initiation. You are truly touched by what it means to be in union, to be in that wedding where you are no longer who you have been.

Finding My Teacher

To me, the most important part of my life is having a spiritual guide, doing my daily practice, and trying to be present and conscious every moment. I met Shahabuddin, my teacher, in Japan about thirteen years ago. I wasn't consciously looking for a teacher. I *was* looking for

Astara

"We are now in an age where God reveals *maya* on a scientific level.
Spirit is a fine matter and matter is a dense spirit. This has been proven
at a subatomic level in quantum physics. To experience that truth found
in physics as a reality, and not as an idea or concept, is *zikr.*"

something, but for *what* I didn't know. Shahabuddin was giving a seminar. At one point, all I could see was his back, yet there was something about the curve of his shoulders that spoke to me about the love that I was always looking for, ever since I was a small child. From a certain age onward I had thought love was a romantic thing, the kind of love I was going to find in a man . . . certainly something worthwhile looking for, and something that was here on earth. But the love I was really looking for was beyond that, although I didn't know that at the time. Still, I recognized this other kind of love that was radiating from this man and so I followed him to this country.

I had traveled to the U.S. before, but I had no idea how difficult it was going to be. From the age of nineteen or so I read English books, newspapers and magazines and I had many English-speaking friends. But there were some surprises when I actually got here. It wasn't any-

thing I couldn't handle, but it took a while for me to get used to it. I had no job. I had no idea of where my teacher was going to be, or if he was going to stay put or to travel. All I knew was that I had to follow him.

Now that I know what it feels like to be where I am now, the life I had before I met Shahabuddin was a shadow of a life. I was very unhappy, in despair. I used to drink a lot and smoke cigarettes. I'm sure I would have done drugs if they were available in Japan, but they weren't. I think I was really struggling in the dark, not knowing exactly what I was looking for.

At first, my new life with a spiritual teacher was like a black and white book without illustrations. Then the illustrations were added. Next the illustrations became full of color. Then the book became like a movie, where the pictures were moving and sound was added, and then it was a panoramic movie as we have the technology for today. Now it feels like I can walk

into this living, green landscape and I can join the movie. My life has transformed from this dull one-dimensional picture to a more and more wondrous, miraculous, spontaneous aliveness! Emotionally I have moved from despair to happiness. I am happy now.

My husband has the same degree of commitment to our teacher. We are following the spirit of Hazrat Inayat Khan. It's the personality of Shahabuddin that is able to step back enough to allow Hazrat Inayat Khan to come through him—that spirit which spoke to me as love radiating from Shahabuddin's back. Having a spiritual teacher who is in a body, a teacher that I can trust completely, and to share this experience with my husband is something I consider to be my greatest blessing. As husband and wife there are differences in our taste, in our personality, in what we feel like doing moment to moment, but our spiritual path is probably the most important element in our lives. To have the same desires, wishes and hopes in that area really unites us.

The Retreat Process

On retreat there are many different kinds of practices that are given to the student from the teacher. This whole process of retreat was given to us so that we can leave behind daily life, where we are engrossed in finding our daily bread, making ends meet, always pursuing what is urgently needed right now. Ordinarily the needs of the soul are put off with the thought, "I should really do this one day, but right now I have something more important to do." After days, weeks, months of putting the soul on the back burner, a retreat allows one to bring the soul to the front and feed it all the nourishment it needs. In daily life it is as if my soul begins to believe that she is

no more than the body and the mind. When I'm on retreat, my soul sees herself. That joy is like a child's joy, and it is very precious.

Over the years I have been trying not to separate retreat from my daily life, but to put my priorities straight in my daily life and feed my soul what it needs. I can't say I'm perfectly successful in that effort, but I have made some headway. I'm finding that the boundary between retreat practice and daily life is dissolving more and more.

On Life and Death

I am convinced that life as we perceive it in these bodies is just a fraction of existence. I don't fear dying, although that is still to be tested. At the same time that doesn't mean life here on earth has less meaning. I quite like it here, so I'm in no great hurry to get to the next place.

As my body is beginning to show its age, complaining about little aches and pains and so on, oddly enough I'm beginning to really appreciate the subtle nuances of being here. To see through these eyes of a human being; to have limitations, struggles on this earth, and to have imperfection. Humanness is, in some ways, so satisfying; to go through all of what we go through. The Sufi path has taught me to appreciate people and has taught me to appreciate each moment as supremely precious.

> We are the mirror, as well as the face in it.
> We are tasting the taste this minute
> of eternity. We are pain
> and what cures pain. We are
> the sweet, cold water and the jar
> that pours.[3]
> —*Rumi* (trans. by J. Moyne and C. Barks)

FARISHTA SPEAKS
ABOUT WOMAN'S ROLE

Women have a particular gift of doing more than one thing at once. Today, women have to juggle children, jobs, home life, spiritual life and creative life. Maybe *that* is the training—just to switch tracks, to be available, to be calm and balanced in the middle of all that; to remember to breathe; to remember that all anybody wants is to be heard, and loved, and listened to. The more I can do that, the closer I get to embodying love itself.

It is time, even on the smallest level, for each individual woman to know and honor what she does that heals and loves and nourishes. It is time for us to know what our Mother, the earth, does, and what other women do to make the world comfortable, beautiful and loving. I want to talk to younger women in my neighborhood and say, "Look how much you do that you don't acknowledge yourself for!" Women today fail to acknowledge the same things I didn't acknowledge in myself, and my mother didn't acknowledge in herself. I want to say to every women out there, "You do wonderful things: you cook, you clean and purify, you grow flowers and vegetables, you wipe the bottoms of the babies, you comfort the children in the night."

We must save the earth for our children and our grandchildren, because the earth will get rid of us—have an earthquake or erupt a volcano—if we don't. She will start over, before we destroy Her. That is a metaphor for all the women, the mothers, who are getting to the end of their rope.

This is also a very hopeful time—we see Mother Mary appearing more often around the world, and there is great hope to believe that we are going to wake up and save ourselves. All of that is about the feminine principle. It is not about making everything matriarchal. It is about balance this time: honoring both the masculine and the feminine, and having that be in perfect balance, like the perfect balance of turning.

You that love lovers
this is your home. Welcome!
In the midst of making form, love
made this form that melts form,
with love for the door,
soul the vestibule . . .
—*Rumi* (*Essential,* trans. by
C. Barks and J. Moyne)

*Farishta Washing Dishes After
a Gathering of Semazens*

Thorn

Thorn is part of a generation that uses tattooing and body piercing as a form of self expression. Her spiritual journey is a practicing of what is true for her and a breaking away from what she perceives as false. Through service she explores the meaning of love, and turning unexpectedly brings a deepening of her spiritual roots and a direct experience of movement as sacred prayer.

The thing that made me stick with turning, despite its difficulties, was the aspect of prayer. As a member of a dance troupe I would always put myself in a prayerful state and try to do my dance as a prayer. But, when you are dancing with a group of people who aren't praying, it is hard to stay in that state. It was really amazing and important to me to be doing this physical form, the turning, in the midst of a group of people who were praying.

Entering into my second year of training, things started to really shift. Finally I felt comfortable with the form itself and I was able to go deeper and deeper into the prayer. After I did a retreat in 1995 with Jelaluddin, the turning physically felt more natural in my body. What an incredible experience it was to go to the *tekke* and pray and turn all day long!

This past year, doing more studying of Rumi and his *Mathnawi* has helped to solidify the turn in my being. I'm finding that turning is a very tenacious practice because I keep trying to ease back from it. I get overwhelmingly busy, and since I'm trying to keep up with my other spiritual practices, and have responsibilities in my other spiritual communities, the turn seems the natural thing to fall away. But it won't let itself fall away. It is really insistent that I stick with it.

In *sema*, I'm often intellectually engaged until we get to the last *selam*. I'm so exhausted by that point, and so connected, that nothing matters anymore, except the turning and the prayer—the constant *"Allah, Allah, Allah"* that is in all. Everything else drops away.

The turn is a community practice. The basis of the form is that I am turning in my body around my heart, but at the same time there is the connection with the whole group of dervishes.

Everyone is working together on creating this prayer, this transformation, in one another. Only in working with each other can we have that transformation.

Back to Roots

Because of my studies in Sufism and the turn I've gone back to re-explore my Catholic roots. I'm trying to discover the connections from the religion of my childhood to my current practice. When Ramadan and Lent overlapped in 1995, many of my Muslim friends were observing Ramadan. I felt I couldn't do that as I'm not a Muslim even though I respect Islam. Instead, I decided to observe Lent, and that is what drew me back into this exploration. This observation went along with my Sufi practices and wiccan practices of death and rebirth—a continuous process that is a large part of my life.

Thorn

"By the fourth *selam* everything drops away except the turning and the prayer."

Rumi's Poetry

I have a fragment of a Rumi poem posted above my desk:

> We've given up making a living, it is all this
> crazy love poetry now . . .[4]
> —*Rumi* (trans. by J. Moyne and C. Barks)

and part of a Rumi poem tattooed on my arm, around a sacred heart:

> . . . Let the beauty we love be what we do,
> there are hundreds of ways to kneel and kiss
> the ground.[5]
> —*Rumi* (trans. by J. Moyne and C. Barks)

Tattoos are spiritual markers for me. When I started getting them ten years ago, it came from a need to have rites of passage that included spiritual reminders and physical markers. All my tattoos have a spiritual meaning to me, and layers of meaning that shift over time.

A Life of Service

I have learned from Sufism that washing dishes is a spiritual practice. An important part of my spiritual practice is learning to serve, and serv-ice is not an easy or natural thing for me all the time. I volunteer at a soup kitchen as a way to get some spiritual food for myself—and hopefully give something back. One thing I have learned in my volunteer work is that being compassionate is not always about giving people what they think they want. Sometimes compassion is actually a very tough path. In this way I'm trying to learn balance in love.

The rituals that my community provides for people who may not otherwise have access to them is also a form of service. I try to give my work over to the Divine every day, and to infuse the work I do with my dedication to God. This intention permeates my life, which is not to say there aren't moments when I am blocked from it and forgetful. Yet I try to keep that focus.

> You went like an arrow to the target
> from the bow of time and place.
> The man who stays at the cemetery
> pointed the way,
> but you didn't go.
> You became light and gave up wanting
> to be famous . . .[6]
> —*Rumi* (trans. by J. Moyne and C. Barks)

*Islamic Design From
Qur'an, Circa 1000*

Violetta

An artist from Yugoslavia, Violetta was brought to the United States by her love for the Dances of Universal Peace. She was given the gift of turning and discovered through the poetry of Rumi the spiritual framework for keeping her heart open in the midst of human suffering.

God arranges all, you know . . . He/She tricks you into things! I was always unhappy. I always felt like I fell from Mars and I was never able to connect with this earth. Nothing ever felt right and I always had a big hole, an emptiness, inside of me. I guess many people feel that kind of hole and try to fill it with drugs or alcohol or whatever addiction, just to feel full. Actually, it can't be filled that way because you long for God, not for alcohol or drugs or sex or whatever that is.

My addiction was depression and daydreaming—I was floating through life. While I was working for a certain company, I met a man who everybody laughed at because he was a vegetarian. This man was a Theosophist and he actually brought me to the beginning of my spiritual quest. At the time, my mind was always asking questions, and Theosophy answered many of them. But when a friend came back from a trip and brought the Dances of Universal Peace, that was a heart opening for me. Theosophy tends to be intellectual, which is fine because you need food for all your bodies—for the physical body, physical food; for the emotional body you need emotional food; for the mental body you need mental food. I became hooked on the Dances. When my friend decided to come to the United States, I felt a huge hole in my heart. I *had* to follow this path. So, the Dances brought me here in 1984. It is just amazing how things work out! I have been doing the Dances ever since.

The Pain and the Open Heart

When the last war started in my former country, Yugoslavia, in 1991, it didn't kill my hopes, but it shattered some of my hopes for humankind. I thought we were more evolved than we are! In Yugoslavia we were always talking about brotherhood and sisterhood; about how, in spite of

Violetta
"I remember getting my *sikke*. There was a beautiful *zikr* at Sami Mahal. It meant more than 'I'm Mevlevi.' It was like being married to God, which is beyond Mevlevi."

having different religions and ethnic groups, we still could all live together in harmony. That was the belief that I was brought up with. Then, all of a sudden, they started killing each other. Basically, I think the war is all about greed—money and power—but it is cloaked in the ethnic thing. Consequently, there is "ethnic cleansing."

Knowing what was happening in Yugoslavia hurt so much. The pain is in my heart because we as a country couldn't live together in peace. You would think that the younger generation would have that desire in their hearts, yet they helped start the war! I was hurting on a spiritual level too, asking, "Why, God?" When I read these verses from Rumi: "Open your hidden eyes and

come, return to the root of the root of your own self . . ." I felt strongly, "Come back, I want to feel that deep connection again! Why has that feeling left me? I want to return to that part of myself."

With Sufism I was introduced to the path of the heart. Although my heart kind of shrunk after the war started, I remembered the teaching: to act as if I have love in my heart whether I feel it or not. I remembered all those beautiful practices I had done when I first came here. Although I was in really bad shape financially, and in other ways, a beautiful love or joy that I know wasn't me was pouring from above, into my heart.

When you go through the whole *sema* every part of your body hurts—your foot hurts, your arm hurts, your back hurts, your legs—and your mind thinks, "Oh my God, I can't make it!" But while the mind is occupied with all that chatter about the aches and pains, the soul can fly out of it and be free. The mind with its constant yapping in the background is always what prevents you from doing things. In *sema* you just get out of the way, so to speak, from all the pains, and you go! Then you meet God in your heart. It might just last for a moment. But that remembrance of those seconds or minutes when you are with the Beloved is worth all of the pain!

Rumi's Poetry

> . . . Come, return to the root of the
> root of your own self! . . .[7]
> —*Rumi* (trans. by A. Harvey)

. . . Even if you have broken your
vows a hundred times
Come, come, yet again come![8]
—*Rumi* (trans. by J. Star)

All you need are those two teachings. I can read all the books, but if I don't have the heart, then what is it for, exactly? You can recite every single verse, from any book, but what is the point? Just "return to the root of the root of your own self." For me, that is the whole point of turning and doing spiritual practices.

Some people only think of God when they go to church on Sunday morning and then go back to their daily life forgetting. My spiritual life is my whole life, it is not something separate. We are like fish in the ocean—we live in God. We can forget that, but we can't separate from it.

> Without love there will be no joy and no
> festivity in the world.
> Without love, there will be no true living
> and no harmony
> If a hundred raindrops pour down from
> the clouds to the sea
> Without love's doing a pearl will not form
> in the deepest waters.[9]
> —*Rumi* (trans. by S. Shiva)

Ya Wadud, The Loving

Mary

From her first glimpse of turning, Mary is inexorably drawn to the practice. She travels with Jelaluddin and other semazens to Turkey on the first trip in 1994, and shares her adventures with humor and candor, raising questions held in the hearts of many American women. Her interactions with ordinary people reflect the interplay of the Divine and the human.

I have tried many spiritual practices and most of them want you to sit still. When I was a young child I had polio, so sitting still is hard to do. It hurts, actually. I have a strong devotional relationship with the Divine, not a remote one. When I found the turn, it met both of my requirements: to move and to embody what I was experiencing, the devotional and the relational sense of it. Turning is not observing or thinking about or praying to. To me, there is a feeling of interacting in the turning.

Our Trip to Turkey

In 1994 we were at the tomb of Rumi, outside in the courtyard, and we were turning on marble as the sun was setting. Along the side of the courtyard, Turkish carpets had been hung on a wrought iron fence. It made the area beautiful, but I didn't realize at the time that it was done so that passersby couldn't see what was going on. The tomb is on a very busy street, with people hawking chestnuts and kebabs. Of course, the onlookers started peering in. There were some police on guard, who shooed them away in the beginning, but once the ceremony started, there were all kinds of people trying to see in through the carpets.

An interesting thing happened at the end of the first *selam,* just before the beginning of the second. There is this pause at the beginning of each *selam,* when you line up. As you walk toward the front of the line, you can see whoever is behind the shaikh. As I walked up, it was crowded, so I stood there for a moment, waiting. Some movement caught my eye, and I realized there was a woman with a scarf peeking in. (Legally the women can't be veiled, so they just wear these large scarves and long overcoats.) I

saw her looking at me. She was quite startled, but I smiled at her, as I will do. Then it was my turn, and I went.

As a group, for the most part, we look pretty androgynous with all of our hair tucked up; we even had our bangs up inside those hats. At the beginning of the third *selam,* this woman was still standing there, but this time she spoke: *"Bayan?"* which is the Turkish word for woman. And I went, *"Evet,"* which is yes. (Before we went on this trip I studied a little Turkish, just to have enough to be polite.) *"Bayan, Bayan!"* she said again. Literally, you could have put a fist in her mouth it was open so wide in her astonishment. It was a special moment, my being there and having studied Turkish so that I knew what she meant. When she said the words, it all came together. She was just glowing.

A Woman Peeks From Behind the Curtain to View the Sema in the Courtyard of Rumi's Tomb

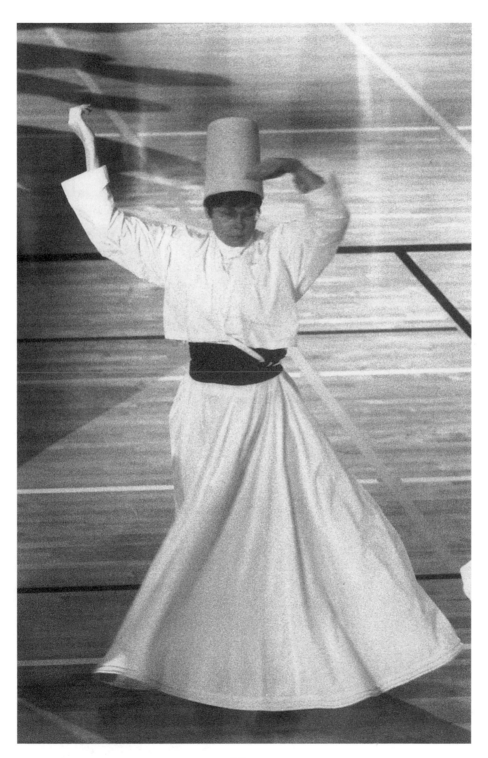

Mary

"Turning has the grace and the form of a feminine practice and the strength
and endurance requirements of a masculine practice: the yin and the yang."

At the beginning of the fourth *selam* she now had the carpet completely turned aside. Some man was trying to shoulder her away and she said something to him, but I couldn't hear it. Then she elbowed him. Obviously, she felt that this was her place. There was a woman out there turning and she wanted to be a part of it.

After the ceremony, all the *semazens* felt like our hearts had been broken. We went directly from changing to getting on the bus . . . very quickly, trying to not draw attention. As we walked through the plaza this same woman was standing there. By then I had on street clothes, and my hair showed. She looked at me and I knew she had also seen my red hair earlier through something she said. I went toward her and she said, *"Bayan, Evet Evet!"* There were more words, and I said in Turkish, "I'm sorry, I don't speak very much Turkish," She took hold of my hands. She kissed my hands and then she just kissed me. I kissed her face. We were both crying.

Tuning to the Moment

Originally, the Turkish musicians refused to play for us because women were going to turn. Before we were all actually in the room with them, Jelaluddin explained that in the history of the Mevlevi there were women shaikhas, and that Rumi had let women turn. After he gave this little history lesson the Turkish men evidently changed their minds.

Jelaluddin did that thing that he does so well—he had a man and a woman turning together. He had Mariam turning on this carpet, a totally irregular surface, very hard to turn on, and she was pregnant; but she did a wonderful job.

At one gathering with the musicians I had the opportunity to interact with the Imam, who was blind. I used to run a shelter workshop for the blind and am accustomed to blindness, so I just started doing what was natural for me. When his tea came, I noticed how he drank his tea: the servers always left the spoon in. So when I handed him the tea, I just turned the spoon the way he was used to. He made somebody tell him how come this woman knew to do that. To me, this is the positive aspect of the feminine principal—to be there, to be helpful, and to be aware of the other person. That allowed us to begin an interaction, to have a conversation. What came out of that process was a relationship between two human beings, and we have a correspondence now. At the time it meant that a couple of the other musicians had to interact with me because this man was interacting with me, and he was the Imam!

Men and Women Turning Together

Turning is not a traditional male practice. I don't think it is gendered at all. In our class in Seattle it is almost fifty percent women. When we are in turn clothing I love to try to guess if the person is male or female, because there is a difference in energy. But, sometimes I can't tell the difference. If I guess that a particular person is a woman, but I'm wrong, it isn't that this man doesn't carry "male energy." It is that he is not identified with maleness at that moment. He is in a more transpersonal state.

Turning has the grace and the form of a feminine practice and the strength and endurance requirements of a seemingly masculine practice. The *yin* and the *yang,* the duality is there, which is what I love about it so much. You have to be fully rooted in your body, fully present in the moment, and connected to something greater than you are, or you can't keep it up. You can't

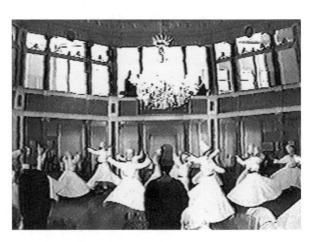

Sema in the Mevlevi Semahanue, Istanbul
"When the *ney* sounded . . . I realized that the reason people come to earth is because of the music of this world . . . to be filled with this beautiful sound." —*Nur Jehan*

drift away, or you will fall over, or run into somebody. You have to be, at all times, aware of what is going on around you. That kind of empathy is the essence of compassion, but without being martyred, without it costing you anything. You just fold your skirts for a moment, or you move back, and still hold the concentration while you are doing it. When I can do that, it is a very profound practice.

The Symbolism and Meaning of Sema

It is deeply significant to me, this intention that we come into the space of *sema* prepared to die to live. That we come in this black garment that represents our tomb. We are wearing this *sikke* which represents our tombstone. Our intention is that we are absolutely going to die to our attachments to the world. That is a very scary thing to truly do because nothing is certain, nothing is predictable. I do think that is why most of the people who turn are middle-aged. I think young people are drawn to the beauty of it.

When I wasn't sure if I could physically do this, Shaikh Majid said, "You don't have to turn with your body, all you have to turn with is your intention."

A Deepening of the Meaning of Sema

At the beginning of each *selam*, the shaikh goes out first and prays for the dervishes, not for himself. Then he steps back. I love what the shaikh prays for us in the first *selam*:

> Turn in the circle of your true Existence
> Be in harmony with your capacity, with
> your created nature
> Be in active submission.

The *semazenbashis* request permission for the group to turn. They request the shaikh's protection, and that is what he is agreeing to when he bows. When each *semazen* goes up to him in the true ritual, he is supporting them in that process. This is a huge commitment for him to make. You can feel from the *semazenbashis* that sense of containment and assistance.

There is a wonderful ending when you sit down and have an opportunity to be quiet.

Other *semazens* kindly come over and bring you your *hurka*, sending you back to the world. That combination of the inner and the outer, the individual experience and the community experience, is profound. The ritual is very clear in that nobody is praying *to* the shaikh, praising the shaikh; he is representing the *sangha*, the *silsila*. He is representing the sun around which the planets evolve; it is not about him as a human being. That is one of the things I respect.

Zikr with the Women

While we were in Istanbul we had an opportunity one night to go to the Halveti-Jerrahi *zikr*. I went upstairs to the balcony with the women and it was just like being back in Iran. I was furious at being separated—it was hotter than blazes up there, stifling, and they had the windows closed. The men were downstairs having a good old time.

All the women were sitting down, but at one point I stood up because I had a cramp in my leg. This woman, I thought of her as Mother Superior, came along and whacked me and told me to sit down. I said, "I'm sorry, I don't speak any Turkish." I was standing against a wall in the back, in the dark. She wanted me to sit down, because, you know, I might give the men a sexual thought. I might distract them from their spiritual experience, poor men, and that really made me mad. But I did sit down, because I didn't want to cause a scene. Originally we had been sitting up front so we could see through the railing, but we kept getting crowded to the back by other women. The local women didn't know who we were or why we were there. I don't blame them. I suppose that for them it was like Christians coming to church only at Christmas and Easter and trying to get the front seats.

As I was sitting against this wall, dying of the heat, furious, unable to see anything, not knowing what was going on, the women next to me shifted so that my leg could fit in. She spoke no English. My Turkish didn't cover all of what she was saying, but essentially I understood, "Here, I'll make room for you." She was squashing herself to do that. We wiggled around and finally

got ourselves figured out. Then she took my hand and she showed me what to do. She started the motions. I didn't let her know that I had done those motions before, because she was doing them a little differently. It was so cool— she just took my hand, she put it right up against her shoulder, and we prayed together. I was no longer mad. I was still too hot, but I was no longer angry. I understood, in that moment, that some of the women were up there gossiping and laughing, pointing at the various guys and yak, yak, yak! and some of the women were having a profound spiritual experience. That woman was my teacher.

I had tea with her several times after that. She thought that we didn't take turning seriously. She said, "Why would you think that you could do something that a boy starts learning to do as a very young child?" She couldn't understand how, after studying for a few years, we could go to another country and do this thing. To her it was such an American, pompous, and inflated thing to do. We continued talking, and after awhile she changed her mind a bit. She could see that, for me, it was an important experience. However, she still thought that I ought to be content to sit up in the balcony, because it was too hard on men who might have sexual thoughts. (Like the poor dears can't control themselves, and like sex is all they can think about?!) I believe they can do more than that. It is really a very interesting statement about how weak the men are. And they aren't. They don't have to be.

Spirituality in Daily Life

What is my spiritual practice? It is the way I eat, the way I recycle, the way I don't waste water. I really try to stay in touch with nature. I have some requirements of myself. One of them is to be kind; I won't say to "all sentient beings," because I have been known to kill slugs that eat things in my garden. It is also the work that I do in the world with women and who I spend time with. Those are all part of my spiritual life.

> They try to say what you are, spiritual
> or sexual?
> They wonder about Solomon and all
> his wives.
>
> In the body of the world, they say, there
> is a Soul and you are *that*.
>
> But we have ways within each other
> that will never be said by anyone.[10]
> —*Rumi* (trans. by J.Moyne and C. Barks)

The Prophet said that women completely dominate men of intellect
 and possessors of hearts, but ignorant men dominate women,
 because (these men) are dominated by their animal nature.

They have no kindness, gentleness, or love, because of the
 animality.
Love and kindness are human attributes while anger
 and lust are animal qualities.
Woman is the radiance of God. She is not your beloved.
She is the Creator—you could say she is not created.
—*Rumi, Mathnawi* vol. 1, 2433-5. (Kabbani and Bakhtiar)[11]

*Rabia Holding
Jelaluddin's Son, Suleyman*

"To meet my Sufi teacher, and be in
his family . . . having this beautiful
love affair with Mevlana Jelaluddin
Rumi and the Mevlevis, these are
the great blessings in my life."

Rabia

*As an elder in the Sufi community, Rabia came to the turn after years of participating in spiritual
life. She shares her own hesitation to embark on the journey and her surrender to the challenge
heard within her heart. Like a small stone thrown into a still pond, the ripples ensuing reflect the
reverberation of turning into her life. With honesty and amusement, she shares the practice and
meaning of turning.*

Why do I turn? Absolutely nothing comes up of
a *why,* because the question takes turning from
an experiential level to a level of brain-mind,
which is very precious, but also makes me want
to conjugate a list of French verbs! I have no idea
why I turn. I could say it is sweet memory. I
could *say* all these things, but they would just be
me looking for the reasons. Turning, and my ex-
perience of learning to turn, is so much deeper.

I remember the first time I saw turning. I was
working at Juvenile Hall as a guidance counselor
and I had to be on duty by twelve midnight. The
sema was at Guzman Hall, at Dominican Col-
lege in San Rafael. I remember the people I saw
that night (the lovely friend, Hasan, who has left

this plane), the turning, and how tight everybody
was in that hall. I recall the feeling of the wind
in my face as the *tennures* went around, and I re-
member the atmosphere as transporting. I had
no doubt that something was happening beyond
what was visually or musically apparent. There
was definitely a crackling in the air.

I had to leave early, while they were still turn-
ing. There was a man at the door, the doorkeeper,
and I could feel his function, as well as his bless-
ing as I left. I felt it all the way from leaving the
sema, to my car, to Juvenile Hall.

How did I get to be a turner? I had met Je-
laluddin Loras, our teacher, when he first came
to this country. I started going to his *zikrs* on

Tuesday nights at Sami Mahal, a Sufi center. He was most kind. Although I was not a *semazen,* or a turner, he would always let me go in the middle and turn. I liked it very much, but I had this list of reasons about why I couldn't turn. What a list it was! "Oh, I could never do it, I'm a smoker." Or, "I wouldn't have the wind," that was one. The big one was that I had had polio in my left arm as a child and always had trouble keeping my left arm up. The other reason had to do with age. I watched the first-year students train, because I lived in a Sufi house in San Francisco. They were a lot younger than I was, and they would come home absolutely dead, exhausted and pulverized by this practice of learning to turn. Of course, I didn't realize it was toughest the first year.

Then the second *sema* came after I had been doing *zikr* for a year, and I knew I *had* to be there. Jelal led a short *zikr* before, with his students, then a longer *zikr* at the end, with everybody doing the movements. It was quite a wild *zikr.* Jelaluddin said, "Go, go, turn, everybody turn!" As I started to turn, this voice inside me said, "No more cheating, you have to do the turn!" I was getting all the great benefits of turning in the *zikr* without going through the training.

That is how I started when it was time. I remember when Jelal put the board down for us to try and he had me do it first. I couldn't even stand straight on the board, much less turn on this thing with the nail coming up through it, and salt on it. I was wobble wobble wobble!

Over time I got my balance. My favorite practice for turning was to stand in the supermarket line and lift one leg and hold that leg up for a while, put it down, and then lift the other leg up and stand some more. Jelaluddin taught us to find balance in our own way, not this particular way. Yes, we all have our own unique way of turning and I just did what I could do. The training was about nine months; it was something like having a child.

In later years I learned more than in that first year of training, because I got out of the way. The real learning to turn is a daily, minute by minute, hour by hour process. This idea of learning to turn is like an outer manifestation of other processes. It is infinitesimally small and minute as well as like the planets rotating around the sun. It made total sense to me that we were the planets.

Turning is not Mevlevi, it is part of Mevlevi. The turn is the outer form. It is an inner and outer experience, but Mevlevi is much deeper that that.

My Teacher, Jelaluddin Loras

Jelaluddin has this incredible magnetism. There is no doubt that light is present around him, with him, and I was attracted to that light. The light had many forms and many hues, but what I was really attracted to was that I loved Jelaluddin. I had a dream where we were both in a *tekke* together—he was the doorkeeper and I had to get permission from him to move. We were friends.

With him I learned something about service and being a slave, and the separation of those two. I certainly learned the turn as much as you can from one human being to another, from him. I respect so much how he taught us. He was rigorous! I don't know how it is now, but it was even more rigorous in the first class. Yet within that rigor was a great deal of love. Some people have a special magnetism and they can use it in many different ways. I am very grateful that Jelaluddin used that for leading *zikr* and teaching the turn, because it is powerful stuff. Also I learned not just from Jelaluddin, but from his father, Suleyman Dede. I feel Suleyman's presence in my life.

How It Feels to Turn

I guess I have as many ordinary feelings in turning as I do walking down the street, getting into a car and getting into traffic. Then, perhaps, everything can become beautiful, as it does when you hear a violin concerto on your car radio. Everything changes.

The last time I turned was in the kitchen where I live. Our friend, Bilal, a beautiful being, was singing from the *Qur'an* and I was cooking dinner, and just for a few minutes I turned. That was my *sema.* That is what the turning is for me, not necessarily getting all dressed up and going

to a *sema*. I can turn while standing totally still, because to turn is to keep moving. It means looking in all directions simultaneously, and not looking at anything in particular. Everything is a part of it! You are not present to, "Oh, I am turning," or even, *"Allah, Allah!"* You are just being turned.

In the singing of the *Qur'an* the sound can turn you—the ecstasy of the singing is contagious. Listening to the musicians and the *ney,* or hearing Coleman Barks read Rumi . . . what else can you do but turn? It doesn't matter what you are doing with your body, if you are doing the prayer, that is turning. It was the prayer that turned Jelaluddin Rumi. Turning didn't make the prayer, his ecstasy created the turning.

One of my other most wonderful experiences was turning in a *zikr* of another order. Shaikh Taner of the Rafa'i Qadiri Order very much encouraged Mevlevi women and men to turn at all his *zikrs*. What I love about the Mevlevis, what I would love in anything like this, is the feeling between the people after you have turned together for a long time. It doesn't matter what your personal ideologies are. Once we are in a mode of practice and working together, we can rise above the distinctions and differences that divide us. This is what the turn does.

This practice of turning is one of the greatest blessings in my life. My children are a great blessing. To have met my Sufi teacher, and be in his family and in his atmosphere for all the years that I was able to be, that was a great blessing. Getting connected with Murshid Sam, because that is how I found everything out, was a blessing. To have this beautiful love affair with Mevlana Jelaluddin Rumi and the Mevlevis, these were the great blessings in my life.

My Spiritual Path

Nothing but pure grace! From the time we are born we are on the spiritual path. When Wali Ali, a Sufi teacher, asked Murshid Sam if somebody was spiritual, Sam said "Is he breathing?" We are all on the spiritual path.

I was a practicing Catholic for thirty-five years, and then one day something just went out the door for me. I got divorced in my early for-

ties, and for a year and a half all I wanted to do was have fun. My boyfriend had a book, *The Only Dance There Is* by Ram Dass, which I decided to read. There was this funny statue on it which had all these arms and legs. The statue was Nataraj. Everything in that book was absolute truth—I felt that I already knew it, instinctively. That's when I started exploring different paths. I went through my honeymoon period of spiritual life, when I saw the world all differently. Of course, it *was* all different!

By great grace, I started going to Sufi dancing. The joy that I felt from the Sufi dancing took over, and I became very active in that group. When I tell this in a linear way it sounds so linear, and yet it is not linear. It is happening every moment—it hasn't stopped! This story doesn't have a beginning, a middle and an end. I could be telling it about yesterday. In a way, it was time for that part of my life to open. It was a perfect Indian thing: first you raise your family, then you do your renouncing, and then your last years are for this work.

Many beings have impacted my life: Samuel Lewis, Hazrat Inayat Khan, Mary, Jesus and Joseph, Jelaluddin Rumi, Papa Ram Das, Mother Krishnabai, whom I met! Just amazing! I've got newer beloveds to add on to that list too, beings who have allowed me to fall in love with them.

Nothing in my earlier life had worked. The great ideal of "the marriage"—the living "happily ever after," having children, having them live happily ever after—was not working out according to my grand plan about life. At twenty-six I almost died, or thought I was dying, because I had cancer. As I have grown older, I've learned that my plans are just that . . . "plans." Often the reality is very different; being able to accept what is, is my greatest challenge and deepest teaching.

> . . . And when the bosom of the motes
> is filled with the glow of the sun,
> They enter all the dance, the dance
> and do not complain in the whirling![12]
> —*Rumi* (trans. by A. Schimmel)

We are motes, little dust motes who turn. We are turning, turning, turning! That is turning.

Prayer Niche
by Najmah Susan Arnold

The portal into the heart has many steps. Bounded by prayer and realization, one enters the innermost center of the heart. *Sura Fatiha* shapes the outer doorway, while the *zikr,* "There is no reality except the One Reality," offers entrance deeper into the soul. Yet only in silence can one enter into the unknowable.

THE INNER CIRCLE

Interviews with Tasnim, Devi and Tamam

In the early years after coming to the U.S., Postnishin Jelaluddin Loras would stand to the side of the *post* during the *sema*. Although he was clearly sent to America to establish the Mevlevi Order and was given *Icazet*—the official paper of recognition—by his father to formally acknowledge his readiness for this position of spiritual power, Jelaluddin placed himself at the side of the *post* as a true act of humility and understanding of what the responsibility of the *post* represents.

Over his twenty-two years of teaching students and conducting the *sema* ceremony in the U.S., Jelaluddin gradually began to stand directly on the *post* as one who is a direct link to the *silsila,* or spiritual chain of the Mevlevi Order, which can be traced back to Jelaluddin Rumi. The Mevlevi *Silsila* is made up primarily of blood relatives who can directly connect their bloodline to Jelaluddin Rumi. From the beginning of the Order, exceptions were made to this custom based on spiritual development, as exemplified by Hussameddin, Rumi's closest disciple who succeeded Rumi as the Head of the Order and then was followed by Sultan Veled, Rumi's son.

In those early years, and in harmony with the Mevlevi tradition of honoring the guest, Jelaluddin would invite shaikhs and shaikhas from the local Sufi communities to stand with him in this place of honor beside the *post*. They would also turn with him in the center of the fourth *selam,* representing their *silsila* as he represented his. The following interviews are with a few of the women teachers so honored.

*Turkish Seljuk Curved Motif
From Illuminated Manuscript*

Tasnim

Tasnim is a representative in the Sufi Order International and a recognized leader of the Dances of Universal Peace. She has participated in sema *as a* semazen *and as a* shaikha. *She describes her meeting with Suleyman Dede, her journey to Konya, a* sema *shared with her daughter, the teaching she received from Reshad Field, and her personal experience with the process of purification.*

I turn, to turn to God. The states that I've experienced in movement, in praying and moving at the same time, erase the separation between the worshiper and the worshiped. Murshid Samuel Lewis says, "The watcher is the prayerful devotee, but the Dancer becomes Divine." When we turn, we pray with our whole body. I turn to get closer to God.

"God," that word itself feels limited to me, so when I say "I turn to God," on one hand it can sound really puffed up, grandiose, and on another level it is so inadequate to say, in words, what that is. I guess if I had to encapsulate it, I would say I turn to know God, to know myself in God, and as God. I think of it is a service, which has the potential to extend blessing. I turn because God turns me.

I remember one incident recently in Minneapolis after having left all my friends from a week of dancing, praying and singing every day. Here I was in the airport and it felt so foreign, I felt like a fish out of water. I had my trusty Walkman with me, and I was listening to some music. I found myself struggling with the irresistible urge to move, to make a spectacle of myself, to stand up and dance in the airport! It is that kind of feeling to turn. Like, *How can I not dance?* Mostly, I see it as grace, a great blessing, and a humbling. I am reminded of the Blessed Virgin Mary who receives the annunciation and says, "I am the lowly handmaiden of God, and I'm chosen to do this? How can I? Why me? Yes, I accept!"

What did I do to deserve this? When you really ask that question, you realize that there isn't anything you could possibly do to "deserve" it.

Spiritual Life

My spiritual life has been filled with grace. I'm not saying I always recognized it, and certainly

Tasnim
"I turn, to turn to God."

not in the beginning. I'm thankful for the wonderment and curiosity that is part of my personality that had me investigating different things. In retrospect, things that I thought were of my own deciding, really weren't. We invoke the spirit of guidance if we ever say, "I don't know what I'm doing or where I'm going, God help me! Guardian angel, lead me." However we phrase it, the minute we ask, the response is there. Then later, when the trials come, you say to yourself, "Do you remember asking for *this?* Yeah, but I didn't ask for *this!*" You asked. It comes! How it comes, in order to prepare us, is alchemy. In alchemy the first thing that has to happen is purification, the *solvae;* those first stages have to do with the dissolution of the aggregates . . . that which we have come to iden-

tify as our self . . . of who we are. Sometimes it's like being in a tumbler—you don't get polished stones without that.

Hopefully, *Inshallah,* as I understand more that we know so little, I become clearer. If it were really "me," I couldn't do it. How can I ever be prepared enough, talented enough, insightful enough, wise enough, compassionate enough to say "Okay, now I'm ready!" So it isn't us! I feel used, which is wonderful! I don't mean that in the negative sense at all. To be used is a blessing . . . used by the Divine. In that sense it is an honor, a gift, to be used, to be tapped on the shoulder like Mary was, and others: "The handmaiden of God—you are it!"

A Teacher of the Dances

I was an initiate in the Sufi Order. Murshid Samuel Lewis, God rest his soul, was still living, but I was in Los Angeles and he was in the Bay Area. There wasn't any dance activity in Los Angeles, so a friend of mine, Charles Lewis, led a little dance group. When he got a job in San Francisco and announced that he was leaving town, I said, "What about our little dance circle?" "Well, you do it!" he responded,

It was dropped in my lap like that! What did I know at the time? Two, three, four dances, maybe? I was a drummer—it was just me and a drum. But that is how I started with the dances. They taught me. They informed me and I kept up. "Perseverance furthers," as it says in the *I Ching.* Two of the qualities in my being are continuity and stick-to-it devotion. I feel that I know how to be a student.

The dances became a practice that still run through my daily life. By beginning to see the cor-relation between *mudras** and postures and phys-ical attitudes, accompaniment, and structure, or support of emotion, to hold a feeling, to express a feeling with the body, with your voice, with your heart . . . that is what I mean by practice.

Murshid Sam
by Fatima Lassar

"The watcher is the prayerful devotee, but the Dancer becomes Divine." —*Murshid Sam*

Practice can be singing *Ram Nam‡* and sweeping, cleaning the kitchen or watering the plants; but to keep God's Name—that is what is important. Just to repeat God's Name, just to think of God, this practice is in all the different traditions. How to pray unceasingly was a ques-tion for the Christian pilgrim. How can I learn that constant prayer of Jesus in my heart? It is not a "How?" it is a "Do it!" Every time you think of it, do it. You will remember more and more and more. The more you do it, it is there.

Now I am privileged to train people and pass on all this wealth. We breathe in and we

**Mudras* are sacred hand gestures, used in classical Indian dancing and in Tibetan Buddhism, which contain layers of subtle meaning.

‡*Ram Nam* is a Hindu chant, used to focus on God.

breathe out, so it is not about hoarding. The moment it becomes, "Look at me, I'm so great!" the flow stops and stagnates, and we are really nothing again. We are nothing anyway but the reflection of God.

Learning the Turn

I encountered the writings of Ibn' Arabi, a Spanish-Arabic mystic who, in the Sufi tradition, is called the Shaikh al-Akbar, the greatest shaikh. One of my prayers became: "I wish I knew someone I could talk to about this; someone I could explore this with." I mentioned it to Reshad Feild who had given a workshop in L.A., and he invited me to come to his group, which at that time was studying what were called "The Twenty-Nine Pages" (Ibn' Arabi's *Treatise on Unity*). That was how my involvement with Reshad began.

Just by being around him I learned things from Reshad. He could be, can be, very hard line, strict and harsh. But what I also saw about Reshad, and still recognize, is a capacity in him to love. From him, I learned how to work with group energy. Did I know I was learning that? No! Now I can look back and I can say that much of what I experienced in those days I use now in my own groups. Things like setting intention, and what that means.

Meeting Suleyman Dede

I studied the turn with Reshad, and it was through him that I met Suleyman Dede. Dede came from Turkey and was presented to us at one of our gatherings—a big party, a barbecue. About that night, I remember receiving a powerful teaching about the tradition of the Guest of Honor. I learned from Reshad what it is to have a guest, how to receive a guest, how to prepare for a guest, how to acknowledge a guest. Dede was our Guest of Honor at this event, and yet people were casually chatting, socializing with each other. At one point Reshad shouted: "What the hell are you people doing? Wake up!" (He was always saying that, "Wake up!") "You think you are awake, but you are really asleep. Who is in this room now? Do you realize what

is going on right now, and you are frittering away this opportunity!"

It was a great blessing to be with Suleyman Dede. Obviously, we didn't have the language to speak with each other in Turkish or English. Yet, there is a phenomenon that can happen between people who don't speak the same language; a communication that happens. That evening, I couldn't take my eyes off him. He was so beautiful, so unassuming, so humble, so tender. I went and sat by his feet, and just stayed there. I felt this rose light coming from him. During this visit Dede said to me, "When you come to Turkey, when you come to Konya, come and be my guest! You'll be my guest."

Trip to Turkey

Dede's invitation set my intention and I planned to go to Turkey in the following year. That was to be my year of spiritual pilgrimage, beginning with the Chamonix Camp in the French Alps led by Pir Vilayat, and from there to Turkey. As I think about it now, I realize that was another example of seeing grace, protection and guidance, all functioning. I didn't know where I was going; I had never traveled abroad; I was just this young American woman with a bright yellow backpack. When I tell people about that trip today they say, "You went to Turkey by yourself?" Well, I guess fools rush in where angels fear to tread.

When I got to Konya, the message came that Dede would meet me. I was to come to the square at 9:00 A.M. When I arrived, Dede was there, nobody else was with him. It was just Dede waiting for me. He took my hand and walked with me. The first thing that you do in Konya is go to Shams. So we went to the tomb of Shams-i Tabriz. Then we went to see Mevlana. Dede introduced me to them both. He was so gracious.

One afternoon we stopped at a construction site. A beautiful two-story house was being built. The man whose house it was happened to be there, and he was dressed in a military uniform, with a breast full of medals. This was in the '60s, and I was totally anti-war and anti-mil-

Ornament from Stone Architecture,
13th Century Turkey
"I had a dream of a beautiful little tree with fragrant flowers.
It had perfect symmetry and beautiful leaves." —*Tasnim*

itary. But here I was with Dede and this regal military man was walking us through the building, saying "This is where the kitchen is going to be, and the living room." He was showing all of this and I was having my opinions.

Later that evening we were in Dede's home, and the dervishes were there. We prayed and afterwards smoked Turkish cigarettes. As we were praying and singing *Ilahis,* Dede would recite *Qur'an.* So beautiful! I had my eyes closed as this was going on and a voice in the room started singing. Oh God . . . the tone, the resonance, the quality of prayer that I was feeling and hearing . . . I had to open my eyes, I had to see who was singing! I opened my eyes and I looked around the room and it was the general! Inside of myself, the part that judged him instantly fell away.

Saying Good-Bye to Dede

I don't know why, but after all these years it still breaks my heart to think about saying good-bye to Dede. He wasn't very tall in stature. He had this little three-piece suit that he wore all the time. Anyway, we had spent all our time together, and finally it was time to go. I was in the

cab with one of the dervishes who was accompanying me. As we were pulling away, Dede was standing by the sidewalk. It was the beginning of evening, dusk. There was a lightpost that he was standing by. I saw this image of a little man in his three-piece suit, standing by himself on the sidewalk, with one hand over his heart and his other hand waving. I looked out the back window of the car and waved to him. Waving and waving, until he was out of sight. We turned the corner, and I couldn't see him any more. That was the last time I saw him.

Turning in Sema

When I met Dede's son, Jelaluddin, I told him about some of these things that I'd experienced with his mother and his father in his home. I told him that I had received so much and wanted to give something back. I said, "I'm at your service, whatever I can do!" and I feel he received that from me. It had been a long time since my forty-day training with Reshad in the turn. There hadn't been an on-going group or any continuation of that practice and I was completely rusty. My form was terrible, and I knew it. (You can't fool anybody.) When I showed up at the *sema,* Jelaluddin said, "*Efendi,* why aren't you dressed?" I replied, "Because I had no intention to turn, to be part of *sema!*" But he said, "Oh yes, you have to turn, go over there where the women are changing. There is extra *tennure,* put one on, get dressed, get dressed!"

I was shaking in my boots, but I got dressed, and I turned! I know that at least the first two *selams* were very difficult for me. It was difficult just to get my footing and to figure out which circle I was in. Am I in the center circle? Am I in the outside circle? My head was swimming with all that, very occupied and preoccupied. I was too much in myself, concerned with how I looked to the audience, and how I looked to all those *semazens* who had been studying and whose form was up to par. So the first two *selams* were difficult for me. I was very thankful for the training that I received from Reshad because I heard his voice in my mind from those days of training saying, "The reason you turn, is to turn

to God. Turn to God!" That thought helped me move past those preoccupations. I wasn't turning for the audience. It wasn't a play or a performance. I wasn't turning for the other *semazens*. I was here to pray, to turn to God. I just let myself go. I let my heart go, and I was able to do it. The other thing that Reshad impressed on us, and he would say this every time: "When your right foot touches the floor, say Allah's name." I took up the practice, I turned and I prayed.

My daughter Eva Latifa had moved to San Francisco, and she had gotten involved in the *mutrip* and learned the music, singing in Turkish. I was there at Jelaluddin *efendi's* request, turning in *sema* and my daughter was singing. That was very moving for me. A great blessing, and unexpected, even though Latifa is also an initiate in the Sufi Order and had been a baby in Pir Vilayat's arms. She has grown up in Sufism, but we hadn't been in the path of Mevlana together. To come together on that evening was so beautiful. I still cherish that blessing.

Training with Reshad Feild

Reshad's forty-day training was intense, rigorous. If there was a lapse in your attendance, you would have to start over and wait until the next forty-day training was offered. We would meet at a recreation center at 6:30 A.M. before we all went to work. We started out with prayer, and then the turn. Reshad is a good teacher. If you have crust, he'll knock it off. It makes you stronger, if you can stand it. If you can't, you'll go elsewhere. He was also rigorous with us. I just thank him a lot. Unless you saw what Reshad had done, you can't know fully what Reshad's devotion is either.

So we began. We started the forty-day training. We had studied that *Treatise on Unity* by Ibn' Arabi, and read from Rumi's *Mathnawi,* of course, making accommodation, preparation. When you turn, or you dance the Dances of Universal Peace, or do any of this work, I think it has to go hand in hand with discipline. The discipline almost always has to begin with a clearing out, and a making space. It is said,

"Whatever you have known in the past, whatever you have learned, come with beginner's mind. You know nothing." That is really hard for us as Westerners. It is very hard to get clear like that. Reshad would emphasize: Unlearn, in order to learn.

Purification

I had a dream. One of those luminous, transformational dreams that showed me very clearly, in symbols, that I had done just about as much as I could do in the outer realms, and that there wouldn't be further admittance to higher realms unless I cleaned up my act.

The dream was of a beautiful little tree, full of fragrant flowers. It had perfect symmetry and beautiful leaves. People would admire it, praise it. But in the roots . . . excuse my language, but this is how it came . . . there was shit in the root system. In terms of symbolism, and particularly Jungian dream symbols, what is underneath is the unconscious content.

On the conscious level I had already been leading dances and classes, I had students and all of that, and I was receiving a lot of acknowledgement for that work. It was like people were admiring this tree, and how beautiful it was, yet they were only looking at the outside. After that dream I went into Jungian analysis. I'm really a strong advocate of doing the psychological work.

You can't storm the gates unless you are ready, unless you have purified. That just means work! It is facing our issues, the things that unconsciously get activated. When we are in a position of following, such as being a student, then we need to look at how we project onto the teacher. Or how we project onto the archetypes of any kind of power or authority figure. One needs to have dealt with unresolved issues with mother, uncle, grandfather, father, whatever all that stuff was, so that you yourself can hold power. To truly cleanse the accommodation for power is what most of us lack, or seem to lack. Power will come when we accept that we have it. So, when we have cleaned out the inner chamber, we can carry it with compassion. It is like, in *kabbala,* there is the right hand of the

path and the left hand of the path, and the central column. They have to balance. They meet in the heart.

I strongly advocate not just doing *wazifa* practice, but also getting some psychotherapy. This is not for everyone, since not everybody has heavy issues. Yet we have all been abused by power, if not from our direct family then by the misuse of power in society. One of the things I did, as purification, was to make retreats with Pir Vilayat. In doing prescribed practices we can allow that energy to permeate us where we have been wounded. We have to face ourselves—the practice of *muhasibi*. You are *never* done.

Well, actually I don't know about never, but there is still a long road up ahead for me!

You push me into the dance.
You pull me by the ears like the ends
of a bow being drawn back.

You crush me in your mouth
like a piece of bread.
You've made me into *this*.[1]
—*Rumi* (trans. by J. Moyne and C. Barks)

*Turkish Tiles From Mosque
of Sultan Murat II, 15th Century*

Devi

Devi and her husband Iqbal are leaders in the Sufi community that first welcomed Jelaluddin Loras to the Bay Area. Devi is an exquisite dancer recognized for her innovative choreography. She had the great blessing of being a close disciple of both Murshid Samuel Lewis, creator of the Dances of Universal Peace and Joe Miller, a well loved mystic who was known for his walks through Golden Gate Park in San Francisco. Here, she reflects on her own experience of surrender through pain and darkness and the challenges facing women of the twenty-first century.

Devi

"Surrender is the big thing . . . to not want anything. To come to the point where the only thing you care about is waking up."

It felt very kind and wonderful to be invited to turn in the fourth *selam* as a teacher. When Jelaluddin first came to California I attended a small *zikr* with him, turning in a studio. The thing I like about his *zikrs* is the fact that he is the person who, bottom line, really loves God. This is his intention when he does *zikr* and it flavors the *zikr*. The only thing that counts to me is the feeling. I don't mean the emotional feeling, I mean the depth of the feeling, the quality of being present. Then, devotion is really quite alive and flourishing so that prayer really happens. Or, you could say the experience is one of . . . communion.

About Murshid Sam and Joe Miller

When I was fourteen I met Murshid Samuel Lewis. I was really taken, and I wanted to be with him and spend time with him. I can remember saying, "Murshid, can I become your disciple?" He gave me a friendly tap on the shoulder, "You already are," he said. That was it.

Murshid always said that I could come and live in Mentorgarten,* but I didn't want anybody to infringe on my daily life, not even my spiritual teacher. He was very understanding about this.

Murshid Sam lived in a state of illumination, which I recognized when I first met him. I said to myself, "Oh, I want to be like him. I want what he has!" So I started hanging around him, until he died.

Recently, I read over all my original practices—I have the exact little pieces of paper that he put them on; all the letters that he sent me. I used to be so alarmed when I would open the mailbox and get a letter with a return address from a certain few blocks away!

I was always most interested in the formless path. I remember that the first time a spiritual practice actually worked for me was when I met Murshid Sam. We were doing Buddhist meditations on love, joy and peace. He said, "Now breathe in all the love you can breathe in." I realized, "My God, this is working!" I was just thrilled.

I don't even consider myself a Sufi. I just consider myself someone who is trying to wake up. In one sense, that is the thing I love about

*Mentorgarten is a Ruhaniat *khanqah* in San Francisco.

Murshid Sam's brand of Sufism, which grabs, steals and takes any spiritual practice that works for someone and says, "Well, okay, we'll use that. We'll try this from Buddhism. We'll do *Ram Nam*. We'll do this from Judaism." To me that is very practical. Because, as Murshid Sam always said, "Sufism is based on practices that work and not theories about them." I don't have any particular alliance to any school of this, that, or anything. My allegiance is to God.

I can remember when the kids in Precita Park in San Francisco would stand around the outside edge of our circle, when we would be doing Sufi dancing, and they would say *"Allah, Allah"* making fun of us. Murshid Sam would say, "They don't know how much it is helping them by saying *Allah!"*

I love Sufi dancing! I find the dances, coupled with the planetary walks, to be absolutely magnificent examples of practices that create an atmosphere, a feeling of unity, that can draw people together of many different levels. In my own work, I have explored movements stemming from *mudras* originating from classical Indian dance. In his papers, Sam writes about movements and *mudras* that are in harmony with nature. Just seeing *mudras,* in certain ways, has an effect.

Sam had *zikr* dances too. Then there are his planetary walks, which I think are extraordinary in how they work. What a wonderful tool they are for understanding your own personality and the personalities of other people. I teach them all the time. My kids love them, because they are so much fun. Of course some of them are very threatening for some people to do, like the "Venus" walk, in which you walk in full knowledge of your beauty and radiate that out to others.

When I met Joe Miller I thought, "Well now, this is a completely different kettle of fish!" He appeared so different from Sam on the exterior level. After Sam died I went to see Joe Miller at a point where I was desperate for answers and for help on a personal level. In the beginning I saw him once or twice and he gave me suggestions. He was a master psychologist, which I wouldn't have known if I had not gone to see

Murshid Sam

"Sufi and other spiritual practices do not bring Grace. For in truth, Grace is always there. Every human being is always under Divine Grace but does not know it; therefore, the practices."

him privately. Because I was so desperate, I really attempted to do what he suggested, and it worked out beyond my wildest dreams! I went to see him once a week every single week for many years, until he died. I really benefited greatly from being in the presence of an illuminated teacher. Although he wouldn't call himself that, that was definitely what he was!

To me, Joe Miller and Murshid Sam are exactly the same, even though on the esoteric level they functioned differently. People could say, "Well, they are both just crazy!" But the fact is, they are so illuminated that their uniqueness is boundless. It is the rest of us who are crazy, because we are so inhibited.

I once read a bunch of letters that Murshid Sam wrote to Joe Miller. They were so wild, so silly . . . so . . . off the wall! Sam talked about who he was, and his illumination. He made incredible

Joe and Guin Miller
and Noah, Golden Gate Park

"If you pay any attention to what I'm saying, you're nuts.
But if you feel what I'm trying to radiate as I talk, then you're
cookin' on the big burner!" —*Joe Miller*

fun of himself. He was very very serious *and* very very silly. Sam was not stuck in any way.

The One Constant

When I was a kid I thought that if I got a rich guy then I would be secure. But I tried that, and it didn't work. I thought, "I will be happy," and that didn't work either. Then I thought that I could prove to myself that I was worthwhile by pursuing a dance career. That didn't work. The one thing that has remained constant is that every moment is my spiritual practice, not some time that I set aside during the day.

A number of years ago I had an experience that radically changed how I viewed myself and everything else. The state lasted for two or three weeks. During this time I actually experienced that I wasn't *anything:* that I wasn't my body, or my mind; I wasn't all the habitual stuff, or my personality or my feeling. I wasn't even an ego. The sense of I-ness wasn't even there, really. I was *present,* but I was something that is indescribable. From then on, everything changed. I couldn't get back into the state, but it swung everything around inside. It is not a state of being happy, because the happiness that I could imagine in my mind is pittance compared to what this real happiness is. Saying these words "real happiness" is a clumsy way to point to something that is indescribable.

Learning Surrender

A number of years ago I thought I was going to die and began to have major anxiety attacks. Of course, being a Capricorn, I could completely keep my life together with my strong will, because I *had* to. But it was hard. I had to face everything that was behind the anxiety, but even after facing all of it, the attacks didn't go away. Anything could trigger it, so I would spend most of my time thinking, "Oh my God, when am I going to have another one?!" I know other people go through this (more people than you would think), because fear of death is so fundamental. I feel great compassion for people who stay in that state for years and years.

I got beyond it. But, if you look at the attitude that I was carrying around with me, "When is another one going to happen?" that in itself is a victim statement. No matter how much I would say to myself, "I'm doing it" (meaning that I was merely creating this in my mind), the reality between *saying* that and *knowing* that required a change in attitude. The instant that I made that jump is when I became indifferent to these attacks, and just absolutely didn't care. In a certain sense you could say I objectified it, rather than pushed it away. I just witnessed it and it stopped, utterly and completely. When care became indifference, it stopped, just

like that. A few times it would reappear, and I would have to surrender once again.

Surrender is the big thing; surrender to not wanting anything, and coming to the point where the *only* thing you care about is waking up. The only thing you care about is finding out who you are. The only thing you care about is surrendering to God.

The Evolving Role of Women

Recently I read a letter that Murshid Sam wrote to me. He was talking about how Hazrat Inayat Khan never got to see the fruition of his work. Sam wrote: "Well, I'm the one who is getting to see the beginning of all this. Hazrat Inayat Khan didn't live to see it. He came and planted the seeds and I'm seeing all the flowers come up." I thank God I'm so lucky to be here now, to witness this flowering too. That is why I am so interested in the present moment.

Suleyman Dede, who lived all his life in the culture of Turkey, said, "Have the men and women turn together." Such a decision breaks with the current tradition. Isn't that an example of a person who is in touch with what is happening and essentially says, "We are going this way; we are making a big left-hand turn!" That's the way of the heart!

When I watched some of the footage of Jelal and his *semazens* turning in Konya, it was absolutely wonderful. I definitely think this is the time for women. Not that it is not the time for men, because I don't think spirituality belongs to either gender. But, on the level of manifestation, it is about time for the women. I am reminded of what Hazrat Inayat Khan said about *women being naturally men's superior, but inferior when they seek to be men's equal.* I think that

is an incredibly accurate statement. It is very difficult for women not to play the same game that men are involved in; difficult for them not to try to do things in the same manner.

So what is going to happen? It is going to be very interesting to see how this changes.

> The minute I heard my first love story
> I started looking for you, not knowing
> how blind that was.
>
> Lovers don't finally meet somewhere.
> They're in each other all along.[2]
> —*Rumi* (trans. by J. Moyne and C. Barks)

Turkish Woman, Early 19th Century

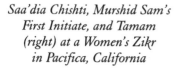

Saa'dia Chishti, Murshid Sam's First Initiate, and Tamam (right) at a Women's Zikr in Pacifica, California

"One who has reached the real Infinity finds himself at one with Life, especially with his fellow creatures." —*Murshid Sam*

Tamam

As a shaikha in the Ruhaniat Society and an initiate of Pir Vilayat, Tamam shares her meeting with Suleyman Dede, her direct experience of the mystery of sema, *and a moment of the extraordinary followed by a revelation of the unity of all beings. Her cultivation of how to be with the true nature of our personal feelings and at the same time relate in a genuine way with another human being speaks to the depth of her spiritual practice. She reflects on the condition of our culture and the possibility contained within the feminine voice with the dawning of a new century.*

Suleyman Dede came to a Sufi meeting that I attended around 1976. I remember the person with him saying, "Oh Dede is tired, he will only spend a few moments. Oh, Dede won't turn. He doesn't do that!" Not only did Dede spend quite a bit of time with us, but he also turned for us. That is when I saw the possibility of what this ancient transmission is. I felt in him so much love and compassion for every living being. He was a truly melted human being . . . he had this quality of being dissolved in love.

After that, Dede's son Jelaluddin visited, and I perceived him as coming from a place of trying to honor, hold and nurture that first seed planted by his father. I remember seeing Jelaluddin turn, feeling that the closest that I had experienced to his level of mastery was attending a rehearsal of the New York Ballet Company and seeing Balanchine working with dancers. Later on, when I saw Jelaluddin work with *semazens,* I felt his mastery, not only of the art of choreography, but also of understanding how to work with

a group and how to make them experience what it was he was experiencing.

Feriste's Baraka

Jelaluddin selected various costumes for the women who were turning as teachers in the center. During one of the first years, we were given a piece of green silk, which we tied around our heads. (We didn't have the traditional tall hat, the *sikke.*) One year, I was offered Feriste's head cloth. Receiving this was an extraordinary experience, and wearing it was a tremendous blessing. I felt something markedly different, which I hadn't felt at other *semas;* like I was being honored. There was *baraka*[*] in that piece of cloth and I sensed the closeness of lineage in a new way.

The Magic of the Mystery

There are various levels to this ritual and practice. First, there is a group of people who are watching and praying, or being meditative, or just observing. Then there is a group of extremely disciplined *semazens* who are turning around the center, in their beautiful white robes and *sikkes.* A sense of joy comes out of that particular circle of energy, and I feel reverence in the presence of this, because it is something very deep that is happening. Then there is an inner circle, consisting of those of us who are honored and asked to do a very slow turn in the middle. That is the mandala of it.

In participating in this inner circle I had to work through layers of stage fright, layers of "getting it right" and layers of trying to absorb what was being asked of me. What is it that I, Tamam, have to offer this evening? What is it that is being evoked? What am I feeling?

The magical part of this practice is what goes on out there while you are turning! The best way I can describe it is that something is descending, something is being offered up. There is the traditional description of a meeting of heaven and earth—we *do* become, at that moment, a bridge between the heavens and the ground as our bodies turn in space. In a sense, we are calling down

Suleyman Dede's Face While Turning

the blessing. There is also something about being a generator. What a generator does is take in energy at one frequency and process it; then it puts it out at another frequency.

Part of the magic is receiving a blessing and having the higher self somehow be able to translate it into the room. There is some wonderful substance that pours out, not just from the people in the middle, but from everyone who is in motion there, as an offering. There seems to be a gathering of whatever that feeling is that gets regenerated and retranslated and sent back. In that way, heaven and earth feel to me as if they are being joined in some magical and mysterious way.

We are talking about something that there are no words for. While in *sema* I try to get out of the way, setting aside my *persona,* so that the phrase, "Use us for the purpose that Thy wisdom chooseth," really can occur at some level. There is a transmission, a *baraka,* that passes through all the people who are in this magical turn. I think that our physical bodies yearn to express that feeling of connectedness with the lineage, the connectedness with the power of love, connectedness with the immense offerings of Jelaluddin Rumi. Maybe we are just opening the faucet, something that simple, allowing whatever it is to come through.

My Spiritual Path

For a long time people kept saying to me, "Well, when are you going to become a Sufi?" I said,"

[*]*Baraka* is spiritual blessing.

When I feel like it. When it is the right time." I didn't want to become a Sufi just because Shabda, my husband, was, but we ended up going to Lama Foundation a year after we got together. While we were there, I did a *zikr* with Pir Vilayat Khan, and had a powerful experience of heightened reality, of oneness with all of creation. I was in a bliss state afterwards. I remember finding my husband and saying, "Oh my God, I am just in this state!" He looked at me in absolute amazement, which surprised me—I thought that when you are a Sufi, this is what happens; that what I was feeling was kind of a "normal" Sufi experience. But, in the subsequent hours I realized that something significant had occurred. I went to Pir Vilayat, "I have had this experience in doing practice with you, that is so powerful, that I probably should take *bayat* with you," I said. On the basis of that, I connected up formally with Pir Vilayat and with the Sufi path there at Lama Foundation.

There is an important addendum to this story. From that moment on I started to feel like I was special, and this sense of specialness was reaching such an unpleasant level that I was no longer simply part of a group of people who were having a beautiful time. Instead, I was beginning to be quite isolated. I went up to the Maqbara, which is the place where Murshid Sam Lewis is buried, and I did a meditation there, asking what I was supposed to do, or if Murshid had any advice. I declared that I would be open to any advice that would come from my own heart in regards to this, or from his heart, or however it would come. What I got was, "You are nothing special. In order to understand this, take your shoes off and walk down the mountain barefoot; feel the earth and feel the leaves and experience all the little growing things. Remember you are part of all of that. If you start thinking that you are special, it is going to be nothing but trouble!"

Only recently have I realized that this was the place from which my feeling about the importance of connecting with the earth, and the simplicity of the earth, and grounding oneself, came. This wonderful spiritual message was a gift. Specialness, I have found, is nothing but separation. Specialness makes us feel very separate. Some good fortune had aligned my cells in a way that I could connect with Pir Vilayat on that particular day—I had an experience that was, in a sense, simply waiting to happen. But really, in the long run, it was no more special than breathing every day, or feeling my heart beat or feeling love for someone.

Daily Life

Living *is* spiritual life. My daily life has to do with being truthful to what is occurring in the moment, and trying to be in a state of awareness about that. If what is occurring is dark or unpleasant, the practice is to acknowledge and give as much space to that as I give to the bright or pleasant things. I try to open the doors in my life that have been closed—the closets that have been crammed full of things that I don't want to deal with, both for myself, and in relation to my husband. I try to get some air in those places. As a result of taking this attitude, my relationship with him has become very rich.

I am no longer trying to be somebody, but to honor what I feel. I don't discuss it in a logical way because feelings and logic sometimes take different directions. I would say the most spiritual thing I do is to try to be true to what I am feeling and to develop as much connectedness and compassion toward whatever beings and situations I come across. I try to be allowing and relaxed. When I get tense and upset about something, I have enough of my own inner "witness" developed that I can just watch that energy as it tears into my life, and I can still have a little more lightness, a little more space, allowing myself to feel what I feel—whether that is to be furious or thrilled. I tend to be in those rich, feeling places more, and less in the numb places—places that are stiff and where there is less feeling.

The hardest thing for me is to simplify. I recently heard a quote from Tolstoy about this man who had committed suicide. His suicide note read, "I did this because I could not simplify my life." That made an impression on me.

Consequently, I spend my time dealing with what I haven't been able to simplify and putting an intention forward to try to make a space between me and my business, and my friends and my business (which is two stores full of things). I am trying to somehow have all these mountains of things be there lightly, so that they don't own me; so that I'm not burdened by them.

Hidden Imagery of Our Prayer

I would love to give a translation that I have to *"Bismillah ir Rahman ir Rahim,"* which is the opening line of the *Qur'an.* Ordinarily this is translated as, "In the Name of God who is Mercy and Compassion." The translation I have to offer is from Saadi's *Desert Wisdom:* "We begin by means of the Entire Unfolding Cosmos from whose Womb is born the Sun and Moon of Love."[3]

I am really interested in semantics, in how words impact the psyche. I think that if one really goes into the Arabic of *Rahman* and *Rahim,* there is a root that has to do with "womb" in it. There is an aspect of the feminine hidden in the word.

The Voice of the Feminine

The time of Rumi's recognition is present right now. When there is such an opening for a particular level of consciousness to be accessed, it feels very important that everything we have previously learned about this realm be shared. Because of this moment, I think the feminine point of view will be especially meaningful, and my hope is that the feminine can continue to be tuned so that it is really the voice of our planet.

Instead of a single voice, a shrill patriarchal reactive expression, we as women need to express what we are intuiting in terms of this physical reality that we live in—its preciousness and its continuity. Life really depends more and more on people being aware, and not focused only on greed. The kind of energy that is running our country and a lot of the world is capitalism, commercialism, the taking advantage of whatever beautiful resources there are, both human and planetary. The quiet voice of the feminine has to speak and express our truth. If we do that, there will be a greater chance for the planet to survive.

I honor what we are doing in this practice of turning because we are tapping into something very rich. As time goes on I think many people will want to know what this turning is; what is this Wedding Night? *Alhamduillah!*

. . .

When the King's reflection dances
 upon the earth
Mud and stone come to life,
 brittle trees laugh,
 barren women give birth.

If his reflection can do this
Imagine what the light of his Face
 can do! . . .[4]
—*Rumi* (trans. by J. Star)

Allah Banner

Persian Embroidery Pattern, 17th Century

SINGERS IN THE MUTRIP

Interviews with Qahira and Latifa

It is told that during the life of Rumi he would often sit and listen to the beautiful music he heard played on a hill near his home. On the day the music stopped, Rumi mourned the death of the woman mystic who expressed the depth of her soul through the sound of her instrument.

The musicians who play for *sema* have been traditionally men. Yet if one brings vines to grow grapes from another country the resulting wine will be nurtured by the soil, air and water of the new. Similarly, the bringing of the way of Mevlana to the United States has been affected by its democratic culture. Consequently, the opportunity for women to share in this tradition has been opened in new ways. Here are stories and insights by a few of the women musicians who are part of the *mutrip* or musical orchestra that creates the music for the *sema*. These women have participated in the Shebi Arus, held each year on December 17th.

Turkish Women Musicians, 18th Century
Courtesy of the
Topkapi Sarayi Museum, Istanbul

Qahira

"Who is this God we pray to?" Qahira asks. With honesty and forthrightness she speaks of her evolving understanding of prayer and her relationship to a personal God, leading to a profound moment of realization on retreat. She begins with her discovery of the value of unity as part of the mutrip *and concludes by candidly sharing the challenges of living in a spiritual household.*

In *sema,* I'm singing written music. There is no improvisation. It is surrendering to unity with the group. If someone were to tell me afterwards that they could hear me singing, then I would know that I was singing too loud. The point isn't to be heard, it is to be cohesive. The point is to have people come away with an impression of beautiful singing.

For me, *sema* is a visceral experience, partly physical and partly in the heart. When you are singing a solo, sometimes you spontaneously sing something that turns out to be really beautiful and it opens your heart. That is a kind of ecstasy that can come from singing spiritual practice. Then there is the aspect of timelessness, of knowing that you are doing something that has been done for centuries. You are part of a continuum that never stops, and it doesn't matter what your identity is.

It would be very hard for me to actually do the turn because I had polio in one leg. Jelaluddin said that he would teach me to do it if I wanted to, and I thought about doing that, but I can already sing and that is what I enjoy. When I first came to his *zikrs,* he would say, "Sing, Qahira! Sing!" I used to feel like I was doing this radical thing—a woman being the one voice ornamenting the main chorus of chanting within a traditional Mevlevi *zikr!* Maybe some of the people who are more traditional would not approve! I was concerned about that. Then Jelal told me about his mother singing and I felt more permission. I want to not step on the toes of this tradition because Jelaluddin is trying to preserve something really special. I know that he is doing something that is not done in Turkey. One could say he is augmenting or embellishing the tradition.

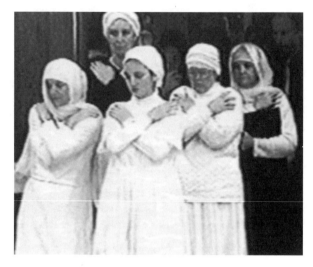

Qahira (left) and Singers in Mutrip
If you take one step towards Allah,
Allah takes ten steps towards you! —Sufi saying

God the Friend

I had this concept that God was an essence that was in everything. But I couldn't buy this stuff about God being somebody that you prayed to. I thought to myself, "What am I doing here? Who am I talking to? Am I talking to my innermost self?" When I went on retreat, I read in one of the *Sufi Message* volumes that to have a complete experience of God realization one must make a personal relationship with God. This is what Hazrat Inayat Khan was recommending right in the middle of my question, "Is there a personal God?" He said that if you start with an impersonal God you are going to have to come to a personal God sometime in your life, and vice versa. I thought, "Well, here I have been perceiving God as universal, maybe I ought to try seeking this personal God!"

I grew up with God the Father that you prayed to and asked forgiveness for all the bad

things that you had done. This was the same God you thanked for your blessings, and you asked for help in the future about things you wanted to accomplish. Hazrat Inayat Khan said to create God in the image that you felt you could respond to. I decided that in order for me to be comfortable with God, God had to be my best friend. So I "created" for myself God The Friend, *Ya Wali,* and I started talking to God all the time. It might be in anger or in pleading, or it might be a general conversation like, "Well I don't know why I did that, but you could give me a little help on this if you would like to." Sometimes I would just be sobbing. "You have got to help me, I don't know what to do here!" I knew it was okay because this Being loved me and was not going to judge me.

After doing this for about eight years, I went on a retreat. The Sufi retreats that I have done have been about nine hours of practices a day; *zikr,* breathing, and walking meditation. I was doing a breathing practice, visualizing a lotus blossom. I don't talk about this too much because it opens it to judgment, but what I experienced was like a deep movement in my heart. Everything just lifted and I was flooded with love for however long it was—it could have been thirty seconds or two minutes or whatever. There was all this light, followed by this blackness, with stars, and all of a sudden there was clearly a communication: "Yes, I exist." There were no words, but it felt like a communication from a living being; an all-powerful love that was beyond human ability.

Since then there hasn't been any question for me. There *is* a being who has the power to communicate that kind of feeling to me and I can't deny that. That experience definitely has come with me into my daily life. I know that life doesn't start and end with me. That experience is always available. I believe it comes from devotion. It is said that: "You take one step toward Allah, Allah takes ten steps toward you!" If I don't meditate, things start to get edges and maybe fall apart a little bit. Daily meditation seems to make the biggest difference for me.

Living in Community

I went into living in a Sufi household just as green as could be, and completely idealistic. My dog had to be interviewed, and I thought, "Was this going to be an acceptable dog that wouldn't bite the Murshid's children?" I washed her, and brought her down to Petaluma, tied her up to a tree. I felt like my seventh-grade teacher who used to say, "Love me, love my dog!" I was just elated to be accepted into this Sufi home.

> . . . I worry I won't have someone to talk to,
> and breathe with.
> Don't you understand I'm some kind of
> food for you?
> I'm a place where you can work.
>
> The bottle is corked and sitting on a table.
> Someone comes in and sees me without you
> and puts his hand on my head like I'm
> a child . . .[1]
> —*Rumi* (trans. by J. Moyne and C. Barks)

When you live with nine to fifteen *murids* in a large household you begin to understand that everyone has their "stuff" and everybody brings it with them. I had an idea about wanting to live a certain way, to do spiritual practice every day with people, and in retrospect, I feel that really made the difference in the whole thing not falling apart. Everybody was a human being, and I didn't expect that when I moved in. I thought these people were going to be holier than other people. Doing prayer or practices in the morning together brings peace to the household. You remember that when you get upset with someone. It is a test to live with that many people. It is hard to live with three or four, let alone nine to fifteen. Four years! God Almighty, that was really hard! To accept everyone's shortcomings was not easy, but the desire to do it comes from the ideal, from wanting to be one with each other.

Each person has a different reason for getting into group practice. Some people need community more than others. It is important to let people be with it in the way they need to.

Whether they need to go to classes twice a week or whether they come once a year to the *Urs*. Obviously they still feel a connection. There is a place for everyone in that. I feel myself more comfortable with being more dervish-like, going when it feels time to go. The rest of my life is so regular. I have to be so dependable for people. This is the one place that I allow myself not to be there every week. I go when my heart says to be there. I used to be annoyed with people that did that. But now I understand the importance of flexibility. We are all there for the same purpose, unity. To experience compassion and love. To find unity with God. If we can do that together, aren't we lucky? Aren't we fortunate that we found that!

Persian Motif From Satin Panel

Latifa

Latifa was born into a Sufi family whose spiritual path has affected her life on many levels. As part of the mutrip, *she sees her mother turning and both are deeply moved by this unique experience. Within the context of daily life, she reflects on the application of spiritual values and how being part of a spiritual community has shaped her growth as a young woman.*

Latifa

"If I approach whatever it is that I have to do with this feeling of excitement and joy of getting to do it, then it changes how I experience it."

When I moved to San Francisco I wandered into the *Semahanue* with some other Sufis and met Jelal for the first time. I began going to his *zikrs*. Jelal knew that I was a musician and he had me singing quite often and playing the *tar* sometimes. It was ecstatic, I loved it! There is a moment when all consciousness of the self drops, when my mouth is open but the music that is coming out of my mouth doesn't even sound like it is me. That's the best.

Sema

The *sema* contains an incredible sacredness. The ceremonial quality that has been preserved is part of what sets the tone from the moment that the *semazens* enter. We as musicians have our hands crossed over our chests, just like the *semazens*. In that moment of entering the space, there is a feeling of, "Now I am empty, I am here to make an offering which doesn't come from me."

When I'm singing there are certain passages in the music where I have to really look at the notes because there are just too many to keep track of. I have it memorized to some degree, but not enough to where I can look up as much as I would like. There are certain musical interludes where I can look up and watch the turning. Still, I never feel separated from what the turners are experiencing. I am experiencing it too, although I have to keep a little part of me to turn the pages and know where we are. I imagine it is the same thing when you are turning; that a part of you has to know where your feet are. It's a selfless feeling of joy. My consciousness of myself comes in and out, but there is just a wellspring of contentment, a completeness, a sense of well-being.

The different *selams* are very different from one another, rhythmically and energetically. What the musicians are playing is complementing what is happening out on the floor with the turners. It is like we start out in this stateliness, this regalness, then at some point early on we drop some of the earthliness and move on into more celestial energies. (It is funny for me to talk about it in this way, because of my peer group. My friends would say sarcastically, "Yeah, woo, celestial energies, yeah, right on!") On the outer plane it is easy to tell what is happening, because it does start out very slowly and then gain speed. The tempo increases throughout until there is a climactic moment in which you feel you have achieved a state and you are in Remembrance with God. That unity is what you are searching for.

Zither Player, 18th Century

*Mimi Playing
the Kanun in Sema*

I have invited friends to come to *sema* and they say, "What is it exactly?" Many people think, "Oh that is where they spin and then they get in a trance." But I tell them it is not about a trance. There is a connection created between the earth and the heavens in our very bodies, our voices, even the vessel of our souls. It is very difficult, one must use the body with great precision. I am not just speaking of the people turning, but whomever is involved in it. You have to apply a precision and a knowledge that requires you to be present on the earth, on this level. Without that, something will go wrong. In its most perfect example, the ceremony as a whole is, just as the body is, a vessel for the connection to God. This seemingly somber kind of abstract ceremony is an outer vessel, and once you get past that, then you can experience the exact same thing without even being the one doing it. The ceremony is a series of . . . not cleansings exactly . . . but a removing of unnecessary veils between you and the Beloved.

Jelaluddin and the Practice of Zikr

Anybody who doesn't know anything else about Rumi will say, "Oh he's the guy who wrote about love." I think that Jelaluddin is doing a beautiful job of preserving the lineage, that essence of Mevlana's energy. Jelaluddin manifests such an outpouring of love. Everything, all the moments, all the music bathed in love. When you have that much love surrounding you, it changes the whole pitch of what you are doing.

I would say his *zikr* is more in the moment. With Jelaluddin there is a freedom, a looseness about it, and perhaps it is horrifying to some. Some *zikrs* are like "You do it *this* way and this is what happens, and that is it." But Jelal knows that to achieve the ultimate goal you don't need to have it be a certain way. At the same time, however, we *are* doing it a certain way. He creates an expansiveness because he has a lightness of heart, and this infectious light shows up frequently. I not only respect him, but enjoy him immensely. When a person has that state of joy then everyone around them can't help but get a

little twinkle in their eye. At the same time, very often he's also a taskmaster.

The Path of Mevlana

Each of the different Sufi Orders emphasizes slightly different things. The qualities of the Mevlevi path—especially selfless love, where the ego is not involved in the process of loving—are much needed ingredients in our society. The freedom that you can glimpse when you have experienced the ecstatic union with the Infinite, the Divine, and the effect that has on your consciousness, is definitely indescribable. Then, when you are back in everyday life, that experience is still with you. It sustains you, and changes how you interact with people. We in this country definitely have some work to do on how people interact.

My Spiritual Journey

My Mom got involved in Sufism when I was one, and I was given my spiritual name when I was two. Sufism has been the most profoundly important element in my life and has sustained me through immense difficulties. A lot of very painful things happened to me in childhood— like my parents divorcing, and my going back and forth between them, and things that happened when my Mom was traveling (that she had no idea about). There was a time in my life where I really could have become a complete criminal! I don't think it would have lasted, but I'm glad I didn't have to go that far!

Through these different stages in life when I was feeling more and more alienated from the world I would see this group of people, mostly at Sufi camp. They would always say to me, "You are special. You have something to do here. Who you are is really important!" Just the love that people who didn't really know me, gave to me . . . was amazing. They didn't know the me that is written down on paper: my social security number or where I live. But they knew the me that maybe I didn't even know! I really thank God for that, because it made me see, "Okay, life is not all pain and horrible things,

even if in this moment that seems to be how things are. Yet I have a feeling that there is another way that life can be."

At a certain point, I began to question. All these people seemed . . . not enlightened . . . but on their way to getting there. It really bothered me how everyone had such an easy time talking about God, because I was really caught up in the Western Christian concept of God, which, if you grow up in this country, even if you don't subscribe to it, is everywhere, and I hated it. It is this patriarchal image of the Big Dude in the sky who is out to get you; or maybe, if you are lucky, he will be nice to you. I had a passionate argument with my Mom once, which really wasn't an argument because she set me straight so quickly. I was really upset with her for saying that she believed in God. My feeling was, "You are a woman! How can you be saying you know God so much?" She responded, "Well, what do you think is my conception of God?"

I just stopped right there and said, "Well, okay, what do you think God is?" Then she told me what she thought God is, and it resonated perfectly with what I thought. After that I became much more involved with the path. My main problem had been with people using the word "God." I found one definition in which the word God comes from a male god in the German pantheon. So I try not to use that word, as much as I can. But then if you say *"Allah"* that word has connotations in the United States of, "Are you a terrorist? Why are you using the word *Allah?"*

At this point in my life I feel at ease with my spiritual practices, very balanced and just happy. The blessings are infinite, everywhere I look, even in all the things that are happening to me that I wish were different. If anything, I just laugh and think, "This is part of what I am learning as I grow up."

An important part of the spiritual journey is surrender. I have been experiencing a lot of that lately—just complete acceptance of the "good" things and "bad" things, and how that acceptance interrelates with what is happening in a way that often changes it.

Day to Day Life

Right now I am in school, so this surrender thing has been helping me. At first I was having a hard time getting into it, saying to myself, "I can't believe I'm taking these classes!" I was taught that discipline means willpower. But it seems to me now that discipline is an extension of surrender. I think of willpower as more ego-involved, and I think of surrender as less ego-involved. Like, my ego is not battling with some other part of myself for me to do something. Then I thought, "Well, you are going to have to take these classes so you can have a horrible time for the next three months and get a C or B because you weren't into it, or you could just say, 'Woo, cool, astronomy, algebra, let's go!'" That is what I did. I was sitting in the coffeehouse studying algebra and it hit me so strongly: "Okay, I'm going to take algebra, and this is going to be fun!" My friends are all like, "Wow, you're crazy!" But it is working. If I approach whatever it is that I have to do with this feeling of excitement and joy about getting to do it, then it changes how I experience it, and how I experience it affects how well I do. So it is kind of a cool circular thing.

Sharing Sema with My Mom

In the very first *sema* that I sang in, my Mom was a *semazen*. It was profound. I was trying not to cry because then I wouldn't be able to read the music. I have seen my mother in states before that I was impressed by. But to know that my voice was contributing to what I witnessed in her, and that we were connected in this experience together, was beautiful. I was overflowing with love. The ecstasy I saw in her was almost unbearable because I couldn't just run up to her and hug her. Afterwards, we just hugged for a long while . . . we couldn't stop!

Rumi

I like Rumi's poem about the chickpea, because I feel like that is what life is about.

> A chickpea leaps almost over the rim of
> the pot
> where it's being boiled.

"Why are you doing this to me?"

The cook knocks it down with the ladle.

"Don't you try to jump out.
You think I'm torturing you,
I'm giving you flavor,
so you can mix with spices and rice
and be the lovely vitality of a human
 being . . ."[2]
—*Rumi* (trans. by C. Barks)

We are the little chickpeas whining, "Oh, this water is burning me! Stop!" And the cook who knows better than we, says "Get back in there, you are not done yet!" I like the humor of that story. If you really think of the chickpea in this pot of boiling water, it is like the intense pain of life. But then, the way in which Rumi tells the story, it is totally funny. It is more about surrender. This is what you are here to do. This is why you are here. So just keep cooking till you are done!

Spiritual Practice Now

I used to do my practices out of a sort of desperation, which probably is true for a lot of people. In that first stage it is, "Okay, I'm saying the words, I'm praying, help me out here!" Now, what it all boils down to for me is being a good person. That is definitely oversimplified, but it is both very simple and very difficult.

If I have to choose between getting my homework done and going to a Sufi class, I'll definitely stay home and get my homework done. I can still be attuned with the people praying. There is no separation; my homework is practice too. The practice extends to everything. I still read books on Sufism, but it is not a priority, although it may be again later. I think that after a certain point, the main thing is how am I doing without the books. That is what I'm working on now.

Every path emphasizes different vibrations. Sufism is a perspective on one's connection to the Divine, the key idea being that separation is an illusion . . . that union with the Beloved is the ultimate.

The people of my generation experience a strange combination of bleakness and yearning.

So much damage has been done on every level— to the planet, to human beings, to animals, everything! At the same time, there is a yearning. Even when I speak with people I'm just getting acquainted with, I can see that they have such a deep hunger to know God. I feel weird saying that, but that is what it is. This feeling of separation that the average human being feels, separation from the Divine, is intensified on the world level because there is such incredible alienation among all people. That is also part of why everyone wants to fall in love, wants to find the right boyfriend or girlfriend, which often can be very destructive because you just blindly rush in and say, "Okay, I need to love."

Sufism is the path of the heart, which for me includes tolerance to whatever practice works for whomever. There is no feeling of, "Well, that practice might be working for you, but ours is better." It is very important to me that you don't have to give up anything of who you are to practice Sufism. Rather, it is an added bonus, a perspective that can enhance your spirituality. You have the freedom to attune to any spirituality, whichever one works for you. I'm completely happy with any practice that works for someone my age, I don't care what it is, as long as they are trying something.

I have an immense feeling of gratitude. For whatever reason, I have had the first part of my quest made so much easier by virtue of my Mom because she was already "connected" by the time I got here. I'm very grateful to be a part of this community, and that the Sufi path has brought people together who have enough similarity, not on the outside, but on the inside, that we can be there with each other. To me, especially growing up feeling like I could not relate to a soul, feeling intensely sad that there was no one for me to talk to about things that I was experiencing, I feel extremely honored and lucky to have it so easy. Hey, you are a fellow seeker on the path of remembrance of *Allah!* Not just a member of a community, you are one of us.

> . . . Cease looking for flowers!
> There blooms a garden in your own home.
> While you look for trinkets
> the treasure house awaits you in your own
> being.
> There is no need for suffering:
> God is here.[3]
> —*Rumi* (trans. by D. Chopra)

Persian Flower From Textile Design

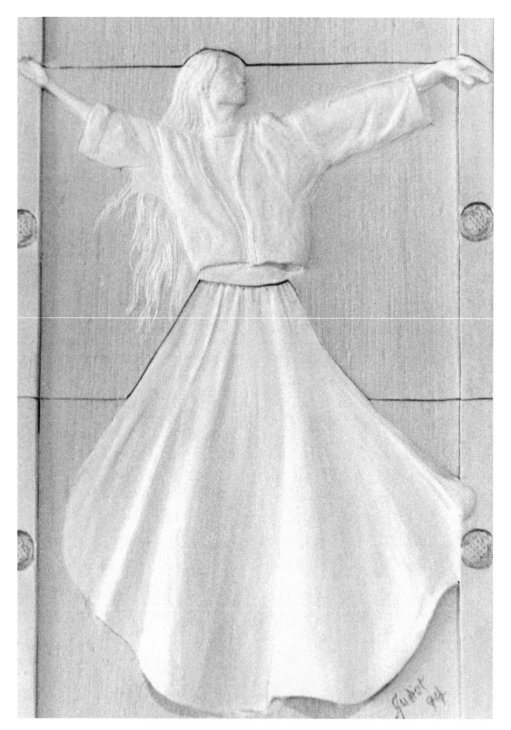

Dervish Sculpture
by Juliet Ehrich

Each culture, each era, offers its perspective and customs.
The old way gives birth to the new expression.

THE NEXT GENERATION

Interviews with Mira, Brieana and Virginia

For many, the spiritual path is a slow awakening that begins in later years. For some, it comes earlier, knocking on the door of the heart as an unexpected guest. It is rare, however, that a very young person is drawn to the mystical tradition, particularly in this culture that is so focused on material success and acquisition. We have seen from the preceding chapters that the way of the dervish is not predictable or logical, but is entered through the doorway of the heart. In this last chapter, we meet the youngest *semazens,* women who hold the promise of the future.

These beautiful young women reveal their thoughts, feelings and aspirations as new explorers to the mystical journey. We are invited to share the vision of the ones whose purity of heart and unfettered view will carry this tradition far into the twenty-first century.

Persian Floral Ornament,
Safavid Era

Mira

Mira speaks from the place of a young girl emerging into womanhood. She chooses the turn as the basis of her major school project and addresses fears and difficulties that face her generation. She regards incidents in her life that have helped her create rules to live by and unfolds her understanding of the nature of God.

I have memories of sitting on my mother's knee at the *tekke* in Vancouver, watching my father turn. I must have been three or four. I remember seeing the skirts . . . that is how tall I was. I can remember watching their feet, smelling the incense and hearing the music. For a large part of my life I never reflected upon my father turning. He went to *sema* once a year, but I didn't really inquire any further. Yet, I always had a feeling that I would be there too.

In the twelfth grade at the Waldorf School you pick a project that will decide whether you graduate from high school or not. I chose to do mine on death and I called it "The Graduation." I chose this subject because it has always been a part of me. The practice of turning fits right in with the consideration of death, with the *sikkes* being the tombstones and the *tennure* as the death shroud. Also, because of the concept of "turning between the worlds," and the "dervish at the doorway."*

The school presentations that I had seen before were usually just a lecture without movement. When one of my friends danced in his presentation it was magical. This was at the end of grade eleven. That's when I decided I wanted to make my project more of a mystical experience. I went to a few turning classes over the summer and started seriously training mid-way through September, when I got my turning shoes.

My eurythmy training from Waldorf has helped me. As a result I consciously know where my body is. I know where my arms are, and I know when they are straight. I love the way that turning makes me feel, even though I don't have it quite down yet. Turning is like teaching your

Mira Turning in Sema

"While the arms are outstretched, the right palm is turned up and the left down. This means we take from God and distribute to people, we don't claim any ownership." —*Jelaluddin Loras*

body a new language. It is not something you can really figure out, you just have to repeat it. Through repetition your body learns to speak fluently, then it becomes magic! I know that one day I won't have to worry about where my feet are, about where my hands are, and where my skirt is. Then I will actually start to touch into what it is really like to be a whirling dervish!

At school, during our mock presentations, we had to say where we were in our project. I expressed to my classmates that I felt the project has to come from the bottom of the soul, and that it has to be something that we have always been connected to and that we continue to be connected to for the rest of our lives.

My First Sema

I'm worried that in *sema* I am going to bump into someone else's *tennure*. When I put my con-

*See Chapter 1, "What is a Dervish?"

centration in my feet, then my arms don't do what I want them to at all! They kind of do the new "whirling dervish kink." I would really like to be very tall, smooth, alive, different and new. I would like to be able to not worry about my feet, or my wobble, or anything. I realized that all I was learning in my turn class was the formula, and that I would have to make some little adaptations for my own body. When I stopped worrying about my wobble, I realized that I wasn't getting dizzy. It was working! The wobble still comes back and haunts me, every once in a while, but I try to pay it due respect and ask it to become a part of my turn versus an enemy of it.

My Spiritual Life

For a long time I haven't been comfortable in using the word "God." Christianity is really built into a Waldorf education because Rudolph Steiner was an esoteric Christian. But he also believed in karma. They don't push Christianity on you, but you learn a lot about it in school. In our country, in our law system, everything is built on Christianity. I built my own reality and it was all based on life. I was so sure of everything—where I came from, where I was going, and what I was doing. As I grew up, I started reading all these books and stories of new religions, as well as the Bible. Then I started to lose faith in what I had originally learned. Today, I do not think God lives in a building, which should be apparent to everyone. I think that God is in everyone. For me, rediscovering Sufism was like putting on the right glove.

Dancing with Death

Last night the *ney* player recited, this poem:

> . . . Where did I come from, and what am I
> supposed to be doing?
> I have no idea.
> My soul is from elsewhere, I'm sure of that,
> and I intend to end up there . . .[1]
> —*Rumi* (translated by C. Barks)

That is exactly how I felt when I was younger. I was able to see fairies very clearly (that is my

name for them; other people call them "elementals"). I still hear their voices every once in a while. I lost the visualness of it when I was about thirteen. On Quadra Island, where I grew up, I started seeing fairies when I was three and they became part of my life. I took everybody on what I called my "Fairy Walk." I explained exactly what this one did and that one did, when you could see them, and when they came out, everything. Then, in adapting to society and to this world I had to lose that. The fairies would rather have me where *they* are, which is where I came from.

Fear and Death

My classmates asked me why I chose death for my project. I'm afraid of pain but I'm not afraid of death. I believe we walk hand in hand with death all the time. My father tells me he was so glad when I reached a stage where I was attached to living. I think that karma is bigger than just one life. It is only our conscious body that fears death. In the moments when we connect with our spirit, then, our spirit is all-knowing. It is like the nucleus, the piece of God that is in everyone. It knows all of your lives and so once you connect with that, then you know where you are going and you don't have to fear death.

When we slap the ground in the *sema,* the *derbi celali,* it is our awakening. It is a reminder to make sure that I have the right perspective on my life, that I don't lose track of death when I am living.

Fairies in a Garden
Stencil painting

Day to Day Life

I go to school, I don't skip. I try to be attentive in the moments when I am being taught, because everything is so valuable. This hasn't always been the way. I love to go dancing. I took up storytelling because I love to tell stories. I have many friends and I try to love everyone. Since I came to that realization my life has been so much easier. Hating people takes so much energy; you have to avoid them or be mean to them. But if you try to love them you can just give them hugs every time you see them and that can become such a wonderful thing!

Rules to Live By

How do you behave so that you can live harmoniously with everyone? How I behave now is harmonious with my world, but it isn't harmonious with everyone's world. To try to play by everyone's rules is nearly impossible. I think we have to bring awakening to everyone and in that way we have to scare some people. We have to make them really afraid because what we are showing them is the potential of their own soul, and that can be a very scary thing, especially when you don't talk to your soul very often.

I cut my hair for several reasons, but a little reason of it was so I could work. So I could fit into somebody else's world. But I think I am done with that now. I don't think that I should really have to fit into anyone else's world except for mine. I want to expand my world until it fits everyone.

> The clear bead at the center changes
> everything.
> There are no edges to my loving now . . .[2]
> —*Rumi* (translated by C. Barks and R. Bly)

Turkish Seljuk Motif
From Illuminated Manuscript

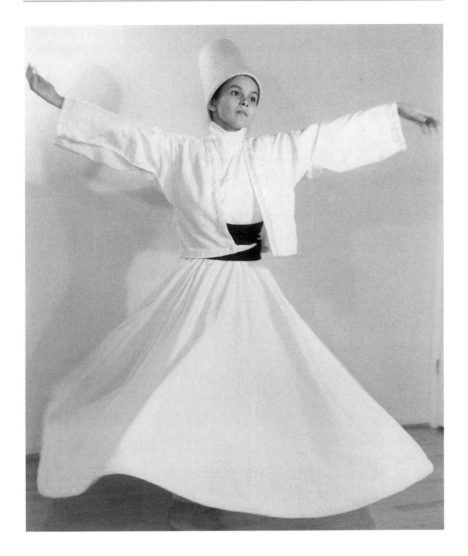

Brieana

O backbone of the world, show
kindness to the seekers of beauty.
—*Rumi* (trans. by S. Shiva)

Brieana

Brieana began turning in her kitchen. At a Mevlevi zikr, *she sees the whirling dervishes for the first time and feels called to begin the training. With quiet dignity, she reflects on the path of the dervish, the physical difficulties of turning, and opens her conscious mind to what is being nurtured and revealed through her inner life. She speaks of her relationship to prayer and Rumi's message to us.*

When I was about nine, my Mom and her best friend were going Sufi dancing. They asked me if I wanted to come and I said, "Oh sure!" I didn't really like it at first, so I just played outside. Then we started going more often, and I started enjoying it. I saw people spinning there. One day I was in the kitchen with my Mom and I was spinning and she said, "Maybe you are a reincarnation of a whirling dervish!" That left an impression on me.

Several years ago, there was a big Mevlevi *zikr* in our area. I met Jelaluddin for the first time. I was part of the larger outer circle while the dervishes were turning in the middle. I had never really seen the formal turn before. I noticed how they turned—the right foot going up

and over the left. It was interesting. The energy was different from Sufi dancing.

It does feel like I've turned before. I guess I'm called to it. When I heard about the turn class I just knew I wanted to go. I knew that it was for me to do. It just feels natural.

My First Sema

I borrowed my *sema* costume. Subhana made the black belt for me, my *sikke* was borrowed from Noor Samad, my *hurka* and *tennure* were from the son of Jabbara. But I did have my own turn shoes.

While we were waiting in the dressing room to begin *sema,* I was silently doing *"Subhan Allah, Alhamdulillah,"* and *"Allahu Akbar,"* using my prayer beads. One of my Sufi friends taught me how to do this because I'm not initiated. She and I do practices together sometimes.

When I say *"Subhan Allah"* I imagine a mist and focus on the quality of purity because *"Subhan Allah"* means purity. *"Alhamdulillah!"* means "Praise the Divine! Joyfulness from the heart." *"Allah Ho Akbar"* means " I am channeling the power of God!" Sometimes after reciting these sacred names, I feel differently than when I started.

In the *sema* ceremony, the *Na'at* is a time to get centered, to get rid of our worldly thoughts and to ground ourselves and be ready to do *sema.* I like the Sultan Veled walk. I like the bowing. It is like saying, *"Namaste!"* to the other person: "I see the God in you and I respect it." It is touching in with everyone and recognizing them before we begin to turn together. I like the part of taking off the *hurkas,* it is kind of suspenseful!

In class we turned to the chant *"La ilaha illa 'llah!"* For me that phrase means, "Rejoicing that the Divine is all there is in everything!" We would divide the turn into three parts to go with the chant. *La—ilaha—illa 'llah.* When we actually started practicing the *sema* ceremony I would often have more energy afterwards. I was very proud when I was able to do four full *selams* in class. The fourth *selam* is so long, somewhere in the middle of it I just get so tired I want to stop, but I don't. The music does this

urgent thing, and I think, "Oh good, it is over!" But then it is not over so I keep turning! Then the music stops and I think, "Now it is over!" But it is not. At the very end, it is as if you are rolling up a ball of yarn, wrapping it up quietly, the turning in the silence.

To me, *sema* means honoring the Divine and the tradition that has been passed down for generations; this tradition of turning, of the Mevlevi Order and of Mevlana. Each time it is passed through a generation something comes into it. This is what it is for us now. The purpose of *sema* is to channel energy. This practice helps yourself and everyone around you feel wonderful.

Day to Day Life

In my day to day life I do whatever I want to do, like ride my bike around. I'm part of a home-schooling group—there are seven of us who share creative writing, music, inspired art . . . things like that. The other students are a little bit older than me. I turned twelve in January.

I took a photography class and learned how to take photographs. I like to paint and write and be outside. I watch movies sometimes, but no TV. Sometimes I like to sew. I like to swim in the ocean, even in Oregon. It is so very cold, but I love it. I just love night and early morning. I like to make dream-catchers.

I want to be an artist of all sorts, to paint and draw and write and do photography. I want to keep turning. I want to travel. I want to go to Indonesia, Syria, Europe, Mexico and also Turkey, to turn at the tomb of Mevlana.

The Sufi Path, The Mevlevi Way

The Sufi path is about love and light. I find most paths are about that even if they disagree on whether God is male or female or whatever. All paths still focus on the same thing. God is everything! God is everyone and energy and light and nature, even things that we perceive as bad in the world, God is that too you know!

A dervish is someone who recognizes the Divine. Rumi tells us many things, like not to forget God in our worldly lives. He is telling us

about the past and the future, and about being loved and loving. I think it is special to be part of this path, because we can pass something along into the tradition. If it were a boat, each person who got in the boat would add a little bundle to it. I like that. One of the things that helped to pull me into turning was that after the turning *zikr,* Isaiah gave me this wooden star necklace and he said, "This is for you sister!" I took it and put it on. That gift told me that this community was special. The star broke on the day of *sema.*

Prayer

I used to turn at night because turn class was at night, but I don't have a favorite time now. I just turn when I feel like it. I don't sit down and do practices every day but always it is there in my thoughts. Whenever it feels right I just get quiet and stop thinking. Praying is energy, sometimes a feeling, or thought, or it can be a conversation. Sometimes I focus on a candle flame or a river, or a leaf . . . something in nature. I sit still and watch it. There is this place in our backyard that used to be a pond. Whenever I try to think about Rumi's time, I imagine him right there turning, between the pond and the Buddha statue and the hazelnut tree.

My heroes are Mary Magdalene (I'm reading a book about her) and Murshid Samuel Lewis, the Indigo Girls, Emily Salinas and Krishna.

> The Sama is peace for the souls of
> the living,
> The one who knows this, possesses
> peace in her heart.
> The one who wants to be awakened,
> is the one who sleeps in the middle
> of the garden . . .[3]
> —*Rumi* (trans. by S. Fattal and
> E. de Vitray-Metrovitch)

Persian Stone Carving
From Palace in Province of Khorasan

Virginia

Virginia touches on the use of spiritual practice in daily life. She describes the deep connection that bonds the turners into an extended family. Her experience of turning in zikr *and* sema *speaks to a state of consciousness that cannot be sought, but is given as a blessing from the Divine Beloved.*

It feels right to turn . . . like it is what I should be doing. It is hard to say how turning makes you feel in words. But I know that when I turn my mind gets empty and I can think more clearly. I can think about the things that have happened during the day, or the week or in my life, and I can sort them out. I feel like somebody cuts the string that attaches me to all the things that I need to do, such as homework. If something happens that I'm not so sure about, or if I'm confused, when I just let go and don't really think about it, just turn, the answer will come to me.

My Dad and I attended a presentation to introduce the turn in Vancouver. A video was shown of turning in Turkey. When there was a chance to sign up for classes, we signed up. It was fun to learn together, to have somebody there that I knew. I became really close to everyone in the class; we were one big family. It was fun turning with my Dad, even though sometimes it was kind of hard to let all the grudges go if we were having a conflict.

My friends know that I turn, but it is like, "Huh, what is that? Yeah, whatever." I don't really talk about it. When I do tell them about it they are curious. I told my teacher in school, and he wanted to know more. Sometimes I show them the *tennure* and the *hurka*. They see that turning is more than just a dance, that it is really something for yourself, inside. It is not a performance.

I will always remember getting ready for my first big *sema*. Everybody was there from different parts of the country, sharing in the experience of the changing room, rushing around ironing *tennures*. My experience was feeling very open to everyone, like we had met each other before and that we were in the same family.

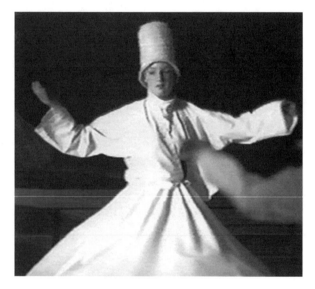

Virginia

You look outward and you see the human faces
Strange people from Rome and Khorasan.
The Beloved proclaimed, "The lesson here is
to look inside so you can see things beside these people."
—*Rumi* (trans. by S. Shiva)

My Spiritual Life

My spiritual life is very special to me. I use it sometimes in everyday life to get things done, like when I'm doing the dishes I sometimes say to myself, *"Estaghfur ul'llah"* or *"Allah."* I start chanting inside myself and it brings rhythm to the work. Soon I forget about what I'm doing, but the *mantra* keeps on going. It is very important to me and I feel more self-confidence through this. I believe I am meant to do this; it is just what I am supposed to do.

The Experience of Zikr and Sema

In *zikr* I forget I am saying the words. The words don't really matter, it's just what you feel inside

yourself. Sometimes you don't realize you are doing the movements, whatever they are; you just forget everything, you feel whole. Other times you feel like you are flying around the room.

In the actual *sema,* all you see is white. At times you are caught up in the mechanical part—how your feet are, what you just did, which circle you are in. Sometimes I can't tell which circle I am in. Then, at other times I forget about the mechanicalness and just whirl! It is really a beautiful thing in your heart. The feeling is like an openness, like a bowl with a big open space, and you are not really there at all. You are looking down on your body, spinning, and you can see everybody there.

So delicate yesterday, the nightsinging birds
 by the creek. Their words were:

You may make a jewelry flower
out of gold and rubies and emeralds,
but it will have no fragrance.[4]
—*Rumi* (trans. by C. Barks)

Unknown Girl Tries Turning After
a Sema, Dancing with Her Shadow

. . . There is someone who looks after us
from behind the curtain.
In truth we are not here
This is our shadow . . .
—*Rumi* (trans. by N. Ergin)

Endnotes

Frontmatter

 i. Abdulbaki Golpinarli, *Mevlana'dan Sonra Mevlevilik* (Istanbul: Inkilap ve Aka, 1983), 280. Based on translations by Ibrahim Gamard and Omid Safi. This *ghazal* was written by Fatima, a devotee of Mevlana Jelaluddin Rumi and the mother-in-law of Sakib Dede, 18th century.

 ii. Suleyman Dede, "Why We Turn," *Lovers of Mevlana,* vol. 2, no. 4 (Winter, 1997), 5.

 iii. Hazrat Inayat Khan, *Path of Initiation* (Zee, Netherlands: Servire, 1979), 172–3.

 iv. Story of Phoenix, from Farid ud-Din Attar, *Mantiq Ut-Tair, The Conference of the Birds,* trans. into French by Garcin de Tassy and into English by C.S. Nott (Boulder, Colo.: Shambhala, 1971), 66–7.

Introduction

1. *Rumi, We Are Three,* trans. by Coleman Barks (Athens, Ga.: Maypop, 1987), 13.
2. *The Dervish Lodge,* ed. Raymond Lifchez (Berkeley, Ca.: University of California Press, 1992), 256.
3. *The Essential Rumi,* trans. by Coleman Barks with John Moyne (San Francisco: Harper, 1995), 17.
4. *Open Secret,* trans. by John Moyne and Coleman Barks (Putney, Vt.: Threshold, 1984), 7.
5. *Rending the Veil,* trans. by Shahram Shiva (Prescott, Az.: Hohm, 1995), 33.

Chapter 1: What is a Dervish?

1. *Rending the Veil,* trans. by Shahram Shiva (Prescott, Az.: Hohm, 1995), 135.
2. Based on a definition by Imam Bilal Hyde, Private Correspondence, 2-17-98.
3. Annemarie Schimmel, *Mystical Dimensions of Islam* (Chapel Hill: University of North Carolina, 1975), 121.
4. *A Garden Beyond Paradise,* trans. by Jonathan Star and Shahram Shiva (New York: Bantam, 1992), 33.
5. *Unseen Rain,* trans. by John Moyne and Coleman Barks (Putney, Vt.: Threshold, 1986), 64.
6. *Rending the Veil,* 88.
7. *Love's Fire,* trans. by Andrew Harvey (Ithaca, N.Y.: Meeramma, 1988), 56.
8. Ibid., 34.
9. *Birdsong,* trans. by Coleman Barks (Athens, Ga.: Maypop, 1993), 25.
10. *Unseen Rain,* 34.
11. *Rumi, We Are Three,* trans. by Coleman Barks (Athens, Ga.: Maypop, 1987), 47.
12. *Lalla, Naked Song,* trans. by Coleman Barks (Athens, Ga.: Maypop, 1992), 77.

Angel Graphic page

1. Sheikh Muzaffer Ozak Al-Jerrahi, *The Unveiling of Love* (New York: Inner Traditions International, 1981), 129–30.

Chapter 2: The Origin of Turning and Sema

1. *Rumi, Fragments–Ecstasies,* trans. by Daniel Liebert (Cedar Hill, Mo.: Source, 1981), 11.
2. Hazrat Inayat Khan, *The Mysticism of Sound* (Netherlands, Holland: Servire, 1979), 79.
3. Layne Redmond, *When The Drummers Were Women* (New York: Three Rivers, 1997), 33–55.
4. *The Essential Rumi,* trans. by Coleman Barks with John Moyne (San Francisco: Harper, 1995), 278.
5. Francis Huxley, *The Way of the Sacred* (New York: Doubleday, 1974), 249. *See also:* Maria-Gabriele Wosien, *Sacred Dance, Encounter with the Gods* (New York: Avon, 1974), plate 42–3, p. 116.
6. Curt Sachs, *World History of the Dance* (New York: Bonanza, 1937), 41–44.
7. Sunil Kothari, *Odissi, Indian Classical Dance Art* (Bombay: Marg, 1990), 1: *The Odissi Dance Path Finder,* vol. 1 (Bhubaneswar: Odissi Research Centre, 1988), 115–123.
8. Sir James Frazer, *The Golden Bough* (New York: Macmillan, 1979), 80.
9. *The Essential Rumi,* 253–4.
10. Wosien, *Sacred Dance,* 35.
11. Huxley, *The Way of the Sacred,* 146–150.
12. Ibid., 156.
13. *Rumi, In the Arms of the Beloved,* trans. by Jonathan Star (New York: Jeremy P. Tarcher/ Putnam, 1997), 25.
14. Metin And, *A Pictorial History of Turkish Dancing* (Ankara: Dost, 1976), 5–16. *See also:* Annemarie Schimmel, *The Triumphal Sun* (New York: State University of New York, 1978), 18–21.
15. Talat Sait Halman and Metin And, *Mevlana Celaleddin Rumi and the Whirling Dervishes* (Istanbul: Dost, 1983), 18.
16. Dr. Javad Nurbakhsh, *Sama in Sufism* (Tehran, Iran: Khaniqahi Nimatullahi, 1997), 11–12.
17. Halman and And, *Mevlana Celaleddin Rumi and the Whirling Dervishes,* 63.
18. Annemarie Schimmel, *Mystical Dimensions of Islam* (Chapel Hill: University of North Carolina Press, 1975), 181.
19. Sheikh Muzaffer Ozak Al-Jerrahi, *The Unveiling of Love* (New York: Inner Traditions International, 1981), 129.
20. Halman and And, *Mevlana Celaleddin Rumi and the Whirling Dervishes,* 68–9.
21. *The Illuminated Rumi,* trans. by Coleman Barks (New York: Broadway Books, 1997), 64.
22. Halman and And, *Mevlana Celaleddin Rumi and the Whirling Dervishes,* 20.
23. *Legends of the Sufis,* selections from Shemsu-'d-din Eflaki, *Menaqibu'L'Arifin,* trans. by James Redhouse (London: The Theosophical Publishing house, 1977), 81. *See also:* Vitray-Meyerovitch, *Rumi and Sufism,* trans. by Simone Fattal (Sausalito, Ca.: Post-Apollo Press, 1977), 43.
24. Annemarie Schimmel, *The Triumphal Sun,* 27.
25. *Rumi: Like This,* trans. by Coleman Barks (Athens, Ga: Maypop, 1990), 61.
26. Vitray-Meyerovitch, *Rumi and Sufism,* 47.
27. Halman and And, *Mevlana Celaleddin Rumi and the Whirling Dervishes,* 63.
28. Vitray-Meyerovitch, *Rumi and Sufism,* 56.
29. Ibid., 83.

Chapter 3: Women Dervishes of the Past. (History)

1. Margaret Smith, *Rabi'a, the Life and Work of Rabi'a and Other Women Mystics in Islam* (Oxford: Oneworld, 1994), 47.
2. Jelaluddin Rumi was born about 1207, Rabi'a in 717.

3. *Doorkeeper of the Heart,* trans. by Charles Upton (Putney, Vt.: Threshold, 1988), 41.

4. Eva de Vitray-Meyerovitch, *Rumi and Sufism,* trans. by Simone Fattal (Sausalito, Ca.: Post-Apollo, 1987), 23.

5. Abdulbaki Golpinarli, *Mevlana Dan Sonra Mevlevilik* (Istanbul: Inkilap ve aka, 1983), 278.

6. Annemarie Schimmel, *The Triumphal Sun* (New York: SUNY Press, 1978), 13.

7. Vitray-Meyerovitch, *Rumi and Sufism,* 20.

8. Schimmel, *The Triumphal Sun, 32. See also:* Vitray-Meyerovitch, *Rumi and Sufism,* 33.

9. *Legend of the Sufis.* Selections from Shemsu-'d-din Eflaki, *Menaqibu'L'Arifin.* trans. by James Redhouse (London: Theosophical Publishing House, 1977), 21–2.

10. Mehmet Onder, *Mevlana Jelaleddin Rumi* (Ankara: Amfora), 55–9.

11. Huart, C.L. *Les Saints Des Derviches Tourneurs,* vol. II (Paris: Ernest Leroux, 1919), 206–8. *See also: Legend of the Sufis,* 101.

12. Schimmel, *The Triumphal Sun, 32.*

13. Erkan Turkmen, *The Essence of Rumi's Masnevi* (Konya: Misket, 1992), 27.

14. *Legend of the Sufis,* 77–78.

15. Ibid., 87–88.

16. *Legend of the Sufis,* 64–5.

17. *This Longing: Versions of Rumi,* trans. by Coleman Barks and John Moyne (Putney, Vt.: Threshold, 1988), 83.

18. *Les Saints Des Derviches Tourneurs,* vol. II, 213–4.

19. *The Hand of Poetry, Five Mystic Poets of Persia,* trans. by Coleman Barks (New Lebanon, N.Y.: Omega, 1993), 86.

20. Turkmen, *The Essence of Rumi's Masnevi,* 49.

21. Schimmel, *The Triumphal Sun, 27.*

22. Turkmen, *The Essence of Rumi's Masnevi,* 49.

23. Dr. Nevit Ergin, *Crazy As We Are* (Prescott, Az.: Hohm, 1992), x.

24. Onder, *Mevlana Jelaleddin Rumi,* 139.

25. *Legend of the Sufis,* 109–110.

26. *Les Saints Des Derviches Tourneurs,* vol. II, 429–30. *See also:* Golpinarli, *Mevlana Dan Sonra Mevlevilik,* 278.

27. Dr. Mikail Bayram, *Fatima Baci ve Baciyan-i Rum* (Konya: Damla, 1994), 5.

28. *Les Saints Des Derviches Tourneurs,* vol. I, 318.

29. Onder, *Mevlana Jelaleddin Rumi,* 135.

30. Golpinarli, *Mevlana Dan Sonra Mevlevilik,* 67–8.

31. *Les Saints Des Derviches Tourneurs,* vol. II, 300–301

32. Golpinarli, *Mevlana Dan Sonra Mevlevilik,* 93–4. *See also:* Talat Sait Halman and Metin And, *Mevlana Celaleddin Rumi and the Whirling Dervishes* (Istanbul: Dost, 1983), 41.

33. *Les Saints Des Derviches Tourneurs,* vol. II, 288.

34. Golpinarli, *Mevlana Dan Sonra Mevlevilik,* 43–4.

35. Ibid., 86, 246, 279, 281. *See also:* Vitray-Meyerovitch, *Rumi and Sufism,* 42.

36. Golpinarli, *Mevlana Dan Sonra Mevlevilik,* 86, 246, 278–9. *See also:* Halman and And, *Mevlana Celaleddin Rumi and the Whirling Dervishes,* 41.

37. Golpinarli, *Mevlana Dan Sonra Mevlevilik,* 278–9.

38. Shems Friedlander, *The Whirling Dervishes* (Albany: SUNY, 1972), 110.

39. Golpinarli, *Mevlana Dan Sonra Mevlevilik,* 279–80. (*Ghazal* translated by Ibrahim Gamard, Private Correspondence 1-24-99).

40. Bayram, *Fatma Baci Ve Baciyan-i Rum,* 5.

41. Cemal Kafadar, "Women in the Seljuk and Ottoman Society," from *Women in Anatolia, 9000 Years of the Anatolian Woman* (Istanbul: Ministry of Culture, General Directorate of Monuments and Museums, 1993), 195.

42. Ibid., 195.

43. Friedlander, *The Whirling Dervishes,* 109.

44. *The Dervish Lodge,* ed. Raymond Lifchez (Berkeley: University of California, 1992), 309. *See also:* Kafadar, *Women in Anatolia,* 196.

45. *Mathnawi of Jelaluddin Rumi,* vol. V, 2045.

Women Dervishes of the Past: Silsila of the Mevlevi Order

1. *Legend of the Sufis,* Selections from Shemsu-'d-din Elflaki's, *Menaqibu' L'Arifin,* trans. James Redhouse (London: Theosophical Publishing, 1977), 122–5.

2. Margaret Smith, *Rabi'a* (Oxford: Oneworld, 1994), 19–112.

3. *Saints Des Derviches Tourneurs,* (*Menaqibu'L'Arifin* by El Eflaki), trans. C. L. Huart (Paris: Editions Ernest Leroux, 1918) vol. I, 328; vol. II, 173, 267, 363.

4. *Legend of the Sufis,* 1.

5. Abdulbaki Golpinarli, *Mevlana'dan Sonra Mevlevilik* (Istanbul: Inkilap ve Aka, 1983), 86. *See also:* Annemarie Schimmel, *I Am Wind, You Are Fire* (Boston: Shambhala, 1992), 13.

6. Eva de Vitray-Meyerovitch, *Rumi and Sufism,* trans. by Simone Fattal (Sausalito, Ca.: Post-Apollo, 1977), 18–20. *See also:* Golpinarli, *Mevlana'dan Sonra Mevlevilik,* 29, 86.

7. Golpinarli, *Mevlana'dan Sonra Mevlevilik.* 25, 67, 278, 284, 358. *See also: Saints Des Derviches Tourjours,* vol. I, 73–5, 98, 156, 171, 225, 235, 310, 354; vol. II: 89, 101, 121, 173, 204–5, 236, 251, 255, 257, 264, 429.

8. Golpinarli, *Mevlana'dan Sonra Mevlevilik,* 67, 278, 358. *See also:* Schimmel, *I Am Wind, You Are Fire,* 31. Dr. Mikail Bayram, *Fatima Baci ve Baciyan-i Rum* (Konya: Damla Ofset Matbaacilik ve Ticaret, 1994) 5. Saints Des Derviches Tourneurs, vol. I, 161, 318.

9. Erkan Turkmen, *The Essence of Rumi's Masnevi* (Konya: Misket, 1992), 26 *See also:* Golpinarli, *Mevlana'dan Sonra Mevlevilik,* 36, 93.

10. Golpinarli, *Mevlana'dan Sonra Mevlevilik,* 3, 36.

11. Ibid., 36, 82. *See also: Saints Des Derviches Tourneurs,* vol. I, 75, 110, 235, 294, 333–4, 339, 362.

12. *Saints Des Derviches Tourneurs,* vol. I, 137–170; vol. II, 208, 348.

13. Golpinarli, *Mevlana'dan Sonra Melevilik,* 82. *See also: Saints Des Derviches Tourneurs,* vol. II: (Ain-el Hayat) 366–7.

14. Golpinarli, *Mevlana'dan Sonra Mevlevilik,* 86, 246, 279, 281. *See also:* Vitray-Meyerovitch, *Rumi and Sufism,* 42.

15. *Legend of the Sufis,* 64–5. *See also: Saints Des Derviches Tourneurs,* vol. I, 256–7, 338; vol. II, 104, 309.

16. *Legend of the Sufis,* 77–8.

17. *Legend of the Sufis,* 87–8. *See also: Saints Des Derviches Tourneurs,* vol. II, 104.

18. *Saints Des Derviches Tourneurs,* vol. II, 353, 370.

19. *Crazy As We Are,* Mevlana Celaleddin Rumi, trans. by Dr. Nevit Ergin (Prescott, Az.: Hohm, 1992), vii. *See also:* Mehmet Onder, *Mevlana Jelaleddin Rumi* (Ankara: Amfora), 55–59. *Saints Des Derviches Tourneurs,* vol. II, 134, 137. *Legend of the Sufis,* 96–7.

20. Vitray-Meyerovitch, *Rumi and Sufism,* 31. *See also:* Golpinarli, *Mevlana'dan Sonra Mevlevilik,* 44, 65, 68, 93–4, 102, 131, 278. *Saints Des Derviches Tourneurs,* vol. I, 54, 303, 317, 364; vol. II, 188, 206–7, 214, 217, 288 295–7, 300, 429.

21. Lucy Garnett, *The Dervishes of Turkey* (London: Octagon, 1990), 173. *See also: Saints Des Derviches Tourneurs,* vol. II, 205–6.

22. Schimmel, *The Triumphal Sun,* 27 *See also: Legend of the Sufis,* 101. *Saints Des Derviches Tourneurs,* vol. II, 206, 213–4.

23. Golpinarli, *Mevlana'dan Sonra Mevlevilik,* 44, 65, 67, 101, 103–4, 122, 131, 154, 278. *See also: Saints Des Derviches Tourneurs,* vol. II, 297 354, 430.

24. *Saints Des Derviches Tourneurs,* (see Cherif) vol. II, 297, 353, 430–1. *See also:* Golpinarli, *Mevlana'dan Sonra Mevlevilik,* 44, 65, 67, 205, 246, 278, 332–3.

25. Golpinarli, *Mevlana'dan Sonra Mevlevilik,* 44. *See also: Saints Des Derviches Tourneurs,* vol. II (Noucret) 288, 430.

26. Golpinarli, *Mevlana'dan Sonra Mevlevilik,* 67. *See also: Saints Des Derviches Tourneurs,* vol. II (Daulet), 430.

27. Golpinarli, *Mevlana'dan Sonra Mevlevilik,* 71–2, 82. *See also: Saints Des Derviches Tourneurs,* vol. II, 346–7.

28. Golpinarli, *Mevlana'dan Sonra Mevlevilik,* 67, 278. *See also: Saints Des Derviches Tourneurs,* vol. II, 363, 430.

29. Golpinarli, *Mevlana'dan Sonra Mevlevilik,* 359–60.

30. Shems Friedlander, *The Whirling Dervishes* (Albany: SUNY, 1972), 110. *See also:* Golpinarli, *Mevlana'dan Sonra Mevlevilik,* 279.

31. Golpinarli, *Mevlana'dan Sonra Mevlevilik,* 280–1.

32. *Woman In Anatolia, 9000 Years of the Anatolian Woman,* Section on Women in Seljuk and Ottoman Society by Cemal Kafadar (Istanbul: Turkish Republic Ministry of Culture General Directorate of Monuments and Museums, 1993), 195.

33. Ibid., 196. *See also: The Dervish Lodge,* ed. Raymond Lifchez (Berkeley: University of California Press, 1992), 309.

34. Golpinarli, *Mevlana'dan Sonra Mevlevilik,* 280–1.

35. Mevlevi Order of America, Program Notes 12-10-94, Sema of 1994, Fairfax, Ca.

Chapter 4: Training of a DervishThen and Now

1. *A Garden Beyond Paradise, The Mystical Poetry of Rumi,* trans. by Jonathan Star and Shahram Shiva (New York: Bantam, 1992), 80.

2. Mehmet Onder, *Mevlana and The Mevlana Museum* (Istanbul, Turkey: Ajans Ltd.), 48–50. *See also:* Shems Friedlander, *The Whirling Dervishes* (Albany: SUNY, 1992), 107.

3. Onder, *Mevlana and the Mevlana Museum,* 50–51. *See also:* Friedlander, *The Whirling Dervishes,* 108.

4. *Magnificent One,* trans. by Nevit Oguz Ergin (Burdett, N.Y.: Larson, 1993), 100.

5. *Dervish Lodge,* ed. Raymond Lifchez (Berkeley: University of California Press, 1992), 261–6.

6. Onder, *Mevlana and the Mevlana Museum,* 51.

7. Eva De Vitray-Meyerovitch, *Rumi and Sufism,* trans. by Simone Fattal (Sausalito, Ca.: Post-Apollo Press, 1977), 37.

8. Onder, *Mevlana and the Mevlana Museum,* 50. *See also:* Friedlander, *The Whirling Dervishes,* 107–8.

9. Vitray-Meyerovitch, *Rumi and Sufism,* 37.

10. Friedlander, *The Whirling Dervishes,* 108–9.

11. Onder, *Mevlana and the Mevlana Museum,* 52–53 *See also:* Friedlander, *The Whirling Dervishes,* 109.

12. Friedlander, *The Whirling Dervishes,* 102–3.

13. The Hymn of Entreaty" Ilahi by Sultan Veled, based on translation by Refik Algan and Camille Helminski, *Wherever You Turn is the Face of God,* Mevlevi Ceremonial Music (Santa Barbara, Ca.: Water Lily Acoustics, 1995) CD, 30, and Ibrahim Gamard, Private Correspondence, 1-29-99.

14. Shems Friedlander, *The Whirling Dervishes,* 112.

15. Talat Halman and Matin And, *Mevlana Celaleddin Rumi and the Whirling Dervishes* (Istanbul: Dost, 1983), 73.

16. Reshad Feild, *The Last Barrier* (San Francisco: Harper, 1976), 143–154. *See also:* Murat Yagan, *I Come From Behind Kaf Mountain* (Putney, Vt.: Threshold, 1984), 145–154. Friedlander, *The Whirling Dervishes,* xix, 30, 101.

17. An "Open Letter" from Postnishin Jelaluddin Loras to the Mevlevi Order from program notes of the *Sema of Beginning,* Mevlevi Order of America, 1993, Fairfax, Ca.

18. *Rumi, In the Arms of the Beloved,* trans. Jonathan Star (New York: Jeremy P. Tarcher, 1997), 182–3.

19. Vitray-Meyerovitch, *Rumi and Sufism,* 49.

20. "Prayer of the Prophet" by Abu Talib Al-Makki found in Annemarie Schimmel, *Mystical Dimensions of Islam* (Chapel Hill: University of North Carolina Press, 1975), 215.

Chapter 5: Shebi Arus: The Wedding Night

1. *A Garden Beyond Paradise,* trans. by Jonathan Star and Shahram Shiva (New York: Bantam, 1992), 80.

2. Ibrahim Gamard, Private Correspondence 1-13-99.

3. Dr. Celaleddin Celebi, "The Gate of Secrets, *Wherever You Turn is the Face of God."* Mevlevi Ceremonial Music (Santa Barbara, Ca.: Water Lily Acoustics, 1995) CD, 11–22.

4. Eva de Vitray-Meyerovitch, *Rumi and Sufism,* trans. by Simone Fattal (Sausalito, Ca.: Post-Apollo Press, 1987), 44–49.

5. Mehmet Onder, *Mevlana and the Mevlana Museum* (Istanbul: Aksit Ltd., 1993), 54–60. *See also:* Talat Sait Halman and Metin And, *Mevlana Celaleddin Rumi and the Whirling Dervishes* (Istanbul: Dost, 1983), 61–71. Shems Friedlander, The Whirling Dervishes (Albany: SUNY, 1972), 88–92.

6. *Unseen Rain,* versions by John Moyne and Coleman Barks (Putney, Vt.: Threshold, 1986), 56.

7. Notes from Turning class lead by Postneshin Jelaluddin Loras, 1982–5.

8. Jelaluddin Loras, "The Sema: We take from God and give to People" *Lovers of Mevlana* (Winter, 1997), 9. *See also:* Andrew A. Moyer, *Soap for the Heart: Dance of the Mevlevi* (Toronto: York University, 1980), 77. Master's Thesis.

9. Prayer in Turkish: Postnishin Jelaluddin Loras, Private Correspondence 1-15-99, translation into English; Ibrahim Gamard, Private Correspondence, 1-18-99.

10. Eva de Vitray-Meyerovitch, *Rumi and Sufism,* 51.

11. *The Qur'an,* Sura Baqara 115–8 translation by Ibrahim Gamard, Private Correspondence, 1-21-99.

12. *Na'at,* translation based on versions: Shems Friedlander, *The Whirling Dervishes* (Albany: SUNY, 1992), 133. "The Gate of Secrets, *Wherever You Turn is the Face of God."* Mevlevi Ceremonial Music (Santa Barbara, Ca.: Water Lily Acoustics, 1995) CD, 25. Ibrahim Gamard, correspondence 11/1/00. According to Ibrahim Gamard the following verse has been omitted from the original in our current version: "On the night of the Ma'raj, the Ascension, Gabriel, the angel was at your stirrup, and then you were standing on top of the nine blue domes of heaven!"

13. Fatiha, first sura of the *Qur'an,* translated by Imam Bilal Hyde, *Lovers of Mevlana,* vol. 2 (Winter 1997), 24.

Chapter 6: Semazens of More than Twenty Years

1. *Like This,* trans. by Coleman Barks, (Athens, Ga.: Maypop, 1990) 20.

2. *One-handed Basket Weaving,* trans. by Coleman Barks (Athens, Ga: Maypop, 1991), 4.

Chapter 7: Members of the First ClassBay Area

1. *Open Secret,* trans. by John Moyne and Coleman Barks (Putney, Vt: Threshold, 1984), 8.

2. *Rending the Veil,* trans. by Shahram T. Shiva (Prescott, Az.: Hohm Press, 1995), 81.

3. *A Garden Beyond Paradise,* trans. by Jonathan Star and Shahram Shiva (New York: Bantam, 1992), 42.

4. *One-handed Basket Weaving,* trans. by Coleman Barks (Athens, Ga.: Maypop, 1991), 74.

Chapter 8: Atesh Bas: The Path of Service

1. Shems Friedlander, *The Whirling Dervishes* (Albany: SUNY, 1992), 58.
2. *Unseen Rain,* trans. by John Moyne and Coleman Barks (Putney, Vt.: Threshold, 1986), 20.
3. *Say I Am You,* trans. by John Moyne and Coleman Barks (Athens, Ga.: Maypop, 1994), 52.
4. *Rumi, Fragments–Ecstasies,* trans. by Daniel Liebert (Cedar Hill, Mo: Source Books, 1981), 11.
5. Ibid., 28.
6. *Birdsong,* trans. by Coleman Barks (Athens, Ga.: Maypop, 1993), 13.

Chapter 9: Zikr: The Practice of Remembrance

1. *Rending the Veil,* trans. by Shahram T. Shiva (Prescott, Az.: Hohm, 1995), 41.
2. *Rumi, In the Arms of the Beloved,* trans. by Jonathan Star (New York: Jeremy P. Tarcher/Putnam, 1997), 17.
3. Annemarie Schimmel, *Mystical Dimensions of Islam* (Chapel Hill: University of North Carolina, 1975), 270.
4. J. Marvin Spiegelman, Pir Vilayat Khan and Tasmin Fernandez, *Sufism, Islam and Jungian Psychology* (Scottsdale, Az.: New Falcon Press, 1991) 65–73. *See also:* Atum O'Kane's Retreats: the alchemical process.
5. Information gathered from participating in annual retreats from 1989 to 2001 as lead by Aziza Scott, head of the Zirat School of the Sufi Order International, based on the "Alchemical Retreat Process" created by Pir Vilayat Khan.
6. *Birdsong,* trans. by Coleman Barks (Athens, Ga.: Maypop, 1993), 44.
7. *The Mathnawi of Jalalu'din Rumi,* Book I, 2020–23, trans. Reynold A. Nicholson (Warminster, Wiltshire: E.J.W. Gibb Memorial Trust, 1926), 110.
8. Samuel L. Lewis, *In the Garden* (New York: Harmony, 1975), 5.
9. Sharif Baba, *Sohbet,* translator Gonul Cengiz Chafied, North Carolina, 10-1-98.
10. *The Essential Rumi,* trans. by Coleman Barks with John Moyne (San Francisco: Harper, 1995), 278.
11. Abdullah Yusaf Ali, *The Qur'an,* (Elmhurst, NY: Tahrike Tarsile Qur'an, Inc., 1987), 1124. See, the "Verse of the Curtain," Surah Ahzab 33: 53.
". . . and when ye Ask (his ladies) For anything ye want, Ask them from before a screen . . ." This verse came through at the time of the prophet's wedding to Zainab. A few of the wedding guests remained behind long after the others had departed. The verse describes proper behavior for guests in the home of the Prophet. It is said that Umar, the second Caliph urged Muhammad to seclude his wives because he feared they (the wives) might be insulted and were physically vulnerable. If we look to the time of the Prophet, there are several stories revealing the vulnerability of the Prophets' wives to the *munafiqun* or hypocrites, who desired to harm or disprove his spiritual leadership, the most famous being the incident with Aishah, his youngest wife, and her necklace.
Here is a summary of that incident: *While traveling with Muhammad on a caravan, Aishah went in the early morning hours to relieve herself, as was the custom. On the way back she discovered that she had lost her necklace and returned to look for it. Meanwhile, the caravan took off, not realizing she wasn't in her litter. She came back to the deserted grounds and sat down, hoping that her absence would be noticed and they would return for her. While she was waiting, Aishah fell asleep. She awoke to find an embarrassed young man, Safwan ibn al-Mu'attal, standing beside her. He helped her to mount his camel and silently led the camel back to the caravan.* (For a more detailed acccount see: *Nabia Abbott, Aishah, The Beloved of Muhammad,* (Chicago: University of Chicago Press, 1942), p. 30–36.)
Some of Muhammad's followers seized on this incident as a powerful weapon, spreading malicious gossip about Safwan and Aishah, and thus began

the "affair of slander" which resulted in Surah Nur 24: 11–20, (Ali, *The Qur'an,* 899–901) supporting her innocence. Thus, the practice of seclusion for the wives of the Prophet protected them from gossip as well as the very real threat of being physically roughed up. It also provided them privacy from the constant stream of visitors to their home. One of the conditions of Atikah bint Zaid, a widow of Umar, the very caliph who had recommended to Muhammad to seclude his wives, was that her new husband would permit her to continue to attend the mosque. (*See:* Abbott, *Aishah, The Beloved of Muhammad,* 88.) For a more in-depth explanation of the verse of the curtain and *hijab* see: Fatima Mernissi, *The Veil and the Male Elite,* New York: Addison-Wesley, 1991), 98–101. Nabia Abbott, *Aishah, The Beloved of Mohammed,* (Chicago: University of Chicago Press, 1942), 20–38.

12. Annemarie Schimmel, *I Am Wind, You Are Fire* (Boston: Shambhala, 1992), 97.

13. Surah 24:30–31 and Surah 33:59 address the issue of "covering" for women. For an interpretation of the meaning and context of these verses see: Abbott, *Aishah,* 22. *See also:* Mernissi, *The Veil and the Male Elite,* 186. Jan Goodwin, *Price of Honor* (New York: Plume: Penguin, 1994), 30.

14. *The Love Poems of Rumi,* ed. by Deepak Chopra (New York: Harmony Books, 1998), 24.

15. *Rumi, In the Arms of the Beloved,* trans. by Jonathan Star, 183.

Chapter 10: Adab: Tradition of the Honored Guest

1. *This Longing: Poetry, Teaching Stories, and Letters of Rumi,* trans. by Coleman Barks and John Moyne (Putney, Vt.: Threshold, 1988), xvii.

2. Hazrat Inayat Khan, *The Gathas* (Katwijk, Holland: Servire, 1982), 192–204.

3. Imam Bilal Hyde, Private Correspondence, 2-17-98.

4. *Rumi, In the Arms of the Beloved,* trans. by Jonathan Star (New York: Jeremy P. Tarcher/Putman, 1997), 158–9.

5. *Rumi, We Are Three,* trans. by Coleman Barks (Athens, Ga.: Maypop, 1987), 44.

6. Nabia Abbott, *Aishah, The Beloved of Mohammed* (Chicago: The University of Chicago Press, 1942), 66–7.

7. Eva de Vitray-Meyerovitch, *Rumi and Sufism,* trans. by Simone Fattal (Sausalito, Ca.: Post-Apollo, 1987), 36–7.

8. Dr. Javad Nurbakhsh, *The Tavern of Ruin* (London: Khaniqahi-Nimatullahi Publications, 1978), 81.

9. Shaikh Taner Ansari Tarsusi er Rifa'i Qadiri, Excerpts from *"Adab, the core of Sufism,"* presented at the International Sufi Symposium, Fremont, Ca., March 1998.

10. Eva de Vitray-Meyerovitch, *Rumi and Sufism,* 37.

11. *Open Secret, Versions of Rumi,* trans. by John Moyne and Coleman Barks (Putney: Vt.: Threshold, 1984), 45.

12. Ibid., 50.

13. "Mevlevi Prayer for Food," *The Dervish Lodge,* ed. Raymond Lifchez (Berkeley: University of California Press, 1992), 298

Chapter 11: Ayn-i Cem: A Ritual from Past to Present

1. An interpretation of Golpinarli, *Mevlana'dan Sonra Mevlevilik,* 413–415 *"Ayn-i Cem,"* based on translations by Shaikha Muzeyyen Ansari, Shaikh Taner, Latif Bolat, and Ibrahim Gamard with additional information and selections of poetry as noted.

2. *Rending the Veil,* trans. by Shahram T. Shiva (Prescott, Az.: Hohm, 1995), 233.

3. Mevlana Celaleddin Rumi, *Divan-i Kebir,* Meter 1, trans. by Nevit O. Ergin (Walla Walla, Wash.: Current, 1995), 14.

4. Ali, *The Holy Qur'an,* Surah LIX, verse 24, 1529.

5. *Open Secret, Versions of Rumi,* trans. John Moyne and Coleman Barks (Putney, Vt.: Threshold, 1984), 9.

6. *Rending the Veil,* 102.

7. Ibid., 142.

8. Abdulbaki Golpinarli, *Mevlana'dan Sonra Mevlevilik* (Istanbul: Inkilap ve Aka, 1983), 414.

9. *Dervish Lodge,* ed. Raymond Lifchez (Berkeley: University of California, 1992), 106.

10. See footnote 1.

Inspirational Turning

1. Halman and And, *Mevlana Celaleddin Rumi and the Whirling Dervishes,* 52–3.

2. *Crazy As We Are,* trans. by Dr. Nevit Ergin (Prescott, Az: Hohm Press, 1992), 4.

3. *Dervish Lodge,* ed. Raymond Lifchez (Berkeley: University of California, 1992), 255–6.

Chapter 12: Forming the Bridge, 1978 – 2001

1. Francis Huxley, *The Way of the Sacred* (New York: Doubleday, 1974), 155.

2. *Birdsong,* trans. by Coleman Barks (Athens, Ga.: Maypop, 1993), 38.

3. *Open Secret,* trans. by John Moyne and Coleman Barks (Putney, Vt.: Threshold, 1984), 22.

4. Ibid., 20.

5. Ibid., 7.

6. *These Branching Moments,* trans. by John Moyne and Coleman Barks (Providence, R.I.: Copper Beech Press, 1988), 8.

7. Andrew Harvey, *The Way of Passion* (Berkeley, Ca.: Frog Ltd., 1994), 40.

8. Jonathan Star, *Two Suns Rising* (New York: Bantam, 1991), 118.

9. *Rending the Veil,* trans. by Shahram T. Shiva (Prescott, Az.: Hohm Press, 1995), 103.

10. *Open Secret,* 11.

11. Shaikh Muhammad Hisham Kabbani and Laleh Bakhtiar, *Encyclopedia of Muhammad's Women Companions and the Traditions They Related* (Chicago: KAZI Publications, 1998), xxix..

12. *Look! This is Love,* trans. by Annemarie Schimmel (Boston: Shambhala, 1991), 61.

Chapter 13: Inner Circle: The Fourth Selam

1. *Say I Am You,* trans. by John Moyne and Coleman Barks (Athens, Ga: Maypop 1994), 70.

2. *The Essential Rumi,* trans. by Coleman Barks with John Moyne (San Francisco: Harper, 1995), 106.

3. *Desert Wisdom: Sacred Middle Eastern Writings from Goddess Through the Sufis,* trans. and commentaries by Neil Douglas Klotz (San Francisco: HarperSanFrancsico, 1995), 36.

4. *Rumi, In the Arms of the Beloved,* trans. by Jonathan Star (New York: Jeremy P. Tarcher, 1997), 32.

Chapter 14: Music: The Mutrip

1. *Open Secret,* trans. by John Moyne and Coleman Barks (Putney, Vt.: Threshold, 1984), 49.

2. *Rumi, We Are Three,* trans. by Coleman Barks (Athens, Ga.: Maypop, 1987), 12.

3. *The Love Poems of Rumi,* ed. Deepak Chopra, (New York: Harmony, 1998), 48.

Chapter 15: The Next Generation

1. *The Essential Rumi,* trans. by Coleman Barks with John Moyne (San Francisco: Harper, 1995),

2. *Night and Sleep,* trans. by Coleman Barks and Robert Bly (Cambridge: Yellow Moon, 1981), see selection entitled "No Wall."

3. Eva de Vitray-Meyerovitch, *Rumi and Sufism,* trans. by Simone Fattal (Sausalito, Ca.: Post-Apollo, 1977), 53.

4. *Rumi, We Are Three,* trans. by Coleman Barks (Athens, Ga: Maypop, 1987), 63.

Last Photograph

Love's Fire: Re-creations of Rumi, trans. by Andrew Harvey (Ithaca, N.Y.: Meeramma, 1988), 108.

Glossary

1. Annemarie Schimmel, *Mystical Dimensions of Islam* (Chapel Hill: University of North Carolina, 1975), 232.

Glossary

Abdas *(Abdest)* (Turkish) Ablutions. Ritual washing for purification. See *Wudu.*

Abdulbaki Golpinarli Acknowledged as both a scholar and a Mevlevi and Bektashi Shaikh. He was known as a Mesnevi Han, the recognized master, in his generation, of Rumi's *Mathnavi.* He translated many writings from Arabic into the modern Turkish. He died in 1982.

Adab (Arabic) Commonly understood to mean refined manners. The ability to manifest right action in the right moment, reflecting attunement to the Divine of a tranquil soul. Respect that comes through graciousness, consideration and love.

Adhan (Arabic) In the Muslim tradition, the call to prayer. It is chanted five times a day by the *muezzin* from the minaret of the mosque.

Ahad (Arabic) A *wazifa* meaning "The Only One." The One full of Grace whose path is the secret of unity.

Alchemical retreat A process developed by Pir Vilayat Khan for personal transformation. It contains seven stages of disintegration and re-creation of the personality drawing on the principles of alchemy to facilitate the participant's realization of the Divine, which lies within.

Alflaki, (Elflaki) Shams' iddin Ahmed A student of Ulu Arif Chelebi, grandson of Rumi. Ulu, on his deathbed asked Alflaki to record the history of the Mevlevi Order. Many historians believe Alflaki's *Maniqib L'Arfin (Legend of the Sufis)* is hagiography, rather that actual recorded history. He died in 1356.

Al Hallaj Husayn ibn Mansur A famous Sufi martyr who was executed for expressing his controversial realizations, the most famous of which is *"Ana'l-Haqq,"* "I am the Truth." He died in 922.

Alhamdulillah (Arabic) Sacred phrase meaning literally, "Thanks be to God!" "All Praise be to God!"

Allah (Arabic) The One True God. From the *Qur'an,* literally "The God," "The One and Only," "One without equal."

Allahu Akbar! (Arabic) Sacred phrase meaning, "God is Great," "God is greater! God is the Greatest!"

Ammachi Born September 27, 1953. Formally known as Amritanandamayi Ma. A devotee of Krishna, she is considered a saint in her homeland of India. She has traveled extensively in the United States in the late 1990s and is known for taking people into her arms and holding them in her lap, while she is in a state of *samadhi,* during a ceremony known as Devi Bhava. This ceremony symbolically enacts being in the Presence of the Mother of the Universe. She has been known to receive 2,000 people individually in one evening.

Anatolia The name used in ancient times for Turkey.

Apsaras According to Hindu methodology, these human/angelic beings were heavenly dancers who came from the court of King Indra.

A Salam Alleichum (Arabic) Traditional greeting meaning "May the Peace of God be with you!"

Atesh Bas (Turkish) Literally means the "fire risker." Mevlana's cook who "sealed" his burnt left toe by covering it with his right. His willingness to serve Mevlana was such an example that Rumi had all his followers stand in *muhur,* the position of "being sealed," whenever they begin to turn. An initiation sometimes given to couples in the Mevlevi Order of America. The name symbolizes total service.

Ayin (Turkish) Literally means "rite" or "ceremony." Can also be ritual prayers set to music.

Ayn-i Cem (Turkish) "Gathering for Prayer." Originally a Mevlevi ritual. In the twentieth century, a small circle of trained *semazens* who use both traditional and inspirational movements developed by Shaikh Jelaluddin Loras.

Baha'uddin Veled The father of Jelaluddin Rumi; recognized as a scholar of Sufism in his time. Died Jan. 12, 1231.

Balkh The birthplace of Mevlana, located in Afghanistan.

Baraka (Arabic) Spiritual Blessing. Sacred energy that permeates the Universe with Divine Love. *Baraka* illuminates the heart of the Lover by manifesting itself through the Ninety-Nine Beautiful Names. (See *Wazifa.*) Said to be obtained through keeping company with one's teacher.

Bayat *(Baiat)* (Arabic) Comes from *"Bay'a,"* oath of allegiance. "Taking hands" with a spiritual teacher, considered a form of initiation. An offering of acceptance and submission to Divine will.

Bayazid Bestami A Sufi mystic and ascetic from Persia who sought to annihilate himself in God. Died in 874.

Bismillah ir Rahman ir Rahim One of the most frequently repeated phrases in the *Qur'an.* Can be translated as, "In the name of God, who is infinite mercy, all embracing compassion."

Bektashi A Turkish Sufi Order founded by the mystic Haji Bektash-i Veli who was a contemporary of Rumi and renowned for his teachings and guidance. He died in 1337.

Bhakti (Sanskrit) Yogic path of devotion.

Chelebi *(Celebi)* Direct descendent of Jelaluddin Rumi.

Chille *(Chilla)* In the context of the Mevlevi tradition, a solitary spiritual retreat that lasts for 1001 days.

Chisti *(Chishti)* **Order** Founded by Abu Ishaq Shami Chisti. Brought to Indian by Moinuddin Chisti. Moinuddin's *dargah* is in Ajmer. His teachings contain three principles of behavior: generosity like the river, affection like the sun and humility like the earth. The Sufi Order International is a branch of this lineage, with Pir Zia Khan, son of Pir Vilayat Khan, as the newly installed leader.

Chuk Refers to a single revolution in the practice of turning.

Dances of Universal Peace Circle Dances using simple movements, *mudras,* songs and chants from various religions. Created by Murshid Samuel Lewis. Commonly called "Sufi Dancing."

Dargah *(Dergah)* (Persian) "Place of the door." A Dervish convent that traditionally contained living quarters, a kitchen, a mosque, and the tomb of the founder. In India it refers to a tomb or shrine of a great being.

Dede Elder or grandfather. A title of respect given in the Mevlevi order.

Derbi Celali (Arabic/Persian) "Blow to Glory!" The moment when the *semazens* slap the ground in unison after the *Na'at* and before removing their *hurkas*. Reflects the awakening to the One True Reality. Symbolic of the moment of awakening on the Day of Judgment.

Dervish *(Darwish/ Darvesh)* (Arabic/Persian) It is composed of two syllables, *dar* and *vish*. *Dar* means "door." *Vish* is from *vihtan,* "to beg." *Vish* is also translated as "thought" or "to sit." One who sits in the doorway between the two worlds. One who resides in the realization of the Divine Presence. A being who radiates the presence of God's love.

Destegul (Turkish) "Handful of roses." A white jacket worn by *semazens* in *sema*.

Devri Veledi (Turkish) (Sultan Veled Walk) During the first part of the Shebi Arus ceremony, this refers to the circumambulation (three times) of the physical space by the *postnishin,* followed by the *semazenbashis* and *semazens,* all wearing their black cloaks.

Divan *(Divane)* A collection of lyrical poetry.

Duhani A felt hat smaller than a *sikke,* worn in the days of Rumi.

Efendi Turkish word used as a title, similar to "gentleman" or "one who holds knowledge"; also implies "dear friend."

Elementals Unseen spirits who are the living beings within the basic elements: earth, water, fire and air.

Elifinemed *(Alif-i namad)* A belt of cloth about four fingers wide and two-and-a-half feet long that is wrapped around the waist of the *semazen*. This belt divides the body into an "upper" and "lower" half, symbolizing the separation of the Divine from the animal nature. At the same time, the word itself contains the first letter of the Arabic alphabet, *alif,* which can represent those who are spiritually free and in true union with God.

Enneagram Refers to a system of nine distinct personality types and their interrelationships based on ancient Sufi teachings.

Estaghfur ul'llah *(Astagh fir ul'llah)* (Arabic) Seeking Divine Forgiveness. An intense longing or burning for the Mercy and Forgiveness of God.

Fana Annihilation, to dissolve or disappear into. To empty one's being of the false self.

Fana fi'sh Shaikh Dissolving one's being into the being of the shaikh. Close loving emulation of a shaikh. One can enter this *maqam* by seeing the aspect of father and mother within God in all things.

Faqir *(Fakir)* Literally, "Poor one." One who wants only God and avoids material attachment, thus is poor in the worldly sense. Emptying one's self to become a vessel for the Presence of God.

Fatiha Opening *sura* (chapter) of the *Qur'an*. The prayer chanted at the end of *sema*.

Feriste Hanum The name Feriste is Persian, meaning "angel." Wife of Suleyman Dede and mother of Jelaluddin Loras. Known as "Mother of the Dervishes" to many American *semazens*. She died September 10, 1994.

Fikr To place a thought on the natural rhythm of the breath in a concentrated manner. The effect of that thought is said to reach every atom of one's mind and body.

Galata Turbe (Tomb of Galata) Also known as the Galata Mevlevihane, "Grand Lodge" of the Mevlevi, located in Istanbul. This Mevlevi compound was built about four hundred years ago and contains a special octagon-shaped room for turning, with a balcony for the *mutrip*.

Gatha (Zoroastrian) Ancient scriptures called *gatha* or *githa,* meaning "music," because they were traditionally sung. Within the Sufi Order, the *gathas* are teachings given by Hazrat Inayat Khan to his disciples in the early 1920s. They consisted of seven subjects in three stages. Each stage consisted of ten lessons.

Gatheka In the Sufi Order, an introductory lesson.

Ghafur (Arabic) One of the beautiful names of God. "The One who is much Forgiving."

Ghazal (Persian) Short, rhyming, lyrical poems usually about love. Rumi's *ghazal* style combined prayer and love.

Gnostic One who possesses esoteric knowledge of spiritual matters. A follower of Gnosticism; a Hellenistic/Jewish/Christian movement in the early centuries of Christianity.

Green Tara She is of the Great Goddess tradition in Tibetan Buddhism and is considered a *bodhisattva,* one who is perfect in every way like the Buddha, but who chooses to relate to the world out of compassion. She is generally depicted with a green body and sitting in a half lotus position with one foot forward ready to serve.

Gulbang A traditional prayer. In the Mevlevi Order, can be offered at the end of a meal, at a spiritual gathering, or at a special ceremony.

Hajj Religious pilgrimage to Mecca. One of the five pillars of Islam.

Hal Mystical condition or state of consciousness. It is said to be a state put into our hearts by God, which we cannot repel when it comes nor attract it back when it goes. A temporary state such as the feeling of ecstasy.

Halife *(Khalif[a])* (Arabic/Turkish) In the early day of the Mevlevi Order, a rank given to the "most sincere" dervish in the order. Can be designated successor or one who is given the role of ambassador for the Order in other countries. Shaikh's assistant.

Halveti Jerrahi Order was founded in Turkey by Umar al Khalwati, who died in 1397. Shaikh Muzaffer Ozak, who was head of the Order in Istanbul in the mid-1990s, helped establish several branches in the United States. Shaikh Muzaffer died February 12, 1985.

Hanum *(Hanim)* (Turkish) From Persian. A title given to women as a sign of respect. Within the Sufi tradition, it implies one who holds a certain level of spiritual attainment.

Hatti Istifa *(Hat-i istivb)* Literally "straight line." Also connotes equator. The invisible centerline bisecting the *sema* hall, on which the *post* is placed at one end. Represents the crossing from this world to the next.

Hayy (Arabic) "The One who is Ever-living and Everlasting. " One of the Ninety-Nine Names of God. Origin of the life force in all of creation.

Hazrat Babajan Died on September 21, 1931 in Poona, India. A marble tomb was built over her remains at the neem tree where she sat for many years giving her unique style of Sufi teaching.

Hazrat Inayat Khan Sufi Teacher from the Chisti Order in India who spread the message of Sufism to the Western world at the turn of the twentieth century.

His lectures and insights are preserved in the series of books known as the Sufi Message Volumes. He died February 5, 1926.

Herkalya *(Harqalya)* (Zoroastrian) "The Heavenly Paradise." Formerly a *khanqah* or spiritual center of the Sufi Order in Marin County, California.

Hu Sacred name of God, divine pronoun. Refers to the Divine Essence beyond all attributes and qualities. Similar to the chanting of *Om* in the Hindu tradition. Ibn' Arabi is said to have used it to evoke the Presence of God.

Hujra Cell or small room in a *tekke* used by retreatant during a *chille.*

Hurka *(Khirqa/Kherqa/Hirka)* (Arabic and Turkish) From the Arabic "torn rag." Patched cloak of the dervishes. In the Mevlevi tradition, a black mantle worn by the *semazens* in the *sema*. Symbolic of the grave or limited ego self. When a *semazen* drops the cloak in *sema,* they shed all attachment to the earth. In ancient times, the *hurka* was given by a teacher to a follower as a tangible recognition of spiritual development.

Husameddin A senior disciple of Rumi who helped record the *Mathnawi* and became the head of the Mevlevi Order after Rumi's death. He died in 1284.

Ibn'Arabi (known as Muhyiuddin, Reviver of the Faith) A Sufi mystic believed to have been born in Spain in 1165 on the Night of Power during Ramadan. It has been said that Khidr gave him his *hurka*. One of his teachers was Fatima of Cordova. He was the author of over three hundred books. He was known as Ash-Shaykh al Akbar, "the greatest master." He died in Damascus in 1240.

Icazet Literally means "permission, license." A formal letter of recognition given from a Pir or Shaikh defining and acknowledging a teacher's authority within a Sufi Order.

Ilahi Sacred songs or hymns sung by Sufis. Usually they are mystical poems sung in gatherings of dervishes. Much of the poetry comes from Yunus Emre and Jelaluddin Rumi.

Imam Leader of prayer within the Muslim religion. Usually recognized as a religious leader.

Inshallah Sacred phrase meaning "If God wills." Used when speaking about the future. By saying *"Inshallah"* we are surrendering to and aligning ourselves with the will of God. In daily conversation, it is a way of remembering and surrendering to God's Presence in our lives.

Ishq Divine Love or Essence.

Ishq Allah Ma'abud Lillah God is Love, Lover, and Beloved.

Jelaluddin Loras *Postnishin* of Shebi Arus. Sent by his father, Shaikh Suleyman Hayati Dede, to share The Path of Mevlana with American men and women. Established the Mevlevi Order in America.

Jihad Commonly understood to mean holy war. The word implies a physical, moral, spiritual and intellectual effort to create a just and decent society. Can also infer an individual's struggle with the *nafs* or limited self.

Joe Miller Beloved friend and teacher of the San Francisco Bay Area Sufis. Known for his famous Thursday Morning Walk through Golden Gate Park and Thursday Evening Music Hour at the San Francisco Lodge of the Theosophical Society. The music hour was created by his wife, Guin. He died August 19, 1992.

Kaaba The most sacred shrine of the Muslim religion. A cubical building in the courtyard of the great Mosque at Mecca. A small sacred black stone is part of the structure.

Kadum A kettle drum, usually two drums played side by side with wooden sticks. This instrument is traditionally used in *sema* music.

Kanun A Turkish stringed instrument used in the *mutrip,* similar to a zither or hammered dulcimer and played with two miniature hammers.

Karim The most Bountiful and Generous One. The quality of generosity. One of the Ninety-Nine Names of Allah.

Karma *(Sanskrit)* Fate. The rhythm of past actions. The law of cause and effect in direct relationship to our thoughts, emotions, speech and actions. Within the Hindu and Buddhist tradition a belief that the karma from one life passes into our next life.

Khadija A widow and business woman who became Muhammad's first wife. Throughout their marriage she was a source of great comfort and support to Muhammad who sought her valued insight. She died in 619.

Khanqah *(Khaneqah/Khankah)* (Arabic /Turkish) A spiritual center. A home where those who are on the path of Sufism live together and practice their faith through the day to day interactions with each other. "The Khanqah is the nest for the bird 'purity', it is the rose garden of pleasure and the garden of faithfulness." Sana'i .1

Khanqah Sam A home by Precita Park in San Francisco where the late Samuel Lewis lived with his *murids.* It still functions as a *khanqah* in the Ruhaniat Society.

Khidr In the Sufi tradition, an immortal teacher who appears in various guises to instruct and guide very special beings.

Khilvat A solitary retreat from daily life to concentrate on spiritual practice. Usually a period of three to forty days.

Konya Formerly the capital of the Seldjik empire in Anatolia. A city in Turkey where Rumi lived most of his life until his passing and where his tomb is located.

Krishna *(Sanskrit)* Krishna is the ideal of Divine love. He is depicted wearing a crown of peacock feathers and playing the flute. His story as an avatar is told in the *Bhagavad Gita.*

Kutup Noktasi Literally means "polar point." The center of the physical space used in *sema.* The *postnishin* or representative of the Way of Mevlana turns in this place in the fourth *salam.*

Lalla A Hindu mystic from the fourteenth century who lived in Kashmir. She was known for wandering and dancing naked in the style of a *sadhu,* singing her songs. Her poetry speaks to her state of realization. She died in 1391.

La ilaha illa 'llah (Hu) (Arabic) Sacred phrase used in *zikr,* on retreat, as a prayer. This thought is a doorway into the one true reality. Through repetition, this phrase can aid one in shattering the veils of illusion. One way of translating it is, "There is no Reality except the Reality of God." It is considered to be an affirmation of inner certainty in the Islamic tradition. The syllable *"Hu"* is added on by some Sufi Orders.

Latifas A system of energy centers like the yogic chakras, which reside in the body and can be developed through breath and prayer.

Matrisse *(medrese)* A university for religious study.

Maqam A spiritual station or stage. Stages of spiritual development on the mystical path. One who is invested with the title Murshid or Pir holds a particular *maqam*

of spiritual development. In Turkish music, a melodic itinerary based on a specific scale.

Maqbara Memorial; final resting-place. The Maqbara of Murshid Samuel Lewis is located at the Lama Foundation in New Mexico.

Mashallah Sacred phrase meaning "As God wills." Refers to what has already manifested in the past.

Mathnawi *(Mesnavi)* Mystical didactic poetry. The *Mathnawi* of Jelaluddin Rumi is considered to be his greatest work. It begins with the famous poem, "Listen to the sound of the Reed, how it tells a tale complaining of separation . . ." It has been called the *Qur'an* in Persian. It contains six volumes of 25,700 verses with twenty-two syllables in each verse in the form of poetic stories and commentaries.

Mesnevi-Han A title conferring recognition to the person who has the greatest mastery of Rumi's *Mathnawi* in each generation.

Mevlana *(Maulana)* In Arabic it means "Our Master." Title given to Jelaluddin Rumi.

Mevlevi The Order of Sufism in Turkey known as the Whirling Dervishes.

Mirabai Born in 1498. A Hindu mystic and devotee of Krishna known for her ecstatic poetry. Death date is uncertain.

Mother Teresa Born 1910. A Roman Catholic nun who began with just herself and then a handful of volunteers responding to the sufferings of human beings in the streets of Calcutta, India. By 1948 a small school was established followed by a home for the dying in 1952, an orphanage and then a clinic serving people who suffer from leprosy. By early 1990s the Missionaries of Charities had spread through the world. She died September 5, 1997. Her work continues to flourish.

Muezzin *(Mu'azzin)* The one who "calls to prayer" the followers of the Muslim religion. It is a prayer known as the *"adhan"* first sung by Bilal, a follower of Muhammad. Traditionally the *adhan* is sung five times a day from a minaret.

Muhur *(mohur)* Literally "the position of being sealed." *Semazens* assume this position of humility throughout the *sema* and always before beginning to turn. It is based on the inspirational behavior of Rumi's cook, Atesh Bas, in his devotion to his beloved Rumi.

Muhasibi *(muhasaba)* The practice of reflecting upon one's thoughts, emotions and actions, done each day usually after evening prayers. The practice of seeing oneself as in a mirror. A willingness to come face to face with all aspects of our being through self-examination of the conscience.

Mukabele Meeting face to face. That moment in the Sultan Veled walk when we as *semazens* face each other across the *post,* greeting each other soul to soul. Another name used for the Shebi Arus, ceremony of the Mevlevis.

Mulla Nasrudin Claimed by many countries as a native, with an erected gravesite located in Turkey. He is used by Sufi teachers as a very human character whose antics reveal the human mind in a playful and delightful manner. Idries Shah has collected many of his tales and made them available to the English speaking world.

Murid A student or disciple who is under the guidance of a teacher on the path of Sufism.

Murshid Sufi spiritual guide. Ideally, one who is receptive to the word of God from within, who is illuminated, and who holds communion with God.

Murshid Sam See Samuel Lewis.

Mutrip (From the Arabic *"mutrib,"* a musician) Turkish musical ensemble that plays for *sema*. The instruments traditionally included are: *ney* (reed-flute), *kudum* (a small kettle drum), *rebab* or *keman* (oriental violin), *kanun* (hammered dulcimer), *tanbur* (long-necked stringed instrument), *bendir* (round frame drum), and *ud* (also known as *oud,* an Arabian lute).

Na'at (Arabic/Turkish) In Arabic, it means hymn of praise and love. It is often a poem sung in honor of Muhammad. In the Mevlevi ceremony, the music of the Na'at (also called the Na'at-i-Serif) was composed by Buhuriz Mustafa Itri (1640–1712). The words of the Na'at were created by Rumi in praise of the Prophet Muhammad: "O Dear Master, friend of truth . . . "

Nafs In Sufism, refers to the false ego. The soul coming from the highest source but having identified itself with the smaller domain of the mind and body has conceived a false idea of itself. In archery, when one misses the mark or target this is a "sin." In a sense, *nafs* is that part of our being that aligns with this missed target.

Namaste (Sanskrit) Literally, "The name is!" A Hindu greeting that acknowledges the Divine within all.

Namaz (Turkish) Ritual prayers *(salat)* of the Muslim tradition. This is one of the five Pillars of Islam. The prayers are performed five times a day in relation to the light of the sun, beginning before the moment of sunrise and ending at the beginning of complete darkness.

Ney Literally means "throat." Wooden reed flute used in classical Middle Eastern music.

Neyzenbashi Chief *ney* player in the *mutrip*.

Ni'matullahi An order of Sufism in Persia (Iran).

Niyat The setting of one's intention particularly in regard to spiritual practice or ritual.

Odissi One of the classical dances of India, developed in Orissa as a form of worship in the temples of Lord Jagannatha, an incarnation of Krishna. It is composed of five types of dances, each a form of prayer and devotion.

Pervane A governor or political leader of a province.

Peshrev Literally means "preamble." Mode in Turkish music consisting of four parts played at the beginning of a classical performance.

Pied Piper (French) Hero in a German legend. Also the main character in a children's story in which the children of the village of Hamelin were mesmerized by the sound of the pipe and followed the piper out of the village.

Pir (Persian, "Old or elder.") A title given to a Sufi guide who is head of an Order. Ideally, the work of the *pir* is helping individuals toward the unfoldment of their soul.

Pir Vilayat Khan Spiritual leader of the Sufi Order International. He was born on June 19th, 1916, the son of Hazrat Inayat Khan.

Post (Means animal skin.) A red sheepskin that is an archetypal symbol of blood, life, the color of love, sacrifice of the self, and the sunset at Rumi's passing. In the Mevlevi tradition, it is the place where the *postnishin* sits or stands during the Shebi Arus ceremony. Traditionally, it is placed near the *mihrab* or prayer niche indicating the direction of Mecca.

Postnishin ("He who sits on the sheepskin.") One who is initiated as a living representative of the lineage of Mevlana in the Mevlevi Shebi Arus ceremony and who leads the ceremony itself. This *sema* is held on December 17th throughout the world, in honor of the passing of Jelaluddin Rumi.

Purification breaths A Sufi breathing practice developed in the Sufi Order International relating to the elements: earth, water, fire, air and ether.

Qadiri Order A Sufi Order in Africa and Asia.

Qalandar *(kalender)* A wandering dervish sect that arose during the early development of Sufism in Turkey. Its roots are steeped in shamanistic tradition.

Qur'an *(Koran)* The Recitation. The Islamic holy scripture that is recorded in the original language (Arabic) as received by Muhammad. It is said that he was visited by the angel Gabriel during the month of Ramadan and was commanded to recite *(Iqra')*. The chapters are called *suras* and the words came to Muhammad spontaneously throughout the remainder of his life. All of the *suras* of the *Qur'an* were recorded before the Prophet's death. The words themselves when chanted correctly are said to have a profound effect on all who hear them.

Rabi'a al'Adawiyya of Basra Recognized as a saint and mystic whose life, teachings and writings remain a source of inspiration to Sufis throughout the world. She died in 801.

Rafa'i Ma'arufi Order of America A Sufi order established in 1992 by Fakir Mehmet Serif Catalkaya (known affectionately as Sherif Baba), of Turkey. He received training in the Helveti, Rafa'i, Qadiri and Bektashi Orders.

Rafa'i Qadiri Order Founded by Shaikh Muhammad Ansari in the early 1900s in Turkey. Shaikh Tanner is the current *pir* of the Order and resides in Napa, California.

Ramadan In Arabic it means "the month of sizzling heat." A holy lunar month of fasting observed from dawn to sunset. This is one of the pillars of Islam. It was during the holy month of Ramadan that Muhammad received his spiritual awakening.

Rasul The Divine message bearer. The *Rasul* has a message for the whole of humanity. Examples would be Buddha, Jesus and Muhammad.

Retreat A period of time in which one leaves behind the outer world and with the guidance and protection of a teacher opens oneself to the inner journey.

Ruhaniat Society Also known as SIRS (Sufi Islamia Ruhaniat Society). Name of the Sufi Order taken by disciples of Murshid Samuel Lewis after his death. In Arabic, *"ruh"* is spirit. In the tradition of Sufism, *ruhaniat* is used to describe the spiritual essence that passes from teacher to students after the physical death of the shaikh.

Rumi Comes from the word "Rum," the name of Anatolia. This name was given to Muhammad Jelaluddin Rumi, the famous Persian mystic poet. He died December 17, 1273.

Saka The sheepskin placed on a bench near the doorway to the kitchen of a Mevlevi *khanqah*.

Salam Sacred word meaning "peace." *"A Salam Alleichum!"* May the peace of God be with you! A greeting given by Muslims to each other.

Salat (Arabic word) To worship. One of the five pillars of Islam is the practice of regular prayer. The Turkish word is *namaz*.

Salik A spiritual pilgrim who studies, meditates and ponders upon the religious teachings of his/her faith and lives his/her life according to those principles.

Sami Mahal Literally means" House of Sound." Formerly a *khanqah* for Sufism in Marin County, California.

Samuel Lewis *(Sufi Sam; Murshid Sam)* Creator of the Dances of Universal Peace. Student of Hazrat Inayat Khan. Friend of Ruth St. Denis. SIRS was founded by his followers. Died January 15, 1971.

Sangha A group of people who come together through the bond of spiritual connection.

Selam *(Salam)* In the Mevlevi tradition refers to the four ritual and musical sections in the sema ceremony (Shebi Arus) during which the dervishes turn.

Sema *(Sama')* "The hearing of the song." The soul of the lover hears the music of the first creation from a time before time. Originally, spontaneous moving or dancing in response to an ecstatic state awakened through the sound of sacred music, poetry or sacred words. In its earliest form it was performed at any time or place even without music. The mystical dance of the Mevlevis.

Semahanue *(Sama-khanah)* In the Mevlevi tradition, a house or hall especially designed for the sema ceremony where dervishes could gather for *zikr, sohbet* and turning.

Semazen "One who listens." One who has undergone formal training in the turning practice of the Mevlevi Order and has participated in at least one Shebi Arus.

Semazenbashi The lead *semazen(s)* who assists the *postnishin* in conducting the *sema* ceremony (Shebi Arus).

Shagal (From *shagil*, literally "being attentive.") Advanced breathing practice that closes the senses to the outer world in order to focus more deeply on inner states of consciousness.

Shahada The great statement of witnessing. This is the first step in becoming a Muslim. It is a declaration of faith.

Shaikh *(Sheikh,* or *Shaikha* in the feminine form). From the Arabic "elder." Generally means "spiritual leader." It is an initiation on the Sufi Path to one who is given the privilege and responsibility of representing a Sufi Order in the capacity of teacher.

Shamanism Ancient religion of Northern Asia that embraced a belief in spirits within the unseen world, which could be contacted by one who was skilled in earth magic and mysticism.

Shams-i Tabriz (Persian/Arabic) The sunlight of Tabriz. Rumi's teacher who was said to have been a *qalandar* (wandering dervish). He met Jelaluddin Rumi in the marketplace of Konya in October of 1244. Shams became the spark that lit the flame in the lamp of Rumi's soul, transforming Rumi into a mystical dervish poet. To Rumi, Shams was the Sun and his beloved friend. Shams disappeared in December of 1248.

Shariat *(Shari'a)* Literally, the "road" or "way." An Islamic term generally referring to religious law. Intended to guide people to act in ways harmonious with God's Will, with other people and with one's innermost soul.

Shebi Arus *(Shab-e-'Arus)* (Persian/Arabic) "The Wedding Night." The formal *sema* observed December 17th each year in memory of the passing of Jelaluddin Rumi.

Sikke *(Sikka)* (Turkish) In the Mevlevi tradition, a tall cylinder-shaped hat or fez made from camel's hair, usually honey-colored, worn by the *semazens* during the *sema* ceremony. It is a symbol of the tombstone.

Silsila Chain of the Order. The succession of spiritual teachers/ leaders of each Sufi order that have passed the tradition of Sufism from generation to generation through the ages.

Sirr-i-Allah *Sirr* refers to the innermost part of the heart. One's own secret with God.

SIRS See Ruhaniat Society.

Sohbet *(Suhbat)* Literally means "company." In Sufism, it is an intimate conversation regarding spiritual matters between the *shaikh* and *murids*. Often it occurs after a gathering such as *zikr*, providing an opportunity for questions and answers.

Subhan Allah (Arabic) Generally, to seek purity from God. *Subhan* is the sacred word for transcendental purity. In Arabic, it also implies "to swim" as in the cosmic ocean of Divine Love. In the *Qur'an* 36:40, the "circling motion" of the celestial bodies around the center.

Sufi *(Mystic, lover of God.)* The term itself is said to have come from *saf* meaning "pure," *suf* meaning "wool," a hair cloth used by followers in the early days of Islam, and *sufiy,* meaning "wise or pious." One who constantly strives to make God a living presence in their being and in their life.

Sufi Order International A Sufi Order from the Chisti lineage headed by Pir Vilayat Khan, the son and acknowledged successor of Hazrat Inyayat Khan. Originally named Sufi Order of the West.

Sufism A mystical path. Its roots are Islam; its stem is truth; the leaves are compassion, mercy, tolerance; the petals are love, harmony and beauty; and its fragrance is *ishq*, passionate love of God. On this path of love, one seeks to know and become one with God in this lifetime.

Sultan Veled In Arabic, *"walid"* is son of the authority. Son of Jelaluddin Rumi. After Rumi's disciple Husameddin, he became the leader of the Mevlevi Order. He created the Shebi Arus Ceremony to honor the passing of his father. This ceremony is still performed throughout the world on December 17th. He died in 1312.

Sultan Veled Walk See *Devri Veledi*.

Suleyman Hayati Dede Shaikh of The Mevlevi Order in Konya, Turkey. He helped to keep The Mevlevi Way alive after the closing of the *tekkes* in Turkey by Ataturk in 1925. He sent his son, Jelaluddin Loras, to America to share the way of Mevlana. He died on January 19, 1985.

Sura Name of the chapters or verses contained in the *Qur'an*.

Sura Fatiha The first chapter of the *Qur'an*, which is the most recited prayer in the Muslim tradition.

Taksim A long solo musical improvisation. In the *sema* ceremony, a *taksim* is played at the end of the fourth *selam* while the *postnishin* slowly crosses the floor to the *post*.

Tar (Also known as a *bendir* or *daf*). A one-sided circular drum made with wood and animal skin, whose various sounds correspond to the elements: earth, wind, fire and water. Often used during *zikr*.

Tariqat *(Tariqa)* "The path." Implies the understanding of the law besides the following of it. A stage of understanding that follows *shariat*. In the stage of tariqat one discovers what really matters. One is able to see the wrong in what is right and the right in that which is wrong. In this stage one begins to understand the true nature of things.

Tasbih Prayer beads, similar to a rosary. Usually a string of ninety-nine beads divided into sections of thirty-three used for counting *wazaif* (the Divine Names of God).

Tassawuri A Sufi practice in which one visualizes being in the presence of one's teacher. Another aspect to this practice is to try by every means to imitate one's

teacher. By trying to "become" the other person, there is the hope and belief that one's being will be expanded and a new level of consciousness awakened.

Tekke (Turkish) Place of repose. In the Mevlevi tradition, a convent for communal life designed to accommodate the dervish life style, including a communal kitchen, separate sleeping quarters, a place for turning, *sohbet* and *zikr,* etc.

Tennure *(Tannura)* Long white dress without sleeves with a full skirt worn by the *semazens.* It represents the burial shroud.

Theosophy (From the Greek *"theos sophia"* meaning "God wisdom.") A term used for esoteric spiritual wisdom independent of religious doctrine. The Theosophical Society was founded by Madame Blavatsky in 1875, author of *The Secret Doctrine.* She died in 1891. It originated as an eclectic approach to spiritual realization based largely on Buddhism and Hinduism.

Ulu Arif Chelebi Grandson of Jelaluddin Rumi and successor to his father, Sultan Veled as *pir* of the Mevlevi Order. During his lifetime the role of women flourished. He died in 1320.

Urs (Arabic) "Wedding." The anniversary of a saint's death.

Wazaif See *Wazifa.*

Wazifa *(Wazaif,* plural) (Arabic: to perform one's duties regularly, such as in an office; thus, sacred office.) The word itself refers to regular daily practice. Commonly known as the beautiful names of God, such as Compassion, Purity, Majesty etc. These Ninety-Nine Divine Names are found in the *Qur'an* and can be given as a spiritual practice by a Sufi teacher to the *murid.*

Whirling Dervishes Members of the Mevlevi Order who are initiated as *semazens.*

Wudu Ablutions. To set the intention of making yourself pure for prayers, through ritually washing the body.

Zarkub, Selaheddin The goldsmith became Rumi's teacher after Shams' final disappearance. Was known for the magnetism of his heart development and humility. His daughter, Fatima, married Rumi's son, Sultan Veled. He died in 1258.

Zikr *(Dhikr)* Remembrance of God. The practice of remembering and invoking God. Can be given as a practice to an individual by a teacher. As a group practice, the names and phrases of God are chanted or sung with simple unified movements. Also refers to the phrase *"La ilaha illa 'llah (Hu)."* "There is no reality, but God."

Translations and Collections of Rumi's Poetry

Angha, Dr. Nahid (trans.) *Selections, Poems from Khayan, Rumi, Hafez, Shah Magh-soud.* San Rafael, Calif.: International Association of Sufism, 1991.

Arberry, A. J. (trans.) *Mystical Poems of Rumi.* Vol. 1 & 2, Chicago: University of Chicago, 1968.

Bly, Robert (trans.) *When Grapes Turn To Wine.* Cambridge, Mass.: Yellow Moon Press, 1986.

Barks, Coleman (trans.) *Birdsong.* Athens, Georgia: Maypop, 1993.

Barks, Coleman (trans.) *Delicious Laughter. Athens,* Georgia: Maypop, 1990.

Barks, Coleman (trans.) *Feeling the Shoulder of the Lion.* Putney, Vermont: Thresh-old, 1991.

Barks, Coleman (trans.) *Like This.* Athens, Georgia: Maypop, 1990.

Barks, Coleman (trans.) *One-Handed Basket Weaving.* Athens, Georgia: Maypop, 1991.

Barks, Coleman (trans.) *The Hand of Poetry: Lectures by Inayat Khan,* New Lebanon, N.Y.: Omega, 1993.

Barks, Coleman (trans.) *The Illuminated Rumi.* New York: Broadway Books, 1997.

Barks, Coleman (trans.) *We Are Three.* Athens, Georgia: Maypop, 1987.

Barks, Coleman, and Robert Bly (trans.) *Night and Sleep.* Cambridge, Mass.: Yellow Moon Press, 1981.

Barks, Coleman, and Nevit Ergin (trans.) *Rumi, The Glance.* New York: Viking, 1999.

Barks, Coleman, with John Moyne (trans.) *The Essential Rumi.* San Francisco: HarperSan Francisco, 1995.

Barks, Coleman, and John Moyne (trans.) *This Longing.* Putney, Vermont: Thresh-old, 1988.

Barks, Coleman, and John Moyne (trans.) *Unseen Rain.* Putney, Vermont: Thresh-old, 1986.

Chopra, Deepak (ed.) *The Love Poems of Rumi.* New York: Harmony, 1998.

Cowen, James (trans.) *Rumi's Divan of Shems of Tabriz.* Rockport, Mass.: Element, 1997.

Ergin, Dr. Nevit O. (trans.) *Crazy As We Are.* Prescott, Arizona: Hohm, 1992.

Ergin, Dr. Nevit O. (trans.) *Magnificent One.* Burdett, N.Y.: Larson, 1993.

Ergin, Dr. Nevit O. (trans.) *Mevlana Celaleddin Rumi, Divan-i-Kebir.* vol. 1 & 2, Walla Walla, Wash.: Current, 1995.

Harvey, Andrew (trans.) *Light Upon Light.* Berkeley: North Atlantic, 1996.

Harvey, Andrew (trans.) *Love's Fire.* Ithaca, N.Y.: Meeramma, 1988.

Harvey, Andrew (trans.) *The Way of Passion.* Berkeley, Calif.: Frog, 1994.

Helminski, Kabir (trans.) *Love is a Stranger.* Putney, Vermont: Threshold, 1993.

Helminski, Kabir (trans.) *Rumi, Daylight.* Putney, Vermont: Threshold, 1994.

Helminski, Kabir (trans.) *The Rumi Collection* Brattleboro, Vermont: Threshold, 1998.

Khalili, Nader (trans.) *Rumi, Fountain of Fire*. Hesperia, Calif.: Cal-Earth, 1994.

Liebert, Daniel (trans.) *Rumi: Fragments–Ecstasies*. Cedar Hills, Mo.: Source, 1981.

Moyne, John, and Coleman Barks (trans.) *Open Secret*. Putney, Vermont: Threshold, 1984.

Moyne, John, and Coleman Barks (trans.) *Say I Am You*. Athens, Georgia: Maypop, 1994.

Moyne, John, and Coleman Barks (trans.) *These Branching Moments*. Providence, Rhode Island: Copper Beach Press, 1988.

Nicholson, Reynold A. (trans.) *Rumi, Poet and Mystic*. Oxford: Oneworld, 1995.

Schimmel, AnneMarie (trans.) *Look! This Is Love*. Boston and London: Shambhala, 1991.

Shiva, Shahram (trans.) *Rending The Veil: Literal and Poetic Translations of Rumi*. Prescott, Arizona: Hohm, 1995.

Star, Jonathan (trans.) *Rumi, In the Arms of the Beloved*. New York: Jeremy P. Tarcher / Putnam, 1997.

Star, Jonathan, and Shahram Shiva (trans.) *A Garden Beyond Paradise*. New York: Bantam, 1992.

Van de Weyer, Robert (ed.) *Rumi, In a Nutshell*. London: Hodder & Stoughton, 1998.

Books

Abbott, Nabia. *Aishah, The Beloved of Mohammad*. Chicago: University of Chicago, 1942.

Al-Ghazali. *The Ninety-nine Beautiful Names of God*. Translated by David Burrell and Nazih Daher. Cambridge, England: The Islamic Texts Society, 1992.

Almaas, A.H. *Diamond Heart: Book One, Elements of the Real in Man*. Berkeley, Calif.: Diamond Books, 1997.

Almaas, A.H. *Diamond Heart: Book Two, The Freedom To Be*. Berkeley, Calif.: Diamond Books, 1995.

Almaas, A.H. *Diamond Heart: Book Three, Being and the Meaning of Life*. Berkeley, Calif.: Diamond Books, 1994.

And, Metin. *A Pictorial History of Turkish Dancing*. Ankara, Turkey: Dost, 1976.

Armstrong, Karen. *A History of God, The 4,000-Year Quest of Judaism, Christianity, and Islam*. New York: Alfred A. Knopf, 1994.

Armstrong, Karen. *Muhammad, a Biography of the Prophet*. San Francisco: Harper-SanFrancisco, 1992.

Attar, Farid Ud-Din. *Mantiq Ut-Tair (The Conference of the Birds),* rendered into English from the French translation of Garcia de Tassy by C.S. Nott, Boulder, Colorado: Shambhala, 1954.

Baker, Mariam. *Woman as Divine: Tales of the Goddess*. Eugene, Oregon: Crescent Heart Publishing, 1982.

Bakhtiar, Laleh. *Sufi, Expressions of the Mystic Quest*. New York: Thames & Hudson, 1976.

Barks, Coleman, and Michael Green. *The Illuminated Prayer*. New York: Ballantine Wellspring, 2000

Bayram, Dr. Mikail. *Baciyan-i-Run*. Konya: Matbaacilik ve Ticaret, 1994. (Sections translated from the Turkish by Shaikha Muzeyyen Ansari.)

Birge, John Kingsley. *The Betashi, Order of Dervishes*. London: Luzac Oriental, 1994.

Brandon, Samuel G. F. *Religion in Ancient History*. New York: Charles Scribner's Sons, 1969.

Brown, John P. *The Darvishes*. London: Frank Cass & Co., 1968.

Brunton, Paul. *A Search in Secret India*. York Beach, Maine: Samuel Weiser, Inc., 1984.

Davis, John. *The Diamond Approach, An Introduction to the Teachings of A.H. Al-maas.* Boston: Shambhala Publications, 1999.

Douglas-Klotz, Neil. (Translations and commentaries.) *Desert Wisdom, Sacred Middle Eastern Writings from the Goddess through the Sufis,* San Francisco: HarperSanFrancisco, 1995.

El Eflaki, Shemsu-'d-din Ahmed. *Menaqib'L'Arifin.* Translated by James Redhouse, in: *Legends of the Sufis.* London: Theosophical Publishing, 1976.

El Eflaki, Ahmed. *The Mesnevi, Book the First.* Translated by James Redhouse. London: Trubner & Co., 1881.

Ernst, Carl W. *The Shambhala Guide to Sufism.* Boston: Shambhala, 1997.

Feild, Reshad. *The Last Barrier: A Journey Through the World of Sufi Teachings.* San Francisco: Harper & Row, 1976.

Frazer, Sir James. *The Golden Bough: A Study in Magic and Religion.* New York: Macmillan, 1922.

Friedlander, Shems. *Ninety-nine Names of Allah, The Beautiful Names.* San Francisco: HarperSanFrancisco, 1993.

Friedlander, Shems. *The Whirling Dervishes.* Albany, N.Y.: State University of New York Press, 1992.

Garnett, Lucy M. J. *The Dervishes of Turkey.* London: Octagon Press, re-printed 1990.

Garnett, Lucy, M. J. *The Women of Turkey and their Folklore.* Vol. 1 & 2, London: David Nuitt, 1891.

Golpinarli, Abdulbaki. *Mevlana dan sonra Mevilevilik.* Istanbul: Inkilap ve Aka, 1983. (Sections translated from the Turkish by Shaikha Muzeyyen Ansari.)

Goodwin, Jan. *Price of Honor.* New York: Plume / Penguin, 1994.

Halman, Talat Sait, and Metin And. *Mevlana Celaleddin Rumi and the Whirling Dervishes.* Istanbul: Dost Publication, 1983.

Huart, C. L. *Les Saints Des Derviches Tourneurs, recits traduits du Persan et Annotes,* Vol. 1 & 2. Paris: Ernest Leroux, 1919. (Selected translations by Drolma Gale.)

Huxley, Francis. *The Way of the Sacred.* New York: Doubleday, 1974.

Inayat, Taj. *The Crystal Chalice.* Lebanon Springs, N.Y.: Sufi Order, 1980.

Kabbani, Shaykh Muhammad Hisham, and Laleh Bakhtiar, *Encyclopedia of Muhammad's Women's Companions and the Traditions They Related.* Chicago: KAZI Publications, 1998.

Keesing, Elizabeth de Jong. *Inayat Khan, a Biography.* Translated by Hayat Bouman and Penelope Goldschmid. The Hague: East-West Publications, 1974.

Khan, Hazrat Inayat. *Character Building, The Art of Personality.* London: Luzac & Co.

Khan, Hazrat Inayat. *The Inner Life.* Katwijk, Holland: Servire, 1979.

Khan, Hazrat Inayat. *The Mysticism of Sound.* Katwijk, Holland: Servire, 1979.

Khan, Hazrat Inayat. *The Art of Personality.* Katwijk, Holland: Servire, 1982.

Khan, Hazrat Inayat. *Healing and the Mind World.* Farham Surrey, England: Servire, 1978.

Khan, Hazrat Inayat. *Spiritual Liberty.* Katwijk, Holland: Servire, 1979.

Khan, Hazrat Inayat. *The Alchemy of Happiness.* Farham Surrey, England: Servire, 1978.

Khan, Hazrat Inayat. *In An Eastern Rose Garden.* London: Barrie & Rockliff, 1962.

Khan, Hazrat Inayat. *Sufi Teachings.* New Delhi: Motilal Banarsidass, 1990.

Khan, Hazrat Inayat. *The Unity of Religious Ideals.* Katwijk, Holland: Servire, 1979.

Khan, Hazrat Inayat. *The Path of Initiation.* Katwijk, Holland: Servire, 1979.

Khan, Hazrat Inayat. *Philosophy, Psychology, and Mysticism.* Katwijk, Holland: Servire, 1979.

Khan, Hazrat Inayat. *The Vision of Man.* Katwijk, Holland: Servire, 1982.

Khan, Hazrat Inayat. *The Gathas.* Katwijk, Holland: Servire, 1982.

Khan, Inayat. *The Flower Garden.* London: East-West Publications, 1978.

Khan, Inayat. *The Gayan.* Tucson, Arizona: Message Publications, 1985.

Khan, Inayat. *The Way of Illumination, A Guide-book to the Sufi Movement.* Southampton: Camelot Press.

Khan, Sufi Inayat. *The Bowl of Saki.* Geneva: International Headquarters of the Sufi Movement, 1921.

Khan, Sufi Inayat. *The Palace of Mirrors.* Farham Surrey, Great Britain: Sufi Publishing Co., 1976.

Khan, Pir Vilayat. *Toward the One.* New York: Harper & Row, 1974.

Kinross, Lord. *The Ottoman Centuries, The Rise and Fall of the Turkish Empire.* New York: William Morrow and Co., 1977.

Kothari, Sunil. *Odissi, Indian Classical Dance Art.* Bombay: Marg, 1990.

Lalla. *Naked Song.* Translated by Coleman Barks. Athens, Georgia: Maypop, 1992.

Lewis, Franklin S. *Rumi, Past and Present, East and West: The Life, Teachings, and Poetry of Jalal al-Din Rumi.* Boston: Oneworld Publications, 2000.

Lewis, Samuel L. *Toward Spiritual Brotherhood.* Novato, Calif.: Prophecy Pressworks.

Lewis, Samuel L. *Spiritual Dance Walks, An Introduction to the Dances of Universal Peace and Walking Meditations.* Fairfax, Calif.: PeaceWorks, 1990.

Lifchez, Raymond, ed. *The Dervish Lodge.* Berkeley: University of California Press, 1992.

Lukach, Sir Harry. *The City of Dancing Dervishes: And Other Sketches and Studies from the Near East.* London: Macmillian and Co., 1914.

Mackenzie, Vicki. *Cave in the Snow: A Western Woman's Quest for Enlightenment.* New York: Bloomsbury, 1998.

Mernissi, Fatima. *Beyond the Veil.* Bloomington, Indiana: Indiana University Press, 1987.

Mernissi, Fatima. *The Forgotten Queens of Islam.* Translated by Mary Jo Lakeland. Minneapolis, Minn.: University of Minnesota Press, 1993.

Merinissi, Fatima. *The Veil and the Male Elite.* New York: Addison-Wesley, 1991.

Moyne, John A. *Rumi and the Sufi Tradition.* Binghamton, N.Y.: Globial Publications, 1998.

Muhaiyadden, M.R. Bawa. *The 99 Beautiful Names of Allah.* Philadelphia: Fellowship Press, 1979.

Murad, Sufi Ahmed. (Samuel L. Lewis) *In the Garden.* New York: Harmony, 1975.

Nurbakhsh, Dr. Javad. *Sama in Sufism.* Tehran, Iran: Khanighani-Nimatullahi, 1976.

Nurbakhsh, Dr. Javad. *Sufi Women.* New York: Khaniqahi-Nimatullahi, 1990.

Nurbakhsh, Dr. Javad. *The Tavern of Ruin.* London: Khaniqahi-Nimatullahi, 1978.

Onder, Mehmet. *Mevlana and the Mevlana Museum.* Istanbul: Aksit, 1993.

Onder, Mehmet. *Mevlana Jelaluddin Rumi.* Ankara: Amfora.

Ozak, Al- Jerrahi, Sheikh Muzaffer. *The Unveiling of Love.* New York: Inner Traditions International, 1981

Özelsel, Michaela. *Forty Days, The Diary of a Solitary Sufi Retreat.* Brattleboro, Vermont: Threshold Books, 1996.

Rabia. *Doorkeeper of the Heart, Versions of Rabi'a.* Translated by Charles Upton. Putney, Vermont: Threshold, 1988.

Redmond, Layne. *When Drummers Were Women.* New York: Three Rivers, 1997.

Rumi. *Signs of the Unseen: The Discourses of Jalaluddin Rumi.* Translated by W.M. Thackston, Jr. Putney, Vermont: Threshold, 1994.

Rumi. *Teachings of Rumi, The Masnavi.* Translated by E.H. Whitefield, London: Octagon, 1979.

Rumi. *The Mathnawi of Jalalu'ddin Rumi.* Vol. 1, 2, & 3, Edited and translated by Reynold A. Nicholson. Cambridge, England: Gibb Memorial Trust, 1926.

Rumi, Jellal-edin and Shems-edin. *The Whirling Ecstasy.* Selections from Huart, C. L., *Les Saints Dervishes Tourneurs,* translated into English by Edicione Sol Publications, Mexico City, 1954.

Sachs, Curt. *World History of the Dance*. New York: Bonanza, 1937.

Schimmel, AnneMarie. *I Am Wind: You Are Fire*. Boston: Shambhala, 1992.

Schimmel, Annemarie. *My Soul is a Woman*. Translated by Susan Ray. New York: Continuum, 1997.

Schimmel, AnneMarie. *Mystical Dimensions of Islam*. Chapel Hill: University of North Carolina Press, 1975.

Schimmel, AnneMarie. *The Triumphal Sun, A Study of the Works of Jalaloddin Rumi*. Albany, N.Y.: State University of New York Press, 1993.

Sells, Michael. *Approaching the Qur'an, The Early Revelations*. Ashland, Oregon: White Cloud Press, 1999.

Shah, Amina. *The Tale of the Four Dervishes of Amir Khusra*. London: Octagon, 1976.

Shah, Idries. *Tales of the Dervishes*. New York: E. P. Dutton & Co., 1970.

Shepard, Kevin. *A Sufi Matriarch: Hazrat Babajan*. Cambridge, Mass: Anthropographia, 1986.

Smith, Houston. *The Illustrated World's Religions*. San Francisco: Harper SanFrancisco, 1986.

Smith, Margaret. *Rabi'a, The Life and Work of Rabi'a*. Oxford: Oneworld, 1994

Spiegelman, J. Marvin, Pir Vilayat Khan, and Tasnim Fernandez. *Sufism, Islam, and Jungian Psychology*. Scottsdale, Ariz.: New Falcon, 1991.

Suhrawardi, Shahabuddin. *Awarifu-l-Ma'arif: Selections from A Dervish Textbook*. Translated by H. Wiberforce-Clarke. London: Octagon, 1980.

The Bhagavad Gita, As It Is. Translated by Swami A.C. Bhaktivedanta. New York: Collier, 1968.

The Glorious Koran. Translated by Mohammed Marmaduke Pickthall. Chicago: Mentor Press.

The Holy Quran. Translated by Abdullah Yusaf Ali. Lahore, Pakistan: Islamic University of Al Iman Mohammad ibn Sa'ud, 1938.

The Odissi Research Centre (ed.) *The Odissi Dance Pathfinder*. Bhubaneswar, India: Smt. KumKum Mohanty, 1988.

Tuglaci, Pars. *Osmanli Doneminde Istanbul Kadinlari (Women of Istanbul in Ottoman Times)*. Istanbul: Cem Yaymevi, 1984.

Tuglaci, Pars. *Osmanli Saray Kadinlari (The Ottoman Palace Women)*. Istanbul: Cem Yaymevi, 1985.

Turkmen, Dr. Erkan. *The Essence of Rumi's Masnevi*. Konya, Turkey: Misket, 1992.

Turkmen, Dr. Erkan. *Rumi, As a Lover of God*. Istanbul, Turkey: Baltac.

Turkmen, Dr. Erkan. *Rumi and Christ*. Konya, Turkey: Matbaaciler, 1992.

Tweedie, Irina. *The Chasm of Fire*, Rockport, Mass.: Element, 1993.

Vaughan-Lee, Llewellyn. *Catching the Thread: Sufism, Dreamwork and Jungian Psychology*. Inverness, Calif.: The Golden Gate Sufi Center, 1998.

Vaughan-Lee, Llewellyn. *Sufism: The Transformation of the Heart*, Inverness, Calif.: The Golden Gate Sufi Center, 1995.

Vitray-Meyerovitch, Eva de. *Rumi and Sufism*. Translated by Simone Fattal. Sausalito, Calif.: Post-Apollo, 1977.

Walther, Wiebke. *Woman in Islam*. Translated by C. S.V. Salt. Montclair, N. J.: Abner Schram Ltd., 1981.

Wilcox, Lynn. *Women and the Holy Qur'an: A Sufi Perspective*. Vol. 1. Riverside, Calif.: M.T.O. Shahmaghsoudi Publications, 1998.

Wosien, Maria-Gabriele. *Sacred Dance, Encounter with the Gods*. London: Thames & Hudson, 1994.

Yagan, Murat. *I Come from Behind Kaf Mountain*. Putney, Vermont: Threshold Books, 1984.

Articles and Other Sources

Ansari Tarsusi er Rifa'i Qadiri, Shaikh Taner. *Adab, the Core of Sufism*. Presented at the International Sufi Symposium, Fremont, Calif., March, 1998.

Baker, Mariam. (ed.) *Lovers of Mevlana.* Fairfax, Calif.: Mevlevi Order of America, 1997, vol. 2, no. 4.

Mevlevi Order of America. *Sema of Beginning* (Program notes). Fairfax, Calif., 1993.

Sultan Veled. *The Hymn of Entreaty,* an *illahi* trans. by Refik Algan and Camille Helminski, in CD pamphlet for album: "Wherever You Turn is the Face of God: Mevlevi Ceremonial Music." Santa Barbara, Calif.: Water Lily Acoustics, 1995.

Kafadar, Cemal. "Women in Sejuk and Ottoman Society Up to the Mid-19th Century." In: *Woman In Anatolia, 9000 Years of the Anatolian Woman.* Istanbul: The Turkish Republic Ministry of Culture General Directorate of Monuments and Museums, 1993.

Image Credits

Opening Images

p. i. *Semazen* and shadow, photo by Bill Kalinowski, courtesy of
 Mevlevi Order.

p. ii. "Butterflies," photo by Bill Kalinowski, courtesy of Mevlevi Order.

p. iii. "Herding Butterflies," photo by Bill Kalinowski, courtesy of
 Mevlevi Order.

Frontmatter

p. viii. *Qur'an* of Fatima binti Maksud Aliyu'l-Rumi el-Katib, courtesy
 of Konya Mevlana Museum.

p. xi. Feriste Hanum, photo courtesy of Nur Jehan.

p. xv. Suleyman Dede, photo by Peter Barkham.

p. xvi. Hazrat Inayat Khan, photo courtesy of Hadi Reinhertz.

Introduction

p. xx. "Phoenix," drawing by Mirabai Chrin.

p. xxi. "Changing Woman," drawing by Deborah Koff-Chapin.

p. xxiii. "Universal Dances of Peace," drawing by Fatima Lassar.

p. xxiv. Tomb of Rumi, photo courtesy of Iris Steward.

p. xxv. "Rumi" by Kemalleddin Behzad, courtesy of the Konya Mevlana Museum.

p. xxvi. "Unseen Being," drawing by Deborah Koff-Chapin.

p. xxix. Shaikh Athan's letter, courtesy of author.

Chapter 1: What is a Dervish?

p. xxx. Nur Jehan, photo by author.

p. 1. Mevlana's Tughra, calligraphy by Hafizullah Chisti.

p. 2. Feriste Hanum, photo by Suleyman Scott Hofman.

p. 3. Hazrat Babajan, by Paul Brunton: *A Search in Secret India* (York
 Beach, Maine: Samuel Weiser, Inc., 1984). Material used by permission.

p. 4. *Sohbet* with Dede, photographer unknown, courtesy of Mevlevi Archives.

p. 5. "Angel," drawing by Fatima Lassar.

Chapter 2: Origin of Turning and Sema

p. 6. Delilah in Hathor's Temple in Abu Smible, Egypt, photo by Laura Legere.

p. 7. Bismillah Thuluth Round, courtesy of Sakkal Designs.

p. 8. (top) Ova spinning down fallopian tube, video still from "Miracle
 of Life," courtesy of Crown Publishing Group.
 (bottom) "Dance of the Gypsies" (19th century), from *Women in Istanbul
 of Ottoman Times* by Pars Tuglaci.

p. 9. Persian stone carving of rider from 6th century, *Persian Designs
 and Motifs* by Ali Dowlatshahi, courtesy of Dover Publications.

Sema: Rumi's Courtyard

Chapter 3: Women Dervishes of the Past

Chapter 4: Training of a Dervish: Then and Now

Sema Stories

(bottom) Linda, still from video of *zikr* at Oddfellows Hall, Seattle, courtesy Mevlevi Archives.
p. 40. Gulistan, photo by Matin Mize.
p. 41. "Prayer of Light" illumination, by Susan Najmah Arnold.

Chapter 5: Shebi Arus, The Wedding Night
p. 42. Brieana, photo by author.
p. 43. Bismillah star, calligraphy by Hafizullah Chisti.
p. 44. Shaikh Suleyman Dede, photographer unknown, courtesy of Mevlevi Archives.
p. 45. Line-up of *semazens,* courtesy of Mevlevi Archives.
p. 46. Postnishin Jelaluddin Loras bowing at *post,* courtesy of Mevlevi Archives.
p. 47. Turning, photographer unknown, courtesy of Mevlevi Archives.
p. 48. Postnishin Jelaluddin Loras turning during fourth *selam,* courtesy of Mevlevi Archives.
p. 51. Turkish design from 16th century manuscript, *Authentic Turkish Designs* by Azade Akar, courtesy of Dover Publications.

The Wedding Night
p. 52. Na'at, illuminated frame by Susan Najmah Arnold.
p. 53. Rashid and Hilal listening to Na'at, still from video by James Dupre.
p. 54. *Semazen* Kera enters the *Semahanue,* courtesy of Mevlevi Archives.
p. 55. (top) *Semazens* enter hall, photograph by Bill Kalinowski, courtesy of Mevlevi Archives.
 (bottom) Bowing at *post,* courtesy of Mevlevi Archives.
p. 56. (top) Close up of the Sultan Veled walk, courtesy of Mevlevi Archives.
 (lower left) Folding *hurka,* photograph by Leslie Hirsch
 (lower right) Line up of *semazens* at Dominican College, courtesy of Mevlevi Archives.
p. 57. (top) Beginning of first *selam,* courtesy of Mevlevi Archives.
 (bottom) First *semazen* begins turning, courtesy of Mevlevi Archives.
p. 58. *Semazens* start forming circle (Feriste), photo by Hadi Reinhertz.
p. 59. *Semazens* turning in place, courtesy of Mevlevi Archives.
p. 60-61. *Sema* in Seattle, photograph by Bill Kalinowski, courtesy of Mevlevi Archives.
p. 62. (top) *Semazens* bowing at *post* before turning, photograph by Bill Kalinowski, courtesy of Mevlevi Archives.
 (bottom) Inner circle, fourth *selam,* photo by Matin Mize.
p. 63. Postnishin Jelaluddin as *Kutup Noktasi,* courtesy of Mevlevi Archives.
p. 64. (top) End of fourth *selam,* seated for *Fatiha,* photo by Bill Kalinowski, courtesy of Mevlevi Archives.
p. 64. (bottom) Kissing of the hands, end of Shebi Arus, courtesy of Mevlevi Archives.
p. 65. Fatiha illumination from the personal *Qur'an* of Imam Bilal Hyde.

Chapter 6: Semazens of More Than Twenty Years
p. 66. "Carpet of Joy," artwork by Susan Najmah Arnold.
p. 67. Wife of Sultan Ahmed III being served coffee, circa 1720, courtesy of Bibliotheque Nationale de France.
p. 68. Noor Karima in *sema,* courtesy of Mevlevi Archives
p. 69. Collage of Shaikh Suleyman Hayati Dede, photographer unknown, courtesy of Mevlevi Archives.
p. 71. Karim and Noor Karima, photo by Hilal Sala.
p. 72. Jelaluddin Loras turning in *zikr* at Claymont, photographer unknown, courtesy of Mevlevi Archives.

Chapter 7: Members of the First Class

Chapter 8: Atesh Bas

Chapter 9: Zikr, The Practice of Remembrance

Chapter 14: Singers in the Mutrip

Chapter 15: The Next Generation

End

For more information on artwork:

Deborah Koff-Chapin	www.soulcards.com
Fatima Lassar	fatimasart@yahoo.com
Susan Najmah Arnold	starnajmah@hotmail.com
Susan St. Thomas	sstmandala@telis.org
Sakkal Designs	www.sakkal.com

Mevlevi Order of America

The Mevlevi Order of America is a non-profit organization with centers in California, Washington, Oregon, Virginia and Hawaii. Throughout the year, classes, workshops and public sharing of *zikr* and *sema* led by Postnishin Jelaluddin Loras are offered. For further information please see: www. hayatidede.org

Index

RENDING THE VEIL: *Literal and Poetic Translations of Rumi*
by Shahram T. Shiva
Preface by Peter Lamborn Wilson
With a groundbreaking transliteration, English-speaking lovers of Rumi's poetry will have the opportunity to "read" his verse aloud, observing the rhythm, the repetition, and the rhyme that Rumi himself used over 800 years ago. Offers the reader a hand at the magical art of translation, providing a unique "word by word" literal translation from which to compose one's own variations. Together with exquisitely-rendered Persian calligraphy of 252 of Rumi's quatrains (many previously untranslated), Mr. Shiva presents his own poetic English version of each piece. From his study of more than 2000 of Rumi's short poems, the translator presents a faithful cross-section of the poet's many moods, from fierce passion to silent adoration.
Cloth, 280 pages, $27.95, Persian Calligraphy ISBN: 0-934252-46-7

RUMI, THIEF OF SLEEP
180 Quatrains from the Persian
Translations by Shahram Shiva; Foreword by Deepak Chopra
This book contains 180 translations of Rumi's short devotional poems, or quatrains. Shiva's versions are based on his own carefully documented translation from the Farsi (Persian), the language in which Rumi wrote.
 "In *Thief Of Sleep,* Shahram Shiva (who embodies the culture, the wisdom and the history of Sufism in his very genes) brings us the healing experience. I recommend his book to anyone who wishes *to remember.* This book will help you do that."—Deepak Chopra, author of *How to Know God*
Paper, 120 pages, $11.95 ISBN:1-890772-05-4

CRAZY AS WE ARE
Selected Rubais from the Divan-i-Kebir of Mevlana Celaleddin Rumi
Introduction and Translation by Dr. Nevit O. Ergin
This book is a collection of 128 previously untranslated *rubais,* or quatrains (four-line poems which express one complete idea), of the 13th-century scholar and mystic poet Rumi. Filled with the passion of both ecstasy and pain, Rumi's words may stir remembrance and longing, or challenge complacency in the presence of awesome love. Ergin's translations (directly from Farsi, the language in which Rumi wrote) are fresh and highly sensitive, reflecting his own resonance with the path of annihilation in the Divine as taught by the great Sufi masters.
Paper, 88 pages, $9.00 ISBN 0-934252-30-0

SONGS OF THE QAWALS OF INDIA
Islamic Lyrics of Love and God —Recordings by Deben Bhattacharya
These recent recordings of a centuries-old musical form were made in Kashmir and in Varanasi, India. Five exquisite songs speak of love, life and death, of God and the dedicated beings, of the Prophet Muhammad and his early followers. Qawali in its current musical form was introduced in India towards the end of the 13th century by a great musician named Amir Khasru, whose ancestors came to India from Iran.
 The name Qawali is also attributed to a rhythm of eight beats, divided 4/4. Qawali is sung in both Hindi and Urdu-speaking regions of North India, usually by professional Muslim Qawals (singers), while the musicians are generally Hindus. The instruments used are those popular with the folk musicians of North India: the harmonium, the *sarangi* or broad-necked fiddle, the barrel-shaped double-headed drum *(dholak)* and a pair of cymbals. Includes photos, introduction and song lyrics
Includes photos, introduction and song lyrics, 60-minute CD, $15.00 ISBN: 1-890772-12-7

NOBODY, SON OF NOBODY
Poems of Shaikh Abu-Saeed Abil-Kheir —Renditions by Vraje Abramian
Anyone who has found a resonance with the love-intoxicated poetry of Rumi, must read the poetry of Shaikh Abil-Kheir (a-bel-kheyr). This renowned, but little known, Sufi mystic of the 10th-century preceded Rumi by over two hundred years on the same path of annihilation into God. This book contains translations and poetic renderings of 195 short selections from the original Farsi, the language in which Abil-Kheir wrote.
 These poems deal with the longing for union with God, the desire to know the Real from the False, the inexpressible beauty of Creation when seen through the eyes of Love, and the many attitudes of heart, mind and feeling that are necessary to those who would find the Beloved/The Friend in this life.
Paper, 120 pages, $12.95 ISBN: 1-890772-04-6

Additional Titles of Interest
HOHM PRESS

THE WOMAN AWAKE
Feminine Wisdom for Spiritual Life
by Regina Sara Ryan

Though the stories and insights of great women of spirit whom the author has met or been guided by in her own journey, this book highlights many faces of the Divine Feminine: the silence, the solitude, the service, the power, the compassion, the art, the darkness, the sexuality. Read about: the Sufi poetess Rabia (8th century) and contemporary Sufi master Irina Tweedie; Hildegard of Bingen, Mechtild of Magdeburg, and Hadewijch of Brabant: the Beguines of medieval Europe; author Kathryn Hulme *(The Nun's Story)* who worked with Gurdjieff; German.healer and mystic Dina Rees . . . and many others.

Paper, 35 b&w photos, 520 pages, $19.95 ISBN: 0-934252-79-3

THE SHADOW ON THE PATH
Clearing the Psychological Blocks to Spiritual Development
by VJ Fedorschak
Foreword by Claudio Naranjo, M.D.

Tracing the development of the human psychological shadow from Freud to the present, this readable analysis presents five contemporary approaches to spiritual psychotherapy for those who find themselves needing help on the spiritual path. Offers insight into the phenomenon of denial and projection. Topics include: the shadow in the work of notable therapists; the principles of inner spiritual development in the major world religions; examples of the disowned shadow in contemporary religious movements; and case studies of clients in spiritual groups who have worked with their shadow issues.

Paper, 304 pages, $16.95 ISBN: 0-934252-81-5

HALFWAY UP THE MOUNTAIN
The Error of Premature Claims to Enlightenment
by Mariana Caplan
Foreword by Fleet Maull

Dozens of first-hand interviews with students, respected spiritual teachers and masters, together with broad research are synthesized here to assist readers in avoiding the pitfalls of the spiritual path. Topics include: mistaking mystical experience for enlightenment; ego inflation, power and corruption among spiritual leaders; the question of the need for a teacher; disillusionment on the path . . . and much more.

"Caplan's illuminating book . . . urges seekers to pay the price of traveling the hard road to true enlightenment." —*Publisher's Weekly*

Paper, 600 pages, $21.95 ISBN: 0-934252-91-2

WOMEN CALLED TO THE PATH OF RUMI
The Way of the Whirling Dervish
by Shakina Reinhertz

This book shares the experience of Turning by women practitioners of the Mevlevi Order of Whirling Dervishes. It outlines the history of the women who have followed this way since Rumi's time, illuminates the transmission of this work from Turkey to America, and highlights the first twenty years of the Order's life in a new country and culture.

The heart of the book is the personal experience of contemporary women—interviews with over two dozen American initiates (from adolescents to wise elders), many of whom have practiced on this path for twenty years or more. Their descriptions of the rituals and ceremonies of the Mevlevi way are offered from the viewpoint of the participant rather than the observer.

"I love the wisdom and fire of this book. It's full of the light of longing and people trying to experience the mystery of that truth." —Coleman Barks, author, and translator of Rumi's poetry.

Paper, 296 pages, 240 black and white photos and illustrations, $23.95 ISBN: 1-890772-04-6

Retail Order Form
HOHM PRESS BOOKS

Name _____ Phone _____

Street Address or P.O. Box _____

City _____ State _____ Zip _____

ITEM NO.	QTY	TITLE	ITEM PRICE	TOTAL PRICE
1		Rending the Veil	$27.95	
2		Rumi, Thief of Sleep	$11.95	
3		Crazy as We Are	$ 9.00	
4		Songs of the Qawals of India, CD	$15.00	
5		Nobody, Son of Nobody	$12.95	
6		The Woman Awake	$19.95	
7		The Shadow on the Path	$16.95	
8		Halfway Up the Mountain	$21.95	
9		Women Called to the Path of Rumi	$23.95	
10				
		Subtotal		
		Shipping (see below)		
		TOTAL		

Surface Shipping Charges
1st book or CD **$5.00**
Each additional item **$1.00**

Method of Shipping
_____ Surface U.S. Mail (Priority)
_____ 2nd-Day Air Mail (Mail +$5.00)
_____ FedEx Ground (Mail +$2.00)
_____ Next-Day Air Mail (Mail +$15.00)

Method of Payment
_____ Check or Money Order—Payable to Hohm Press
P.O. Box 2501, Prescott, AZ 86302
_____ Credit Card by phone—call 800.381.2700
_____ Credit Card by fax—call 520.717.1779

Credit Card Information
Card # _____
Expiration Date _____

Order Now!

Call 800.381.2700
or fax your order to
520.717.1779

**Visit our website to view
our complete catalog:
www.hohmpress.com**